THE MISSISSIPPI

★ AND THE MAKING OF A NATION ★

FROM THE LOUISIANA PURCHASE TO TODAY

★

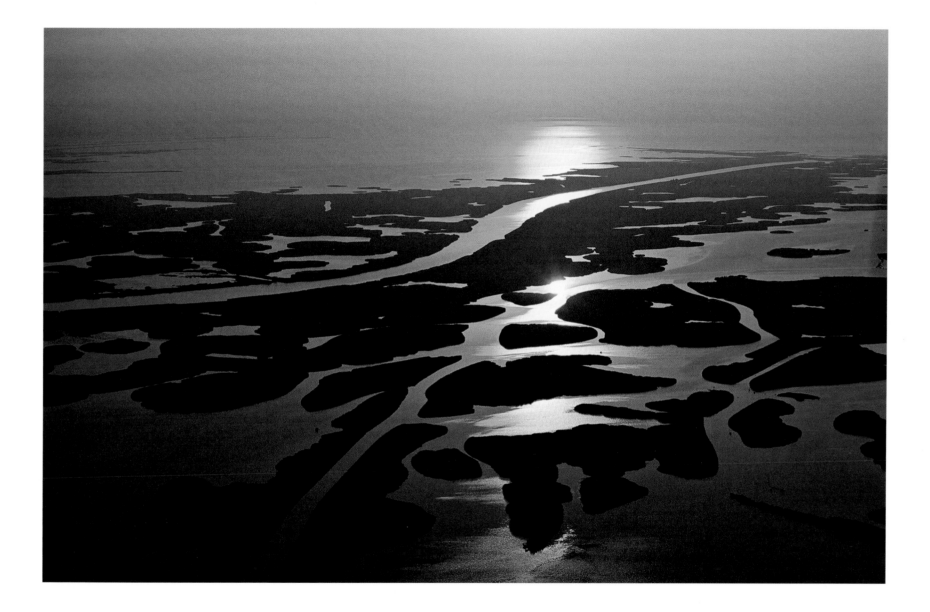

Land melts into water at the mouth of the Mississippi River.

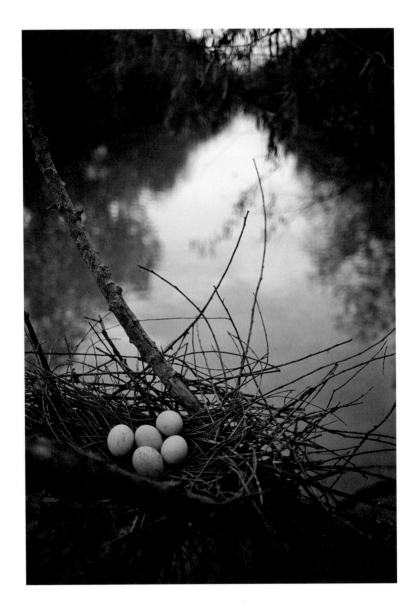

A quiet Delta backwater offers sanctuary to a heron's nest.

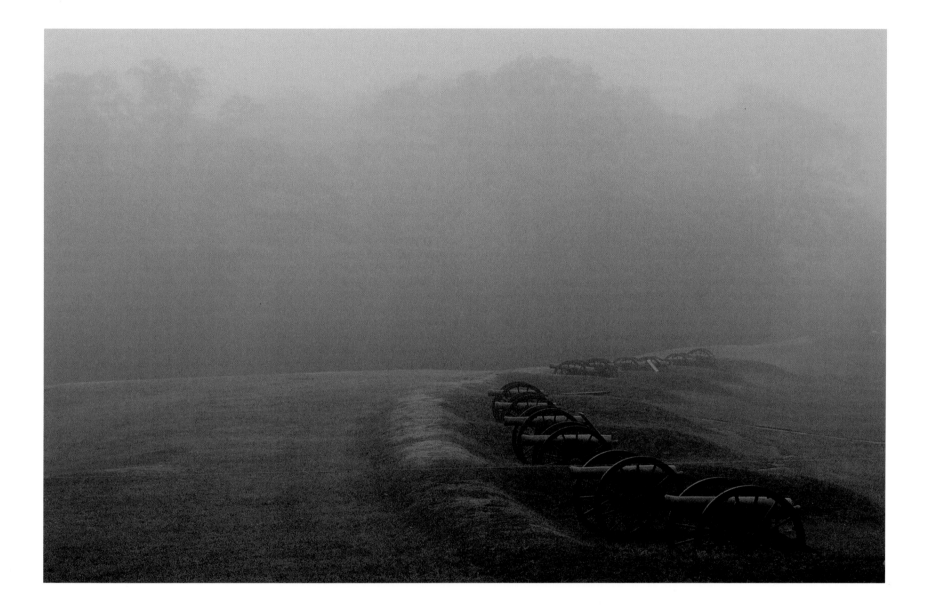

Union cannon emerge from the fog at Vicksburg National Military Park.

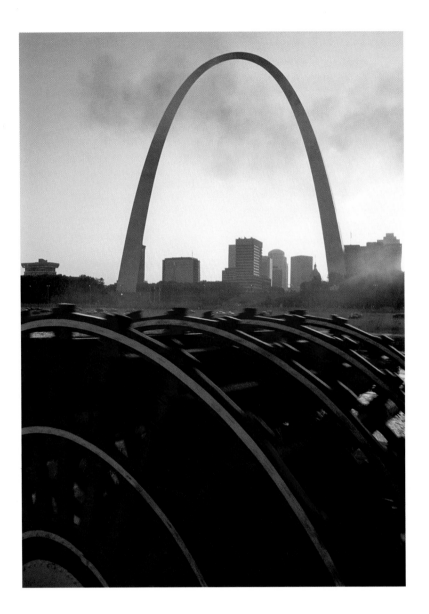

The Gateway Arch in St. Louis commemorates America's Westward Expansion.

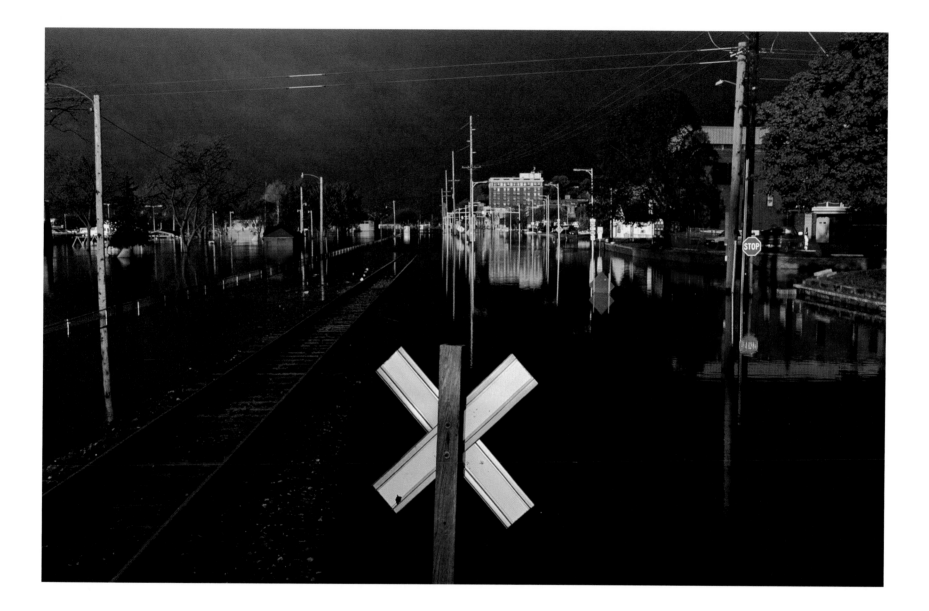

Floodwater mirrors Muscatine, Iowa, in the spring of 2001.

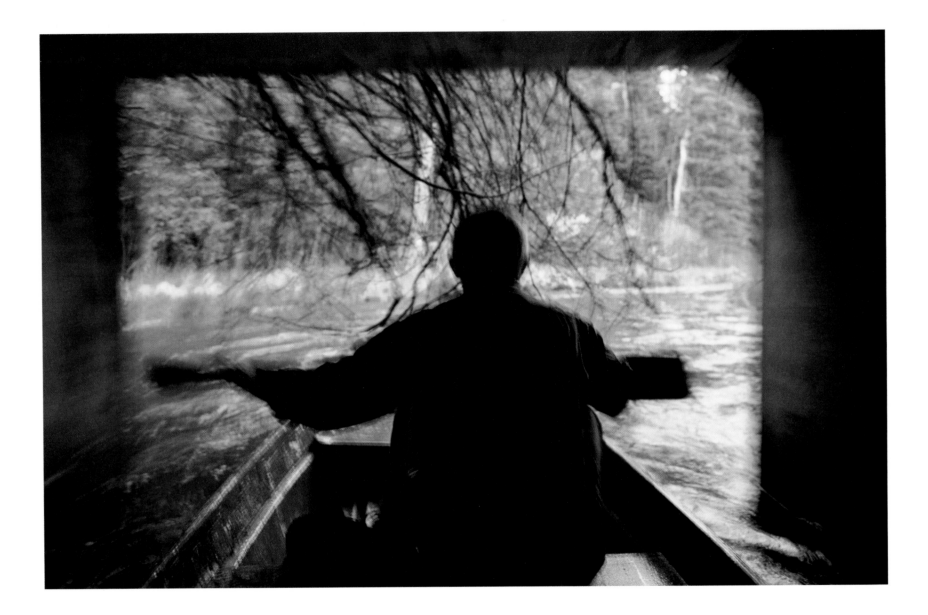

A canoeist navigates the headwaters of the Mississippi River.

The Mississippi River begins at Lake Itasca, Minnesota.

STEPHEN E. AMBROSE

THE MISSISSIPPI

★ AND THE MAKING OF A NATION ★

FROM THE LOUISIANA PURCHASE TO TODAY

DOUGLAS G. BRINKLEY

PHOTOGRAPHS BY SAM ABELL

★

NATIONAL GEOGRAPHIC

WASHINGTON, D.C.

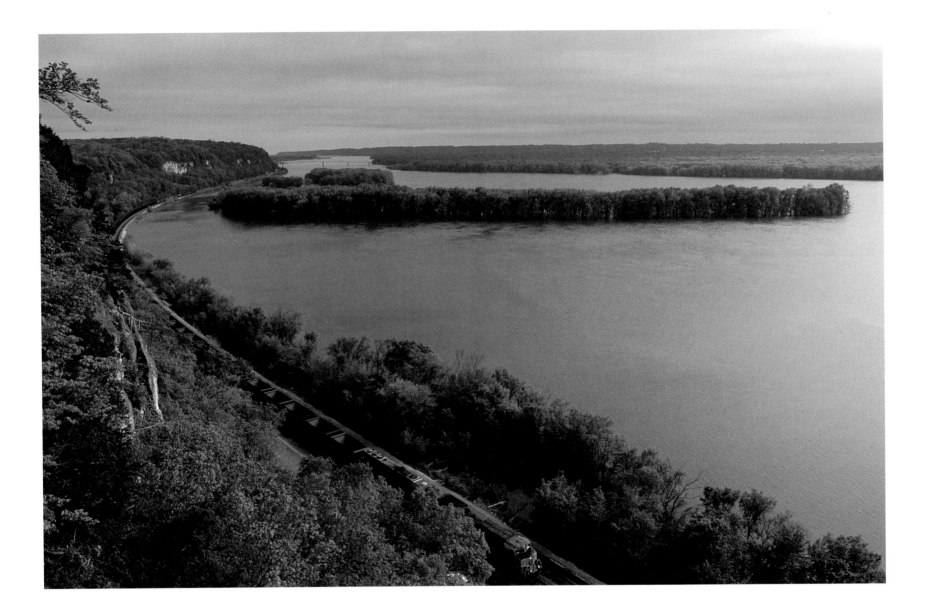

Dedicated to all those who live along the Mississippi — STEPHEN AMBROSE AND DOUGLAS BRINKLEY

To Cliff Rahn, Lyle Myers, and Allen Kringlee, Men of the Mississippi — SAM ABELL

A northbound train parallels the Mississippi near Savannah, Illinois.

CONTENTS

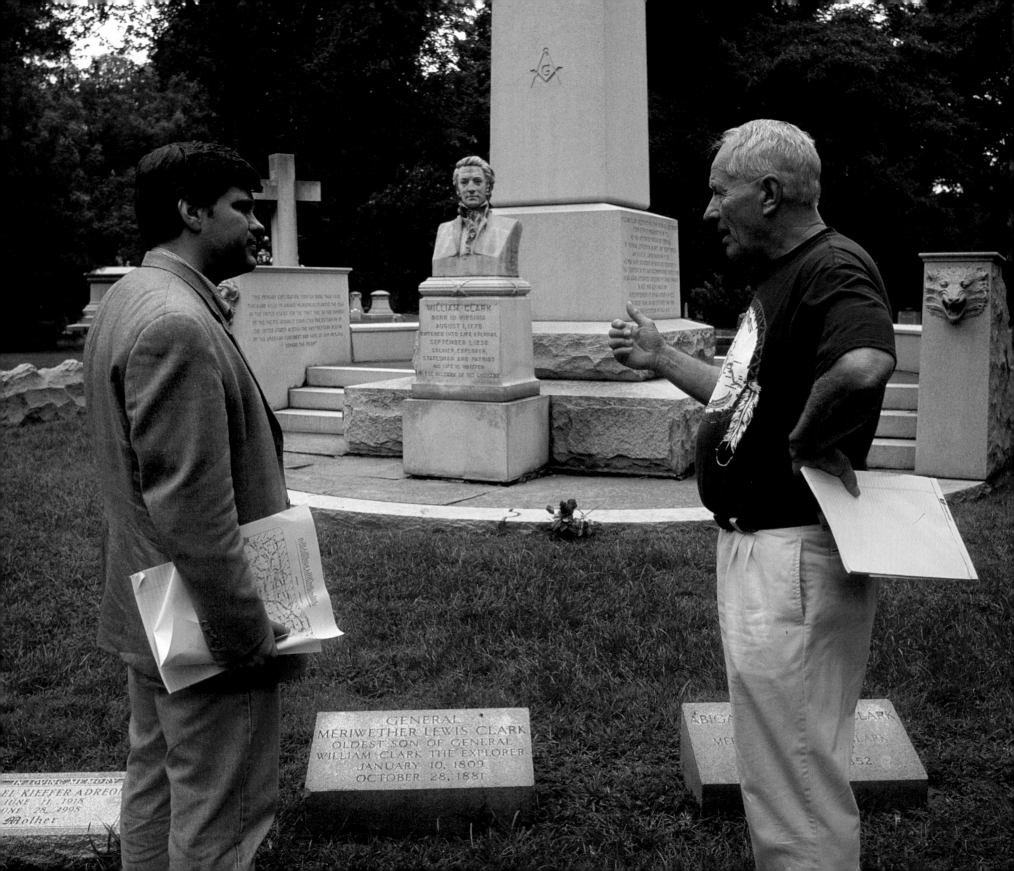

INTRODUCTION

★

I WAS BORN ON THE SANGAMON RIVER in Illinois, grew up on the Rock River in Wisconsin, went to school on the banks of the Mississippi River, and spent most of my career at the mouth of the Mississippi. On these rivers I swam, canoed, hunted deer in Wisconsin and ducks in Louisiana. With my family I've camped on islands in the Mississippi. We walked across it at Lake Itasca. In New Orleans, we cross by ferry. I've driven Hwy. 61 many times, up- or downriver and on the east side, Wisconsin to Louisiana or reverse. This was before the Interstate, so I got to know the towns along the river. The river is in my blood. Wherever, whenever, it is a source of delight. More, it is the river that draws us together as a nation.

Tex McCrary said on June 6, 2000, that he was pleased to see the National D-Day Museum opening in New Orleans "on the river that was Mark Twain's heart of America." It is our lifeblood. Whenever it was blocked or threatened by an enemy, Americans kept it open. To do that, my great-grandfather, Sgt. Pleasant Bishop, actually fought with Gen. Ulysses S. Grant at the battle of Vicksburg during the Civil War.

The river has always drawn me in with its history. I became a Civil War historian because I wanted to know how the Union opened the river. Thomas Jefferson's Louisiana Purchase, agreed to by Napoleon in 1803 when he realized that Jefferson would fight for New Orleans if necessary, did not settle the question of who would control the river. In the War of 1812 the British and their Indian allies, including the Sauk war leader Black Hawk, tried to take control of the upper river. They were stopped at Fort Madison, Iowa. In 1815 the British attacked New Orleans, but were defeated by Gen. Andrew Jackson and his American frontiersmen. In 1832 Black Hawk and the Sauk and Fox, called the "British Band," tried again to drive back American settlers on the Illinois and Wisconsin banks of the river, with the by-then President Jackson to stop them. In the Civil War it was the Confederates who attempted to wrest control of the river, only to lose to Ulysses Grant's Union forces.

At Bellefontaine Cemetery, in St. Louis, Missouri, authors Stephen Ambrose and Douglas Brinkley pay homage to William Clark, co-captain of America's epic Lewis and Clark expedition, 1803-1806, which explored the Louisiana Purchase west of the Mississippi River.

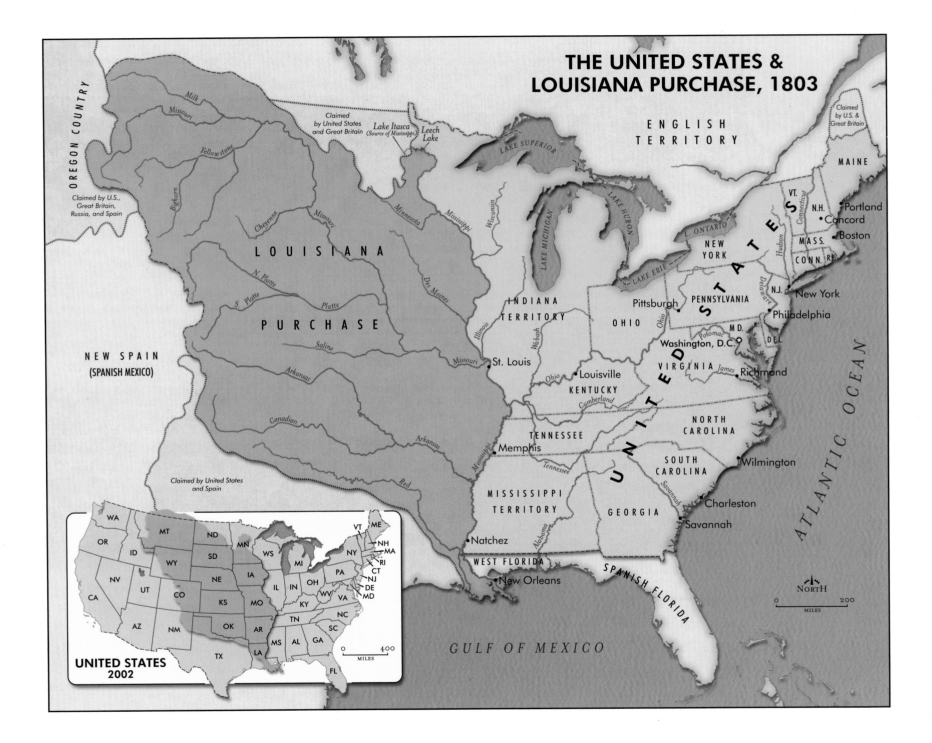

THE UNITED STATES & LOUISIANA PURCHASE, 1803

OREGON COUNTRY

Claimed by U.S., Great Britain, Russia, and Spain

NEW SPAIN (SPANISH MEXICO)

Milk

Missouri

Yellowstone

Bighorn

Cheyenne

Missouri

N. Platte

S. Platte

Platte

Saline

Arkansas

Canadian

Arkansas

Red

Claimed by United States and Spain

Claimed by United States and Great Britain

Lake Itasca (Source of Mississippi)

Leech Lake

Minnesota

Mississippi

Wisconsin

Des Moines

Illinois

Missouri

LOUISIANA

PURCHASE

St. Louis

LAKE SUPERIOR

ENGLISH TERRITORY

LAKE MICHIGAN

LAKE HURON

L. ONTARIO

LAKE ERIE

INDIANA TERRITORY

Wabash

OHIO

Ohio

Pittsburgh

PENNSYLVANIA

Louisville

KENTUCKY

Cumberland

Ohio

Washington, D.C.

VIRGINIA

James

Richmond

MD.

DEL.

Potomac

NEW YORK

Hudson

Connecticut

VT.

N.H.

MASS.

CONN. R.I.

N.J.

MAINE

Portland

Concord

Boston

New York

Philadelphia

UNITED STATES

Claimed by U.S. & Great Britain

Delaware

TENNESSEE

Memphis

Mississippi

Tennessee

Tennessee

NORTH CAROLINA

SOUTH CAROLINA

Wilmington

Charleston

Savannah

Savannah

GEORGIA

MISSISSIPPI TERRITORY

Alabama

WEST FLORIDA

Natchez

New Orleans

SPANISH FLORIDA

ATLANTIC OCEAN

GULF OF MEXICO

NORTH

0 200
MILES

UNITED STATES 2002

WA
OR
ID
MT
ND
MN
WS
VT
ME
NH
NY
MA
RI
CT
NJ
DE
MD
NV
UT
WY
SD
IA
MI
PA
CA
CO
NE
KS
MO
IL
IN
OH
WV
VA
AZ
NM
OK
AR
TN
KY
NC
TX
MS
AL
GA
SC
LA
FL

0 400
MILES

In World War I, President Woodrow Wilson made New Orleans a naval base. In World War II, the Germans tried with submarines to close down the river. President Franklin Roosevelt sent anti-submarine patrols to the Gulf of Mexico to end the threat. In that war, Andrew Higgins built in New Orleans the landing craft that helped win victory in the Atlantic and Pacific. St. Louis built airplanes. The Rock Island Arsenal in Illinois made mortars and howitzers. Minneapolis packaged rations that fed the troops overseas.

My life on the Mississippi has included a fine moment: I was 23. I was duck hunting at Pass à Loutre, one of the three mouths of the river. The pirogue tipped. I was standing in muck almost up to my knees—with no other boat nearby.

Rather than think of my predicament, I exulted at the thought of being at the spot where earth meets sea and life began. I was on the last deposit of sediment from the topsoils of every state between the Appalachian and the Rocky Mountains. To my right, the open Gulf of Mexico. To my left, Head of Passes, where the river divides into its three main channels. I thought of Abraham Lincoln and his love for the river. And the love of all those who have lived in the valley from ancient times, including Native Americans, Spanish, French, Asians, African-Americans. All around me were raccoons, water snakes, rabbits, and turtles, egrets, ibis, ducks, hawks, osprey, herons, and more. This primeval spot was bursting with life eons ago and still is today. It is America's opening to the world, and its welcoming to ships from around the world. It seemed to me that the Mississippi River does not divide the United States in half but rather draws the country together, that it is the spine of America.

In December 1956, at age 20, I did for the first time something nearly everyone living in the Mississippi Valley wants to do—go to New Orleans. Sin, fun, commerce, a conglomeration of races—all this and more at the port city. When I left Madison, Wisconsin, hitchhiking, it was below-zero weather. Two days later, New Orleans had bright sunlight and 70 degrees. They let you live here? I thought. Where do I sign? I fell in love with the city on my first day in the French Quarter. I have spent much of my working life there and still love it more than four decades later.

Among many other attractions, New Orleans offers food, music, Mardi Gras. It is America's favorite party city. But above all else it has the river—relatively narrow, deep and fast. It is always in your mind; directions given in New Orleans are "upriver" or "downriver" or "away from the river." Working boats of all types are on it. Walking on the levee gazing at the river on one side and the French Quarter on the other is what I do for pleasure.

New Orleans's love affair with its own history draws me there, especially to Jackson Square, where Gen. Andrew Jackson sits on his rearing horse. Inscribed on the monument had been his words from the Nullification Crisis of 1832, when at a banquet South Carolina Senator John C. Calhoun gave the toast, "The Union: next to our liberties, the most dear." Jackson followed with: "The Union: it must be preserved." When the Confederates took New Orleans in 1861 they scratched out Jackson's words. When Union Gen. Benjamin Butler regained command, he replaced and added to them: "The Union: it must and shall be preserved."

Perfect, I thought in 1956 and still do.

In 1957 I went to Baton Rouge to study under Dr. Harry T. Williams at L.S.U. For my M.A. degree. That summer, before school, I got a job at the Dow Chemical Plant on the

The Louisiana Purchase territory of 1803 spans 885,000 square miles across the nation, which essentially doubled in size. At the heart runs the 2,350-mile-long Mississippi River, the nation's "spine," writes Stephen Ambrose. "Its watershed formed the basis for our modern American map."

river's West Bank. For two months I rode the ferry, twice a day. I learned something about that stretch of the river—where the whirlpools were, low water or high, and more.

When working on this book with my friend Doug Brinkley, I traveled upriver on the *Delta Queen*. Being on a steam-powered vessel designed in the 19th century along the river at the beginning of the 21st century is a reminder that, in human terms, the Mississippi is timeless. Much of what Doug and I saw as we traveled is what the French explorers Jacques Marquette and Louis Joliet saw in 1673 when they came from Green Bay down the Fox and Wisconsin rivers, then took the Mississippi to the mouth of the Arkansas. We saw what Robert de La Salle saw in 1682 when he traveled from Illinois to New Orleans, except that the Indians are gone. Their homes are replaced by cities, bridges, power plants, their canoes by barges carrying coal, grain, and fertilizers.

Yet many stretches of the river are unchanged. The banks are tree-lined. The islands are numerous and teem with hawks, eagles, osprey, and deer. As we rode the *Delta Queen,* a storm drove us. It was followed by a clearing sky and gorgeous light that revealed blue, some clouds, a white wake from a paddleboat, and all shades of green. Sam Abell, a National Geographic photographer, accompanied us. He took scores of pictures, which appear in portfolios throughout the book. He called parts of the river an island paradise.

We saw what then-farmer Abraham Lincoln saw when he descended the Mississippi by raft with cargo in 1828, when he was 19, and again in 1831. On the second trip, to the port of New Orleans, he saw a slave auction and vowed that if he could, he would strike those shackles forever. Huck Finn and his slave companion, Jim, descended the river on a raft in the most famous journey in American literature. They ran past the islands we passed. You don't see rafts nowadays, but close your eyes and you will.

History is about people. Characters sparkle from the Mississippi River from its source to its mouth. In this book, Doug Brinkley and I attempt to describe some of them, what they did on, or to, or in defense of the river. This is not a travelogue, which we wouldn't know how to do anyway, and we decided early on that we couldn't possibly write a history of the river—that would mean volumes. Instead we concern ourselves with the people who lived along it. We look at warriors and what they did, musicians and what they produced, authors and their writings, explorers and adventurers and their accomplishments. We have traveled the length of the river, Doug and I, by boat and helicopter and car. What follows is what two historians talk about when they are on the river, discovering new things about their nation's heritage.

STEPHEN AMBROSE,
New Orleans, April 12, 2002

★

THE MISSISSIPPI RIVER never ran through my boyhood—but it did course through my imagination. The first time I saw the river was from the back seat of a Pontiac station wagon on a summer family vacation. We had left our home in Perrysburg, Ohio, for Disneyland. With great fanfare my mother, a high school English teacher, pointed out to my sister and me the generic highway sign: "The Mississippi River" as we crossed the I-55 bridge that connects Illinois to Missouri. From an automobile zooming 55 miles an hour beside rattling semi-trucks, the Mississippi looked muddy and polluted. With the Jefferson Memorial Expansion Arch looming before us, and the impressive St. Louis skyline, the river offered the excitement of a sewage canal. My imagination had been spoiled by Walt Disney: In his theme park I could hear the calliope on the wedding-cake-like steamboat

Mark Twain, explore Tom Sawyer's island, hide in Huck Finn's caves, and ride on Mike Fink's keelboat. It was "one-stop shopping," as Wal-Mart's Sam Walton used to say: the entire Mississippi River romance experience for a C, D, and E ticket. By comparison climbing the Cahokia Mounds near St. Louis, once home to the largest pre-Columbian settlement north of the Valley of Mexico, was dullsville.

In school I did learn that the Mississippi River constantly flooded and abruptly changed direction. Mark Twain used to tell the story of being unnerved as an apprentice river pilot in 1857. His teacher explained that even if he memorized every detail of the 1,200 miles of river between New Orleans and St. Louis, he might have to "learn it all again in a different way every twenty-four hours." The river was a living entity running through the heartland of America.

My interest in the Mississippi matured dramatically when as a high school senior I read Richard "Dick" Bissell's *A Stretch of River* (1950), about a roguish deckhand working on a towboat on the upper Mississippi. Brimming with real-life misadventures, the book made the Mississippi both awesome and tangible, a wild waterway I wanted to explore.

But it was New Orleans that made me fall in love with the Mississippi River. I'll never forget the first time I took the free ferry which has run between New Orleans (east bank) to Old Algiers (west bank) without interruption since 1827. Gazing down at the turbulent current, I felt the river's awesome power. It is nearly 200 feet deep at Algiers Bend, a treacherous spot. Ships round this hairpin turn every 15 minutes, sometimes lose power, then twirl sideways, spinning like an unleashed top. The danger is palatable. In December 1996, a 70,000-ton bulk-carrier named the *Bright Field* acidentally rammed into One River Place, a high-rise condominium on the east bank, causing millions of dollars in damage. Teenagers have made bets,

boasting they can swim from New Orleans to Old Algiers—the *Times-Picayune* obituary page tells their final stories. The Mississippi River bridges, near the ferry crossing, have a strange history of being a suicide jump-off site. There, renegade logs sometimes course down the river at 30 miles an hour. If hit in the head by one, death is almost certain.

In his unpublished "On the Road" journals, novelist Jack Kerouac recalled the first time he crossed the river on the Old Algiers ferry. It was dusk, and a fallen tree passed him. He studied the "Odyssiac log," imagining it hailed from lonely Montana and slipped by Hannibal and Cairo and Greenville and Natchez at night undetected. He imagined that this log, serenely turning over and over, would end up in the Gulf of Mexico, then pass around the Florida Keys, and eventually be found by a sad fisherman in Senegal or Ghana. Rivers, he mused, were the great connectors of people and nature and earth. "And what is the Mississippi River?" he asked. "It is the movement of the night and the secret of sleep and the emptier of American Streams which bear (as the log is borne) the story of our truer fury."

Given our joint affinity for the mysteries of the Mississippi River, Steve Ambrose and I thought traveling its length would be the ideal way to commemorate the bicentennial of the Louisiana Purchase of 1803, deemed the most significant real estate transaction in history. Shortly after the treaty was signed in Paris, Gen. Horatio Gates penned President Thomas Jefferson a congratulatory letter. "Let the land rejoice," he wrote, "for you have bought Louisiana for a song." In doing so Jefferson assured that the Mississippi River would remain an American possession and, to the millions who live along it, for whom this book is dedicated, a passion that never fades.

DOUGLAS BRINKLEY,
New Orleans, April 15, 2002

HEAD OF PASSES

★

This "dark and inexorable river...rolling like a destiny,
through its realms of solitude and shade."

FRANCIS PARKMAN

Napoleon Bonaparte discusses the sale of the Louisiana Territory with his ministers
Charles-Maurice de Talleyrand and François de Barbé-Marbois. Although reluctant to
cede Louisiana to the Americans, Napoleon felt he could not hold on to the colony dur-
ing the impending war against England.

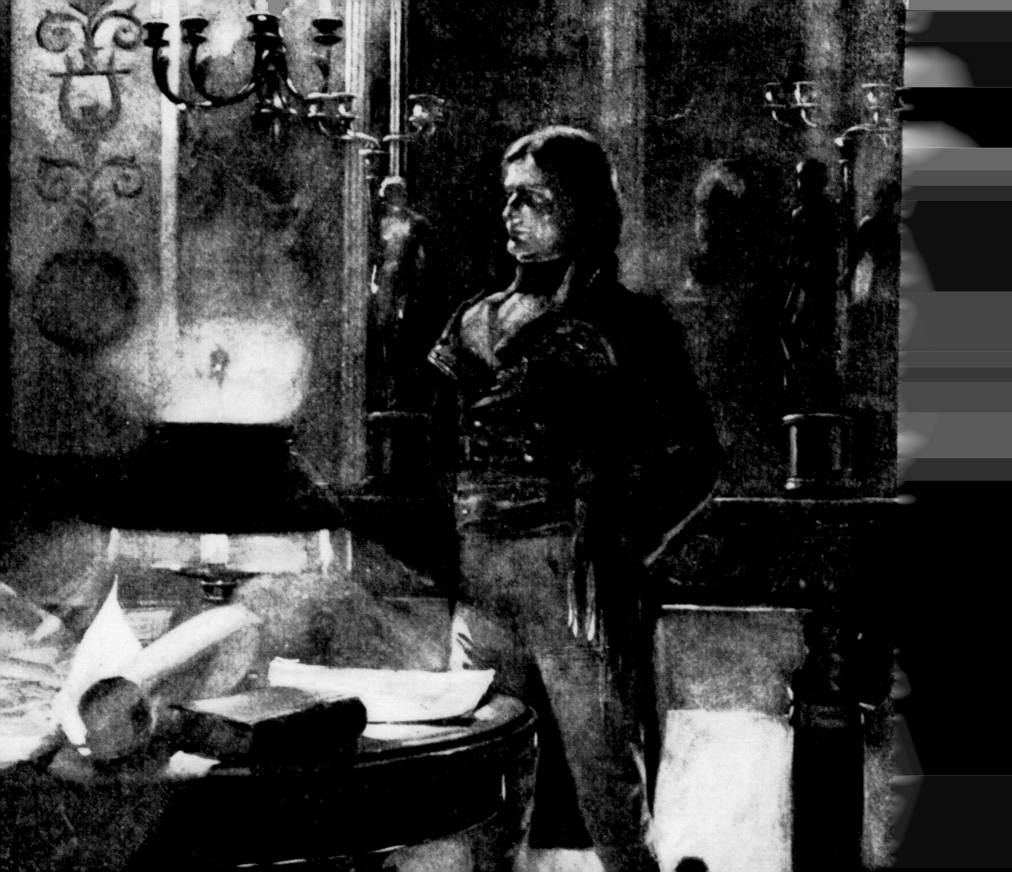

IT WAS MARCH, THE REST OF NEW ORLEANS WAS RECUPERATING FROM MARDI GRAS, and we were hovering in an Astar 350-2 helicopter, 600 feet up, over the bountiful, blue waters of the Gulf of Mexico. Our pilot was Jere Cobb, a 65-year-old former Marine, who worked for NASA from 1963 to 1977, training the Apollo astronauts how to carefully land their lunar modules on the moon. We couldn't have been in steadier hands as we approached the most wondrous aerial site in America: the mouth where the three main passes of the Mississippi River rush into the sea. Ships from all over the world move up this swollen river from the Gulf. And there, standing lone guard, the Southwest Pass lighthouse, a pragmatic Statue of Liberty, welcomes to the United States rusted Russian tankers and freshly minted Scandinavian luxury liners, hulking banana boats from Honduras and bulging barges from Malaysia.

To Americans, however, we were propelling over the geographical end of the Mississippi River, and technically that is correct. But looking down from our helicopter, it was virtually impossible to pinpoint where the river ceased and where the Gulf began.

Since the last ice age ended, the river has dramatically changed course at least six times, creating a complex deltaic plain. Guidebooks explain that the Mississippi River suddenly separates into well-demarcated channels like fingers in a glove or like a bird's foot, but in truth there is something less controlled and more primal about the river's end. It's as if a huge dam were exploding, creating a vast coastal marsh, and as if the river's raging currents were reluctant to surrender their awesome power to the saltwater sea. The Mississippi River Delta simply keeps on fanning out, with no defined boundary, in a watery vastness.

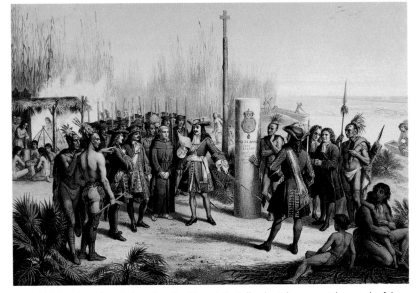

In 1682 French explorer Robert Cavelier, Sieur de La Salle planted a cross at the mouth of the Mississippi, claiming the land west of the river for his king.

The river discharges between 600,000 and 700,000 cubic feet of water per second into the Gulf of Mexico, one result being that Louisiana's 3.5 million acres of coastal marshes equal more in area than the entire state of Connecticut. Even on clear days—which this one was—a slight fog filters over the grassy islets and half-drowned oil platforms that dot the Gulf, proud survivors of ferocious hurricanes and tropical storms. This was the ragged boot of Louisiana, a confusing mishmash of peninsula and archipelagos, open lakes and bays. Exotic waterfowl swirled in feeding frenzies all around us. On the east bank of the river, to our surprise, large waves were crashing on a two-mile-long sandbar, which resembled some forlorn Caribbean beach. Inside the helicopter, with the doors removed, a sultry sea breeze engulfed us as we peered straight ahead up the

Delta and were overcome with awe: before us lay big, raw, expansive America.

Nearly every drop of rain that falls west of the Appalachian Mountains and east of the Continental Divide on the Rocky Mountains finds its outlet to the sea at the mouth of the Mississippi. The great river, an ecological microcosm of North America, starts as an inglorious trickle at Lake Itasca in Minnesota, where a visitor can step across it. Soon the river is rolling along, in some places a mile wide, carrying deposits from such rivers as the Minnesota, Wisconsin, Iowa, and Illinois, then journeying southward to merge just above St. Louis with the mighty Missouri and, farther on, with the Ohio River near Cairo, Illinois. Before long, the river takes in the St. Francis, Yazoo, Arkansas, and Ouachita, and surges imposingly through New Orleans. The Mississippi eventually empties into the Gulf of Mexico through three main channels: Southwest Pass, Pass à Loutre, and South Pass, each extending like a long, thin pencil with its banks as close as a few hundred yards.

The combined Missouri-Mississippi River forms a huge drainage system, a watershed for more than 1.2 million

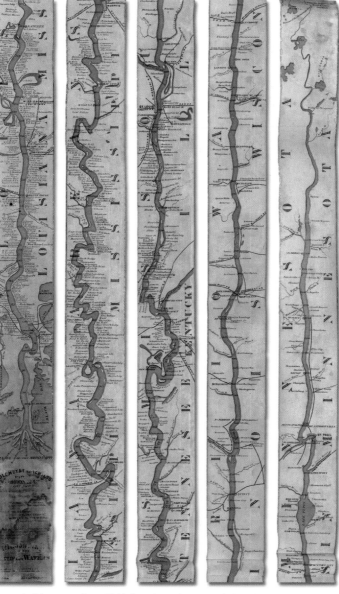

A ribbon map from 1866, here in sections, reveals the Mississippi River from its mouth at the Gulf of Mexico to its source at Lake Itasca.

square miles of land covering about 40 percent of the continental United States, including all or part of 31 states and Canada's provinces Alberta and Saskatchewan. That is a larger area than the land drained by all but two other of the world's rivers, larger than China's Yellow River, Africa's Nile, India's Ganges, and Europe's Rhine. Only the Amazon and Congo exceed it in size.

The Mississippi, formed nearly two million years ago, is also one of America's unmistakable icons. Indeed, the very notion of the "heartland" emanates from its muddy depths. The Ojibwe Indians called it "Mezzi-sippi," or "Big River," but it was also known in the Algonquin language as "the Father of Waters." Mississippi is a word, Walt Whitman once observed, that "rolls a stream three thousand miles long." On the Hennepin map of 1697, it was spelled "Meschasipi," although Franciscan father Louis Hennepin referred to it as "the river of wild bulls" for the many buffalo herds along the northern reaches of the river. The Spanish of that era often called it "Escondido," for hidden, or murky river. Poet T.S. Eliot, raised in St. Louis, deemed it a "strong, brown God,"

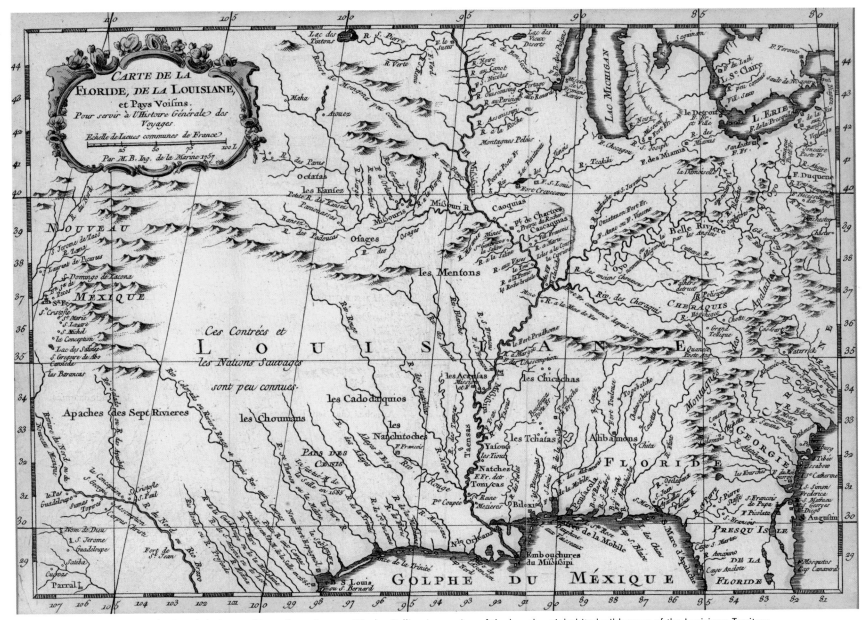

A 1759 map by French hydrographic engineer Jacques Nicolas Bellin gives a view of the largely uninhabited wilderness of the Louisiana Territory—stretching along the west bank of the Mississippi—and the coast of West Florida. In 1803 France held the Territory and the port of New Orleans, and Britain claimed West Florida and its ports on the Gulf of Mexico. President Thomas Jefferson believed that the very survival of new settlers in the United States hinged on controlling the Mississippi as a main artery of commerce. Farmers needed an outlet west of the Appalachians for their produce, floating their goods to market. They shipped flour and corn, cotton and tobacco, indigo, sugar, pelts, and hides downriver. There was no more important commercial highway on the continent than the Mississippi River.

whereas Missourian Mark Twain, whose best writing centered on the river itself, dubbed it "the body of the nation." Recent travelogues on the Mississippi carry predictable titles such as *Big Muddy,* or *Old Man River,* or *River of Forgotten Days.* But our favorite description came from historian Francis Parkman who deemed it a "dark and inexorable river...rolling like a destiny, through its realms of solitude and shade."

Whatever it's called, the Mississippi River alone represents more than 2,350 miles of America's lifeblood—the vital economic engine and the mythic symbol that flows through our history, our continent, our music, our literature, our lives. Millions of Americans get their drinking water from the river; millions more take advantage of its recreational offerings. Forty percent of all North American bird species use the Mississippi flyway. The waterway is essential to the ecological health of the entire continent. Less concretely but no less important, America's great river remains a potent symbol.

Hovering in our helicopter over the river's convergence with the Gulf of Mexico evoked images for us from our national heritage: the Corps of Engineers and Huckleberry Finn, flatboatman Abraham Lincoln and keelboater Mike Fink, Indian warrior Black Hawk and bluesman Robert Johnson. The French explorer Robert Cavelier, Sieur de La Salle, naturally came to mind because it was here, in 1682, at the mouth of the Mississippi, that he claimed the vast territory in front of us for France, planting a cross in the soil and naming the area Louisiana to honor his king, Louis XIV. (Known as the

President Thomas Jefferson envisioned a United States that would extend to the Pacific Coast in an "Empire of Liberty."
COLLECTION OF THE NEW-YORK HISTORICAL SOCIETY, NEG. #1867.306

Sun King, Louis XIV was uninterested in La Salle's new acquisition, deeming the immense virgin wilderness "quite useless.") But no other figure loomed larger in our imagination that March afternoon than Thomas Jefferson, whose Louisiana Purchase of 1803 nearly doubled the size of the United States.

Volumes have been written about the fluke circumstances which allowed Jefferson to purchase the vast Louisiana territory for $15 million (three cents an acre) from the tyrant Napoleon Bonaparte, who in 1802 had been declared consul of France for life. If Toussaint L'Ouverture, for example, the ex-slave and dictator of Saint-Domingue (present-day Haiti) hadn't led a revolution that annihilated French invasion troops on the island that very year, it's doubtful whether Napoleon would have jettisoned his dream of a North American Empire.

Just read Henry Adams's remarkable *History of the United States 1801-1809,* and you'll also learn that, had it not been for an outbreak of yellow fever, or storms off the coast of Holland, or the threat of an Anglo-French war, the destiny of America would have been quite different. Far from being inevitable, the Louisiana Purchase, which overnight alleviated anxiety in the United States about having a foreign nation dominate the Mississippi Valley, seems in retrospect to have been a divine act of Providence. But this is too supernatural an explanation for fact-obsessed historians like us to accept. Quite simply, the Louisiana Purchase was the direct result of the cunning Jefferson's longstanding, unshakable vision of a

United States that would stretch to the Pacific Ocean. And documentary evidence bears out this assertion.

By the time Jefferson was elected president in 1800, hundreds of thousands of Americans hungry for fertile land had moved to the Mississippi and Ohio River Valleys, displacing dozens of Indian tribes, such as the Choctaw and Shawnee, in the process. These hardscrabble farmers floated their harvested crops down the Mississippi on primitive boats to New Orleans to sell at market or to export abroad. More than any other politician of his era, Jefferson understood that the Louisiana Territory was not a "howling wilderness," as Delaware's Senator Samuel White deemed it, but 828,000 square miles of glorious future for American commerce and agriculture. Although the author of the Declaration of Independence had never been to New Orleans, he realized that whoever controlled this bustling port owned the Mississippi River and had the power to open or close it to commerce from the States at will, and thereby had, as he phrased it, "a hand on the throat of the American economy." He understood that the great river did not divide the North American continent in half, but rather drew the continent together.

Ironically for Jefferson, considered by pro-British Federalists like John Adams as being a Francophile (Jefferson had been the U.S. Minister to France from 1785 to 1789), the iron hand he had to deal with to acquire Louisiana belonged to Napoleon, the most powerful man in the world.

France had ceded the Louisiana Territory to Spain near the end of the French and Indian Wars in 1762. But in 1800 the French ruler had hoodwinked the King and Queen of Spain into swapping the Louisiana Territory plus a half dozen ships for a small section of northern Italy to be called the Kingdom of Etruria—mainly modern-day Tuscany. This trade served to elevate the Spanish king's son-in-law from a mere Duke of Parma to King. Known as the Treaty of San Ildefonso, this supposedly secret, lopsided deal gave Napoleon an extraordinary springboard on which to rebuild a French empire in the Western Hemisphere. After only a few months in office, a worried Jefferson commented that if the unconfirmed reports were true, that Napoleon had really obtained all of Louisiana from Spain in a secret pact, then "it would be impossible that France and the United States can continue long as friends."

Anxious to avoid war with France, but hell-bent on America controlling the Mississippi River, Jefferson sent his close friend Robert R. Livingston to Paris to try to stop the San Ildefonso deal if it hadn't already been consummated, or to purchase New Orleans outright from Napoleon if France actually owned it. Although Livingston spoke little French and was half deaf, he had served in the Continental Congress, had helped draft the Declaration of Independence, and was New York's most prominent landowner. A true Renaissance man, Livingston believed in Jefferson's agrarian dream of an "Empire of Liberty," and was a leading authority on soil conservation, water purification, and stockbreeding. Although some of Livingston's ideas were failures—he tried unsuccessfully to mate his cows with elk, for example—he was an indefatigable risk taker. And Jefferson knew that the brilliant Livingston was also an avid believer in the steamboat, a transportation innovation in the experimental stage which, if developed properly, could overnight transform the Mississippi River into a thoroughfare for Western commerce, as indispensable as the Hudson River was for merchants in the East. Just as a few years later Jefferson was wise to choose Meriwether Lewis to lead the Voyage of Discovery to find a route to the Pacific Ocean, he couldn't have found a better minister to France

to negotiate with Napoleon than the reliable Robert Livingston. Presenting himself to Napoleon on December 6, 1801, in the ornate audience room of the Tuilleries Palace, Livingston quickly learned that the French leader was his own counselor.

Napoleon planned to dispatch 5,000 to 7,000 troops to conquer Saint-Domingue and then sail to New Orleans to plant the French flag into Louisiana soil, much as La Salle had done two centuries earlier. This news catapulted Jefferson into action. He refused to let France control the Mississippi River; thousands of American families needed it for their economic survival. In April 1802, Jefferson wrote to Livingston: "There is on the globe one single spot, the possessor of which is our natural and habitual enemy. It is New Orleans, through which the produce of three-eighths of our territory must pass to market, and from its fertility it will ere long yield more than half of our whole produce and contain more than half of our inhabitants. France, placing herself in that door, assumes to us the attitude of defiance.... The day that France takes possession of New Orleans fixes the sentence.... From that moment, we must marry ourselves to the British fleet and nation.... Every eye in the United States is now fixed on this affair of Louisiana. Perhaps nothing since the Revolutionary War has produced more uneasy sensations through the body of the nation."

Realizing that French spies might intercept and read this letter, Jefferson purposely raised the specter of war with France over New Orleans. As an insurance policy, Jefferson wrote to French Physiocrat, Pierre Samuel Du Pont de Nemours. He had known Du Pont de Nemours for more than 20 years and underscored in his letter the importance of the United States acquiring the Louisiana Territory that same April: "This speck which now appears as an almost

invisible point on the horizon, is the embryo of a tornado which will burst on the countries on both sides of the Atlantic.... That it may yet be avoided is my sincere prayer; and if you can be the means of informing the wisdom of Bonaparte of all its consequences, you have deserved well of both countries." If President Jefferson had formally delivered these threatening lines as a public address, it would have been deemed an intolerable insult. But in letter form it served as the perfect ruse. Jefferson masterfully articulated his insistence on controlling the Mississippi River to Napoleon without having to embarrass him.

While there is no proof that Jefferson's letter to Livingston or to Du Pont de Nemours was ever read by Napoleon, today it should be embraced as brilliant diplomacy. For, as the governor of Kentucky wrote to President Jefferson, speaking for the American settlers squeaking out a living on the Louisiana frontier, "The Mississippi is to them everything. It is the Hudson, the Delaware, the Potomac, and all the navigable rivers of the Atlantic states formed into one stream."

Realizing how violently Jefferson opposed the French occupation of Louisiana, and having suffered a military trouncing in Haiti, Napoleon decided to withdraw from North America in early 1803. He was now set on stripping Egypt from England in a military confrontation—an enterprise that required money, not subtropical swampland and the Port of New Orleans. After great deliberation, on April 11, 1803—a year after Jefferson's letter to Livingston—Napoleon instructed his Minister of Finance, François de Barbé-Marbois, to negotiate with the New York diplomat. "I renounce Louisiana," Napoleon told his minister. "It is not only New Orleans that I will cede. It is the whole colony without any reserve. I renounce it with the greatest regret."

When told that Napoleon was willing to sell the entire

Louisiana Territory for $22.5 million, a startled Livingston gulped with joy. This was an area larger than the combined size of present-day Spain, Portugal, Italy, France, Germany, the Netherlands, Switzerland, and Great Britain, extending to today's Canadian border and encompassing land from which 13 states were to be carved. Although Livingston, along with special envoy James Monroe, whom Jefferson had just dispatched to France, weren't authorized to make a deal, they wisely seized the day. Together they quickly agreed with Napoleon's odd demand that all Louisiana Territory occupants must become U.S. citizens, an insurance policy that some future American president wouldn't sell the landmass off as a colony to Britain or some other enemy of France. And after weeks of intense negotiations with Barbé-Marbois, the price was haggled down to $15 million—the greatest real-estate steal in world history. On May 1, 1803, Napoleon ratified the treaty, and the following day Barbé-Marbois, Livingston, and Monroe signed the papers.

Jefferson, however, didn't learn of the Purchase until July 3, offering Americans the greatest Independence Day gift imaginable. A jubilant Jefferson had achieved his dream: an Empire of Liberty for the bargain price of $15 million. He fed the story to a Washington, D.C., newspaper, the *National Intelligencer*, which pronounced July 4 a day of "widespread joy of millions at an event which history will record among the most splendid in our annals."

The *National Intelligencer* got it right. Our reason, in fact, for helicoptering over the Head of Passes was to pay homage to Jefferson's Louisiana Purchase on the eve of its bicentennial. The National Geographic Society had asked us to travel the length of the river from Pilottown, Louisiana, to Lake Itasca, Minnesota, and to write about various historical events which have occurred along its banks and in its waters since 1803. Over a two-year period, we would visit all ten main-stem states which lie along the Mississippi, using various modes of transportation. It was our dream job, the ideal way for two American historians to begin the third millennium.

Unlike most river chroniclers, we decided to travel upriver instead of down, starting in our shared home states of Louisiana (work) and Mississippi (residence). We found ourselves riding a bauxite barge to Baton Rouge and poling a replica keelboat in Natchez. We steamboated on the *Delta Queen* from St. Louis to St. Paul and canoed the icy headwaters in Minnesota. We drove so many miles of the Great River Road which parallels the Mississippi River from Louisiana to Minnesota—always following the green and white pilot-wheel highway markers—that it became a second home. And always, much as we did at the start of our trip helicoptering up the Southwest Pass, we spoke of Jefferson's grand diplomatic accomplishment with reverence and endless gratitude.

In preparation for this helicopter flight, we visited the National Archives in Washington, D.C., to carefully study the original Louisiana Purchase agreement which is made up of many documents—some in English, some in French. For historians there is no greater joy than to conduct research there, where a mere 20 minutes after showing proper identification, heading to the appropriate reading room, filling out a form, requesting specific documents from the *Guide to the National Archives of the United States,* and donning white cotton gloves, you can suddenly be holding in your hands such

In signing the exchange agreement, at right, on behalf of his people—*le peuple français*, or "PF"—Napoleon Bonaparte agreed to sell the Louisiana Territory to the United States for 60 million francs, or $15 million. The Louisiana Purchase consisted of three agreements between France and the United States: a treaty of cession and two agreements, including this one, providing for the exchange of monies in the transaction.

Article 13.

La présente Convention sera ratifiée en bonne et due forme et les ratifications seront échangées dans l'espace de six mois à dater de la date de la signature des Ministres Plénipotentiaires, ou plus tôt s'il est possible.

En foi de quoi les Plénipotentiaires respectifs ont signé les articles ci-dessus, tant en langue française qu'en langue anglaise, déclarant néanmoins que le présent Traité a été originairement rédigé et arrêté en langue française, et ils y ont apposé leur sceau.

Fait à Paris le dixième jour de floréal de l'an onze de la République française et le trente Avril mil huit cent trois.

Signé: Barbé-Marbois, Robert R. Livingston et Ja. Monroe

Approuvé la Convention ci-dessus en tout et chacun des Articles qui y sont contenues. Déclare qu'elle est acceptée ratifiée et confirmée et Promets qu'elle sera inviolablement observée.

En foi de quoi nous avons fait les présentes, signées, contresignées et scellées du grand Sceau de la République.

À Paris le Deux Prairial an onze de la République française vingt deux Mai mil huit cent trois.

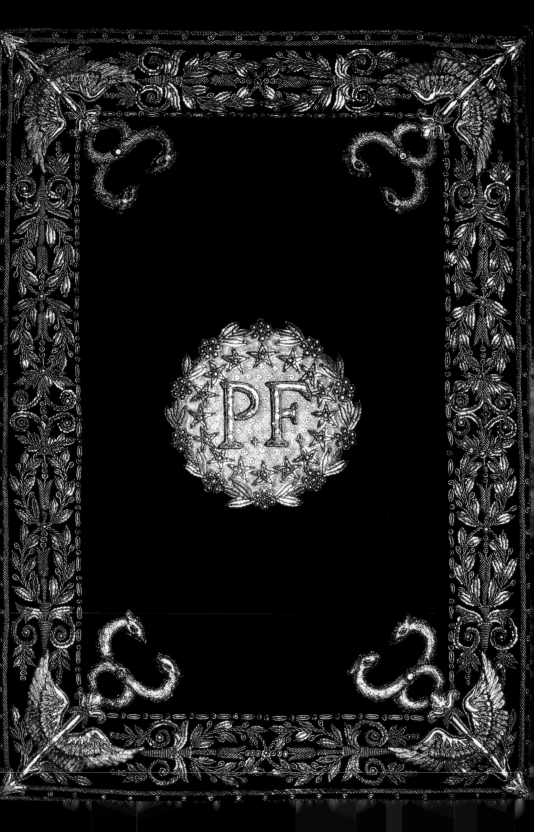

treasures as the Louisiana Purchase documents that were signed by the American negotiators Robert Livingston and James Monroe in Paris and sent to Jefferson. The most interesting document we encountered, however, was the French exchange copy of one of the agreements regarding the financial aspects of the transaction. The document was written in a beautiful French scrawl and bound in a volume with a purple cover, in which the initials P.F. are prominently embroidered. The archivist told us this stood for *peuple français,* or the French people. The last page of the document was signed by Bonaparte, First Consul of the French Republic, and by his foreign minister, Charles Maurice de Talleyrand.

So it was that a short time later we found ourselves flying north from the Head of Passes toward Pilottown, a graveyard quiet village that consists of a single row of houses paralleling the Mississippi River for a half-mile. Built on stilts in the 1890s, the community claims only a dozen permanent residents, almost all in the senior citizen category. It was the starting point of our journey.

Pilottown is too small to maintain a general store, forcing the inhabitants to go by boat upriver some ten miles for groceries and hardware; no roads reach Pilottown. A weathered palmetto tree at the dock gives this tiny port a deceptively West Indies feel. In truth, however, you can hear the call of the Cajun in Pilottown, where jumbo shrimp are not a delicacy but a daily staple. Passerine birds congregate here in spring. They are sitting calmly on various manmade structures, exhausted from their flight across the Gulf. They return again in fall when they travel southward. Some of the river pilots and their families used to make their homes here, but today most prefer the modern conveniences of New Orleans or Baton Rouge. A pair of white clapboard shore houses serve as second home to the pilots who spend two out of every four weeks on duty here. They conduct business via telephone or fax or sleep in the dormitories. It is here that seafaring merchants from around the world first see the American flag holding sentry duty from a tall iron pole. Every foreign-registered inbound and outbound ship on the Mississippi uses the pilots to steer them from the Gulf of Mexico to Baton Rouge and back. Each ship must have a pilot on board to battle dense surface fog, unpredictable currents during high water, sandbars, flocculation, and suction caused by ships' passages that can pull them into banks or toward other ships. The Associated Branch Pilots handle the first treacherous leg of the journey, often encountering in the Gulf high seas, blowing storms, and no less an obstacle—language barriers. They are called the Bar Pilots because of their reputation of safely piloting ships through the ever-changing sandbars, altered constantly by the tremendous flow of the waters at the mouth of the Mississippi.

They are the modern Mark Twains, aware of every bend, every snag, and every bayou coming into the river. They steer the vessels to Pilottown and are relieved by members of the Crescent River Port Pilots Association, who then pilots the ships to anchorage upstream. These pilots, in turn, are replaced by members of the Crescent River Pilots Association, who take the ships into wharves.

The associations are sometimes compared to medieval guilds. Years ago only the sons of pilots could join, but today merely a few sons and daughters maintain the tradition, in a career that is well paid, up to $314,000 per pilot per year. They make sure that tankers don't run aground and help vessels navigate the river when flooding occurs.

Over the centuries the annual flood of the Mississippi covered the land beyond its banks. The river deposited its

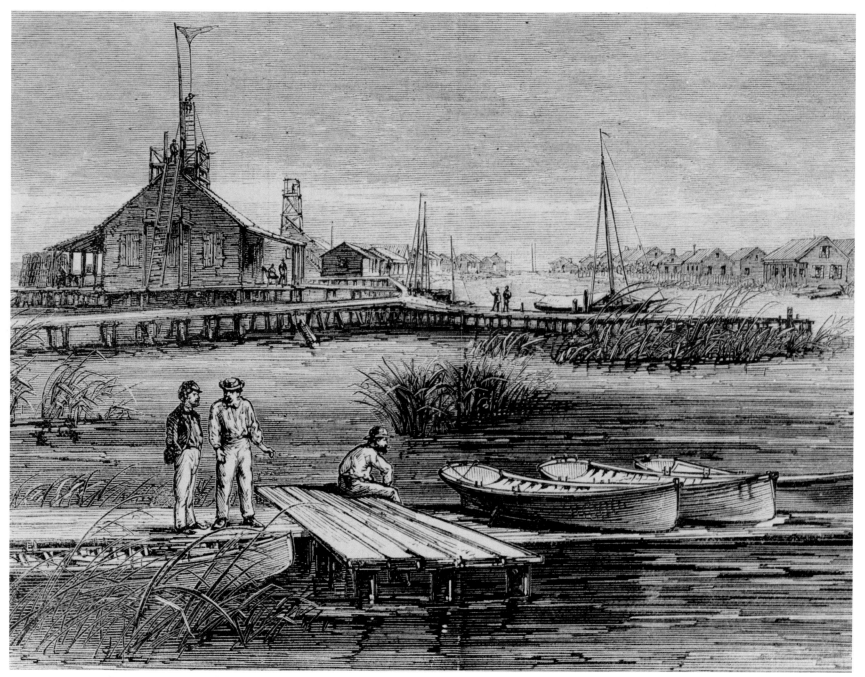

Gateway to a nation, Pilottown in an 1871 view appears as a tranquil port at the river's mouth, home to skilled pilots of the turbulent river.

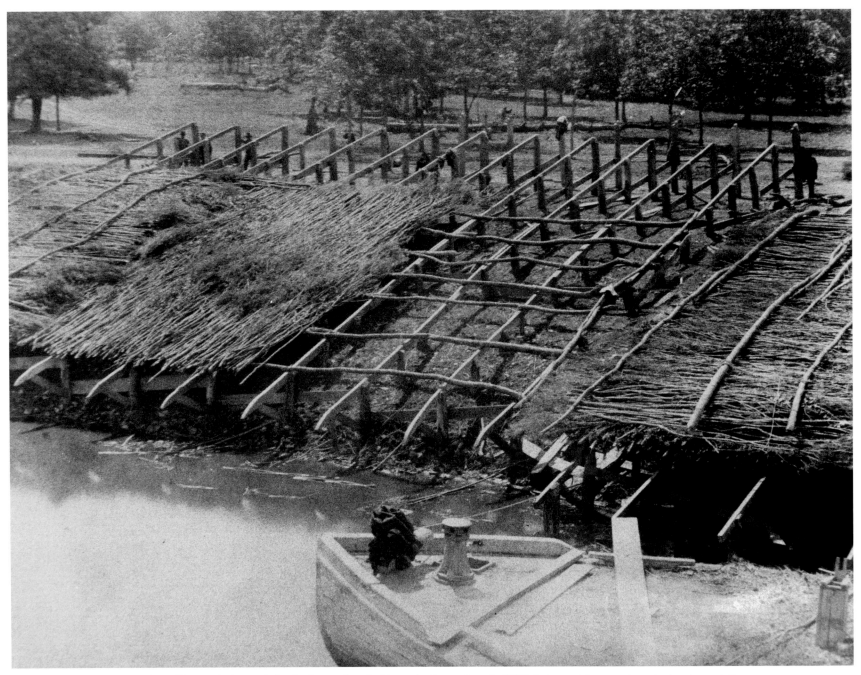

Weaving willow trunks into a timber lattice, workers fashion a fascine mattress in 1882, to be used in an underwater barrier, or jetty.

sediment, making the land the richest topsoil in the world. By the early 19th century, the sandbar that built up at the mouth of the river, the ultimate deposit of Mississippi River sediment, was often too high for the larger and faster ships. At the time of the Louisiana Purchase, for example, those ships had to wait in the Gulf of Mexico or in the Port of New Orleans for a rise in the river before they could pass. Decades went by and the sandbars continued to grow. In 1852 some 40 ships were stranded there. In 1859 an inspector of the U.S. Army found more than 20 ships in the Gulf of Mexico waiting for passage. Some ships waited for nearly three months.

We found ourselves wondering, as our open helicopter circled above the mouth of the river, what on earth a sailor on a ship sitting in the Gulf did for so long: no entertainment, no fresh vegetables, fruit, or meats, only rainwater to wash in and drink. The report also listed 50 ships tied up at the dock in New Orleans, waiting for sufficient depth to get out into the Gulf of Mexico. At least those sailors could enjoy the delicacies of the French Quarter. Thus the world's greatest highway had a barrier at its mouth, not an impassable one but a growing one, not permanent but increasing with time. Everyone who lived in the Mississippi Valley—businessmen in New Orleans, officials of ship companies, farmers throughout the drainage system, coal miners, and others—wanted it open.

By 1870 the freedom of navigation on the Mississippi River that had been purchased by Thomas Jefferson was being denied by a sandbar. For four decades the U.S. Army Corps of Engineers had attempted to solve the navigation problems, but after many failures the Corps now proposed to build a canal. Fort St. Philip Canal would be running parallel to the river and be deep enough for ocean vessels. General Andrew Atkinson Humphreys, chief of the Army

Corps of Engineers and a powerful molder of public opinion, threw his support behind the proposal. But Congress hesitated with appropriations for a project estimated at a cost of $10 million.

Then, in February 1874, the charismatic James Buchanan Eads came to Washington, D.C. Eads declared that the canal would never work and proposed instead to build jetties out into the Gulf of Mexico from the termination of the riverbanks. At that point the river slowed down and spread out, causing the final dropping of sediment and sand, which created the sandbar. Eads claimed that his jetties would use the force of the river's current to scour out the sandbar at the mouth.

Humphreys said it could not be done. He claimed the river would simply form a new sandbar beyond the jetties, so more jetties would have to be built. And the water would quickly become too deep to build jetties. It was all quite impossible.

Humphreys's arguments might have carried the day because of who he was and because the American experience with canals had been good overall. But he was up against Eads, who had become the most famous engineer in the United States, the man who was building the great railroad bridge over the Mississippi River in St. Louis that would open on July 4, 1874, and be proclaimed a marvel unrivaled. It would be the first steel bridge, and it would be a joy to look at. Eads had designed it and was building it over various loud and powerful objections. This bridge would not be able to carry a train, the critics said, yet it was still carrying trains a hundred years later.

Eads knew the river better than anyone. In 1833, when he was 13 years old, he traveled on a steamboat with his mother and sisters to St. Louis. Near the dock, the boat's boiler exploded, and the steamboat went down. Eads and his

family plunged into the river, and they were pulled ashore. Four decades later, he began to build his bridge over the river on the Missouri side at the very spot where he had climbed up the riverbank. As a young man he became a self-taught engineer in St. Louis. The river was his life. He wanted to start a salvage business, bringing up cargo from the multitude of wrecks on the river. But the Mississippi River was muddy and swift, and below a few inches of water there was no light to enable him to explore and recover sunken cargo. Historian John M. Barry, in his classic work *Rising Tide: The Great Mississippi Flood of 1927 and How It Changed America*, notes that Eads "designed a diving bell and, although men already worked underwater using various kinds of snorkel-like apparatuses, he is generally credited as its inventor."

With his bell, Eads descended to the bottom of the river and felt its strength. The river's main current reaches nine miles an hour; some currents move even faster. The Mississippi carries tons of earth, as much as 50 pounds of mud in about a thousand cubic feet. Several million tons of mud are deposited daily in the Gulf. The river is never calm; it swirls in eddies and whorls, turning this way and that in continuous loops that sometimes approach 360 degrees. The turbulence creates ever-changing deep pools and shallow paths at the bottom.

Into this violence Eads went. His feet were his anchor and transportation; he felt with his hands. In John Barry's judgment, "Eads had spent years walking along that bottom, had been embraced by the river, had come as close to being part of it as was possible to do and live." In the process he found many wrecks, hauled them up, and got rich. Then he

James B. Eads built jetties at the mouth of the Mississippi to deepen the channel and make it navigable for oceangoing vessels.

began building the bridge, using his unique talents as an engineer to make it possible. So along with his knowledge, he brought his reputation into the fray with Humphreys.

Eads had gotten the idea for jetties back in 1837, when a tree-covered island near St. Louis was growing and threatening to cut the city off from the river. The 17-year-old Eads watched Capt. Robert E. Lee, then of the Army Engineers, and his unit deal with the problem. The resourceful Lee built a jetty into the river that directed the force of the main channel against the island and rapidly washed the island away. Eads wanted to do the same at the river's mouth. "I believe man capable of curbing, controlling, and directing the Mississippi, according to his pleasure," Eads declared with undaunted optimism.

Humphreys opposed the project furiously, so much so that one senator declared that "every attempt that has ever been made to induce the Corps of Engineers to listen to the recommendations made by the ablest civil engineers in the country has been resisted with an obduracy that is beyond belief."

Eads had an advantage, which was his ability to raise private money. Humphreys's proposed canal would be 18 feet deep, if it worked. Eads told Congress that his jetties would produce a 28-foot-deep channel for the cost of $10 million. And he made an extraordinary offer: He would build the jetties at his own risk. The government would not pay him until he had obtained a 20-foot-deep channel. At that point, the government would pay $1 million, and $1 million more for each additional two feet in depth until the channel reached a depth of 28 feet. The remaining $5 million would be paid

in installments for annual upkeep.

Five years earlier the transcontinental railroad had been built, in part, with that sort of government subsidy. The Central Pacific and the Union Pacific Railroads got government bonds and public lands for each 20-mile section of track they laid, but only after government inspectors had approved the construction.

Eads raised the money. And through the year 1874 Eads and Humphreys battled. Appealing to members of Congress, Humphreys swung the House to pass a bill calling for the Corps of Engineers to build the canal. In the Senate, Eads prevailed. The two houses finally appointed a commission with three members from the Corps of Engineers, three civil engineers, and one from the U.S. Coastal Survey. In the end the commission recommended installing jetties by a vote of 6 to 1. President Grant signed a bill, on March 3, 1875, that called for jetties at South Pass. Eads was to construct a 30-foot-deep channel for $5 million, with an additional $1 million to be held in escrow for 20 years.

At about 100 river miles south of New Orleans, the river comes to the Head of Passes where, as noted, it divides into three main channels, Southwest Pass, Pass à Loutre, and South Pass. Eads wanted to put his jetties into Southwest Pass, but the commission decreed South Pass. So it was there that Eads began his work in June 1875. He got down into the river, delighted to find a sandbar of light, silty sediment. He knew that farther on, beyond the bar, a strong coastal current would flush the deposits away and not form a new bar.

Andrew Humphreys,
chief of the Corps of Engineers,
proposed a canal in a long
feud with Eads over the
best solution for the Mississippi.

Eads's crew began by driving guide pilings for the jetties into the bed of the Gulf of Mexico until they extended for more than two miles. Eads patented a method of constructing fascine mattresses, made of flexible willow tree trunks, that would shore up the guide pilings. Workers bound the willows together, placed them into wooden containers, which they again bound together with bolted lumber, then lowered the 35-by-100 feet long mattresses into the guide pilings. The men weighed down the mattresses with stone and sank them in layers. River sediment would fill in any open spaces.

In less than a year the jetties began to compress and increase the force of the river's current, scouring the bottom. Eads was proved right: The channel was growing wider and deeper. Yet the irrepressible Humphreys published reports that the jetties would fail and that sandbars were forming beyond the jetties.

Humphreys's reports spread and panicked investors. Eads's stock fell rapidly by 50 percent, and he had to borrow more money. But to disprove what the Corps of Engineers had declared, he needed the report itself. The Corps refused to make it public. Eads appealed to Congress and the Secretary of War and eventually got Humphreys barred from the project. But Humphreys continued with his relentless hostilities behind the scenes.

Thus did America's two greatest engineers go after each other in their quest to be proved correct and to control the great river. In their bones they were sure they were right. The prosperity of the future for millions of Americans depended on which one really was right.

Despite these problems, Eads managed to raise the necessary funds and continue his work. On May 12, 1876, there was a dramatic test when the oceangoing steamer *Hudson* came to the mouth of the river. The ship was 280 feet long, weighed 1,182 tons, and drew 14 feet 7 inches. The channel was found to be about 16 feet deep, but the tide was falling. Eads, confident of the new depth, stood fast and directed the pilot to head to the jetties. The ship moved on at full speed and was received with cheers from the workers all along the jetties. Newspapers everywhere proclaimed, "The channel is open!"

Eads completed his work on the jetties in July 1879. The channel was now 30 feet deep and clear of any new sandbars at the mouth. The South Pass was, indeed, open for oceangoing vessels.

When Eads started the project in 1875, New Orleans shipped several thousand tons of cargo from its port. A year after Eads finished, in 1880, the port handled multiple times that amount. New Orleans moved rapidly from ninth largest port in the nation to second largest port, with New York in first place. Today it is America's fourth largest port, handling a total of 40 million tons of international and domestic cargo a year. South Pass is still used by the smaller vessels, but today it's the Southwest Pass, with new jetties constructed between 1908 and 1923, where the river pilots direct large oceangoing vessels. The traffic on the river is as great as on the interstate highways with their constant rumble of trucks and semitrailers. Just wander around the wharves of New Orleans, and you'll see Japanese steel and Costa Rican coffee, Venezuelan iron and Indonesian rubber. Talk to any of the ship captains who are beneficiaries of Eads's jetties, and you'll find they are all overwhelmed by the power of the Mississippi River. "Nothing can stop it," our friend Captain Garry Mott believes, distrusting levees and jetties. Fortunately Eads—and today's crackerjack river pilots—have collaborated across time to make jamming on sandbars largely a hazard of the past.

North of Pilottown lies Venice, Louisiana, the first town on the Mississippi River as you're going upstream, where the Great River Road begins and ends. This is Plaquemines Parish, the equivalent of a county, a gateway community for the Delta National Wildlife Refuge where a dazzling array of animal species coexists with oil derricks. Jetta and Texaco operate 78 oil and gas wells in the refuge, with the result that helicopter ports are scattered around Venice, always ready to ferry workers offshore to pumping stations and drilling sites. Venice is also full of renegade fishermen, and the town's handful of motels offer weekly rates to geologists and trappers, petrochemical engineers and roughnecks.

This is not the picturesque Mississippi of the irascible Tom Sawyer rolling boulders off the white cliffs of Hannibal, but an unvarnished outpost where boom or bust depends on the weather, and rust is the unintentional color of choice. There is a "last chance" mentality that permeates throughout Venice, reminiscent of venerable trading posts, which used to dot the Natchez Trace and Santa Fe Trail during the days when the great Apache chief Geronimo ran free. Sit on any bar stool long enough, downing Dixie beer, and you'll hear sorrowful laments of tattooed watermen bemoaning their shipwrecked lives. In Venice Marina the fishing skiffs and houseboats aren't polished for show as in some precious Cape Cod town. They're bruised and battered, and the always-broke owners are boastful of the scars.

From Venice you can drive on Louisiana Highway 23 to New Orleans, 70 miles away to the northwest, passing through towns with names that reflect the varied origins of the earliest settlers, including Buras, Empire, Nairn, Port

Sulphur, Magnolia, Bohemia, Point-à-la-Hache, Phoenix, Carlisle, Jesuit Bend, and Belle Chasse.

A few miles north of Venice is the restored Fort Jackson on the river's west bank, and just above it on the east bank are the ruins of Fort St. Philip. These forts—which we helicoptered over and toured from the ground—had been built or improved starting in 1822 by the U.S. War Department as part of a string of coastal defenses along the Gulf of Mexico. The work was done under the supervision of Simon Bernard, a French military engineer who fought with Napoleon in his youth. Bernard had studied fortifications designed by the master, the Marquis du Vauban. Fort Jackson was named for General Andrew Jackson, who recommended the location. (The Spanish had built Fort Bourbon on the site, but it was destroyed in a hurricane in 1795.) The fort was an exact Vauban design, with its pentagonal shape and five bastions. There was a glacis, two parapeted walls separated by a moat, and a double-arched ceiling vault that provided strength to the casemates and a bombproof chamber. The brick casemates had punctured walls with embrasures for 16 guns. Heavy artillery fired from the top of the wall; the fort could accommodate 97 guns.

Fort St. Philip, upstream on the opposite bank, had been built by the Spanish, who called it Fort San Felipe. It withstood a nine-day bombardment by a British squadron in January 1815, preventing the British fleet from proceeding upriver to aid General Pakenham in the Battle of New Orleans. A bend in the river just below the forts forced sailing ships to tack to negotiate the bend and fight the current. Fort Jackson was situated so that it could provide cross fire against any enemy ship. Together, the forts could stop and/or sink vessels coming down or going upriver. The forts held garrisons of U.S. troops from 1832 until January 1861, when the first stirrings of the Civil War were felt.

Fort Jackson today is a historical park run by Plaquemines Parish. On a walking tour you can cross the moat on a drawbridge and see guardrooms, a museum room containing relics found on the site, casemates, the rampart, the hotshot oven, the location of two mortar guns, and a 6-inch Rodman cannon, formerly located on the outer wall. In 1960 Fort Jackson, along with Fort St. Philip, was designated a National Historic Monument. And recently two other historic markers were erected overlooking the river at Fort Jackson: one to commemorate the first Mardi Gras celebration, held in 1699, and the other championing Eads's great jetty-building feat as a National Historic Civil Engineering Landmark.

Following upriver from Forts Jackson and St. Philip by helicopter we saw the Barataria Bay on our left, an area named by the French, translated among other possible versions as "fraudulence at sea" because so many pirates lived in the surrounding bayous.

It was here that the notorious pirate, Jean Lafitte, leader of the Baratarians, lived hiding out in various low-lying islands turned smugglers' dens. Over the years novelists have portrayed him as an outlaw buccaneer with a handlebar moustache, blessed with good looks and boundless energy, and a patriot at heart. This is a false impression. As Lyle Saxon explains in his book *Lafitte the Pirate*, he was essentially a thieving scoundrel, a murderous thug who profiteered in the slave trade and executed rivals for sport. He did make a fortune in pirated gold bars, silver, and jewels. Even today, treasure hunters comb the islets of Barataria Bay with metal detectors hoping to find his hidden booty.

On our right was the Intracoastal Waterway, surrounded by salt marshes, drainage ditches, and nameless small ponds. Each riverbank had two manmade levees as protection against floods but these were also used by locals for jogging,

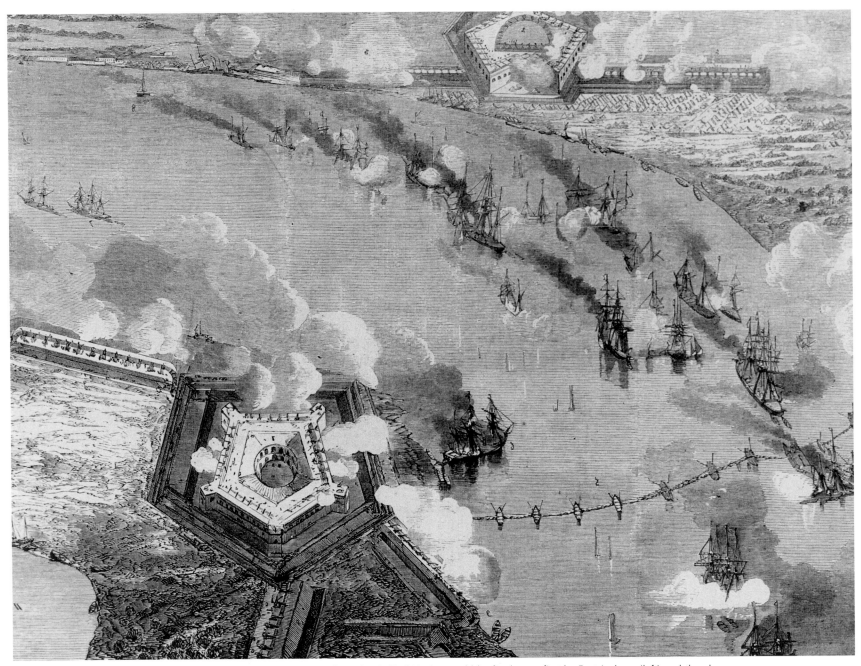

Enemy ships approaching New Orleans from the Gulf of Mexico would be fired upon first by Fort Jackson (left) and then by
Fort St. Philip across the river, or stopped by a chain stretched to the opposite bank, as in this 1862 view during the Civil War.

dog walking, and contemplation. Dozens of massive silos also lined the river to off-load grains for destinations across the United States. Spring had not yet arrived, and the willow trees along the river were barren, resembling a long chain of sticks. Occasionally we saw a noble grove of live oaks or a flock of wintering warblers feasting on a cluster of fruiting elderberry bushes. Smokestacks from Getty Petroleum chemical facilities seemed less toxic when we were hovering above them, surrounded as these were by grazing cattle and cypress swamps. As small clouds drifted over the river, they left dark shadows dancing on the muddy surface, making crazy patterns. Oil wells were pumping steadily for riches. Mounds of coal and sulfur lined the western bank, reminding us that this is an industrial river, not a scenic postcard attraction. There was so much water on all sides of us that land—firm, solid land—seemed like a rare commodity. "It is a place," Harnett T. Kane wrote in *The Bayous of Louisiana* in 1943, "that seems often unable to make up its mind whether it will be earth or water, and so it compromises."

Since commercial fishing constitutes the main harvest in Plaquemines Parish, it seemed astonishing to see rows and rows of neatly lined citrus trees planted along the river for more than 40 straight miles. Unlike the sandy dirt of Florida, the rich alluvial soil of this area comes from the 31 states drained by the Mississippi. The result is that the sweetest, tastiest oranges in the world are grown here.

The Jesuits, who were granted a tract of land in 1727, brought the first citrus trees to Louisiana. Records show that the first citrus trees in Plaquemines Parish were planted at Fort Mississippi, an early Spanish fort located near present-day Carlisle. It was during this same period that missionaries also planted citrus groves in California and Florida. Although the soil here is perfect for citrus growing, the weather is not. Wind scarring is commonplace, and in 1989

a full frost wiped out nearly all the citrus trees in Louisiana. Recovery, however, has been quite successful. Today, thanks to the Louisiana State University Experimental Station located in Port Sulphur, there are more than 200 citrus growers in the parish, who have cultivated some 100,000 trees along the riverbank. They grow Satsuma mandarins and navel oranges, along with grapefruits and lemons. The only disadvantage of flying over this part of the Mississippi River instead of driving up Highway 28 was not being able to buy a bag of sweet, blemish-free Louisiana oranges at a roadside stand. Squeaking out a living in this highly unpredictable parish is clearly a hard life. Pollution besieges the lower river, with the Louisiana section alone receiving 97 million pounds of toxins annually—although tighter environmental standards are starting to reduce that staggering statistic. A surprising number of abandoned boats dotted the landscape, rotting away in little murky back bayous, vegetation sprouting from their half-sunken hulls. Many of the small, ramshackle trailer homes we flew over had broken motorboats sitting off their gravel driveways, obviously unseaworthy, but somehow deemed still too valuable for their owners to discard, an eyesore to most but to these Louisiana families, a faded memory of some fishing glory past. Miles away we spotted charter boats taking tourists out in search of menhaden, drum, and snapper. Louisiana's commercial fishing industry produces about 25 percent of all the seafood consumed in America and holds the record for the largest catch ever in a single year: 1.9 billion pounds. But along the Mississippi, the main action revolved around the gigantic tow barges and oceangoing behemoths, some as long as three football fields, which looked from our bird's-eye view like toy ships meandering up the river to New Orleans, the skyline of which loomed before us like the Land of Oz. ★

NEW ORLEANS

★

"The Mississippi River and its tributaries...
is by far the most important stream on the globe."

WALT WHITMAN

In this 1885 bird's-eye view of New Orleans, the Vieux Carré—heart of the colonial city—is divided from the burgeoning American neighborhoods by Canal Street, the broad boulevard running from the river to the lakeshore (upper righthand corner).

THE OLD ADAGE THAT ALL ROADS LEAD TO ROME applies to virtually all the great European capitals. In Paris, Madrid, and London, as in Rome, the town center is the convergence point. But the American urban grid disperses the city outward. And so Atlanta's Peachtree Street, for example, doesn't run into the city, but out to the high-tech suburbs, and industrial parks, and on into the countryside, as is true of most other cities in the United States. But New Orleans is different. Whether you approach the city via the Mississippi River or by Interstate 10, you're drawn immediately to Jackson Square, the site of St. Louis Cathedral and the Cabildo, one of the most historically significant buildings in the entire Deep South.

St. Louis Cathedral is the focal point of Jackson Square. It sits majestically facing the Mississippi, flanked on the east by the Presbytère and on the west by the Cabildo, buildings of Spanish provenance constructed during the 1790s. In addition to lending Jackson Square a sense

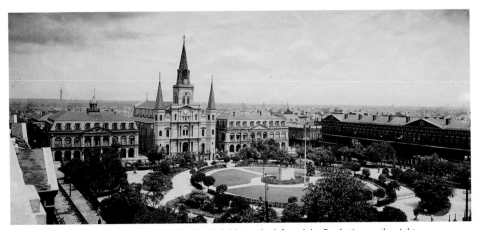

St. Louis Cathedral, framed by the Cabildo on the left and the Presbytère on the right, stands watch over Jackson Square, which was once used as a military parade ground.

Lafayette, who fought in the American War of Independence and was also a hero of the French Revolution, traveled in the United States in 1824 and 1825, the city spent $15,000 to redecorate the Sala Capitular for his five-day stay. After the Civil War, the Louisiana Supreme Court convened there

of aesthetic balance, these structures have been the scene of significant events in American history. Cabildo is the Spanish word for council, and the building's original purpose was to house the governing council. The building was opened in 1799, and only four years later Spanish governance which had lasted from 1762 to 1803 came to a close.

In 1803 Louisiana once again became a French possession— this time for only 20 days. America's President Thomas Jefferson purchased the Louisiana Territory from France's Napoleon for $15 million. The site of this transfer was the Sala Capitular, or Capital Room, on the second floor of the Cabildo. The building housed the Superior Court for the Louisiana Territory from 1803 to 1812. When Marquis de

from 1868 to 1910. During this time the room witnessed several landmark lawsuits. One of the notable cases was *Plessy v. Ferguson* in 1892. In March of that year, Homer Adolph Plessy, a black activist for the cause of civil rights, boarded a whites-only car on the East Louisiana Railroad. He was told to move to a car for blacks, and when he staunchly refused, he was arrested. When the case came to trial, Judge John H. Ferguson ruled against Plessy, and so Plessy appealed to the State Supreme Court. Here, too, at the trial in the Cabildo, Plessy lost his case. Plessy next appealed to the United States Supreme Court. In 1896 the highest authority in the land upheld the Louisiana State Supreme Court's ruling, establishing a legal precedent for the Jim Crow laws of "separate

but equal." In 1911 the Cabildo was incorporated into the Louisiana State Museum and today houses exhibits on the history of the Lower Mississippi Valley to 1877. Most prized among the museum's possessions is one of Napoleon's death masks. The story behind this artifact illustrates the complex web of allegiances that prevailed in the Territory even after its acquisition by the United States.

When former French Emperor Napoleon Bonaparte was exiled for the second time in 1815, he was deported to the remote South Atlantic island of St. Helena. Some of his officers fled to New Orleans, a city known to be sympathetic to Napoleon. By 1821 these officers had hatched a plot to rescue Napoleon from his prison. Even the mayor of New Orleans went along with the plan, offering him a house in the French Quarter. Napoleon's officers enlisted the aid of some Louisiana pirates and set sail for St. Helena. A few days before the rescue was to take place, Napoleon died. Although the former French emperor never made it to New Orleans, a death mask did. Dr. Francesco Antommarchi, a doctor who practiced in New Orleans and who also performed the autopsy on Napoleon, donated this particular death mask to the city in 1834. The house that was said to be readied for Napoleon is now a bar and restaurant, known as the Napoleon House.

It's commonplace today to consider America's acquisition of the Louisiana Purchase—which nearly doubled the

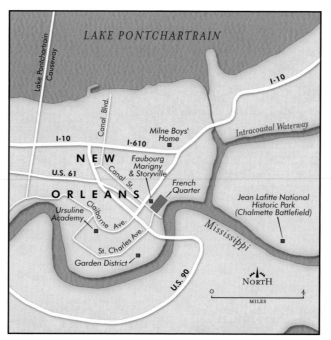

The port of New Orleans, at the mouth of the Mississippi River, was a key acquisition in the Louisiana Purchase.

size of America—an incomparable accomplishment for Jefferson. Tourists visit the Sala Capitular with a combination of intellectual curiosity and patriotic pride, to see the restored transfer room, looking much as it did in 1803. What many Americans don't realize is how viciously Federalist politicians denounced Jefferson for what they deemed an unconstitutional transaction. New Englanders, fearful that these new Western Territories would someday take control of the government, evoked shrill dissent. Josiah Quincy, a Massachusetts Congressman, actually urged the northeastern states to secede "amicably if they can; violently if they must." After all, Jefferson was up for reelection in 1804. His opponents wanted to tattoo the phrase "idiotic folly" onto his chest for allowing Napoleon to snooker Jefferson into purchasing "a wilderness unpeopled with any beings except wolves and wandering Indians." A favorite ploy was to break down the $15 million into comprehensible amounts: as much as 433 tons of silver, enough to fill 866 wagons lined up for nearly six miles, or a sufficient amount to pay 15,000 soldiers for 25 years.

The critics had a right to be concerned. There was no constitutional provision for a president acquiring new territory and granting automatic citizenship to the inhabitants. Jefferson, it seemed, was putting his grandiose notion of an "Empire of Liberty" ahead of the Constitution, and in many ways he was. But in August, as the country was debating

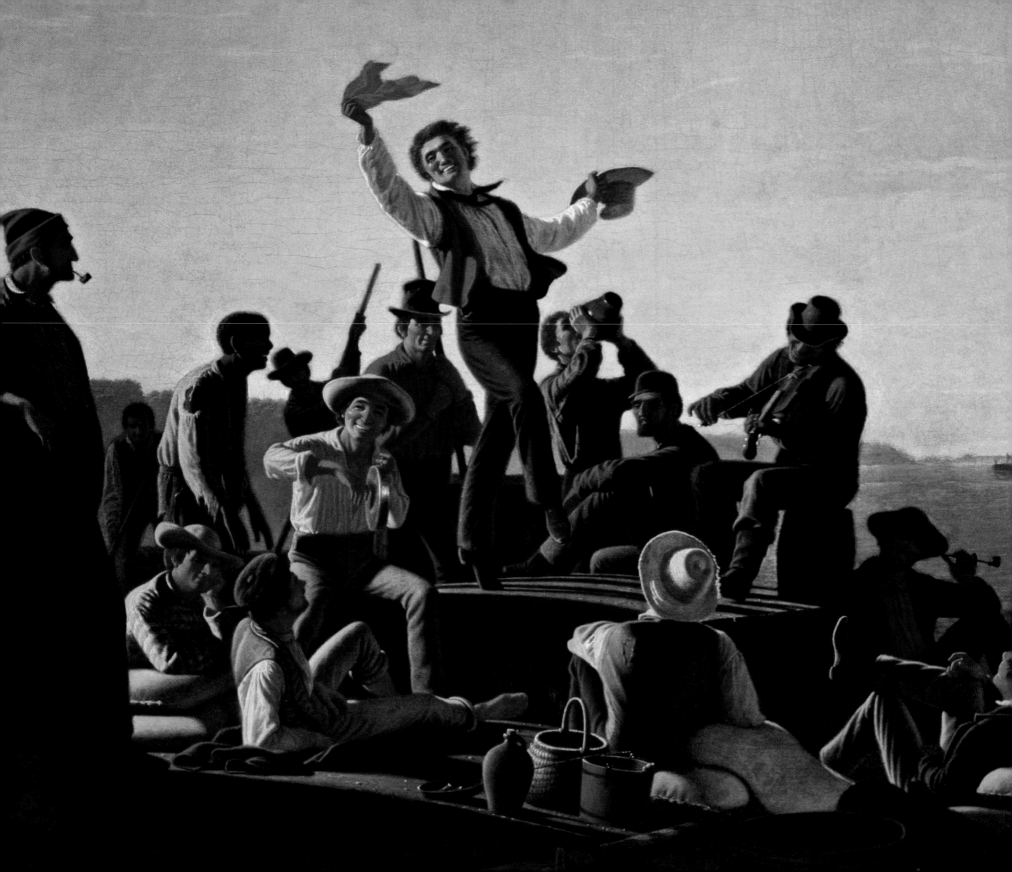

whether the Purchase was legal, Robert Livingston sent a dispatch from Paris that Napoleon was prepared to void the purchase if the Senate tried to modify the agreement. This catapulted Jefferson into action. Opting not to amend the Constitution, he submitted the treaty to Congress on national security grounds: A menacing France *had* to be removed from America. The gamble worked: On October 21, 1803, after limited debate, the Senate ratified the treaty by a 24 to 7 margin.

Now the official transfer ceremonies could begin. Spain was livid over what it saw as Napoleon's treachery and Jefferson's illegal purchase of the territory it had so recently ceded to France. But Spain's King Charles IV was in no mood for war with either France or the United States, and he reluctantly agreed to the transfer. On November 30, 1803, two Spanish grandees—Governor Manuel de Salcedo and Marquis de Casa Calvo—placed the keys to the city's forts on a silver platter and presented them to French representative Prefect Pierre Clément de Laussat. A public ceremony followed: The Spanish fired a lone cannonball into the Mississippi and played the Spanish anthem one last time, as a silent crowd watched the raising of the French tricolor.

The stage was now set for the Americans to take control of the Louisiana Territory. Jefferson appointed two commissioners—William C.C. Claiborne, former Governor of the Mississippi Territory, and James Wilkinson, Commanding General of the United States Army—to oversee the transfer. Nearly all the French citizens Claiborne encountered along

The new governor of the Territory of New Orleans, William Claiborne, complained that the city was overrun with "adventurers" and "vagabonds."

the river were mortified that their beloved homeland was being passed like an unwanted baton to Yankee Doodle rabble. When Jefferson purchased Louisiana, he did not ask the French citizens of New Orleans if they wanted to be Americans. He just did it.

Claiborne did his best to reassure everybody that the United States would honor the rights of all citizens in the vast territory. Despite widespread doubt and fear, the grand moment arrived without incident. On December 20, 1803, Claiborne and Wilkinson met French representative de Laussat in the Sala Capitular and signed the transfer document. Wild cheers erupted from outside. Americans began singing old victory songs from the Revolutionary War, such as "The Riflemen of Bennington" and "The Death of General Wolfe," while the French residents looked on in dismay. Some of the French wept openly. The French flag came down, and the Stars and Stripes went up. The Mississippi and New Orleans now officially belonged to the United States. Claiborne was appointed governor of the Territory of Orleans, amid widespread calls for statehood— an event which eventually took place in 1812, putting an 18th star on the United States flag.

At the time of the Louisiana Purchase, New Orleans offered as offbeat an assortment of characters as any city in the western hemisphere. The population of 10,000 was composed of Spanish Creoles, Kentucky frontiersmen, Appalachian hill folk, French dandies, Portuguese fishermen, Castilian soldiers, West African slaves, Acadian

American traders on flatboats flooded into New Orleans after 1803, as in this scene by George Caleb Bingham, transforming the French city into a Yankee boomtown.

drifters, Saint-Domingue rebels, Baratarian pirates, Choctaw guides, and Yankee clerks. It was a wide-ranging, incorrigible, multicultural stew of surreal proportions.

In 1803, three different flags flew over the Crescent City, so named for its position in a crescent-shaped bow of the Mississippi River. The Spanish, French, and finally the American banners were raised, but the real ruler was international trade. Bounded on three sides by swamps, residents looked to the riverfront for their economic life. Here were bales of cotton to make the Egyptians envious, rice on par with that of the Orient, sugarcane for the rum makers of Philadelphia, and tobacco leaves that would fill elegant pipes from Paris to Pisa. Noisy keelboatmen, called "kaintocks" by the Creoles, arrived from Ohio River towns like Pittsburgh, Pennsylvania, and Paducah, Kentucky, with whiskey breath and mud-caked garb, to unload flour and corn, tobacco and hemp, deer hides and beaver pelts on the teeming docks. After selling their merchandise, many of these tradesmen fanned out in search of fistfights and dice rolls in the French Quarter. They had abandoned their mule-drawn ploughs and had come to New Orleans for hard currency and midnight kicks. The Spanish and French disdained them. The Louisiana Territory was now part of the United States, and these newcomers were claiming their hard-earned booty after arduous months of growing crops. They had come to recodify French and Spanish laws into English.

"The more I became acquainted with the inhabitants of this Province," Governor Claiborne wrote Secretary of State James Madison after the transfer, "the more I am convinced of their unfitness for a representative government."

They may have been separated by class, country of origin, and skin color, but they shared a common bond: the river, which at the dock off Canal Street was 2,200 feet, or nearly a half mile wide. Directions from one place to the next were given as either upriver or downriver. Fear of flooding meant levees had to be built, canals dug, and drainage ditches filled. Canal Street, the widest avenue in the States, became a boundary line between feuding Creoles in the Old Town, now known as the French Quarter and Faubourg Marigny, and the incoming Americans who settled upriver in Faubourg St. Mary. The wide, well-maintained median down the center of Canal Street was called the neutral ground, a place where the two communities could mingle over matters of trade, city governance, and gossip.

A reminder of how nervous French-speaking citizens were about the Louisiana Purchase appears in a letter President Jefferson wrote to the nuns of the Ursuline Academy in the spring of 1804. (It is now on permanent display in a glass case at the academy's museum on State Street.) Established in 1727 by Ursuline sisters from Rouen, France, the academy is the oldest school for women and the oldest Catholic school in America. The nuns had been dispatched to the New World by King Louis XV, 45 years after La Salle claimed the Mississippi River for France. Their mission was to educate girls of all races and ethnic origins— a policy quite radical for its day. With St. Ursula and St. Angela as their patron saints, the nuns, despite complaints, taught women of African and Native American origin. "Nobody thought that women were important enough to educate in those days," Barbara Turner, the president of the academy said. "But the Ursulines understood the concept that if you educate the mother, you educate the family."

Before long the nuns had become an integral part of New Orleans, opening their school in the French Quarter and purchasing a tract of land that ran from the Mississippi to Rampart Street. They founded the first orphanage for girls. When the Natchez Indians massacred hundreds of French settlers at Fort Rosalie in 1729, the nuns provided

housing for the surviving women and children. They led the crusade to overturn the so-called rule of thumb that allowed men to beat their wife with a stick as long as it wasn't wider than the width of her thumb. They opened the first home for battered women and staffed the first hospital; one of the nuns became the first pharmacist in the Louisiana Territory. Their role in 18th-century New Orleans was crucial, and even hardened Protestants saluted them.

Because both Spain and France were Catholic countries, the nuns never worried about which flag flew near their convent. But they became concerned after Jefferson's Purchase. They read the U.S. Constitution with its clause that church and state must remain separate, interpreting this to mean schools must be nonreligious. Would Jefferson close their academy? Governor Claiborne visited the nuns and offered verbal reassurances, but that was not enough. On March 21, 1804, the Mother Superior, Marie Theresa Farjon of St. Xavier, wrote to Jefferson, expressing hope that the U.S. government would not close their school. "This request of the Ursulines of New Orleans," she wrote, "is not dictated by personal interest nor ambitious aims."

Jefferson felt strongly that religion was an essential aspect of American life and considered churches the cornerstones of any community. On May 15, 1804, he replied: "The principles of the Constitution and the government of the United States are a sure guarantee to you that your school and its properties will be preserved to you sacred and inviolate and that your own institution will be permitted to govern itself according to its voluntary rules, without interference from the civil authority. Whatever diversity of shade may appear in the religious opinions of our fellow citizens, the charitable objects of your institution cannot be indifferent to any; and its furtherance of the wholesome purposes of society by training up its younger members in the way they

should go, cannot fail to ensure it the patronage of the government it is under." The sisters read the letter with great relief. In the years following the Louisiana Purchase, they became the school of choice for the children of New Orleans's most prominent families, yet they also continued to teach the disadvantaged.

New Orleans continued to grow, as Americans settled west of the river and sent corn and cotton, indigo and tobacco to a world market. The new trade from the United States to the West Indies and Europe had brought on various trade restrictions from Britain and France. Trade disputes combined with old grudges over the War of Independence flared into a declaration of war with the British in 1812. By 1814 Britain was entrenched in Canada, at the northern end of the Mississippi. The British had an alliance with some Native American tribes on the west bank of the river, stretching far inland. Britain also had the seafaring knowledge to sweep up the river, perhaps as far as St. Louis.

General Andrew Jackson of Tennessee, known as Old Hickory because of his toughness, believed the British would target New Orleans next. On March 27, 1814, his men had broken the power of the Creek Nation, a mighty confederation of Indian tribes in Georgia and Alabama. Moving south, he had taken Spanish Pensacola, in the Florida panhandle, then driven the British out of Mobile, Alabama. Now he marched his troops from Mobile to New Orleans.

Jackson was born in 1767, the youngest of three sons of Scotch-Irish immigrants. Jackson's father died shortly before his birth. Both his brother and his mother died during the Revolutionary War, and Jackson was a 14-year-old irregular fighting the British when he was captured. When he refused to polish a British officer's boots, the officer slashed him with a saber. Now, as a general leading the Tennessee militia, he could even up old scores.

Souvenir de la neige du 14 Février 1895

Jackson signed up anyone who would fight and eventually formed an army of roughly 5,000 men. In addition to Tennessee and Kentucky militia units, he enlisted the help of the pirate Jean Lafitte (who owned a house at 941 Bourbon Street) and nearly a thousand of Lafitte's men, along with a hodgepodge of others. Jackson said the British were "the common enemy of mankind," and nothing drew the men together more than their hatred of the British.

After a skirmish with the British redcoats on December 23, 1814 in Lake Borgne, Jackson retreated and built a defensive position along the Rodriguez Canal, a narrow strip of dry land between the Mississippi and a cypress swamp. Jackson made the canal wider and deeper and filled it partly with water. His men built a mud rampart, thick enough to withstand a cannon shot. A stubbled sugarcane field gave the American artillerymen a clear field of fire.

General Edward Pakenham—a veteran of the Napoleonic Wars and the Duke of Wellington's brother-in-law—was in command of the 10,000 British men. On January 8, 1815, he sent 5,400 of his soldiers into battle. The redcoats marched in ranks, bayonets fixed, for about a quarter mile toward the earth fortifications. The Americans astonished the British with the accuracy of their long-rifle fire. During the battle, you could hear the beating of a drum to sound calls for commencing and ceasing fire. The drummer, Jordan Bankston Noble, was a 14-year-old former slave from Georgia who volunteered with the 7th Regiment. He was stationed next to the company commander and played on that cold January day like a man possessed. British soldiers fell across the line. Still they came on. General Samuel Gibbs's brigade came under fire from Tennesseans holding the American left flank near the swamp. Many officers, including Gibbs, were killed. General John Keane, trying to come to Gibbs's aid, ordered the 93rd Highlanders to march diagonally across the field. The movement exposed the regiment to a raking fire that inflicted heavy casualties, including Keane himself. Pakenham rode forward to rally his men, but he was also shot and killed. At last, the British withdrew and carried Pakenham's body away, stuffed into a barrel filled with rum. No one knows what happened to the other dead British soldiers; they are probably buried on or near the battlefield, the National Park superintendent believes.

The battle lasted only half an hour. British casualties exceeded 2,000; the Americans lost seven men and had six wounded. The victory was a thorough thrashing of the British. Later a British quartermaster lamented that his comrades had been "swept from the face of the earth."

Jackson later praised his ragtag troops for their courage and patriotism: "Natives of different states, acting together, for the first time, in this camp, differing in habits and in language have reaped the fruits of an honorable union."

Some say the Battle of New Orleans of January 8, 1815, was pointless. After all, the war had already been ended by the Treaty of Ghent in Belgium on December 24, 1814. News of the signing of the Treaty did not reach Washington, D.C., until February 17, 1815. Neither government had gone through its ratification. The British did not build their Empire by retreating from victories. Had they won, they may well have decided to stay. Pakenham had carried orders to set up a civil government in New Orleans.

Through cunning and courage in battle, Jackson was transformed into a national hero. His acclaim was a springboard to the presidency in 1828. As a tired and triumphant Jackson left the White House in 1837, he was asked if the

Ursuline nuns from France established the first school for girls in 1727 in the French Quarter. In February 1895 they enjoyed an unusual snow.

Battle of New Orleans had genuine historic significance. Jackson glared: "If General Pakenham and his 10,000 matchless veterans could have annihilated my little army..., he would have captured New Orleans and sentried all the contiguous territory, though technically the war was over.... Great Britain would have immediately abrogated the Treaty of Ghent and would have ignored Jefferson's transaction with Napoleon."

Today the fighting ground called Chalmette Battlefield is run by the National Park Service as part of the Jean Lafitte National Historic Park. You can see where nearly all the action took place from a single spot. The American line, behind the ditch, is on a flat field, where the redcoats marched toward the earth fortifications. You can wander in their footsteps trying to imagine the British soldiers fitted in bright red coats, faces determined, marching in columns, being cut down by the American frontiersmen. Visitors can stop at the Chalmette Monument, which was erected in 1840 when General Jackson visited on the 25th anniversary of the battle. They can pause at the antebellum Beauregard House that overlooks the river and the Chalmette National Cemetery, which was established in 1864 as a final resting place for Union soldiers who died in Louisiana in the Civil War, including many Afrian Americans. You can get to the park by car or by paddle wheeler from the French Quarter. History buffs hold a

An 1815 engraving and watercolor shows the positions of the British and American lines during the Battle of New Orleans.

reenactment each year on the anniversary of the battle, with cannon fire and marching soldiers.

In the Louisiana State Museum, visitors can see the drum Jordan Bankston Noble used during the battle. Biographical facts regarding Noble, who had a black father and a white mother, are vague, much of it derived from newspaper clippings and an autobiographical letter he wrote to his friend Edward Wharton, editor of *The Daily Picayune*. After the Battle of New Orleans, Noble became an overnight celebrity. His calling card read: "Jordan B. Noble, the veteran drummer who had the pride and satisfaction of beating to arms the Americans...on the 8th January, 1815." Soon military units involved in Indian skirmishes in Florida and the Carolinas wanted him attached to their company. The Washington Artillery recruited him in 1847 to drum them to victory in the Mexican War. At age 60, he served under Union General Benjamin Franklin Butler in the Civil War. Seldom was a black soldier treated with such respect by whites.

According to Elizabeth Mullener of the *Times-Picayune*, Noble was a mascot of the Crescent City for 75 years. He was a guest of honor when a statue of General Jackson was unveiled at the Cabildo. The statue shows the hero on his horse, the animal reared up on its hindquarters. The inscription ends with: The Union must and shall be preserved.

When the Emancipation Proclamation celebration was

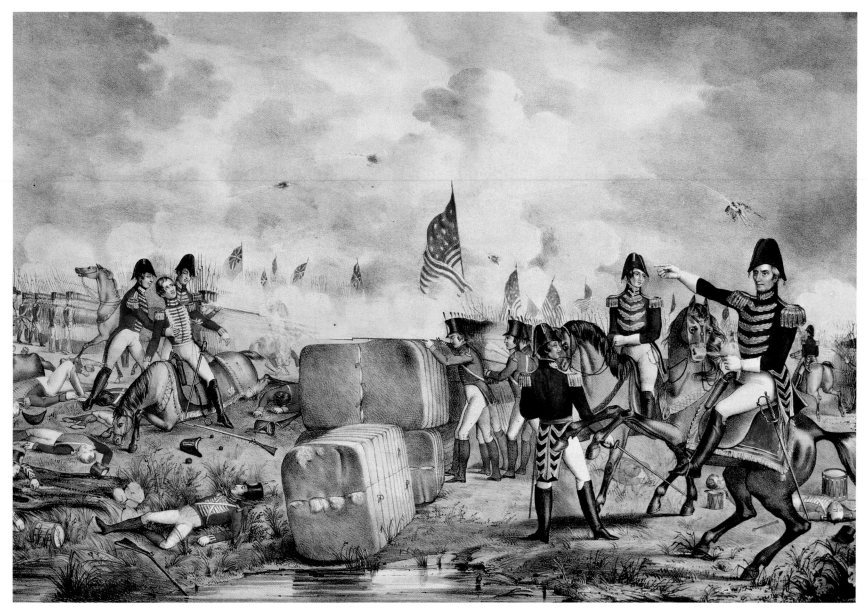

In this John Landis painting of the Battle of New Orleans, Andrew Jackson is shown on horseback (far right), commanding the American assault as British General Edward Pakenham falls dead. Pakenham was "cut asunder by a cannonball," while riding across the battlefield to rally his men. Pakenham had ordered his army to advance on the Americans at dawn on January 8, 1815, under a veil of fog. The fog lifted suddenly, exposing the British on a flat sugarcane field to the Americans who were entrenched behind a mile-long breastwork of sugar barrels and packed earth. When the redcoats marched to within 500 yards, the Americans unleashed their cannon and opened fire with rifles and muskets. It was "the most murderous [fire] I ever beheld before or since," one hardened British veteran reported. A British officer far removed from the frontline reportedly surrendered because "these damned Yankee riflemen can pick a squirrel's eye out as far as they can see it." The battle was over in half an hour, leaving 2,000 British casualties; the British withdrew.

held in Congo Square in 1863, Noble was there to provide backbeat as Abraham Lincoln's resounding words were read. He also played his drum at the funeral procession for President James Garfield, after his assassination. Noble's obituary in the *Times-Picayune* read: "The famous drummer boy of New Orleans has gone to join his comrades of many campaigns. Peace to him and honor to the brave man who served his country so often and so well."

Anyone with a free hour should venture over to St. Louis Cemetery No. 2, Square 3, and leave a drumstick at his grave as an offering of thanks.

The history of war tends to focus on admirals, generals, and strategists. Only recently have other figures secured their place in war history. Our victory in World War II, for example, was made possible not only by Patton, Eisenhower, and Clark, and but also by the industrial might and mobilization provided by the home front. It was Higgins Industries in New Orleans that produced the landing craft—LCVP, LCP, LCPL, LCM—and got the troops to the conflicts. The name of Andrew Jackson Higgins has largely faded from memory. The boat builder was a Nebraska-born Irishman often dismissed by New Orleans's social elite as a crude, hard-drinking outsider who lacked manners. But his feat of building 20,094 boats during World War II is not forgotten by military historians—or by the veterans.

By September 1943, a total of 12,964 of the United States Navy's 14,072 vessels had been designed by Higgins Industries: 92 percent of Navy landing craft were made by Higgins. "Higgins's assembly line for small boats broke precedents," Franklin D. Roosevelt's former advisor Raymond Moley wrote in *Newsweek* in 1943. "But it is Higgins himself who takes your breath away, as much as his products and his ability to multiply his products at headlong speed. Higgins is an authentic master builder, with the kind of willpower, brains, drive, and daring that characterized the American empire builders of an earlier generation."

Higgins's wartime success lay in the fleet of schooners and brigantines he built to carry his lumber. In 1937 Higgins owned one small New Orleans boat yard where roughly 50 people worked. By the time Japan bombed Pearl Harbor, he had designed prototype landing craft. Higgins Industries expanded into eight plants, employing 30,000 workers able to produce 700 boats a month.

In his book *Andrew Jackson Higgins and the Boats That Won World War II,* historian Jerry E. Strahan recounts the boat-building mania that swept over the Port of New Orleans. Higgins Industries constructed high-speed PT boats and various types of steel-and-wood landing craft. He made the D-Day landing of June 6, 1944 possible. "Without Higgins's uniquely designed craft," writes Strahan, "there could not have been a mass landing of troops and materiel on European shores or the beaches of the Pacific Islands."

General Eisenhower said Higgins was "the man who won the war for us." So crucial was Higgins's amphibious warfare craft that a disgruntled Adolf Hitler called him the New Noah. He was a boat builder who never let a soldier or sailor down. Higgins died in New Orleans in 1952. A half century later, he is enshrined as one of the effective armorers in America's "Arsenal of Democracy" at the National D-Day Museum, situated only three blocks from the Mississippi.

Tourists to New Orleans often visit the beautiful mansions that line St. Charles Avenue and the Garden District and enhance the French Quarter. Poet Andrei Codrescu once wrote: "If New Orleans went into the memorial plaque business for all the writers who ever lived here, they would have to brass-plate the whole town." At 505 Dauphine Street, for example, you can tour the cottage where Haitian-born illustrator John James Audubon worked on his *Birds of*

America series in 1821 and 1822. A bookstore at 624 Pirate's Alley was William Faulkner's home from 1925 to 1926, where he wrote his first novel, *Soldier's Pay.* French Impressionist artist Edgar Degas stayed at 2306 Esplanade Avenue from 1872 to 1873 to visit his mother's relatives and paint, among others, "A Cotton Office in New Orleans," his uncle's place of business. Playwright Lillian Hellman was born on June 20, 1905 in a boardinghouse at 1718 Prytania Street in the Lower Garden District. Author F. Scott Fitzgerald started *This Side of Paradise* in a tiny white cottage at 2900 Prytania. Visitors snap pictures of the various residences of playwright Tennessee Williams: 722 Toulouse, 431 Royal, 710 Orleans, 708 Toulouse, 538 Royal, 632 St. Peter, and 1014 Dumaine.

Most of these writers were transients, drifting into town to eat beignets at Café Du Monde, the poor man's idea of a Paris bistro, and drink gin fizzes at the Sazerac bar. They came to throw beads at Mardi Gras festivities, take the ferry across the river to Algiers, and dance until dawn on Bourbon Street.

When author Sherwood Anderson arrived, he was so enamored with the culture, he wrote fellow author Gertrude Stein that New Orleans was "the most civilized place on earth," and penned an article entitled "New Orleans, the Double Dealer, and the Modern Movement in America." Some writers spent a few years in New Orleans during the Roaring Twenties, hosting literary soirees in their homes. Others, like Jack Kerouac, rambled

Even as an old man, Jordan B. Noble was celebrated as the boy who drummed the Americans to victory in the Battle of New Orleans.

into the Big Easy to soak up "kicks, joy, and darkness" for only a memorable week.

Yet Walt Whitman is the true poet laureate of the city. He arrived in New Orleans on the steamer *St. Cloud* on February 26, 1848, accompanied by his brother, Jeff. A native New Yorker, Whitman had left Brooklyn after a heated dispute with his editor over the Wilmot Proviso, which held that slavery should be forbidden in any territory, a proposal Whitman strongly supported. Two days later, he started his journey. "Being now out of a job, I was offer'd impromptu (it happen'd between acts one night in the lobby of the old Broadway theater near Pearl Street, New York City), a good chance to go to New Orleans on the staff of *The Crescent*, a daily to be started with plenty of capital behind it," he wrote.

He was a 29-year-old reporter, and the experience of traveling down the river of his dreams left him breathless. "The Mississippi and its tributaries...is by far the most important stream on the globe," Whitman wrote in his journal. "Only the Mediterranean Sea has play'd so much part in history, and all through the past, as the Mississippi is destined to play." New Orleans in 1848 was the fifth largest city in America with some 160,000 residents, plus what historian David S. Reynolds surmised was "an equally large floating population of visitors and sailors." Ostensibly Whitman had come to work as the assistant editor of *The Daily Crescent* newspaper, at 93 St. Charles Avenue. But it was the cobblestone wharf—teeming

with citizens flush with victory from the Mexican War—which Whitman remembered best. "From the situation of the country, the city of New Orleans has been our channel and *entrepot* for everything," Whitman later wrote. "It had the most to say, through its leading papers, the *Picayune* and *Delta* especially…. No one who has never seen the society of a city under similar circumstances can understand what a strange vivacity and rattle were given throughout by such a situation. I remember the crowds of soldiers, the gay young officers, the receipt of important news, the many discussions, and the returning wounded."

The Whitman brothers rented a ghastly boarding house room crawling with cockroaches and garbage flies at the corner of Poydras and St. Charles. They soon found a more liveable garret at the Tremont House. At *The Daily Crescent*, Whitman was responsible for coordinating assignments for three staffers and overseeing the layout. But Whitman also answered mail, solicited advertisers, and swept the floor.

Whitman's favorite spot was the levee. "I used to wander a midday hour or two now and then for amusement on the crowded and bustling levees," he later recalled in the *New Orleans Picayune*. "The diagonally wedg'd-in-boats, the steve-dores, the piles of cotton and other merchandise, the carts, mules, Negroes, etc. afforded never-ending studies and sights to me. I made acquaintances among the captains, boatmen, or other characters, and often had long talks with them—sometimes finding a real rough diamond among my chance encounters." He loved browsing around the French Market on a Sunday morning. "The show was a varied and curious one…. For there were always fine specimens of Indians, both men and women." His New Orleans sketches are a mixture of slang, poetry, and prose—the famous free-verse style which would become the hallmark of *Leaves of Grass*.

Whitman basked in New Orleans food and nightlife. He spent evenings drinking in barrooms, usually at the St. Charles Hotel, which had opened in 1837. Once he met Gen. Zachary Taylor—the hero of Buena Vista, who many predicted would become the next president—at a perform-ance of the play "Model Artists." Whitman congratulated him on his victories. "The house was crowded with uniforms and shoulder-straps," he wrote. "General Taylor was almost the only officer in civilian clothes; he was a jovial, old, rather stout, plain man, with a wrinkled and dark-yellow face, and… show'd the least of conventional ceremony or etiquette I ever saw."

New Orleans's hedonistic charm soon wore off on the Whitman brothers. Jeff, who worked at *The Daily Crescent* as a copyboy, grew homesick. In May, Whitman got in a nasty dispute with the owners of the paper over money, causing him to quit. And there were the realities of slavery. Only a few blocks from Whitman's apartment, at 67 Gravier Street, Africans were sold to the highest bidder by the offices of Pierson & Bonneval, Auctioneers. Whitman could not bear to witness the slave pens any longer. On May 27, 1848 he and his brother boarded the *Pride of the West* and headed north. Whitman wrote "I Sing the Body Electric" about the auctioneering of human flesh. Although Whitman contin-ued to sing the praises of New Orleans, he lamented that a city so great could tolerate such savage barbarity with a Mardi Gras smile and a gentlemanly bow.

Even during Whitman's days New Orleans was a gour-mand's dreamland. Highly seasoned meals such as red beans and rice were introduced from the Caribbean. The French cooked with long-simmering sauces based on roux by heating fat and flour together in cast iron skillets. The raw oysters which arrived by the bushel full from the Gulf were consid-ered the finest in the world and were shucked and devoured in numerous bars in the French Quarter. Most of the spicy

In this 1873 painting by Edgar Degas of his uncle's cotton business in New Orleans, buyers and brokers examine samples of cotton laid out on the table. "One does nothing here," complained Degas, "nothing but cotton. One lives for cotton and from cotton." Sugar and cotton were then the city's two main exports.

food served in restaurants such as Galatoire's was referred to as Creole cooking. This unique blend of French, Spanish, African, and Caribbean cuisine had become New Orleans's culinary trademark. Gumbo—a stew made with seafood, vegetables, and chicken or sausage—became a local standard. At Mardi Gras time, King Cake—sweet brioche, iced in the carnival colors of gold, green, and purple—was served on every street corner. Poor New Orleans's cooks even tossed crawfish, which in the 19th century were easily collected in drainage ditches all over the city, into their specialty étouffées.

Although the city's cooking styles and ingredients easily blended nationalities and ethnicities, race relations were not as carefree. The abolition of slavery did not mean the end of racism. Storyville, a lively part of town where jazz was born, was primarily black, and has been largely demolished, as if to erase its history. In October 1997 only a dozen people placed a lone wreath next to a near-fallen state historic signpost on the Basin Street traffic island to commemorate the centennial of Storyville, the notorious red-light district. From 1897 to 1917 residents and visitors in this 16-block area scoffed at Victorian mores. The bordellos served as jazz workshops for such legends as Jelly Roll Morton, Tony Jackson, Clarence Williams, and King Oliver. More than 2,000 prostitutes once worked in Storyville, a vice theme park created by Alderman Sidney Story, whose goal was not to promote prostitution but to corral all prostitutes into one section of town. State legislator Tom Anderson, Louisiana's foremost pimp, ruled the

The vices of Storyville—prostitution (left) and absinthe—set the mood for a new form of music—New Orleans's vibrant jazz.

bordellos and sex shows for 20 years until the city closed the businesses in 1917. Navy officials feared seamen shipping out of New Orleans in World War I would contract venereal diseases. Today only five unmarked buildings remain of Storyville. The rest, even ornate Victorians, were razed in the 1930s and '40s.

Yet Storyville still echoes with musical memories. A high-end brothel known as Lulu White's Mahagony Hall is a parking lot today. Of the hundreds of Storyville "cribs"—small rooms with doors facing the streets for seductive posturing—only two abandoned ones remain. Frank Early's Saloon on Bienville Avenue, a rickety wooden building where the musician Tony Jackson wrote the song "Pretty Baby" about his homosexual lover, is one of the rare survivors—a convenience store today for the Iberville Projects.

But if you pause at the statue of Louis Armstrong in Congo Square, the actual spot where many experts believe jazz was born, you can almost hear the music.

Louis Armstrong grew up in the Back o' Town neighborhood, an area so rough it was known as The Battlefield. His father played little part in Louis's life, and he was exposed at an early age to prostitution, gambling, and gun and knife fights. As much as the poverty and the violence that permeated The Battlefield, music played a central role in this community. Armstrong was not bitter about the disadvantages he faced as a child and somehow escaped falling into the life of crime that seemed inescapable for many in his neighborhood. That is not to imply that Louis didn't have a

In a 1931 reunion with former band mates of the Waifs' Home for Boys, Louis Armstrong sits in the center. The band gave him his musical start.

mischievous streak. In a defining episode of his life, on New Year's Eve, 1912, the 11-year-old Armstrong fired a pistol into the night to celebrate. He was apprehended and placed in the Colored Waifs' Home for Boys. In this large Greek Revival mansion Armstrong learned to play an instrument. A teacher at the Waifs' Home bought him a banged-up cornet and invited him to play in the Home's marching band. When Armstrong left, his musical talent was well known. He was told, he could hold on to the cornet until he had earned enough money to buy his own. Armstrong did return the cornet, and it was kept at the Home as a keepsake. Today it is on display at the Old U.S. Mint, and you can tour the Colored Waifs' Home—renamed the Milne Boys' Home—at 3420 Franklin Avenue. As a tribute to the jazz great, the city runs the Louis Armstrong Manhood Development Program out of the estate, whose mission is to turn boys into leaders.

Armstrong gained recognition for his musical genius in his native New Orleans, but he lived there only during the early years of the 20th century. It was the time of Jim Crow laws, and for all its diversity, New Orleans was part of the segregated South. In 1922, at the age of 21, Armstrong joined the band of another New Orleans native, cornet player Joe "King" Oliver, in Chicago. Armstrong toured extensively with Oliver's ensemble and soon became a star in his own right, touring North America and Europe and becoming a celebrity on both continents.

Although he bought a home in Queens, New York, in 1943, Armstrong often said, "I'll do anything for New Orleans." By serving as an informal ambassador for the city, Armstrong did much for his hometown, reigning as Mardi Gras King of Zulu Parade in 1949, and bringing his hometown with him wherever he went. Tourists still arrive in New Orleans on jazz pilgrimages, looking for Armstrong sites. The 400 block of South Rampart Street remains the site of several buildings, such as the Eagle Saloon and Odd Fellows Hall, where Armstrong performed music as a youth. Other sites were razed in the name of development and progress.

Only in recent decades has New Orleans begun to give Armstrong his proper due. Perhaps the most prominent showing was made on August 4, 2001 in honor of his centennial birthday celebration. The Marsalis clan (father Ellis, along with his sons Branford, Wynton, Delfaeyo, and Jason), and Ellis's former student Harry Connick, Jr., played a concert at the University of New Orleans called "From Satchmo to Marsalis: A Tribute to the Fathers of Jazz." As part of the same weekend's festivities, the New Orleans International Airport was formally renamed the Louis Armstrong International Airport.

Often people ask if Armstrong—who used to perform on Mississippi River boats—participated in the Civil Rights Movement. Armstrong's views on race were complex and at times difficult to ascertain. What is true is that Armstrong fought for civil rights in ways he felt he could have the most positive, long-lasting impact, that is, through music. Armstrong—whose nickname "Satchmo" is a shortening of the British "Satchel Mouth"—taught the world that improvisation is high art. In his autobiography, *My Life in New Orleans*, Armstrong wrote that he believed music was the ultimate example of freedom and democracy. Listen to his records, and you'll hear how he developed a sound both individualistic and universal. Whether he was listening to a hurdy-gurdy man performing for tips, an Italian organ grinder, the calliope on the riverboat, African rhythms being played in Congo Square, or the American premieres being given at the French Opera House, Armstrong was a glorious sponge with a keen sense of blues expression who evaded simplistic jazz categorization to become the most important musician of the 20th century. In New Orleans his spirit lives on. ★

THE DELTA

★

"...five thousand square miles, without any hill save a few bumps of earth which the Indians made to stand on when the river overflowed."

WILLIAM FAULKNER

An 1861 map of the Gulf Coast shows the Mississippi fanning into many branches at Head of Passes. COURTESY LIBRARY OF CONGRESS

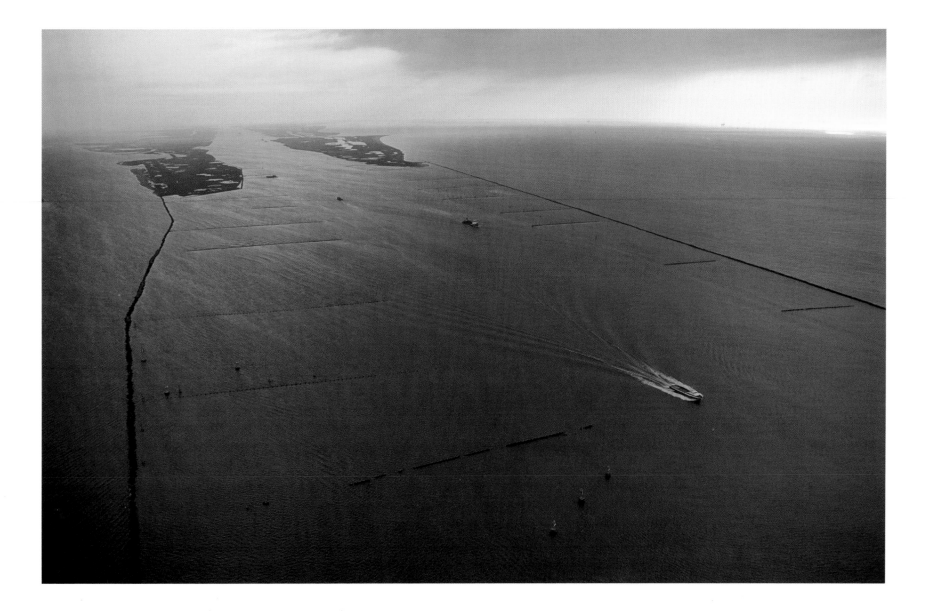

Leaving North America behind, a ship cuts between the jetties at Southwest Pass on its way to sea.

A prize tarpon hangs in front of a "fishing wall of fame" in a marina and bait shop in Venice, Louisiana.

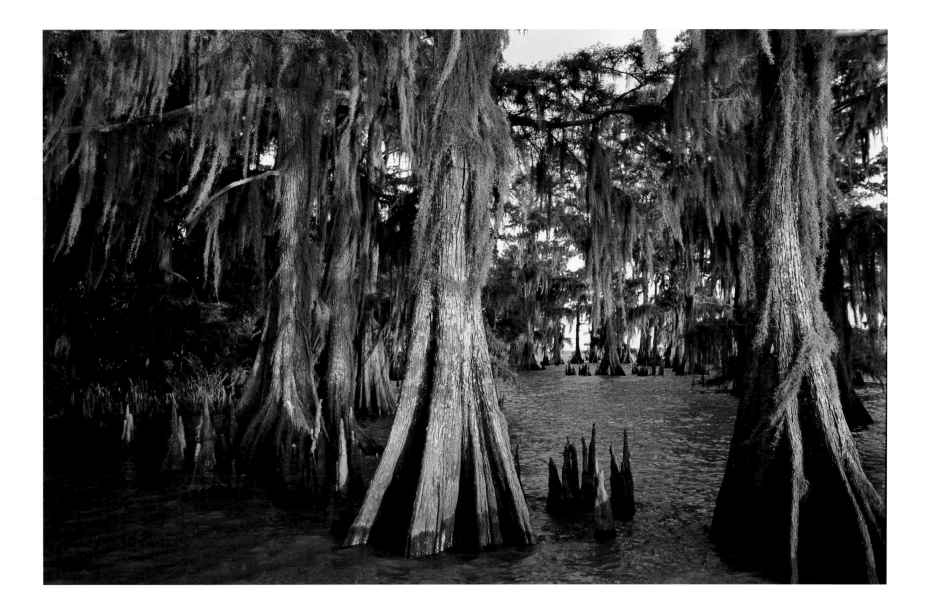

Moss-draped cypresses root in the swamp of the Atchafalaya Basin, west of New Orleans.

Visitors to this cabin in the swamp near Venice, Louisiana, can reach it only by boat, not by car.

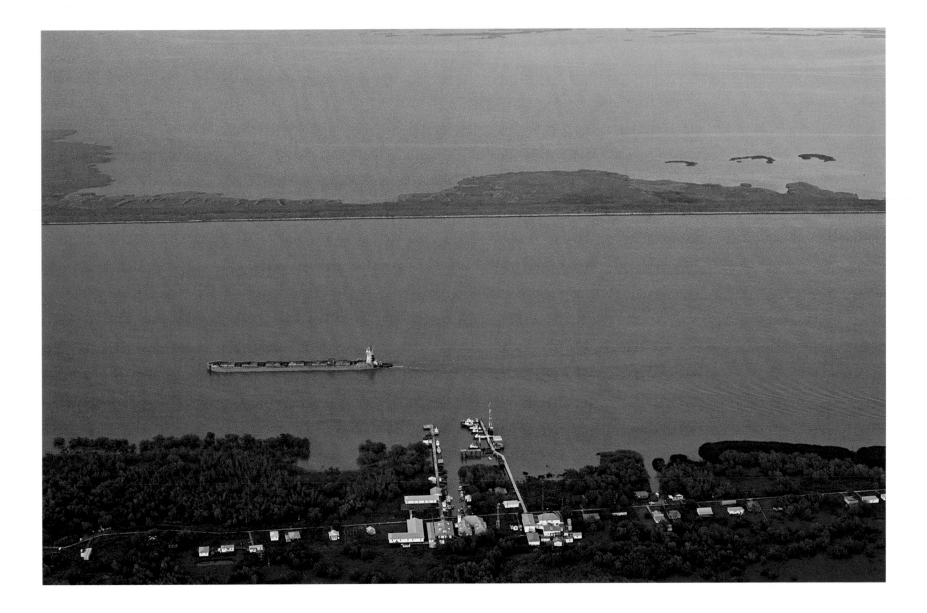

An ocean-bound freighter passes Pilottown, the last settlement before the Gulf of Mexico.

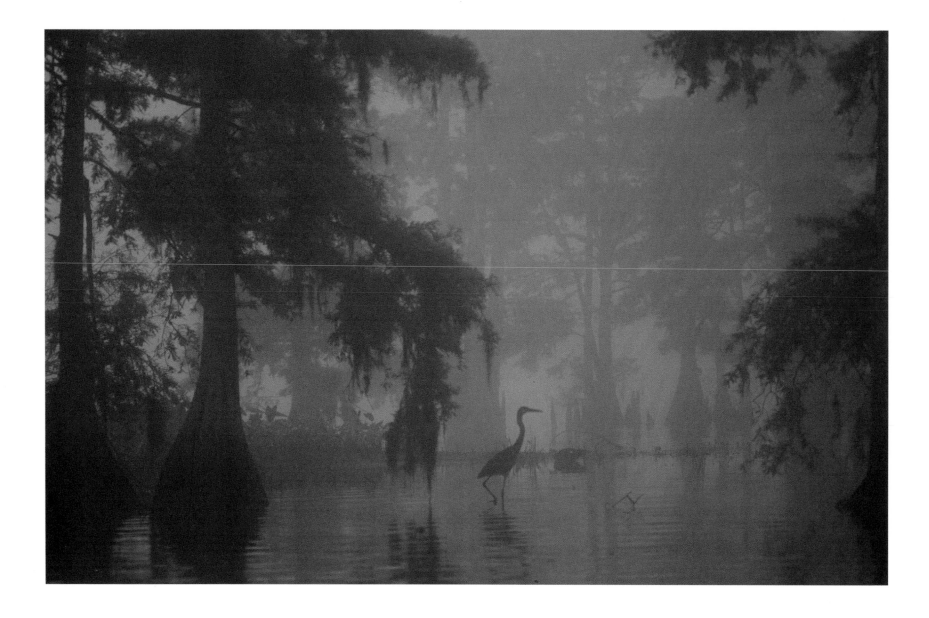

Its world veiled in mist, a Great Blue Heron wades in a cypress swamp in southern Louisiana.

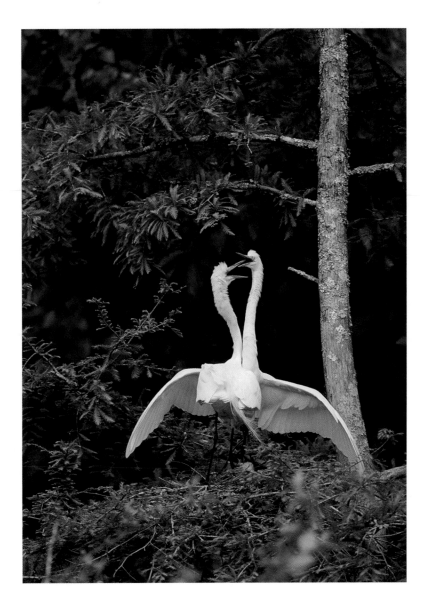

At a tree-top rookery in the Atchafalaya Basin, two Great Egrets dance in courtship, seeming to become one.

The blooms of a yucca plant frame Oak Alley Plantation in Vacherie, Louisiana. The mansion's 28 Tuscan columns match the number of live oak trees forming an avenue that extends for a quarter mile from the house to the Mississippi River.

RIVER ROAD PLANTATIONS

★

"In all of us there is a hunger,
marrow deep, to know our heritage."

ALEX HALEY

WALK INTO ANY HOTEL OR MOTEL LOBBY in the Greater New Orleans area, and you'll find racks of colorful brochures touting the delights of various Haunted House Tours, Swamp Boat Adventures, and Cajun Country Excursions. At the more upscale end are the pamphlets luring tourists to the "Great River Road Plantation Parade." Visitors could "experience the charm" of some dozen antebellum mansions lining the Mississippi from New Orleans to Baton Rouge, take in the antebellum splendor of Bocage, a fine example of Greek Revival architecture said to be built by a French relative of Christopher Columbus, or dine at Nottoway, another grand house offering old-fashioned Southern hospitality.

What's being sold, of course, is the rosy image of the pre–Civil War South as romanticized by lady novelists such as Emma Dorothy Eliza Nevitte in her 1850 best-seller *Shannondale* and Eliza Ann Dupuy in her 1857 novel *The Planter's Daughter: A Tale of Louisiana*. Missing from these nostalgic "moonlight and magnolias" come-ons, celebrating the life-styles of Confederate cavaliers, coquettish belles, and grinning mammies is any mention that the entire plantation system was based on the practice of slavery. Even Harriet Beecher Stowe's *Uncle Tom's Cabin*, despite its rousing abolitionist message, romanticized the image of the genteel planters.

The reality was quite different. Because of the factor of labor, the size of a plantation was usually figured in number of slaves. At the onset of the Civil War, with a white population of slightly over eight million in the South, there were only a handful of "great planters" who owned a hundred slaves or more. Perhaps 2,500 owners had as many as 30

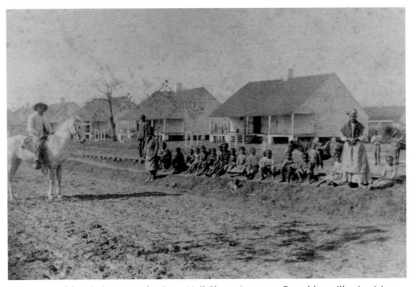

Children of freed slaves on the Evan Hall Plantation near Donaldsonville, Louisiana, sit outside their homes—a row of former slave cabins—in 1888.

slaves, and perhaps 46,000 about 20 slaves. Most of these large plantations spread out along the Mississippi River. Land-holdings ranged from small vegetable farms to several-thousand-acre sugarcane or cotton plantations. On large plantations slaves performed the field and maintenance work, but even small farms held at least one slave carpenter or blacksmith. Servants and nursemaids lived in the "big house," whereas field workers stayed in separate slave houses out back—in long barracks or small huts. The slave quarters are rarely mentioned in any accounts.

But Kathe Hambrick, a former IBM systems designer, who came home from Los Angeles to manage her family's funeral business, was shocked to discover that the "Lost Cause" version of Confederate history was still being propagated at most of the historic homes along the river. "I went on tours at plantations all over Louisiana and Natchez, and I found that the story of slavery was missing," she explained.

"People had questions that weren't being answered. Guides were afraid to say the word 'slave,' preferring the more genteel 'servant' or 'help.' It really disturbed me. It was a tragedy. That's when I decided to do something."

Hambrick's first step was to visit the gift shops at plantations up and down the river and confront their owners about selling offensive Jefferson Davis iconography and Aunt Jemima-type trinkets. With the help of a local genealogist, she studied the slave records of the Houmas Plantation. The estate was sold on April 15, 1858 by John S. Preston of Columbia, South Carolina, to John Burnside of New Orleans, who for $1 million got a plantation consisting of a substantial mansion, 12,000 acres ideal for cultivating sugarcane, and more than 200 slaves. Now, thanks to Hambrick's research, those 200 forgotten African Americans have regained their names. "I wanted to restore dignity to my ancestors," she said. "There is nothing quaint about the chains of the Middle Passage." She has found records for more than 4,000 Louisiana slaves and has raised the funds to open the River Road African American Museum in Darrow, Louisiana, on the grounds of the Tezcuco Plantation.

The first thing a visitor to the museum sees is a plaque bearing a quotation from Alex Haley's African-American saga *Roots:* "In all of us there is a hunger, marrow deep, to

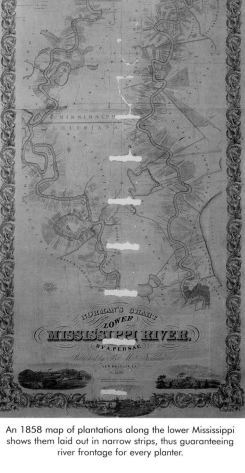

An 1858 map of plantations along the lower Mississippi shows them laid out in narrow strips, thus guaranteeing river frontage for every planter.

know our heritage. To know who we are and where we came from. Without this enriching knowledge there is a hollow yearning. No matter what our attainment in life, there is a vacuum, an emptiness, and the most disquieting loneliness." Then, lining the walls next to an 1895 reproduction of the Emancipation Proclamation of 1863 are displays of original slave letters and documents of purchase from plantations in surrounding parishes.

Other exhibits aim to explain everything from legal issues to health conditions to the African diaspora. We learned that slaves in antebellum Louisiana had severely circumscribed legal rights. They could appear in court as plaintiffs, but only to claim their freedom, which was virtually never granted. Although occasionally allowed to testify for or against their peers, slaves were never permitted to speak in court regarding whites or free persons of color. Another display describes the most common food for Great River Road plantation slaves: hoecakes, a practically nutritionless cornmeal batter, fried on the blade of a field hoe over an open fire. We're also reminded that words such as jambalaya, goober, gumbo, banjo, mamba, tote, mooch, and mosey are all of African origin. Among the artifacts on view are some carefully crafted drums, which slaves once used to communicate across the vast fields.

Much of the River Road museum is devoted to great African Americans from the parishes along the Plantation Parade. Among the forgotten men is Abe Hawkins, one of the most celebrated jockeys in American horse racing from the mid-1800s to 1867. Upon reading historian Edward Hotaling's book *The Great Black Jockeys,* we became enamored with Hawkins's journey from slave to free man of national prominence. Hawkins was born into slavery in the late 1820s or early 1830s. The young jockey was sold by Adam Bingham of Mississippi to Duncan Kenner, owner of Ashland Plantation near Gonzales, Louisiana.

Since the 1600s, plantation slaves had often been trained as jockeys. Kenner, one of the early leaders of thoroughbred horse racing in Louisiana, was a state legislator and delegate to the provisional Confederate Congress in Montgomery in 1861. His stable of horses at the time of the Civil War was among the best in the state, and his prize slave jockey—who wore his red-on-red colors—a turf sensation. To Hawkins, horse racing was a ticket to a better life: He avoided the drudgery of the sugarcane fields which Kenner's 473 other slaves were forced to endure.

Hawkins, who weighed a mere 87 pounds and was known for his solemn, melancholy demeanor, focused intently on honing his riding skills. He notched his first notable victory riding Louisiana-bred Lecompte to win both heats of the Jockey Club Purse against the great Lexington, the pride of Kentucky thoroughbreds, at the Metairie Race Course in

WILSON CHINN, a Branded Slave from Louisiana. Also exhibiting Instruments of Torture used to punish Slaves.
Photographed by KIMBALL, 477 Broadway, N.Y.
Entered according to Act of Congress, in the year 1863, by GEO. H. HANKS, in the Clerk's Office of the United States for the Southern District of New-York.

An 1863 image from the Civil War era documents the inhumanity of slavery which included "disciplining" by branding.

New Orleans in April 1854. "I have seen all the best jockeys in Europe," said Robert Alexander, Lexington's later owner, and "not one of them is nearly his equal." Year by year after that, Hawkins's legend grew.

Even before Robert E. Lee's surrender at Appomattox Courthouse on April 9, 1865, Hawkins had become a de facto free man. As the Yankees took over Ashland, he disappeared and reappeared in 1864 on the premier racing circuit, first in Missouri, then in New Jersey, finally in New York at the grand old track at Saratoga Springs (which supplanted New Orleans as America's racing capital). By then he had won and saved a small fortune. Among other major races, Hawkins won Saratoga's 1866 Travers Stakes on Merrill.

Artist Winslow Homer was at Saratoga one season and sketched a grandstand of Yankees cheering the horses and jockeys on. Blacks were not allowed in the stands. Everywhere Hawkins went, sportswriters and crowds of racing fans cheered the erstwhile slave's formidable riding skills, which included the forward-leaning style. Some 30 years later the white jockey Tod Sloan popularized this style as the "American Seat." Yet even the Northern newspapers referred to Hawkins only as Old Abe, never hinting at his family name. In his time, Hawkins became one of the most famous athletes in America, a man who, one commentator wrote "never had a superior in inducing a horse to make the greatest effort he was capable of."

Meanwhile Duncan Kenner had fallen on hard times. During the Civil War, Federal troops occupied Ashland for four days and confiscated or destroyed almost everything of value. Kenner had avoided Union capture and was sent by Jefferson Davis as Confederate Minister Plenipotentiary to Europe in 1865 in a last, desperate attempt at winning foreign recognition for the Southern cause. After the war Kenner's property was confiscated by the U.S. government, causing Ashland to fall further into ruin. Like most of the wealthy Mississippi River planters of the antebellum period, he had to rebuild from scratch in the era of Reconstruction.

Hawkins heard of Ashland's destruction and offered to send Kenner some money. Kenner replied that he didn't need any money but that Abe could come back to Ashland. When Hawkins returned, he was racked by tuberculosis.

Hawkins died in 1867 and was buried, according to his wishes, under a live oak tree on the eastern bank of the Mississippi overlooking the old training track at the Ashland Plantation. His obituary in the magazine *Turf, Field, and Farm* remembered the great jockey as "a master of his profession and not less faithful than he was competent.... Good riders and strictly honest ones are rare, therefore the death of Abe is an irreplaceable loss to the American turf."

Eight years later, another African-American jockey, Oliver Lewis, would win the first Kentucky Derby on Aristides in 1875. Black jockeys won 15 of the first 28 derbies; then, one by one, they were forced out of the sport. By 1911 they had all but disappeared, and the once celebrated Hawkins was simply erased from the history books.

Having learned about these jockeys made us wonder why Hambrick would place one of those three-foot-high cast-iron statues of a black jockey holding a lantern in front of the museum's exhibit on the legendary rider. Like most Americans, we had considered these lawn ornaments an ugly racist affront. But the River Road museum reveals the meaning behind the lawn jockey: It was created to commemorate a black American hero—and later came to symbolize others like Hawkins.

Legend has it that on an icy night in December 1776 when General George Washington decided to cross the Delaware River to launch an attack on the British at Trenton, he had with him one Jocko Graves, a 12-year-old African American. Graves volunteered for service in the Continental Army and bravely sought to fight the redcoats. Washington deemed him too young for combat and ordered the boy to stay put, to look after the horses, and to make sure to keep a lantern blazing along the Delaware so the company would know where to return after battle. And so Graves dutifully stood and waited with his lantern, even as a heavy snow fell, and the temperature dropped to zero. Many hours later, Washington and his men returned to the sight of their reserve horses tied up and the motionless figure of Graves, frozen to death with the lantern still clenched in his fist. It is said that Washington was so moved by the young boy's devotion to duty and the revolutionary cause that he commissioned a statue of the "faithful groomsman" to stand in Graves's honor at the general's home, Mount Vernon.

Historians have not been able to verify this story. Mount Vernon is one of America's most carefully documented historic homes, but no evidence to this story has been found. The legend survives as a symbol of the important role such groomsmen and other African Americans played during the Revolution. Though the origins are unknown, the lawn jockey tradition can be traced to at least the early 1800s.

By the time of the Civil War, these Jocko statues could be found on plantations throughout the South, and it is said that some acquired a fitting purpose: like the North Star that pointed fleeing slaves to their freedom, the Jocko statues

pointed to the safe houses of the Underground Railroad. Along the Mississippi River, a green ribbon tied to a statue's arm—whether clandestinely or with the owner's knowledge—indicated safety; a red ribbon meant danger. Thus the original lawn jockey statues fetch thousands of dollars today as artifacts of the Underground Railroad that conducted so many African-American slaves to freedom.

In addition to its primary focus on antebellum slavery in Louisiana, the River Road African American Museum also deals with more contemporary history. One section of the museum is dedicated to African-American musicians hailing from Great River Road plantation country such as the legendary part-Creole Negro, part-Choctaw Indian composer Claiborne Williams. He was born in Plaquemines Parish on the Valenzuela Plantation in 1898. The release of his first song, "You Missed A Good Woman When You Picked All Over Me," is thought to mark the first appearance of the word "jazz" on a piece of sheet music. Williams's countless recording projects helped launch the careers of Sidney Bechet, Coleman Hawkins, and many other late jazz luminaries. Antoine D. "Fats" Domino, a rock and rhythm-and-blues (R&B) pioneer whose record sales were second only to Elvis Presley's in the 1950s, was reared in Vacherie, and Ernie K. Doe, whose 1961 R&B single "Mother-in-Law" reached No.1 on the Billboard pop and R&B charts, called Thibodaux home. Similarly, the brilliant cornetist Joseph "King" Oliver, born just across the Mississippi River on May 11, 1885, in Abend, Louisiana, served as the single greatest influence on renowned jazz trumpeter Louis Armstrong. Yet Oliver remains sadly forgotten outside the music industry.

Anybody familiar with jazz has heard fantastic stories about the short, barrel-chested King Oliver's journey up from the sugarcane fields of Louisiana. Blinded in one eye as a child, he learned to play the trombone and cornet sitting on fruit crates, or leaning against a brick wall in downtown Donaldsonville. Embarrassed by his deformity, he would often blow his horn with a brown derby tilted over his bad eye, earning him the nickname "Ol' Cocky." On clear mornings he would scour the banks of the river in search of discarded gizmos he could place in front of his cornet to create wild and original sounds. He is said to have used everything from tin cups and snuff boxes, to jelly jars and ladies' church bonnets to turn the blues upside down.

In his early 20s he drifted downriver to New Orleans and played in marching bands such as The Olympia and The Onward Brass Band. By all accounts he was a rough-hewn character who often carried a pistol in his coat. Bandleader Edward "Kid" Ory, from the nearby hamlet of LaPlace, Louisiana, dubbed him "King" for playing the most innovative cornet and developing much of the phraseology that made up the vernacular of jazz's roots. Eventually Oliver formed the Creole Jazz Band in New Orleans, bringing the group to Chicago in 1919 to play at the Dreamland Ballroom. For a few years Oliver roamed the country with his band playing in juke joints and dance halls in at least a dozen states. Back in New Orleans he became mentor to the young Louis Armstrong, who called him Papa Joe. There was a frenzy to Oliver's playing, which some likened to attending a Holy Roller meeting on All Saints Day. To his protégé Armstrong, who played second cornet in his ensemble, he was unquestionably "the strongest and most creative" musician to romp the Vieux Carré. "Had it not been for Oliver," Armstrong would remark long after he himself became a celebrity, "jazz would not be what it is today." Papa Joe recognized Armstrong's budding genius and brought him to Chicago in 1922 to play in King Oliver's Creole Jazz Band. Indeed, Oliver introduced Satchmo to the world.

In this painting—"Life on the Metairie" by Theodore Moise and Victor Pierson—members of the Metairie Jockey Club gather at the race course outside New Orleans in 1867. Duncan Kenner, who once owned the famous black jockey Abe Hawkins, stands sixth from left. The painting suggests that horse racing at the time was a white man's sport. In some ways that was true. It was the nation's most popular sport and national pastime, and blacks were not allowed in the stands. Horse racing had been perceived as a "gentleman's sport," meaning for rich white men only. When a white tailor challenged a Virginia planter to a horse race in 1674, the York County Court fined the tailor, ruling that horse racing was "a sport only for gentlemen." The governor later organized a day of racing, but limited contestants to "the better sort of Virginians only." In antebellum America, white men owned, bred, and bet on horses, but turned the riding over to trained jockeys and retired to exclusive racing clubs. Prior to the Civil War, most jockeys were black and many, like Abe Hawkins, began as slaves. By the turn of the 20th century, black jockeys were pushed aside and largely forgotten.

Within a few years, however, the Creole Jazz Band dissolved, and Oliver teamed up with "Jelly Roll" Morton to record a pair of duets that are considered landmark New Orleans-style recordings in jazz history. His new band, the Dixie Syncopators, recorded some extraordinary compositions such as "Dipper Mouth" and "Willie the Weeper." Even as his star shone, King Oliver was in ghastly physical condition. An omnivorous eater, he weighed 250 pounds and loved nothing more than sugar sandwiches, the staple snack of his childhood in the cane fields of Louisiana. By the early 1930s his teeth had rotted away due to pyorrhea, and he had no money for proper dental care. Despondent, he stopped touring, put his cornet in its tattered case, and lived in a small rooming house in Savannah, Georgia. The great King Oliver now struggled for Great Depression nickels by working as a janitor in a poolroom. He died on April 10, 1938, and although he is celebrated the world over as the greatest artist of all in the classic style of New Orleans jazz, the State of Louisiana has failed to properly honor him.

The same can be said of the remnants of a downtown Donaldsonville building with a rich musical history, which Hambrick is also determined to preserve. Donaldsonville, a city some 8,300 strong, is located between New Orleans and Baton Rouge on the west bank of the river and has long been the commercial center of Ascension Parish. Founded by La Salle in 1682 when he encountered the Chetimatches Indians at the junction of the Mississippi River and the bayou he called Lafourche (French for fork), Donaldsonville soon became a favored destination for Acadians—French people banished from Nova Scotia by the British in 1755. By 1758, the town was the second largest Acadian settlement in the Louisiana Territory. Donaldsonville was also the official headquarters of pirate Jean Lafitte, who planned many of his bold raids from his Old Viola Plantation between 1810 and 1814. In 1830 Donaldsonville had the distinction of temporarily becoming the state capital for a year, an event which still makes the locals proud. Visitors can choose among attractions, including a commemorative cannon recently placed on the site of Fort Butler, a Confederate stronghold burned by Union troops in 1862, and several memorials to black troops who fought at Fort Butler. A monument celebrates Pierre "Caliste" Landry, a slave born on the Prevost Plantation in 1841 who in 1868 won the distinction of becoming the first black man to serve as a mayor in the United States. Yet the most historically significant edifice in downtown Donaldsonville is the True Friends Benevolent Association Hall at 711 Lessard Street, built in 1883 by freed slaves as a place for African Americans to hold political rallies and social events. Today, across from Mike's restaurant with the sign "Hog, Cracklin' and Fried Gizzard," the Hall remains off limits by neglect, though that is about to change.

A few years ago Hambrick acquired the True Friends Hall to become part of the River Road African American Museum and to ensure the posterity of the Association, which for decades helped poor black members pay medical bills, funeral expenses, and the like. In its heyday this half-block-long, two-story building, with a wooden balcony and four red brick columns, served as a regional entertainment center for all the African Americans who eked out their living along this part of the Mississippi River.

As True Friends members and relatives migrated into New Orleans, the Association's ties with the local Mardi Gras celebration formed and grew into festive traditions. In the early 1900s a procession of the Zulu Social Aid and Pleasure Club traveled by boat up the Mississippi to Donaldsonville and then paraded down Railroad Avenue to

the Hall, where a raucous annual carnival ball shook the rafters past dawn.

Not only on Mardi Gras did the True Friends Hall host a veritable Who's Who of jazz and blues royalty: All three pioneers of New Orleans's early jazz style—King Oliver, trombonist Kid Ory, and pianist Ferdinand "Jelly Roll" Morton—performed there often. Ory even called the Hall "home, sweet home." The gig was so esteemed that when a young Fats Domino arrived one Saturday night to find the house piano missing, his friends borrowed a truck, and hauled it back to the True Friends Hall so he could perform well into the next morning.

Hambrick plans to refurbish this building as well as another donation, the 4,000-square-foot Central Agricultural School, to create a new River Road African American Museum complex. Her indefatigable efforts are succeeding in bringing forgotten history to the "Great River Road Plantation Parade."

But Hambrick's greatest accomplishment rests in the grisly reminder hanging on a wall of her museum: an iron human neck collar festooned with four-inch spikes, the horror of which no longer bears excuse or requires explanation. "Most living Americans do have a connection with slavery," historian John Hope Franklin recently wrote. "They have inherited the preferential advantage, if they are white, or the loathesome disadvantage, if they are black; and those positions are virtually as alive today as they were in the 19th century." The River Road African American Museum and Gallery leaves one wrenched at the memory of the millions who suffered under the worst impulses of mankind, yet oddly hopeful that the work of people like Hambrick will give life to the African proverb on the papers she handed us on the way out, reading, "Until the lion writes his own story, the tale of the hunt will always glorify the hunter."

Not far from Donaldsonville is a plantation site in Vacherie well worth visiting for literary reasons alone. Laura Plantation, the oldest surviving antebellum complex in St. James Parish, began as a Colapissa Indian village called Tabiscania. Frenchman Guillaume Duparc acquired the property in 1804. He immediately built a raised Creole villa and laid the foundation for a 12,000-acre sugar plantation. A few years later, he died of cholera. For the next 85 years only women operated the Creole family business: Duparc's widow, Nanette Prud'homme; his daughter, Elisabeth Locoul; and his great-granddaughter, Laura Locoul. During the Civil War the plantation was temporarily used as a makeshift hospital; with the exception of that brief interlude, it remained a working sugar mill until 1981.

The plantation gained notoriety recently because Norman and Sand Marmillion, principals in the Laura Plantation Company, discovered a handwritten manuscript composed in 1936 by Laura Locoul Gore recounting her nearly 100 years of life along the river. First published in 2000, *Memories of the Old Plantation Home and A Creole Family Album* is a marvelous insider's account populated by French aristocrats, Creole colonials, Civil War heroes, cunning businesswomen, and loyal slaves. While they are clearly the biased reminiscences of a white woman of privilege, there is an unadorned honesty to her story. But it was the publication of another book—*Louisiana Folk-tales* in 1895—that truly made Laura Plantation special.

During the Reconstruction Era, the distinguished educator and scholar Alcée Fortier, who was raised near Laura Plantation in Vacherie, began canvassing the parish in search of West African folktales. He had been enchanted as a youth by stories his grandfather had told him in French patois of Piti Bonhomme Godron (The Tar Baby) and a hilarious trickster rabbit named Compair Lapin. As

a professor of Romance Languages at Tulane University in New Orleans, Fortier, who had published important articles on folklore and linguistics, decided to collect the engaging tales he had first heard at his grandfather's knee. He returned to the River Road on a mission, notebook always in hand.

After interviewing numerous ex-slaves, Fortier was able to deduce that these colorful animal stories had made their way to America via slave ships from the Sene-Gambian River region of Africa. They had been passed down orally for centuries. He recorded the tales of Compair Lapin and Compair Bouki—Brother (Br'er) Rabbit and Brother Bouki (bouki is a West African term for hyena, but the slaves in Louisiana changed it to a goat) at Laura Plantation. Fortier also found out that variations of these West African stories existed in the Caribbean, with Compair Lapin called Malice in Haiti and Brother Rabbit in Bermuda. Although Fortier had collected hundreds of tales, which he first published in the *Journal of American Folklore,* an anthology entitled *Bits of Louisiana Folklore,* 1888, and *Louisiana Folk-tales,* 1895, it was his retelling of Br'er Rabbit's antics that brought him academic recognition. Ten years after the publication of Fortier's folktales, Joel Chandler Harris, the enterprising editor of the *Atlanta Constitution,* adapted the Br'er Rabbit stories and made them his own, churning out so-called Uncle Remus stories for popular consumption. Over time everybody from *Harper's Weekly* to Walt Disney heaped praise on Harris for his innovative characters, and his home, Wren's Nest, an estate in Atlanta, is even a state historic site. The pioneering folklorist Alcée Fortier is remembered only in folklore centers at Indiana University and New York University. Meanwhile the Laura Plantation is working hard to bring Fortier's accomplishments to light.

Among the special features of Louisiana's plantations are the magnificent live oaks (*Quercus virginiana*) draped with Spanish moss. Plantation slaves used to say: "They grow for 200 years, then live for 200 years, then die for 200 years." Whatever their age, it's impossible not to be moved by the majesty of these oaks.

Over the years poets have extolled their unrivaled glory. Pulitzer Prize-winning poet Robert Penn Warren, while a professor of English at Louisiana State University, paid homage to their "subtle and marine" mysteries in his elegant paean, "Bearded Oaks." When Walt Whitman traveled by steamboat to the region in 1848, he wrote, "I Saw in Louisiana a Live Oak Growing," which appeared in the third edition of *Leaves of Grass:*

All alone stood it, and the moss hung down from the branches,
Without any companion, it grew there,
Uttering joyous leaves of dark green....

"New Orleans is the cradle of jazz," wrote "Jelly Roll" Morton in the late 1920s, "and I happened to be its creator."

King Oliver's Creole Jazz Band posed for this photograph in 1922 in San Francisco while on the Vaudeville Circuit, shortly before Louis Armstrong joined the group. Oliver (third from left) is standing next to Lil Hardin, the band's piano player and Armstrong's future wife. Armstrong once said that Oliver was the best musician he knew, but Oliver quietly regarded his protégé as the better cornet player. Hardin once overheard Oliver say, "As long as I keep [Louis] with me, he won't be able to get ahead of me. I'll still be the King."

At the small gazebo in the sleepy town of St. Martinville, tourists can marvel at the exquisite Evangeline Oak, next to Bayou Teche, which was the inspiration for Henry Wadsworth Longfellow's 1849 epic poem of ill-fated lovers and Acadian exile. He was originally told the story of Evangeline's plight by Reverend H.L. Conolly of Massachusetts, who had heard the saga from a parishioner. The narrative poem, *Evangeline, a Tale of Acadie,* recounts the expulsion of French settlers from Nova Scotia during the French and Indian War (1754-1763) and their resettlement in Louisiana. Two lovers—Gabriel Lajeunesse (a black-smith's son) and Evangeline Bellefontaine (a farmer's daughter)—are separated during the expulsion. The heartbroken Evangeline searches for her lost fiancé and waits for him at the giant oak in St. Martinville; he never arrives. She spends the rest of her life looking for him, eventually finding him as an old man dying of fever in Philadelphia. The long poem was an enormous success, with 12 editions appearing within the first three years of publication.

The live oak stands in the Longfellow Evangeline State Commemorative Area which is funded by an organization that interprets the history of the French-speaking people along Bayou Teche and compares the traditional Acadian homesteads to French Creole plantations. This tree is a holy shrine to Cajun folks, and Longfellow, who never visited Louisiana, is their poet laureate. Myth has it that Evangeline is buried under St. Martinville Church, but records reveal that all Acadian immigrants were buried at a rural campsite five miles away. In town a bronze statue of Evangeline is modeled after the Mexican actress Dolores Del Rio, who played the folk heroine in a movie.

Br'er Rabbit, riding the back of a buzzard in this 1881 illustration, was a favorite character of slave storytellers. He always outwitted his captors.

The live oak in New Roads—a town of 5,000 nestled along the Mississippi across the river from St. Francisville—where James Ryder Randall, a young English teacher at Poydras College, used to sit to think about Chaucer and Shakespeare, is also of literary interest. One afternoon in April 1861, he sat under the oak's expansive shade and read a New Orleans newspaper, which featured a story about a bloody battle near his hometown of Baltimore. A wave of melancholy swept over him, and he wondered if his family and friends were still alive. Pulling his inkwell and sketchpad out of his satchel, he penned the moving lyrics of "Maryland, My Maryland," a cathartic outpouring which became the official anthem of his beloved state.

Perhaps the most famous Louisiana oaks grow in front of Oak Alley, the so-called Grand Dame of the Great River Road. Built in 1839 by a wealthy French Creole sugar planter, this classic Greek Revival-style home, with 28 eight-foot-round columns surrounding it, is a national treasure. Its original name was Bon Sejour, meaning Pleasant Sojourn, but to the admiring Mississippi riverboat passengers it was Oak Alley, and the designation stuck. Tourists flock to Oak Alley near Vacherie for numerous reasons: to study the mansion's antebellum architecture; to see the plantation which served as novelist Anne Rice's inspiration for Oak Haven in her *Witches* series, and as the site for the movie adaptation of *Interview With a Vampire*; to hear fabulous tales of the Antonio Sobral family, who purchased the home in 1881, the eight children transforming it into a beehive of various entrepreneurial activities; or to hear the ghost story of a young woman who mysteriously shows up in an old-fashioned dress in dozens of photographs. But the oak trees are the main attraction, extending for a quarter mile to the river. These astounding trees, planted by an unknown Frenchman more than a hundred years before the manor

was constructed, are evenly spaced at 80 feet apart, with a 100-foot-wide, leaf-draped avenue between the two rows. It stands as the quintessential Hollywood plantation, last seen in a number of film sequences for *Primary Colors,* starring John Travolta.

There is a lush coolness to this plantation, unlike any other along the Great River Road. The Big House was designed in the pre-air-conditioned era for maximum comfort in summer. A 13-foot-wide veranda encircles the house, providing shade all day long. The tall windows and doors face each other for cross ventilation and the ceilings are 15 feet high. Architect Jacques T. Roman's smartest move was making the walls 16 inches thick so that even on a hot July afternoon you can sit in the parlor in comfort.

The oak trees transform these 1,125 acres into a cool oasis. Many of the limbs have grown so heavy that they touch the ground, with a spread of 118 feet. In the back of the house, belles in hoopskirts give guided tours and serve pink lemonade and sweet tea with old-fashioned Southern hospitality. No longer standing are the 20 slave cabins that used to line the road leading to the cane fields and pecan orchards.

However, the most magnificent tree in the entire Mississippi River Valley, perhaps in the entire United States, is not a giant oak, but a bald cypress (*Taxodium distichum*) believed to be between 800 and 1,500 years old, with a circumference of 53 feet and a height of more than 100 feet. It is the largest tree in America east of the Sierra Nevada Mountains and grows on tiny 35,000-acre Cat Island, in West Feliciana Parish. The bald cypress prefers wet, swampy soils, and this giant's reddish-brown bark has weathered to an ashy gray. "Wherever the water stands in pools, and by the edges of the lakes and bayous, the giant cypress loom aloft," Theodore Roosevelt wrote after participating in a 1907

hunting expedition near Cat Island. "In stature, in towering majesty, they are unsurpassed by any trees of our eastern forests." Early river explorers were astonished by Louisiana's abundant stands of bald cypress, its hard wood easy to saw and chop, but nearly impossible to burn. So useful was this "wood eternal" that by the beginning of the Civil War, much of the state was deforested. Although John James Audubon saw Ivory-billed Woodpeckers and Carolina Parakeets here before the species became extinct, few people have ventured onto this peninsula of swampland bound by the river on three sides and by the Tunica Hills on the backside. The area became a National Wildlife Refuge in October 2000. During the rainy season, between December and April, this refuge is often flooded, making visits difficult.

Finding the champion cypress is no easy task, and we couldn't have done it without the guidance of Keith Ouchley, executive director of The Nature Conservancy of Louisiana. When the first Europeans landed in North America, they described 24 million acres of unbroken forest along the river from southern Illinois to the Gulf of Mexico. Ouchley, whose Ph.D. dissertation from Louisiana State University was entitled "Bottomland: Hardwood Ecology in the Lower Mississippi," has spent his entire adult life studying this alluvial valley which is now 80 percent deforested. Like a modern-day Audubon, Ouchley has dedicated his life to understanding the historical ecology of what he calls America's Amazon. He once spent four months living in the swamps, listening to the sad lament of the Summer Tanager, and studying the migratory habits of the Solitary Sandpiper. His home is an 1850 antebellum cottage called Riverview, which sits on a bluff overlooking the Mississippi River.

We drove 10 miles down the unpaved Creek Road in a Toyota 4-Runner truck to get to the refuge gate, for which Ouchley is one of a handful of people with a key. Any attempts by Georgia Pacific or the Corps of Engineers to restrain this land have failed. With no man-made levees to interfere, Cat Island constantly floods, making it a pristine patch of wilderness along a river choked with commerce. Here is an ecosystem essentially in its natural state. Wherever we looked, we saw dense clusters of black willow with Snowy Egrets and Great Blue Herons feeding on Mosquito Fish in various elbow lakes and bayous and sloughs. Deer and rabbits dashed in front of our truck seemingly for the adrenaline rush. Clusters of pepper vine lined the road like kudzu, and we marveled at the solid stands of young cypress that surrounded us. The farther into the interior we went, the larger the cypress trees loomed.

Cat Island has the highest density of old-growth cypress in the world, all of them hollow inside. To see the champion, however, we would have to hike through the swampland, which meant getting wet. We put on boots and started traipsing through this wondrous hardwood forest, Ouchley explaining everything from the leaf structure of Nuttall Oaks to how he had gotten bitten numerous times by Banded Water Snakes, Milk Snakes, and King Snakes. All around us were ancient cypress with massive buttresses at their base, which add support in the unstable soil. Surrounding these trees were singular "knees" standing above the black ooze, which resemble little gnomes straight out of J.R.R. Tolkien's *The Hobbit*. We went inside many of the cavernous hollow trees which serve as homes for hibernating Black Bears, roosting Big-eared Bats, and migratory

Acadian lovers Evangeline and Gabriel hold hands beside Bayou Teche in St. Martinville in this 1929 illustration of Longfellow's poem *Evangeline*. The poet described how Evangeline waited in vain for her lost lover after their expulsion by the British from Nova Scotia in 1755, but did not meet him again until they were old.

Wood Ducks, which nest in their tops. We only saw huge Underwing Moths, which look exactly like cypress bark; when we flushed them out, we could see their salmon-colored wings.

About every 20 yards we eyed a gigantic cypress that we knew *had* to be the champion; we were wrong. Like the great groves of sequoias in Humboldt County, California, the real attraction of Cat Island isn't a particular tree, but the entire ecosystem. We kept trudging through the swamp, keeping our eyes out for snakes. At last, there it was, the champion bald cypress, its base large enough for 50 people to hug at once. We stopped and sat on a fallen pecan log near the giant and contemplated this natural marvel that was a thousand years old when Grant seized Vicksburg. Its heavy limbs came in all sizes and shapes, too surreal to describe in words. We took some photographs, none of which did the tree justice.

Most miraculous about this towering cypress is that it has survived the buzz-saws of the Timber Company (a subsidiary of Georgia Pacific) and the toxins which are routinely dumped in the river by the petrochemical facilities around Baton Rouge. This magnificent bald cypress is a national heirloom, as nourishing to our own democratic psyche as the Grand Canyon or Yellowstone. Other famous trees in America include the Charter Oak in Hartford, Connecticut, where the official charter for the Connecticut colony was once hidden, and

In Louisiana swamps, "overshadowed by millions of gigantic dark cypresses," John James Audubon painted the Ivory-billed Woodpecker.

the General Stewart Sequoia in Sequoia National Park, California, a huge giant wide enough for a camper truck to drive through. In our opinion, however, America's national tree is the Cat Island bald cypress, which sits smack in the middle of the Mississippi River. But whatever the preference, it is important to remember, as Theodore Roosevelt so elegantly reminded us nearly a hundred years ago, "To exist as a nation, to prosper as a state, and to live as a people, we must have trees."

When driving across the Mississippi River Bridge on I-10 in Baton Rouge, you get the feeling that little of historical importance ever happened in this petrochemical center located 80 miles northwest of New Orleans. Everywhere we looked, we saw fast-food restaurants, strip malls, industrial parks, and oil refineries. Baton Rouge became such an industrial center in 1909 when the Standard Oil Company built a huge refinery there. Due to the city's proximity to the oil fields of Texas, Oklahoma, and Louisiana, other petrochemical companies moved in, taking advantage of the low-cost ocean and river transportation. So many companies operated out of Baton Rouge that dock facilities were expanded in the 1920s, and the Port Allen-Morgan City Cut-Off Canal was constructed.

The only landmark building in town is the 34-story art deco Louisiana State capitol, which was built in 1932 by the populist governor Huey P. Long; three years later he was

assassinated in one of the capitol's corridors. Nicknamed the Kingfish, Long is buried in the capitol gardens. In 1946 novelist Robert Penn Warren wrote *All the King's Men* about Long's flamboyant style and demagoguery, a man who controlled every level of Louisiana politics. We went to the 27th floor observation deck in the capitol, which offers a view of the river as it snakes its way to the Gulf of Mexico, but it was the rows and rows of oil and chemical facilities which dominated the panorama.

If you pause long enough in the rotunda and study the walls, you can learn about Baton Rouge's past from the bronze and marble decorations. In recent years the town was noted more for college football and Kris Kristofferson's song "Me and Bobby McGhee," which begins with the hobo line "Busted flat in Baton Rouge."

Upriver from Baton Rouge sits St. Francisville. With its back to the Tunica Hills, the town fronts the Mississippi River, a geographical feature that acted as the lifeblood of the town during its early days. The hills, ravines, and bottomlands of the St. Francisville region contribute to an astounding ecological diversity that has attracted bird-watchers and naturalists such as Audubon, who moved here in 1821. In his journal he wrote, "The rich magnolias, covered with fragrant blossoms, the holly, the beech, the tall yellow poplar, the hilly ground, and even the red clay all excited my admiration…and surrounded once more by numerous warblers and thrushes, I enjoyed the scene." Audubon's drawings

While living in Louisiana, Audubon earned money painting portraits and teaching drawing in New Orleans, but his greatest accomplishments were his meticulous bird studies.

and observations of botany and ornithology thrived while he lived in St. Francisville, and he would later refer to West Feliciana Parish as his Happyland.

St. Francisville is every bit as rich in history as in nature. Exploring St. Francisville today, a visitor would be struck by the number of stately, historic homes such as Rosedown and Catalpa Plantation. What would not be as apparent is the fact that St. Francisville was once the capital city of an independent nation, the Republic of West Florida.

During the days of the Spanish Empire, the colonies of East and West Florida were administered separately. The name East Florida referred to the Florida Peninsula, whereas West Florida encompassed the western portion of what's known today as the Florida panhandle, the Gulf Coast of Alabama and Mississippi, and the southeastern corner of Louisiana that lies east of the Mississippi River and north of New Orleans. This region is blessed with natural harbors. Modern-day port cities that were once part of West Florida include Pensacola, Florida; Mobile, Alabama; Gulfport and Biloxi, Mississippi; and Baton Rouge, Louisiana. As the northern boundary of West Florida was changed on several occasions, Natchez and Vicksburg, at times, both lay within its borders.

During the Colonial Period of American history, Spain, France, and Great Britain all sought control of the territory, frequently using the local Choctaw and Chickasaw Indians as

allies in an attempt to build consensus against one opponent or another.

In the power plays and diplomatic maneuvering of those days, the colonial powers found the aid of the local tribes invaluable. After all, they comprised the majority of the inhabitants of West Florida; French and Spanish colonials were only a sparse presence along the coast and the rivers. But after the Treaty of Paris of 1763, which ended the French and Indian Wars, this slowly began to change. The terms of this treaty gave West Florida to Great Britain. Meanwhile pioneers from the Atlantic seaboard colonies began to arrive. Newcomers from Virginia, the Carolinas, and Georgia poured in, settling mostly in the districts of Mobile and Natchez.

The Peace of Paris, in 1783, encompassed a collection of treaties at the conclusion of the American Revolution. The treaties were multilateral in nature, involving land-swaps between the newly formed United States, Great Britain, France, and Spain. In one condition of these treaties, Great Britain was to recognize the United States's independence, as well as to cede West Florida to Spain. But the immigration patterns that had been established in the previous 20 years were irreversible. Settlers continued to arrive from what were no longer British colonies, but the newly independent American states lining the South Atlantic seaboard and the Tennessee Valley. These pioneers sought markets for their crops and goods. Some found their way down the Mississippi to Natchez, St. Francisville, Baton Rouge, and New Orleans; others followed the Alabama and Tombigbee rivers to their outlet at Mobile. The Americans grew increasingly worried that the Spanish would block all the outlets to the Gulf of Mexico.

When Jefferson negotiated the Louisiana Purchase in 1803, he attempted to secure West Florida along with the Louisiana Territory. Debate raged over the historic occupation and colonial boundaries of West Florida. Both Spain and the U.S. claimed the region, each citing historic precedents. And so, for the next several years, West Florida was in diplomatic limbo. Spain exercised at least nominal control. The citizens were split in their allegiance, with no party able to muster a simple majority. Some favored the United States, some Spain. Some even hoped to revert to British rule, yet others sought independence and autonomy. The greatest percentage of the population wanted to become part of the United States, but any move in this direction was viewed as rash and dangerous. People feared that overt allegiance to the United States would incur a speedy military strike from Spanish garrisons in East Florida or the Caribbean.

By 1810, West Florida was in turmoil. A majority of the citizens were opposed to Spanish rule, but they were anything but united in their opinion of what to do about it. Anti-Spanish sentiment ran strongest in the western reaches of West Florida, around Baton Rouge and St. Francisville—both the wealthiest and the most densely populated parts of the territory. The residents in these parishes relied on trade along the Mississippi, and they expressed their commercial achievements by building ornate manorial homes. These citizens were hurt most by Spain's taxation practices and what was seen as a corrupt governing body.

During the sultry summer months of 1810, intrigue, rumors, plots, and allegations swirled around the future of West Florida. On July 25, Richard Duvall hosted a convention at his house at St. John's Plains, a few miles outside of Baton Rouge. Despite the differing allegiances of the Conventionalists, they did manage to organize a militia. On the night of September 25, 1810, a force of 250 militiamen stormed Baton Rouge and seized control of the city. Immediately following the coup, the same Conventionalists

assembled once again, this time at St. Francisville. Here they issued a formal declaration of independence and raised the lone white star set against a deep navy blue background that had been agreed upon by the convention as the national flag of the Republic of West Florida. With St. Francisville as their capital, the rulers of West Florida wasted no time in setting diplomatic wheels in motion. Within a few weeks, the convention issued a proclamation to residents of Mobile and Pensacola calling for a united front. They drafted a constitution based closely on that of the United States, and on November 10, 1810, they elected the senators and representatives of the Republic of West Florida. To solidify their international standing, they elected Fulwar Skipwith as governor of the state on November 26th.

The declaration of independence, while not as hostile toward Spanish authority as a plea for annexation to the United States would have been, was still a daring move. And yet it had not engendered the greatly feared military retaliation from Spain. Ultimately, the goal of the citizens of West Florida became annexation by the government of the United States. On December 7, 1810, William Claiborne, governor of the Louisiana Territory, took action. He traveled by boat from New Roads, Louisiana, across the Mississippi River to St. Francisville, West Florida. In the process, he was crossing an international boundary which he would never again traverse. On that day in St. Francisville, Governor Claiborne presided at the lowering of the lone-star flag of the Republic of West Florida and the raising of the flag of the United States in its place. The assembled crowd offered up cheers, out of respect both to the flag of West Florida and to that of the U.S., as well as to the peaceful transfer of power. Although there was fear of insurrection, the leaders carried out peaceful transitions in Baton Rouge, Mobile, and Pensacola.

The mixture of peoples in this part of the Gulf South has been, historically and culturally, one of the region's greatest assets, but also frequently has resulted in shifting allegiances and violent conflict. Claiborne wrote of the inhabitants of West Florida that, "A more heterogeneous mass of good and evil was never before met in the same extent of territory."

Drive north from St. Francisville on Highway 61 through West Feliciana Parish, and your route will take you through the Tunica Hills. The landscape is gently rolling, but seems almost dramatic when compared to the surrounding flatlands of the Mississippi's plain.

About 10 miles out of St. Francisville, after passing turnoffs to communities with names like Hardwood or Solitude, you can spot the first of several roadside signs advertising cold beer and daiquiris to go. They seem strangely placed here, in an area that is entirely rural. The market for roadside refreshment is seasonal and exists solely for its proximity to the Louisiana State Penitentiary at Angola. The "season" lasts only for the month of October.

Every Sunday in October is occasion for the Angola Prison Rodeo. As alcohol is not allowed inside the penitentiary, rodeo fans can choose to stop on the way for a little Sunday morning sustenance, Louisiana-style. The prison rodeo is but one aspect of Louisiana that has long relied on creative and not-so-creative ways to earn profit off convicted criminals. One crucial distinction today is that the proceeds are placed in the Inmate Welfare Fund. But the organization of the prison has not always been so altruistic.

Angola Penitentiary sits on a peninsula, a flat protrusion of sediment deposited through the ages by the Mississippi's spring floods; it is surrounded on three sides by the river and on the fourth by the Tunica Hills. The Mississippi's powerful, unpredictable currents here present an obstacle almost as daunting as the chilly waters of San Francisco Bay

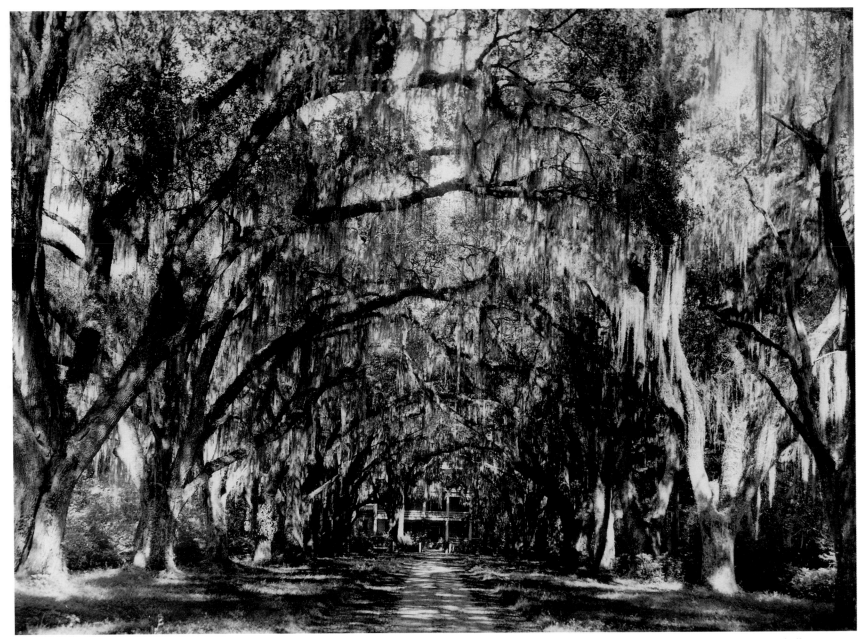

Rosedown Plantation in St. Francisville, with its neoclassical, columned facade and double front galleries, was home to Louisiana cotton baron Daniel Turnbull, one of the nation's wealthiest men prior to the Civil War. The plantation covered more than 3,400 acres and, at the peak of the cotton production years, used as many as 450 slaves. After the Civil War, the plantation went into decline, but stayed in the hands of the Turnbull family until 1955. The new owners have restored the house and formal gardens to their pre-1860s state.

did to inmates on Alcatraz. Many prisoners have tried to escape Angola by swimming the river; few are known to have survived. The rich soil of the peninsula was once intensively farmed as a plantation based on slave labor, but with the Emancipation Proclamation, it lost its economic viability.

Soon after the end of the Civil War, New Orleans businessman Samuel James took over the 18,000-acre operation and, in 1869, turned it into a convict-lessee work camp. James was soon the wealthiest man in Louisiana. In 1901, the state purchased the property, and one year later made it into a penal farm. Prisoners still cultivate cotton, hay, and other crops, and raise livestock. Angola is entirely self-sufficient for food, and to this day it retains the nickname The Farm.

For all the characteristics that set this prison apart from others, Angola has the distinction of having housed and inspired one of America's most prolific and influential troubadours of the 20th century.

Huddie Ledbetter, or Leadbelly, as he is better known, was both a highly respected musician and a colorful individual in other walks of life. Even many of his loyal fans, who love his original compositions like "Goodnight Irene" or "Midnight Special" or "Cottonfields," might be surprised to learn that Leadbelly was a ferocious civil rights warrior.

Leadbelly was born in Shiloh, Louisiana, in 1889, but he spent most of his youth in the nearby cotton fields of Caddo Lake, Texas. There he learned songs from African-American cowboys. After getting a girl pregnant at age 15, Leadbelly fled the work fields of Texas for the red lights of Shreveport, Louisiana. The bordellos, gin mills, and juke joints on Fannin Street soon became Leadbelly's favorite haunts; the walking bass lines he heard groaning out of the all-night halls became his adopted riffs for country guitar playing. "Boogie-woogie was called barrelhouse in those days," Leadbelly, with his trademark red bandana tied around his neck, later recalled. "At that time anyone could walk into a barrelhouse and just sit down and start playing the piano."

It was there, in 1912, that he met the legendary Texas bluesman "Blind Lemon" Jefferson (after whom the 1960s Jefferson Airplane musicians named themselves). For the next several years the two busked for money in the streets of Dallas. But Leadbelly's luck soon ran out. In 1918 he was arrested for killing a man and sentenced to 30 years at Huntsville Prison Farm in Texas. Many bluesmen and civil rights activists would later sing about the ball-and-chain around their legs; Leadbelly lived with one for years. He grew famous while in prison, both as the "king of the 12-string" and as the "number one man in the number one gang in the Texas pen." Leadbelly was released early from prison for good behavior and perhaps because the wardens liked his songs, but it would prove not to be the end of his dealings with the law.

On January 15, 1930, Huddie Ledbetter was involved in some sort of altercation with a man named Dick Ellet in Shreveport, Louisiana. Various accounts of what transpired that winter day contradict one another. It is not clear what happened, but Ellet suffered a stab wound on one arm, and Leadbelly was convicted of assault with intent to kill. He was sentenced to six to ten years' hard labor and sent south to the Angola Prison Farm, arguably one of the roughest correctional facilities in the nation at that time.

As prisoner LSP # 19469, Huddie Ledbetter's experiences at Angola ran the gamut. There is no doubt that he endured the trying hardships of life on this Mississippi River penal farm. Leadbelly worked the cotton fields under the blazing Louisiana sun. As we stand on the same ground, the sun beating down relentlessly, we longingly gaze into the distance at

the low ridge of the Tunica Hills. We can make out the trees there, and we can imagine the respite their shade would afford. We know that any discomfort we feel is but a drop in the proverbial bucket compared to what Angola prisoners suffer in these fields. In addition to farm labor, Leadbelly was sometimes assigned to levee patrol along with other inmates to protect the prison compound from the Mississippi when it was swollen with spring run-off and rains. This proud man could not endure such treatment without retaliating in some way. Leadbelly is known to have been disciplined at least twice, receiving 10 lashes from Captain Pecue on November 21, 1931, for "laziness" and 15 lashes on June 27, 1932, again from Pecue, this time for "impudence."

But Leadbelly was shrewd enough to stay out of trouble most of the time and was eventually rewarded with better jobs as camp waiter, tailor, and laundryman.

If it is possible to have high points while serving a prison sentence, Leadbelly's came on the weekends. Inmates had Sundays off and sometimes Saturday afternoons as well. These times were for recreation, and Leadbelly's musical abilities became legendary within Angola. He would pick his 12-string guitar and belt out lyrics that expressed a hurt and longing all the prisoners in Angola could identify with. In some way Leadbelly's playing would help to replenish the emotional reserves that all the inmates called upon simply for survival through each hellish week. Soon Leadbelly's reputation brought him the sort of break he was looking for.

Blues singer Huddie Ledbetter, better known as Leadbelly, made his way from Angola Prison to Harlem's nightclubs and Hollywood.

During this time musicologist John Lomax and his 18-year-old son Alan were on a field expedition to record indigenous folk songs of the South, compiling recordings for the newly formed Archives of Folk Song in the Library of Congress. In the summer of 1933 Warden L.A. Jones received a letter from John Lomax, asking if Jones knew of anyone in Angola Prison worth recording.

Jones knew of many inmates who played music, and he invited the Lomaxes to bring their mobile recording "studio" to Angola—and Louisiana, this land by the river, where hardship and sorrow have inspired much of American music. One day while the Lomaxes were recording, Captain Andrew Reaux brought them Huddie Ledbetter. The father-and-son team were astonished at the number of songs Leadbelly could conjure up from his repertoire. The Lomaxes recorded seven different tunes, some several times. They made two recordings of "Angola Blues," a heartfelt lament that embodied the suffering administered in the name of justice. The original discs can be viewed today at the Library of Congress in Washington, D.C. The Lomaxes were thrilled to hear a man of Leadbelly's talent and to have the chance to record his music for posterity. But it was the performer's emotional intensity that struck them most. Not only did he pick guitar with a rare, evocative power, but his voice was also one of heartfelt conviction, his original songs masterworks of poetic intensity. Novelist Richard Wright wrote in 1937, "When 50-year-old Huddie Ledbetter plants himself in a

chair, spreads his feet, and starts strumming his 12-string guitar and singing that rich, barrel-chested baritone, it seems the entire folk culture of the American Negro has found its embodiment in him."

In the summer of 1934, the Lomaxes were again in southern Louisiana, and on July 1, they went to Angola to record Leadbelly for a second time. Leadbelly had written a song to Louisiana Governor O.K. Allen in 1932, and the Lomaxes said that if he sang it again, they would record it and take it to the governor. John and Alan Lomax dropped off the recording of Leadbelly's song in Baton Rouge with Governor Allen's secretary, and on July 25, 1934, the governor signed an order commuting Leadbelly's sentence. He walked out of Angola a free man on August 1.

After Leadbelly's release from Angola Prison, the Lomaxes took him to New York to record approximately 500 of his songs. It was the 1930s in Greenwich Village, and the folk revival was unleashed, with Leadbelly as the crown prince. Before long Leadbelly was singing with Woody Guthrie and Joshua White and Sonny Terry and Brownie McGhee. American popular song now had authentic roots. For the next 15 years Leadbelly sang his songs and maintained his dignity. Angry that a black man could be arrested for just looking at a white woman (or yellow woman, as he termed it), Leadbelly started singing in protest. As Wright said, the "white landlords" in the South began fearing his "bitter biting songs." To Leadbelly, lyrics were weapons to smash Jim Crow, and he soon started writing them at an astonishing rate. In the song "The Bourgeois Blues" he condemns segregation in our nation's capital:

The white folks in Washington
They know how,

They chuck you a nickel
Just to see a nigger bow.

Lyrics like these soon caused the FBI to keep a watchful eye on Leadbelly. By the end of World War II he had given up singing about the sharecropper South and was composing urban songs in support of jazzman Bunk Johnson, baseball player Jackie Robinson, the United Nations, and FDR. And he attacked the smug racism of Jim Crow Hollywood long before Jesse Jackson took up the cause:

I want to tell you people something that you don't know,
It's a lotta Jim Crow in the movin' picture show.

On the banks of the river, which had fostered commerce and given rise to the American "castles" that characterize historic towns such as St. Francisville and Natchez, Angola Prison is a monument to a different past. The history of incarceration in Louisiana is rife with horrific tales of torment and injustice.

Huddie Ledbetter never forgot what life was like on this Mississippi River "plantation." Today "Angola Blues" remains a haunting song, a remnant of the impression left by the Louisiana Penal System on Leadbelly, a man who left a deep mark on the American music of the 20th century.

At Angola when a spring fog comes off the river, or when the suffocating heat of July hangs like a cloak in the air, the weather serves almost as an embodiment of the painful history that permeates so much of the Lower Mississippi River Valley. It is a past of suffering, but one that nevertheless has left us with a legacy of extraordinary artistic expression. The anguish from which Leadbelly sang was a symptom of the inequality and hardship experienced by African Americans from the Gulf of Mexico all the way through the Mississippi Delta. ★

As steamboats ply the Mississippi, a wooden raft laden with timber rides the current past Port Gibson, in this 1856 engraving. Before the advent of the steamboat in 1809, thousands of rafts, keelboats, and flatboats floated downriver to bring goods to market.

NATCHEZ

"The village of Natchez is the most beautiful
that could be found in Louisiana [territory]."

JESUIT ANDRÉ PERICAUT

CERTAIN AMERICAN CITIES LIKE CONCORD, Santa Fe, and San Francisco have a deeper history than others—as if everything that ever happened there should be recorded in ledgers for posterity. Natchez, the first European settlement on the lower Mississippi, is such a locale. Time stands still on the high bluffs of Natchez, yet it is impossible to pinpoint precisely when this lush, alluvial valley—compared by early explorers to the biblical Eden—first became a community. Archaeologists believe a great ceremonial center called Anna Mounds, which consisted of at least nine mounds overlooking the Mississippi River, was built by a native community of the Mississippian culture around A.D. 1200. And if you drive up Highway 61 just 10 miles north of Natchez, you can climb Emerald Mound, built up around A.D. 1400. It is the largest ceremonial mound along the lower Mississippi. Even today, visitors standing on top of the eight-acre site are engulfed by an ethereal calm as they imagine the ancient civil processions and solemn religious rituals when worshippers sought favors of their gods.

European explorers arrived in the 17th century and slowly transformed Natchez, first into a military outpost and then into one of the greatest commercial centers along the Mississippi River. A French expedition led by Robert Cavelier, Sieur de La Salle down the river made first contact with the Natchez Indians in 1682, and by 1700 French Jesuits had temporarily settled here.

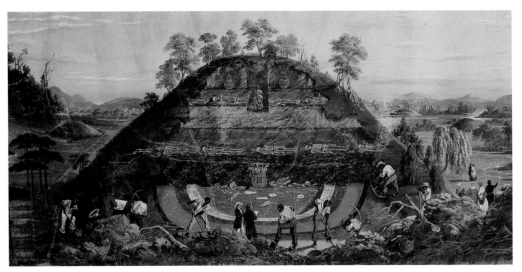

A Native American burial mound, one of hundreds on the banks of the Mississippi, exposes its treasures to excavators in 1844 in this idealized rendition.

again. The British took possession of the east bank of the river in 1763 and then surrendered the land to the Spanish in 1779. Spanish engineers laid out the town. In 1798 Natchez came under American control. Today Natchez residents claim to be living in the oldest continuous settlement on the lower Mississippi River.

"The village of the Natchez," Jesuit André Pericaut wrote in 1704, "is the most beautiful that could be found in Louisiana." Jean-Baptiste Le Moyne, Sieur de Bienville, the founder of New Orleans, established Fort Rosalie in Natchez in 1716. The Indians massacred the French in the garrison in 1729, and the French forced out the Indians

Our historical excavation of Natchez begins in 1803, the year the territorial legislature incorporated the town's population of approximately 1,400. At the time, only a mayor, a clerk, and three aldermen made up the city government. This insular cabal was responsible for overseeing both civil and criminal cases and had the power to levy fines up to $50, to order public floggings, and to place lawbreakers in

public stocks. This may seem simplistic by today's standards, but Natchez was on its way to becoming the most civilized town on the Mississippi between New Orleans and St. Louis.

Municipal records from 1803 to 1817 show that the city budgeted one-third of its expenses to help the poor and sick. Anxious to bring to the region the best health care and safety measures, the citizens of Natchez mandated tough building restrictions to minimize fires and enacted programs to control epidemics like cholera, yellow fever, and smallpox. They established a special "city watch" to quarantine townspeople stricken with the dreaded plague. People with contagious diseases were driven out of town and placed in an isolated hospital to recover. After the Louisiana Purchase, Natchez citizens began importing doctors from New York, Baltimore, and Richmond to educate them on the newest medical advances.

An influx of lawyers from the Atlantic seaboard around the time of the Louisiana Purchase transformed Natchez into the most litigious center of the lower Mississippi River. Eight attorneys became members of the local bar by 1804, and within two years they filed dozens of lawsuits, many over land disputes. As authors David G. Sansing, Sim C. Callon, and Carolyn Vance Smith of *Natchez: An Illustrated History* point out, one out of every ten Natchezians was sued—or sued multiple times. By far the most famous case ever tried was that of Aaron Burr, former vice president and the duelist

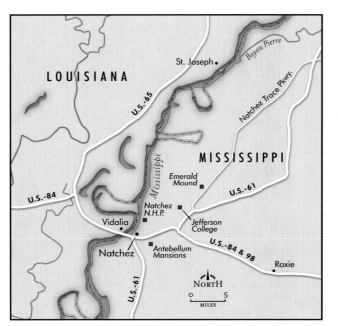

At Natchez, Mississippi, the river passes the notorious Natchez Trace, today a parkway, where explorer Meriwether Lewis died.

who killed Alexander Hamilton. President Jefferson claimed that Burr was guilty of treason.

Despite a promising beginning, no figure in American history was as unfairly maligned as Aaron Burr. The son, grandson, and great-grandson of celebrated clergymen, two of whom were college presidents, Burr was a true battlefield hero in the American Revolution. His heroic deeds in the Canadian campaign were so celebrated that images of young Burr hung on schoolroom walls well into the 20th century. The pictures show Burr in his tricornered hat in a raging Quebec blizzard. He is being fired upon and is bravely carrying the body of General Richard Montgomery, his wounded commander, back to the American lines.

After the war, Burr—an abolitionist who also believed in equal rights for women—became attorney general of New York, U.S. senator, and Thomas Jefferson's Vice President. Handsome, brave, and ambitious, he caused jealousy among other politicians of his generation, especially Alexander Hamilton, who repeatedly attacked in public Burr's supposedly sordid character. Hamilton's attacks on Burr led to a political showdown. In May 1804 Burr met Hamilton in Weehawken, New Jersey, and killed him in a pistol duel. Hamiltonians now wanted Burr's head on a stick. Meanwhile, Jeffersonians despised Burr, who had positioned himself as the leading political rival of the beloved Sage of Monticello. Everywhere Burr looked in Washington,

D.C., and in New York, he saw enemies—so he headed West; he traveled down the Mississippi and ended up in Natchez.

Burr had devised a mission to establish a settlement along the Ouachita River approximately 100 miles west of Natchez. He put together an exploratory team of nine cannonless ships and 75 men—part of a scientific inquiry, he claimed, that was similar to the expedition led by Lewis and Clark. Unbeknownst to Burr, as he descended the Mississippi River, President Jefferson issued a proclamation warning citizens in the Southwest to beware of the "treasonable expedition." Jefferson feared Burr might soon become an American Napoleon by seizing Spanish lands west of the Mississippi, and he was determined to have Burr arrested. John Adams, incensed that the President of the United States would circumvent the law in such a flagrant fashion, wrote Benjamin Rush that "the lying spirit" of the Virginian was "at work concerning Burr" and that even if the former Vice President's guilt would have been "as clear as the noonday sun...the first magistrate ought not to have pronounced it before a jury had tried him."

In January 1807 Burr's small flotilla landed at Bayou Pierre north of Natchez near the home of Judge Peter Bruin. Historian Henry Adams, in his *Second Administration of Thomas Jefferson,* quoted from the diary of a Territory of Mississippi judge who witnessed the arrival of Burr's small expedition: "Ten boats, about one hundred men and not a gun apiece for them—a mighty force to erect a new and independent empire. If one were to believe the President's assertion of Burr's felonious intentions, then Burr...[is] the greatest Don Quixote." The letters Burr wrote on his voyage were filled with optimism about exploring the Ouachita and

the "cordial reception" he garnered upon arriving at various settlements along the Mississippi. He had no idea that Mississippi's acting governor, Cowles Mead, had already called out the militia to arrest him.

Many of the people in Natchez saw Burr as a hero. They did not hold it against him that he had killed Hamilton in a duel—such affairs of honor were commonplace in river country. After all, adventurers looking for western lands and easy fortunes constituted the very essence of Natchez. Many Natchez citizens were furious when the head of the militia, Major Ferdinand Claiborne, arrested Burr and his cohorts and took them into custody. Judge Thomas Rodney then ordered a grand jury to present formal charges against Burr and set a bond of $10,000. With lightning speed, friends of Burr raised bail, and a leading Natchez attorney agreed to represent the former Vice President at a hearing on February 2, 1807, in the territorial capital of Washington, located just a few miles north of Natchez.

The hearing was held on the campus of Jefferson College. A large crowd packed into the small brick building for what was to be called the grandest trial of the new century. For days, the citizens of Natchez had feted Burr, and there was a general feeling that he was innocent. "For the first (and, fortunately, the last) time in American history, a resident had indicted a citizen by Presidential proclamation," Roger G. Kennedy wrote in *Burr, Hamilton and Jefferson: A Study in Character.* "[Jefferson's] agents had offered a reward of $5,000 for Burr's apprehension, never mind the warrant." The jury had to decide whether Burr and company had violated George Washington's Neutrality Act of 1794 by assembling armed men to invade the colonial possessions of

After delivering the fatal shot in a duel on July 11, 1804, which killed Alexander Hamilton, former Vice President Aaron Burr abandoned politics and embarked on an expedition to the West. He journeyed down the Mississippi River, arriving in Natchez. There he was arrested for treason.

Spain. Jefferson's charges of conspiracy to commit treason were levied against Burr, but the grand jury found him innocent. The foreman even reprimanded the territorial officials for arresting such a distinguished citizen without a warrant. At that juncture, Burr, to the delight of his supporters, blurted out, "I quite agree!" Burr stayed in Natchez for awhile, lodging with Col. Benijah Osman, his old friend from the American Revolution, and enjoyed the pleasures of the refined plantation life for a spell.

But the law—and Jefferson—were still on his trail. With a bounty on his head, Burr soon fled Natchez in buckskin disguise, but was captured by federal authorities at McIntosh Bluffs on the Tombigbee River in Alabama. He was taken to Richmond, Virginia, where he was tried in the U.S. Supreme Court on charges of treason. Chief Justice John Marshall dismissed the trumped-up charges and released Burr when his chief accuser, President Thomas Jefferson, refused to testify. Following his trial, a depressed Burr fled to Europe, eventually returning to New York to practice law until his death in 1836.

While the Burr trial was the talk of Natchez in 1807, an event in New York occurred which would forever change life on the Mississippi River. The indefatigable inventor Robert Fulton, with financial backing from Robert Livingston of Louisiana Purchase fame, built the steam-propelled *Clermont* and launched it on August 9. The steamboat traveled successfully from New York City to Albany up the Hudson River in a record 32 hours. The two New Yorkers had met in Paris when Livingston was the American envoy, and they soon found out they shared a belief that steam navigation was the wave of the future. Together they built an experimental steam vessel that operated briefly on the Seine in France. Some scholars have even suggested that Livingston worked so diligently to negotiate the Louisiana Purchase because he dreamed of making a fortune running steamboats up and down the Mississippi.

Fulton and Livingston already had a monopoly on steam power on the rather tame Hudson River and hoped to control the franchise on the western rivers. But the Mississippi was a wild beast of a river, as unpredictable as stormy weather in the Gulf of Mexico during hurricane season. After the technological breakthrough of the *Clermont,* Fulton and Livingston acquired exclusivity from the Orleans Territory for a Gulf of Mexico-Natchez run for four years. The *New Orleans,* a 116-foot-long and 20-foot-high paddlewheel steamboat, would be built in Pittsburgh on the Monongahela a mile from where the river joined the Ohio. It's cost: $38,000. Their dream was to prove the endurance of steam power by having the *New Orleans* descend all the way down the Ohio and Mississippi rivers until it reached the city of its namesake. They hired as captain Nicholas J. Roosevelt, the great-granduncle of Theodore Roosevelt and a fellow New York patrician who thought there was a fortune to be made constructing steamboats west of the Allegheny Mountains for use on the Mississippi River. The risk was great. If the *New Orleans* ran into a single sandbar, or encountered torrential rains, or experienced a cataclysmic boiler explosion, their investment—not to mention the lives of the crew—would be lost. The spring flood had been exceptionally high, and the river had overflowed many miles beyond its banks. This triggered the most serious outbreaks of dysentery and smallpox within memory in the Ohio Valley. Equally worrisome was the advice Roosevelt received from veteran flatboatmen and keelboaters when he made an exploratory journey down the Mississippi to study the current: The shifting bottom of the river would make it futile to use steam-powered boats. These hardened rivermen laughed at drawings of the *New Orleans,* calling the contraption a "dainty

teakettle" on a ferocious river made for roughneck men of Herculean brawn. Clinging to the old business axiom "Nothing ventured, nothing gained," and believing Roosevelt to be an intrepid pioneer-captain with enough grit to navigate to success, Fulton and Livingston launched the *New Orleans* from Pittsburgh on September 27, 1811, for a nearly four-month voyage into the perilous heart of the American wilderness.

As chronicled in Mary Helen Dohan's *Mr. Roosevelt's Steamboat,* the trip was filled with moments of both pure bliss and near disaster. On the positive side, Roosevelt's wife, Lydia Latrobe, daughter of Benjamin H. Latrobe, the architect who designed the U.S. Capitol in Washington, D.C., gave birth to a son, Henry Latrobe Roosevelt, aboard the steamboat as they neared Louisville, Kentucky.

"It was announced one morning, that there had been a rise in the river during the night and that Mrs. Roosevelt had become a mother," a crewmember later recalled. Everybody celebrated this event as a great omen, the birth of a child signifying the dawn of the steamboat era in the West. Ironically, a few days later, the central Mississippi Valley was hit by an earthquake of more than eight on the Richter scale, the most severe ever recorded in North America. The earth cracked wide open, and parts of the riverbanks sank because of the violent swells. Entire towns along the Mississippi were destroyed. Islands crumbled into the river, limestone cliffs tumbled into the debris-filled water, and recurrent tremors jangled everyone's nerves. The death toll of less than ten along the earthquake zone was, however, surprisingly low.

The *New Orleans* survived the quake, but the crew's journey suddenly became a harrowing obstacle course. Wherever the boat anchored, the crew had to cut through trees that had been felled by the quake and lay blocking the channel. Treacherous new snags and sandbars had appeared. Only with great difficulty did the crew find passage between rocky islands, sandbars, and driftwood scattered in bewildering new patterns.

Stories about the quake were heard wherever they went. "In a bend of the river ten miles below Little Prairie, Missouri, a settler had a house with a well and a smokehouse some distance away," Pulitzer Prize-winning author Marquis Childs wrote in *Mighty Mississippi: A Biography of a River.* "When his wife started to go for a pail of water the morning after the quake, she could find neither the well nor the smokehouse. They were on the opposite side of the Mississippi. The quake had caused a fissure, and the river had thus found a new channel, cutting the bend in two."

The crew of the *New Orleans* felt lucky to have avoided any such freakish mishaps. The Native Americans they encountered saw this technological marvel as the epitome of evil. They blamed the quake on the hyperkinetic paddles of the steamboat, which the Chickasaws derided as the "fire canoe." They saw its bright white exterior as a sign of the "European devil" overtaking their tribal homelands. For the next hundred years, many Native Americans refused to ever board a steamboat.

After about a month of what Lydia Latrobe-Roosevelt called "pure anxiety and terror," the *New Orleans* finally approached Natchez, where a large crowd had assembled to witness the historic arrival. Because the current was fierce, Roosevelt had difficulty docking the indefatigable *New Orleans,* and the engines kept shutting down. His struggle kept the witnesses silent. When at last the *New Orleans* landed, the story goes, a black servant of planter Samuel Davis loudly shouted out: "Old Mississippi got her master, now!"

Most Natchezians had assumed the earthquake had sunk the steamer. When the Roosevelt party walked down the gangplank, they were received like heroes. "I was dozing

This view of Natchez, thought to be painted by John James Audubon in 1823, is the earliest known landscape painted in Mississippi.
At the time, Natchez was a prosperous and beautiful town on the banks of the river, as suggested by the red brick buildings, cupolas, steeples,
white-columned plantation house, and ruins of Fort Rosalie on the far shore. Audubon appears in the landscape as the artist, approached by two men riding a horse.

quietly on my hill when I was somewhat startled by a loud, hoarse cough, apparently from the lungs of a mastodon," planter Joseph D. Shields later recalled about the arrival of the *New Orleans.* "I looked up and saw the most extraordinary monster that ever met my vision; the smoke fumed from its nostrils, and it coughed at every step; it moved like a thing of life and literally walked upon the water."

While everybody applauded Roosevelt for his bravery, some skeptics pointed out that steamboating downriver from Pittsburgh was not the same as journeying upriver. One evening, at a dinner party aboard the *New Orleans,* guests argued about whether steamboats would ever really be able to go against the strong Mississippi current. After an hour of good-natured bickering, Roosevelt took them up to the deck. Unbeknownst to the guests, they had just gone two miles upriver from Natchez. The stunned passengers were now believers: The steamboat era was upon them.

The rest of the journey from Natchez to New Orleans was easy. A historic marker across from Jackson Square in the namesake city commemorates the ship's arrival on January 10, 1812. Newspapers across America deemed the Roosevelt expedition a phenomenal success. The *New Orleans* was soon making regular runs between New Orleans and Natchez until 1814. That year the venerable steamer hit a snag near Baton Rouge and sank. But the age of steam power had come to the Mississippi River to stay.

The boatmen and fortune seekers who arrived in Natchez in the early 19th century did not gravitate to the wealthy manors on top of the 200-foot bluff. Instead, they gathered along the waterside near the half-mile-long wharf. On this broad mud flat between river and bluff, a notorious community was built. Natchez-Under-The-Hill, as it was known, was more than just a river port; it was a rowdy gathering place for thieves and rounders, cutthroats and prosti-

tutes. "All the pleasures were to be had at Natchez-Under-the-Hill; they ran out to meet you," wrote Marquis Childs. "One traveler noted that screaming bawdy-tongued women had been known to tear the clothes from a man's back in the street. The shouts and roaring curses, shrilling fiddles, and drunken laughter continued all through the night, the noise was so loud sometimes that it came to the ears of respectable Natchez on top of the hill." In his *Travels Through the Western Interior of the United States* (1808-1816), Henry Ker deemed Natchez-Under-The-Hill "the resort of dissipation," a place where the "bold-faced strumpet, full of blasphemies, looks upon the virtuous part of her sex with contempt and hatred." The reason for so much debauchery was simple: from Natchez on, the Mississippi was broad and deep and relatively easy to navigate.

But it's a mistake to portray Natchez-Under-The-Hill as merely an immoral cesspool. Following East Coast custom the city appointed a harbormaster in 1821 and built five landings at Natchez-Under-the-Hill: one for steamboats, one for flatboats, one for rafts of firewood and cordwood, one for livestock, and one for flatboats, keelboats, and larger steamboats. It was a place where swashbuckling adventurers came to seek quick fortunes and earnest farmers came to sell their goods. As newcomers arrived with nearly every kind of boat and intention imaginable, the etiquette of Natchez became: "Don't ask too many questions." An inquisitive remark or ill-considered jest might bring sudden death.

Today, Natchez-Under-The-Hill caters to tourists who descend from steamboats like the *Delta Queen* and the *American Queen.* They are ready to hear gripping stories about how a dozen horses once galloped unharnessed down Silver Street, or how a tattooed keelboatman from Wheeling named Grunt Boy guzzled a gallon of Monongahela whiskey on a midnight dare. Most of the curio shops in the district are

kitschy souvenir stands, but the old Under-The-Hill Saloon still operates at 33 Silver Street—an avenue once lined with sturdy red brick buildings destroyed by gradual erosion, recurrent landslides, and intense earthquakes. The saloon offers a tame glimpse back in time to when skullduggery, cheap whiskey, illicit love, and five-card stud were staples of life for the rivermen who stopped here. Located some 20 yards from the Mississippi River, visitors to the eccentric pub are greeted by rocking chairs on the front porch and a sign that reads "Beware Pickpockets and Loose Women." Hundreds of dollar bills are thumbtacked to the ceiling and are taken down only on Christmas Eve and Independence Day—when the drinks are on the house. A pair of dachshunds are often found wandering around the bar, drinking beer out of customers' glasses. The musty walls are lined with vintage photographs and riverboat models which conjure up the halcyon days when cotton was king. Behind the bar is a fish tank with tinfoil barbs, two Bowie knives, and a collection of Chickasaw arrows discovered in nearby ravines. A musty back room seats visitors, where you would expect one-eyed Caribbean pirates with swords to swap yarns over San Juan rum.

The saloon is a good place to soak up the roguish essence of Natchez-Under-The-Hill, but the best place to learn about historic Natchez is the Natchez Intermodal Reception Center, which opened in June 1992. At the center—which serves as headquarters for the Natchez National Historic Park and National Park Service—we were greeted by a large neon billboard announcing all the civilizations that have populated Natchez: Natchez Mound Builders, A.D. 1200-1730; New France, 1716-1763; British West Florida, 1763-1779; New Spain, 1779-1798; Mississippi Territory, 1798-1817; United States, 1817-1860; Confederate States of America, 1861-1865; United States, 1865-present. Designed by architect Ronald Filson, this post-modern museum offers first-rate displays including maps, music, and photographs. A replica of the pilot house from the steamboat *Charles Rebstock* is shown; its route between Natchez and Saint Joseph, Louisiana, provided merchants, farmers, and the owners of plantation stores with important transport service in the early 1880s. A romantic, 25-panel 1850s panorama painted by Philadelphia artist I.J. Egan, entitled "Monumental Grandeur of the Mississippi Valley," shows three Natchez-area scenes: the Natchez Indian massacre of the French at Fort Rosalie; an idyllic scene in the countryside around Concordia Parish, across the river from Natchez; and the small steamboat *Magnolia* traveling near the Emerald Mounds just north of Natchez.

Looking westward from the visitors center across the Mississippi, you can almost feel the drumbeat of the Arizona Apache and the frantic California Gold Rush of 1849. Yet the steady barge traffic and the stench like burnt cabbage from trees being digested at the nearby International Paper Mill remind us that the romantic interpretation of the Mississippi River can be exaggerated. Instead of native plants we saw nothing but kudzu-choked ravines. The U.S. Department of Agriculture imported kudzu from Asia during the Great Depression to help prevent soil erosion throughout the South. It is an experiment run amok. The green leafy vine can grow more than three feet a night, and kudzu roots grow 40 feet deep into the soil. Even if the vines die from frost, the deep roots continue to grow new plants at an alarming rate. Kudzu has covered—and ruined—over two million acres of forestland in the South.

The visitors center is also a good starting place for exploring the Natchez Trace, a deeply rutted buffalo trail, which became a 450-mile Indian footpath linking the loess bluffs of the Natchez Indians to the forested expanses of the

Cumberland River Valley. The Trace—French for "a line of footprints"—played an essential role in America's Westward Expansion. Other footpaths have evolved into thoroughfares for the march of American civilization: the Boston Post Road, El Camino Real, and the Wilderness Road, to name just a few. But none matched the Trace for drama and mythmaking. From about 1785 farmers and merchants floated their produce down the Ohio and Mississippi rivers. Isolated from the Atlantic Coast by the Appalachian Mountains, they sold their goods at the global market that was opening up from Natchez and New Orleans. Rather than traveling back against the strong current on the Mississippi, they sold their craft for timber and walked or rode back on horseback to Nashville along the Trace. The U.S. government quickly recognized the trail's potential—designating it a mail route in 1800. Under Jefferson's order, it was cleared and widened to serve as a military road. Andrew Jackson marched up the Trace victoriously after the Battle of New Orleans.

As travelers began streaming up the Trace, Jefferson was amazed that such an "immense swarm" took to the road at once. In his marvelous book *The Devil's Backbone: The Story of the Natchez Trace,* author Jonathan Daniels writes about the hazards travelers encountered. Swamps, floods, and disease-carrying insects often made the Trace impossible for travel.

A sketch entitled "Natchez ballroom" leaves the viewer to wonder whether the dancers are in a mansion on the bluffs or a tavern under the hill.
SCHARFF COLLECTION, NATCHEZ HISTORICAL SOCIETY

But the heavy influx of travelers using this crude trail soon turned it into a clearly marked path. "Not strangely, it became a robbers' road," Daniels wrote. "It was the thoroughfare of the hunted and the hunting—of men going to get what they wanted or others fleeing from what they only too well deserved. Flatboatmen headed homeward met other men headed south. Among them were traders, medicine peddlers, and missionaries. And sometimes pretend preachers were the worst plunderers. They praised the Lord while confederoles in their congregations picked pockets."

Merciless highwaymen with nicknames like David Dead and Gizzardman lay in wait for the easy pickings on this thoroughfare where travelers often had pockets jingling with coins or flush with pouches of gold. It was, as Daniels calls it, "the highway of the grasping hand." The most lethal robber band, headed by a Revolutionary War veteran named Samuel Mason, stalked the Trace from east of Vicksburg. Mason's most dangerous sidekick was a desperado named Little Harpe, who was "Wanted: Dead" in Kentucky for killing nearly 40 people. But by 1810 the highwaymen had practically disappeared. Overnight inns (called stands) had opened along the Trace, transforming the wilderness path into a tame road. And the Trace became largely irrelevant in January 1812 when the steamer *New*

Orleans arrived in Natchez, eliminating the need for overland travel homeward. Today, the 450-mile modern Natchez Trace Parkway is operated by the National Park Service and provides a journey through one of America's most tumultuous times and places.

Because of its picturesque setting, many landscape painters spent time in Natchez. "Natchez," presumed to be painted by John James Audubon in 1823, is considered the earliest known landscape painted in Mississippi. Modeled on the romantic landscapes of the Hudson River school, Audubon's painting is of a prosperous family approaching the city from a distance. It's a valentine to a Mississippi River town emerging like magic in the remote wilderness.

Not all the landscape painters who visited Natchez saw the town in such a friendly fashion. The Swiss artist Karl Bodmer took the steamboat *Homer* down the Ohio and Mississippi rivers to New Orleans in 1832. His sponsor, Prince Maximilian of Wied, wanted him to sketch the wildlife of this exotic region as it was described in the *Journals of Lewis and Clark*. On his return trip upriver, Bodmer spent eight days in Natchez and was aghast, calling it "a bad and dirty place, notorious on account of its gamblers and disorderly women." But even Bodmer had to admit that the twilight seen in his watercolor "Lighthouse at Natchez" was one of the most beautiful he ever witnessed.

Historically, Natchez has been home to explorers. It has also been the site of a transformation in the African-American experience, from slavery to the modern civil-rights movement. We visited the three-story brick townhouse of William Johnson, a person of color who became a businessman and slave owner himself in the 1840s. In 1990 the National Park Service acquired his residence at 210 State Street—typical of the area's middle class 19th century dwellings—to illuminate the story of free blacks in Natchez.

Born a slave in 1809, Johnson was freed in 1820, when he turned eleven. His master—Captain William Johnson—had successfully lobbied the state to grant the boy his freedom. A grateful Johnson began working as an apprentice in his brother-in-law's barbershop, and he soon prospered. Within a few years Johnson owned land and up to 15 slaves. He also operated three barbershops and became known as "The Barber of Natchez," engaging in farming, real-estate rentals, moneylending, and land speculation.

But Johnson did not have the same rights as whites. Free blacks could not vote, hold public office, serve in the military, or testify in court against a white person. This makes it all the more remarkable that he could rise to respectability and affluence. He gave historians a rare gift: a 2,000-page diary detailing his deepest convictions and business activities. It is the most comprehensive journal kept by a free black man before the Civil War. He was a shrewd businessman, even collecting debts from whites—unheard-of behavior for a Mississippi black man of that era. "Business has been very Lively and a very greate Quantity of persons in town to day—Mr. Edward Thomas paid me to day fifty Dollars," he recorded in his diary on January 1, 1838. "It was a debt that Mr. Marshall, the portrait Painter, Owed me for house rent... Messrs. Barlow and Taylor paid me To Day One Hundred Dollars, money that I Loaned him...."

Unfortunately, Johnson paid for these deals with his life. His local prominence could not protect him in a tangled boundary dispute with Baylor Winn, who allegedly killed Johnson in 1851. "Our city was very much excited on Tuesday morning, by learning that what could only be deemed a horrible and deliberate murder had been committed upon an excellent and most inoffensive man," the *Natchez Courier* reported on June 20. "It was ascertained that William Johnson, a free man of color born and raised in

Natchez, and holding a respected position on account of his character, intelligence, and deportment, had been shot." The Winn murder trial was the talk of Natchez as litigation dragged on for two years. Finally Winn was found innocent under a ruling that a case could not be brought against a white man who murdered a black man.

Johnson was not the only prominent African American living in Natchez in the 19th century. At the Natchez National Cemetery, more than 2,000 African-American Civil War veterans are buried. Another local hero of color was Wilson Brown. Born a Natchez slave in 1843, Brown was ready to fight for the Union when the Civil War broke out. An expert navigator of the Mississippi River, he eventually was assigned to serve as a shell boy on board the U.S.S. *Hartford* during the infamous Union-Confederate naval battle at Mobile Bay in August 1864. The Union gunboats fired away at Fort Morgan when suddenly the *Hartford* was bombarded by Rebel cannon fire. Brown was knocked unconscious while four of the six men in his station were killed. Regaining consciousness, the 21-year-old returned to his post on the deck and single-handedly continued to fire away at Fort Morgan. Brown's bravery at Mobile Bay became legendary, and he was awarded the Medal of Honor for his courage. Brown died in 1900, and his gravesite in Section G (number 3151) is a good place to contemplate the role African-American soldiers played in the Civil War.

The most famous African American from Natchez is novelist Richard Wright. Yet searching for fragments of

Novelist Richard Wright, in Chicago in 1928, left Natchez as a young man. His book *Black Boy* describes his impoverished childhood in the segregated South.
CARL VAN VECHTEN

Wright's life in Natchez is no easy task. Officials at the Natchez Intermodal Reception Center were unable to offer us directions to the small farm 22 miles outside of town where he was born on September 4, 1908, or to his boyhood home at 20 East Woodlawn. With the assistance of the Natchez Association for the Preservation of African-American Culture (NAPAC), we were able to visit both sites.

Although the gift shops sell dozens of pro-Confederate books, finding Wright's *Uncle Tom's Children* (1938), or his award-winning *Native Son* (1940), or *Black Boy* (1945) is difficult. There is, however, a kiosk devoted to Wright at the Reception Center.

We wandered around the Delta cotton fields north of Natchez near the town of Roxie, where Wright's grandparents once toiled as slaves. "I was born too far back in the woods to hear the train whistle," Wright recalled, "and you could only hear the hoot owls holler." It's still that way today. Rickety shacks and abandoned work sheds populate the area. At the time of Wright's birth, the South had just one staple crop: cotton. But by the time Wright left the Delta in 1927—the year of the Great Flood—things had changed: the soil was eroded from growing too much cotton; the insatiable boll weevil had come up from Mexico and devastated crops; and heavy flooding of the Mississippi, Pearl, and Yazoo rivers left plantations devastated. These floods had such an impact on Wright that he wrote three stories about them: "Down by the Riverside," "Silt," and "The Man Who Saw the Flood." There is no historic marker designating Wright's birthplace, but the impoverished sharecropper existence he was born

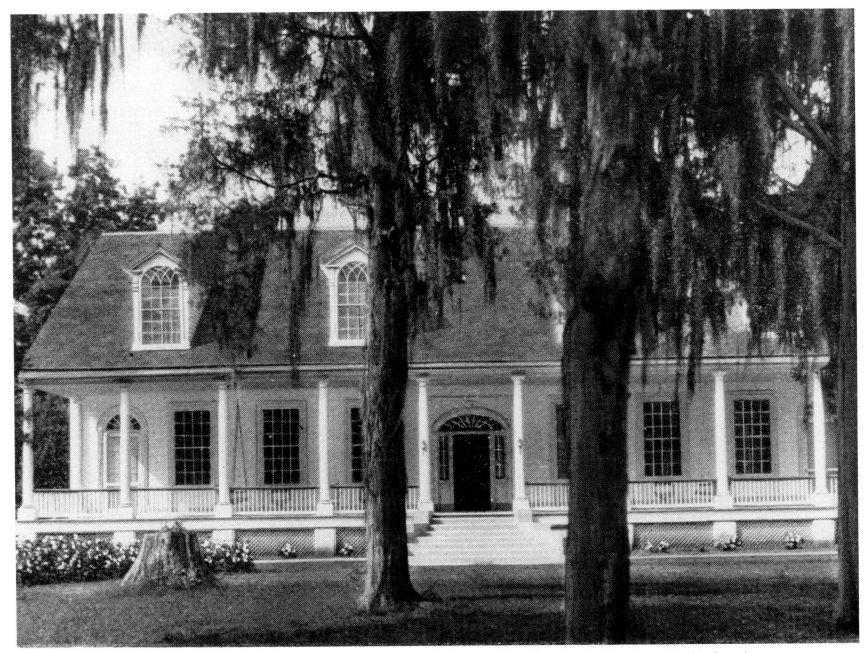

Site of Jefferson Davis's second wedding, The Briars is a typical example of an early 1800s Mississippi plantation home. The white frame house with its wide front gallery and sloping roof is far more modest in style than the Greek Revival mansions that were in vogue later in the century. The Briars sits atop a bluff several hundred feet high, overlooking the Mississippi River and the Louisiana lowlands across the way.

into is apparent from the barren fields nearby. In his essay "How Jim Crow Feels," Wright examines the depravity and vulgarity of growing up a poor black man in rural Mississippi, where the Ku Klux Klan was considered a respectable civic organization.

When Wright was two years old, the family moved to Natchez. The home still stands. Located just a block from the Zion Chapel AME Church, the Richard Wright home is well-kept and privately owned. Wright opens his autobiographical narrative *Black Boy* at this location. He torches the parlor curtains with fire when he was four years old and gets whipped by his mother with an elm-tree branch. She lashes him so hard he loses consciousness, breaks into a fever, and has horrific hallucinations that haunted him into adulthood. "For a long time I was chastened," Wright writes, "whenever I remembered that my mother had come close to killing me." At the conclusion of *Black Boy,* Wright makes his escape from the violent South to the so-called promised land of Chicago.

From the Woodlawn Avenue home, you can walk to the Mississippi, where a historic marker pays homage to Wright. He used to come to this spot to see the steamboats unloading passengers and cargo. The memories stayed with him forever. "There was the faint, cool kiss of sensuality when dew came on to my cheeks and shins as I ran down the wet green garden paths in the early morning," Wright wrote. "There was a vague sense of the infinite as I looked down upon the yellow, dreaming waters of the Mississippi River far from the verdant bluffs of Natchez."

Perfectly balanced and wholly unsupported, the spiral staircase at Auburn— built in Natchez in 1812—remains an architectural wonder.

Most tourists come to the Natchez area to visit the nearly 50 palatial antebellum mansions. Natchez is home to more pre-1860s buildings than any town its size in the United States. Per capita Natchez was the richest American town of the 1850s, boasting more millionaires than New York, Boston, and Philadelphia. Today owners open their doors to the general public during spring and fall. Tourists can visit Auburn, an imposing brick mansion; The Burn, a Greek Revival-style home; Dunleith, a Greek Revival surrounded by colonnaded galleries; Longwood, an octagonal home; Stanton Hall, a gigantic residence covering an entire city block. And then there is Rosalie, a square house of red brick with a stately two-story portico, located on the bluff above Natchez-Under-The-Hill on property that was once part of Fort Rosalie. Union troops used the mansion as a headquarters during the Civil War, and General Walter Gresham and his family made it their residence.

Our favorite home is The Briars, accessible only from the rear of a Ramada Inn parking area where a white sign reads "1818." In 1975 interior designers Newton Wilds and Robert Cannon acquired The Briars and turned it into a Bed-and-Breakfast. Called a "planter's cottage" by architectural historians, The Briars sits on the highest point of the river between New Orleans and St. Louis. As we drove through the gates of the secluded house, a small billboard proclaimed that Jefferson Davis was married here.

The wedding took place in February 1845 while the war with Mexico was garnering all the national headlines. (Davis

had been previously married to Sarah Taylor, daughter of President Zachary Taylor. She died of yellow fever just months after the marriage.) Davis, a former U.S. senator and secretary of war under President Franklin Pierce, wed his beloved second wife Varina Howell—often called the Rose of Mississippi—in the parlor of this river estate. After the simple wedding, an elaborate breakfast for family and close friends was held in the ballroom upstairs.

Sixteen years later, Davis, as President of the Confederate States of America, would lead the South in its attempt to secede from the Union. A copy of Davis's last portrait hangs over the parlor mantel.

Judge John Perkins of Virginia built The Briars (named for the briers in the adjacent woods) in 1818 based on an English model. The Mississippi can be seen from every room and cottage of the complex. Both the front gallery of the main house and the rear loggia have cross ventilation on sultry summer days. The house is a fine example of federal ornamentation designed by Levi Weeks, a renowned Philadelphia architect.

Weeks's arrival in Natchez in 1812 changed the face of the community. His towering, white columns now symbolize Mississippi River plantations in the public imagination. He was born in Greenwich, Massachusetts, in 1776. Weeks's father was a cabinetmaker and delegate to the state convention that wrote the Massachusetts Constitution. Like his father, Weeks loved working with wood and took up carpentry as a vocation. At age 22 he moved to New York City to train as an architect alongside his brother, Ezra. Just as his blueprints began to attract notice, however, Weeks was arrested and tried for killing his girlfriend, Julia Sands. Weeks had the good fortune to retain Aaron Burr as his trial lawyer, and he was acquitted. But his reputation was ruined.

Weeks decided to head to the "Empire" out West to start a new life. He journeyed down the Ohio River, staying for two years at a time in Cincinnati and Marietta, Ohio, and Lexington, Kentucky. In 1809 Burr urged Weeks to head down the Mississippi to Natchez, describing it as a place where "a stigmatized man could start over." Weeks took his advice and wasn't sorry: He soon married the coveted Ann Greenleaf and formed an architectural partnership with Joseph Bryant.

Weeks brought with him a trunk full of manuals on Georgian and Federal style buildings and began designing everything from the Natchez Hospital to the First Presbyterian Church and the east building of Jefferson College. He transformed the lower Mississippi Valley just as Pierre L'Enfant had transformed Washington, D.C., and Christopher Wren had made London. His most noted estate was Auburn, built for a wealthy farmer named Lyman Harding. Weeks's use of the classical front portico supported by two-story columns changed architecture in the South.

"The brick house I am now building is just without the city line and is designed for the most magnificent building in the Territory," he bragged to his Massachusetts friend Epaphras Hoyt in September 1812. "[It will be] the first house in the territory on which was ever attempted any of the orders of architecture." By mixing Georgian and Federal styles—and creating grand front entrances to fit the ventilation needs of the subtropical climate—Weeks's designs became a fixture in Natchez and a prototype well beyond the Mississippi Valley. Auburn's portico predated—and would influence—renowned Southern homes. However, Auburn's interior details were somewhat behind the times, relying on pattern books dating back as early as the 1730s.

One Natchez local made another contribution—the Bowie knife. Across the river near the town of Vidalia, Louisiana, Jim Bowie, one of the heroes who died at the

Zipporah Carpenter, mistress of the Natchez manor house Dunleith, poses outside her home in 1898 with family members and servants.
The black women were part of a large staff employed at the mansion, which was built in the 1850s by Carpenter's husband, a wealthy cotton broker.

Alamo, became a legend. It was at a treeless batture—the land between the river and the levee—that Bowie first exploded into the annals of American folklore. His famous knife duel is still celebrated annually in a spring re-creation along the river. And at the nearby Sandbar Café, where freshly caught catfish are fried to perfection, the walls are adorned with hunting trophies, riverboat memorabilia, and a historic marker which reads: "Jim Bowie, wounded as a second in the Wells-Maddox duel and wielding the awe-some blade of his design, killed Norris Wright September 19, 1827. The modified knife later became known as Bowie Knife." Bowie became the most famous knife-fighter west of the Appalachians because of this duel. His heavy, custom-made 9-inch blade gave him the ability to chop as well as thrust. During the Civil War, both Union and Confederate soldiers strapped Bowie knives to their waists for protection.

Bowie, born in Kentucky in 1796, moved with his family to Louisiana as a seven-year-old boy. Bowie's father had acquired a Spanish land grant on Brushley Bayou and built a home for his wife and four sons. During this time, horse traders in Louisiana were already searching for riches in Texas, including the lost gold of El Dorado. In 1809 the Bowie clan moved to a plantation near Opelousas, Louisiana, and started growing cotton, raising cattle, and selling slaves. When young Jim became a teenager, his primary responsibility was floating lumber down the Mississippi to New Orleans. A hearty, rough-and-tumble youth of six feet, Bowie soon garnered a reputation as a first-class frontiersman who could break wild horses, ride

The legendary knife-fighter Jim Bowie shared with other southern frontiersmen of his day a willingness to avenge any slight, real or imagined.

alligators, and tame bears. Though liked by most, he also had a reputation for being somewhat of a hothead: When insulted, he always sought instant revenge. Jim and his brother Rezin became partners with the pirate Jean Lafitte and began dabbling in the lucrative stolen-slave market in the Caribbean and the Gulf of Mexico. They accumulated $65,000 and then retired from the unsavory business.

The brothers were anxious for even more riches; soon they tried their hand in land speculation and became close with wealthy planters around the Natchez area. This time, though, the venture failed. Many citizens considered the Bowies nothing more than a pair of swindling con men and slave thieves. The Baltimore-born Norris Wright, for example, who was the maverick sheriff of Rapides Parish and a local banker, refused to grant the Bowies a loan they needed to save their farm. Later, Jim Bowie promised vengeance on Wright. One afternoon in Alexandria, Louisiana, Norris Wright and Jim Bowie began bickering. Norris pulled out a pistol and shot Bowie in the chest. The bullet, however, was not fatal. Bowie was able to wrestle Wright's gun away and started bloodying him with his fists. Some people said Bowie would have killed Wright with his bare hands if the fight had not been stopped. Shortly thereafter, Rezin gave his brother a large hunting knife to use as protection, made especially for him by former Philadelphia silversmith James Black, who had recently moved to the area. The knife was modeled on the Mediterranean dirk knife and the Spanish dagger.

The historic Sandbar Duel took place shortly after noon

on September 19, 1827. Along the fringe of the batture was a cluster of willows struggling to survive in depleted soil and periodic overflows from the river. This area supplied a modicum of shade where the seconds could wait and watch. Exactly what transpired along the river is uncertain, but a few facts are undisputed: a duel commenced between Samuel Levi Wells and Dr. Thomas H. Maddox from Alexandria, Louisiana. Each man fired two pistol shots at the other one and missed. Having settled their differences with honor, they shook hands and walked over to greet their seconds. They uncorked a bottle of wine in recognition that the honor of both duelists had been preserved. Squinting in the shade with dozens of other men was Jim Bowie, who had little regard for the system of the *affaire d'honneur*. But he had journeyed by boat to the sandbar to serve as a second at the invitation of Wells. In part Bowie came to the duel because Norris Wright—his archenemy—was serving as a second for Maddox. Bowie was hoping to settle an old score.

As the wine was consumed, the ten opposing seconds began quarreling. A fight quickly ensued. Suddenly the *affaire d'honneur* turned into a full-fledged melee. The principal characters in the free-for-all were Jim Bowie, General Samuel Cuny, and George C. McWhorters, followers of the Wells faction; and Norris Wright, Colonel Robert A. Crain, Alfred Blanchard, and Carey Blanchard, followers of the Maddox faction. Weapons were drawn. Alexander Crain fired at Samuel Cuny. When Cuny fell, Bowie fired at Crain but missed. Wright shot Bowie near the stomach. An adrenaline-crazed Bowie then drew his awesome knife and chased after Wright. The Blanchard brothers shot Bowie in the thigh, and Wright and Alfred Blanchard stabbed him in several places. Bowie was lying in the mud with multiple wounds. Everyone assumed Bowie was close to death. As Wright bent over him, Bowie grabbed Wright by the collar, held him in a vice, and stabbed him to death with his knife. Bowie then went after Blanchard, who had already taken a pistol ball, and slashed him across the abdomen. The battle of the sandbar was over in 10 minutes.

They pulled the sword from Bowie's chest and bandaged him in an attempt to stop the bleeding. A doctor used his scalpel to remove the bullets Bowie had taken in his arm and hip. Members of the Wells party built a willow stretcher for Bowie and ferried him to Concordia, Louisiana. He convalesced for many months at the home of a friend in Natchez, and Bowie's reputation spread as the man with the enormous knife who knew how to kill with it. It was his good fortune that Samuel Wells placed a letter in the *New Orleans Argus* on September 24, offering vivid details of what took place on the sandbar. The hero of his story was Bowie, and his formidable knife was described in exacting detail. Stories of Bowie's prowess eventually appeared in Washington, D.C., and Philadelphia newspapers. He became a frontier celebrity, moving to New Orleans for a time.

For the next nine years, he wandered about the Mississippi River country and Mexican Texas, looking for land deals, card games, and beautiful women. By the time he arrived at the Alamo, he held the title of colonel of citizen rangers. When the Mexicans attacked the Alamo on March 6, 1836, Bowie was confined to a cot, suffering broken ribs and pneumonia. All 189 defenders perished at the Alamo. Bowie was shot twice in the head. In death the indomitable Natchez knife fighter became immortal in the annals of Texas history.

As we prepared to leave Natchez, the antebellum mansions locked their stately doors once again, and all we could hear was faint laughter from the wharf-front saloon and the roar of semitrailer trucks racing over the twin steel bridges linking Mississippi and Louisiana. ★

THE OLD SOUTH

★

"The rich magnolias, covered with fragrant blossoms, the holly, the beech, the tall yellow poplar...and even the red clay all excited my admiration...."

JOHN JAMES AUDUBON

Windsor Plantation near Fort Gibson represented antebellum splendor in Mississippi. OHIO HISTORICAL SOCIETY

The mansion survived the Civil War, but fell victim to a fire in 1890.

Delta fieldworkers return at dusk with a load of cotton. IRA BLOCK

A Union soldier, cast in bronze, stands silent watch at Vicksburg.

Live oaks and azaleas line the drive to a Mississippi plantation.

A dirt road mimics the flow of a Mississippi backwater near Vicksburg.

A lone obelisk honors the soldiers who fought at Vicksburg.

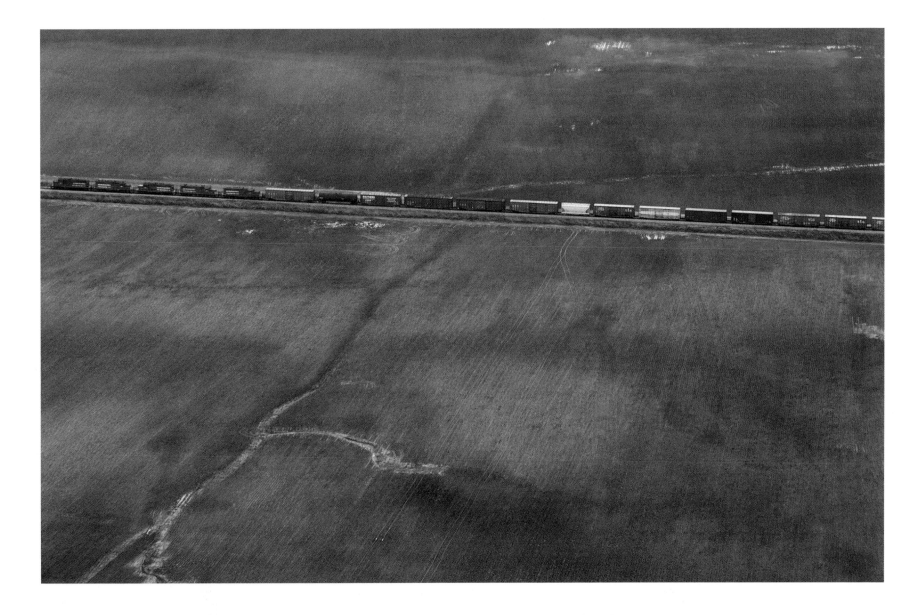

A freight train crosses cotton fields east of Port Gibson, Mississippi.

THE DELTA: FROM VICKSBURG ON

★

"…while I rejoice that Vicksburg is ours, it gives me no pleasure to see the destitutions and the sufferings of fellow mortals in the Rebel Army…."

Union Sgt. Pleasant W. Bishop

A romanticized version by an unknown artist depicts Grant's assault on Vicksburg in 1863. The city on the bluff seems an unreachable goal with its rugged terrain and ravines.

THE DELTA QUEEN DOCKED AT DAWN into the same landing that 19th-century steamboats used. We ambled down the gangplank to board a tour bus headed up the bluffs to the 1,800-acre Vicksburg National Military Park, the site of the famous Union siege in the Civil War. In 1876 the Mississippi River cut a new path, west of Vicksburg. From 1899 to 1902 the Corps of Engineers diverted the Yazoo River to flow into the old riverbed, so today it is the Yazoo, not the Mississippi, that flows past Vicksburg, once known as the Gibraltar of the Confederacy. But the site hasn't changed. Hills and ravines predominate, along with memorials built by the Southern and Northern States that were involved. There are 17,000 Union dead in the National Cemetery at Vicksburg. And it's the strategic brilliance of Gen. Ulysses S. Grant that permeates every trench and fortification of this remarkable park.

Vicksburg had fewer than 5,000 residents in 1860. It was not a rail center and had no war industries. But it stood on a 200-foot bluff on the eastern bank of the river, downstream from a hairpin curve. The curve caused traffic on the river to slow. The bluffs gave the Confederates a location for their big guns. At Vicksburg the Confederates stopped all downstream traffic.

In January 1861, on the eve of the Civil War, the Louisiana State Militia had seized Forts Jackson and St. Philip even before the state legislature had passed an act of secession. The militia quickly gave over to the Confederate Army. The garrison strung a chain across the river, floated on barges and hulks. The chain and the forts blockaded the river, and thereby protected New Orleans

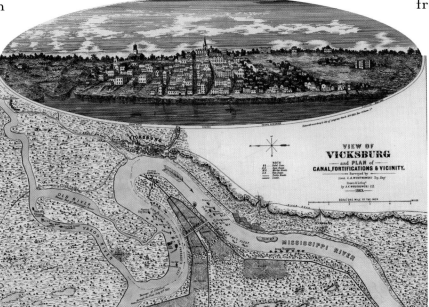

Marked on this 1863 drawing and map of Vicksburg is the canal
Gen. Ulysses S. Grant ordered his Union troops to dig
in an attempt to bypass the well fortified city high on a bluff.

from a seaborne assault. The Confederates had the ironclad ram *Manassas,* the unpowered *Louisiana,* and the unfinished *Mississippi,* both also ironclads, along with an assortment of other ships. On October 11, 1861 the *Manassas* dropped downstream to attack the steamer U.S.S. *Richmond* and two sailing vessels, all ironclads. This was the first action between ironclad ships on the river. The Union vessels had moved up to the Head of Passes to stop Confederate blockade-runners from getting to New Orleans; the *Manassas* sent them back into the Gulf. By this time most of the Mississippi River below St. Louis was in Confederate hands.

President Abraham Lincoln knew the river had to be reopened. In January 1862, he told Adm. David Farragut to

take New Orleans. Farragut was born in Tennessee in 1801 and made his career in the Navy. He was married to a Virginian, but he stuck with the Union.

Farragut's fleet consisted of 24 wooden steamers carrying 200 guns, plus 20 schooners and six shallow-draft gunboats, or mortar boats, with a 13-inch mortar. In late February 1862, Farragut reached Ship Island off Biloxi, Mississippi, which had been occupied by the Union. From there he sent the heavier ships of his squadron to the mouth of the river—this was some 20 years before Eads built his jetties—to start the difficult task of getting over the sandbars and then assembling at the Head of Passes. Not until April 15 could this be done. By then the mortar boats were part of the flotilla, and troops commanded by Union Gen. Benjamin Butler were on Ship Island, waiting to enter New Orleans when it was possible.

The mortar boats were just downriver from Fort Jackson, where they were protected from Confederate gunfire by the bend of the river and by dense woods on the bank. Each Union ship had the top of its mast camouflaged by tree branches. On April 16, the Union mortars began firing at Fort Jackson. The bombard-

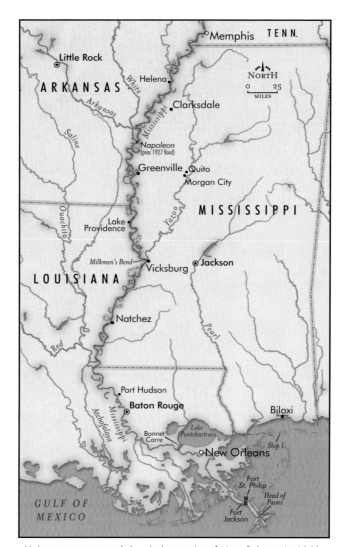

Union troops secured the vital port city of New Orleans in 1862. Next, the Confederate stronghold Vicksburg was key to controlling the Mississippi.

ment lasted for five days. On April 20, three Union gunboats managed to breach the chain across the river, but still the Confederates continued to hold Fort Jackson. On April 22, 1862, Farragut gave up on the mortars and assembled his captains on his flagship, the *Hartford*. He told them he intended to run past Forts Jackson and St. Philip the next night and gave them detailed instructions. Some of the captains were opposed to hazarding the attempt (which had not been authorized in Farragut's orders), but Farragut's determination is best expressed in a letter to his wife before the battle: "As to being prepared for defeat, I certainly am not. Any man who is prepared for defeat would be half defeated before he commenced."

At 2 a.m. on April 24, the admiral gave the signal to start. Leading the procession through the breach in the chain were six gunboats and two sloops of war, with the others following. At 3:30 a.m. the forts spotted the ships and opened fire on them. Each Union ship opened fire in return as it came in range. General Butler described the sight: "Twenty mortars, 142 guns in the fleet, 120 in the forts, the crash of splinters, the explosion of the boilers and magazines, the shouts and cries, the shrieks of scalded and

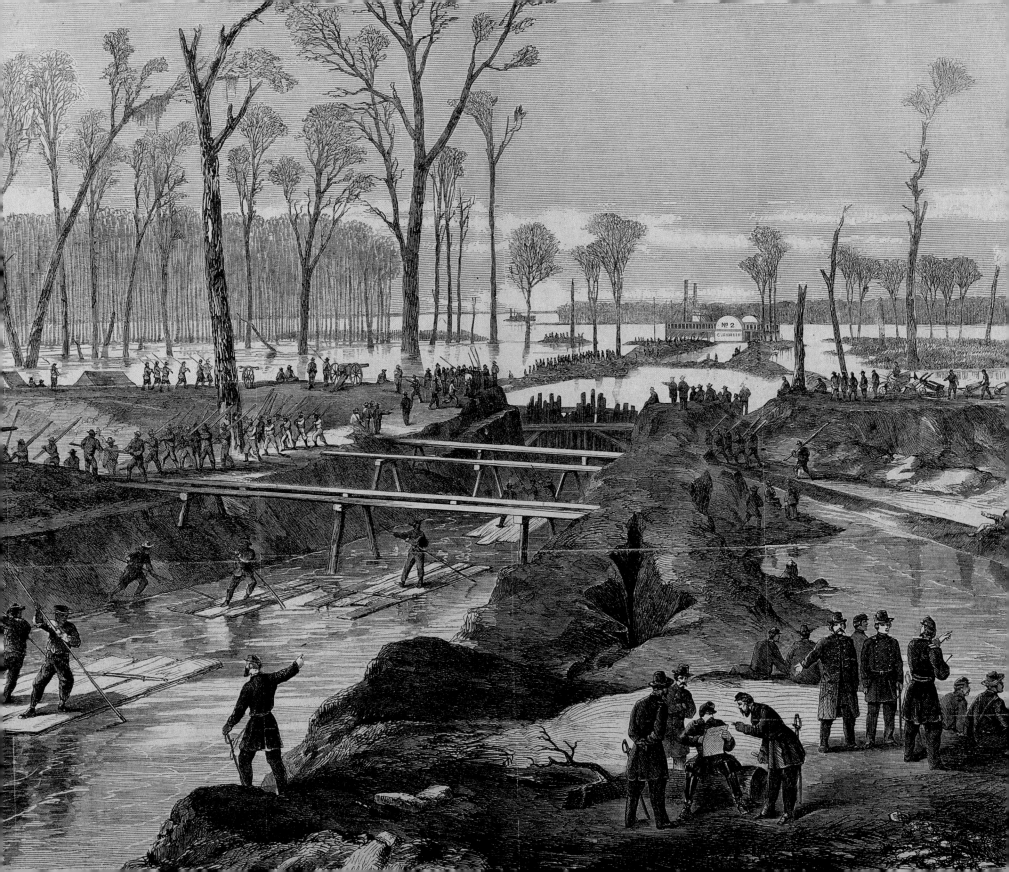

drowning men; add to this, the belching flashes of guns, blazing rafts of burning steamboats, the river full of fire, and you have a picture of the battle." Union steamers and sailing ships crowded the river, tacking around the bend, continuing up current.

The Confederate defenders relied on the cannon in the forts, which contained about 1,000 men commanded by Gen. J.K. Duncan.

Every Union ship was hit at least once during the run by cannon fire from the forts and from the *Louisiana,* which was unfinished but tied up at the fort. Farragut's flagship, the *Hartford,* was hit 32 times. Three Union sailors perished and ten were injured. *Hartford* ran aground above Fort St. Philip and caught fire, but Farragut's crew extinguished the blaze. The ship backed off the shore and continued upriver.

Above the forts, the Confederate fleet made a brave but futile fight. Most of the ships were sunk. The ironclad *Manassas* tried to ram the Union vessels. She did strike the *Brooklyn* but was driven ashore and sunk. Union casualties were 37 killed and 146 wounded. Farragut had passed the forts. His was the only battle fought at the mouth of the river. Farragut proceeded upriver, then dropped anchor off New Orleans. There were fires, deliberately set on cotton bales, and a hostile mob. But the Confederates had retreated, making New Orleans an open city.

Major General Grant knew he would "go forward to decisive victory."

After Farragut got to New Orleans, Forts Jackson and St. Philip surrendered. Most of the men in the forts were conscripts from New Orleans, many of them Germans or Irishmen who had no interest in the Southern Cause. They had mutinied and refused to continue a hopeless fight. So the Southerners stacked their rifles and put up their hands. The forts once again belonged to the Union.

Although the Union took control of New Orleans then, the Confederates still held both banks from the city all the way to St. Louis. Farragut set his ships and gunboats to clearing the lower end of the river. On May 7, 1862, Baton Rouge surrendered without a fight. Farragut pushed up the Mississippi, fighting his way forward. At Port Hudson he ran past a furious cannonade and overcame the near-grounding of the *Hartford.* He even ran the batteries at Vicksburg, Mississippi, there to be surprised by the sudden appearance of the Confederate ironclad *Arkansas.* His fleet had a running fight with the *Arkansas,* which he was determined to destroy but could not. He returned to New Orleans.

Lincoln knew that Vicksburg would be the key in this campaign. After the Union seized New Orleans, Lincoln examined a map with a visitor. "See what a lot of land these fellows hold," he declared, pointing to Texas, Louisiana, and Arkansas, "Vicksburg is the key, and all that country is ours. The war can never be brought to a close until that key is in our pocket."

In January 1863, Grant's soldiers began digging the canal that would allow Union ships to move south of Vicksburg without encountering enemy fire
Working beside former slaves who had deserted local plantations, the soldiers labored in the mud for two cold months.
When the canal was nearly completed in mid-March, torrential rains collapsed it. The river then flooded, nearly drowning the men. Grant abandoned the project, confessing later that he had never been optimistic about its success, but "let the work go on, believing employment was better than idleness."

Grant agreed. He had been working on the problem since the war began. Grant was born in the Ohio River Valley at Point Pleasant. After graduating from West Point in 1843 and serving in the Mexican War, he left the army in 1854 and tried, unsuccessfully, to make a living for his family in St. Louis. In 1860 he moved upriver, to Galena, Illinois, where he was a clerk in his family's leather-goods store. He returned to service when the Civil War began and soon rose to general. Now he was ready to free the Mississippi River.

In 1861 a visitor to his small headquarters at Ironton, Missouri, found Grant, then a colonel commanding an Illinois regiment, under a tree drawing lines on a map with a red pencil. Grant explained that the lines were invasion routes into the Confederacy. The one that stood out was down the Mississippi River past Vicksburg. Based on this, he set in motion what would become the greatest military campaign ever conducted on the river.

Grant's Vicksburg campaign foreshadowed warfare of the future. It featured mobile forces and partisans striking far behind the lines, joint army-navy operations, amphibious assaults, forced marches, pitched battles, field engineering of great resourcefulness, logistical triumphs, and intelligence and counterintelligence activity. The opposing Confederate armies had some decisive advantages. They were fighting on their own soil, with the full support of the population—the white population, that is, as the black slaves deserted when they could, many of them joining and working for the Union Army. The Rebels were well supplied and motivated, superb soldiers. And they held the river. It was as critical to them as it was to the Yankees.

Various attempts to take Vicksburg by coming at it overland, from the east, failed. In January 1863, Grant took command of all the armies heading for Vicksburg. His base was in Memphis. He moved much of his force to the west bank of the river, then downstream as far as Lake Providence and Milliken's Bend, Louisiana. There he put the men to work, digging. He wanted to avoid the Confederate guns at Vicksburg by straightening out the river. That would leave Vicksburg high and dry. It required an engineering feat whose time had not yet come. Through January and February tens of thousands of men dug dirt for the proposed canal. The efforts involved an enormous amount of material and exertion by the troops. But the attempt to divert the Mississippi River from its channel failed.

Grant gave up on the canal, but not on Vicksburg. In his memoirs he explained, "There was nothing left to be done, but to go forward to decisive victory." That thought, he added, had been in his mind from the moment he took command. He passed on that determination to his staff, his commanders, and his troops. Theodore Lyman, a Harvard graduate serving on the staff of Gen. George Meade described Grant as a man who "is the concentration of all that is American."

ELEVATION

The first river warships of their kind, James Eads's ironclads were steamboats encased in iron, each hull mounted with 13 guns.

In late March 1863, Grant had evolved a new plan. He proposed to move his army south of Vicksburg in barges through a series of bayous west of the river. Some overland marching would be necessary. At the same time Admiral David Porter's gunboats and large transports would run past the Vicksburg batteries. They would meet the troops south of Vicksburg and ferry them across the river. Grant would then attack Vicksburg from the south and east.

Two of Grant's generals, William T. Sherman and James McPherson, told him he was dead wrong. Sherman said that by crossing the river south of Vicksburg, Grant would be cutting himself off from his supply base and putting himself voluntarily in a position that an enemy would be willing to maneuver for a year to get him into. He wanted to return to the east bank and continue the overland campaign. Grant replied that he would have wagons along to carry ammunition and other essential supplies.

Through April, Grant's men worked their way down the west bank through flat bottomland and numerous bayous. Meanwhile Porter's fleet had passed the batteries at Vicksburg. It was a memorable night that saw more cannon fire than at any other time on the river. Grant got his army across the Mississippi River. In his memoirs, he described his feelings at this point: "I felt a degree of relief scarcely ever equaled since. Vicksburg was not yet taken, it is true, and I was now in enemy territory with a vast river and the stronghold of Vicksburg between me and my base of supplies. But I was on dry ground on the same side of the river with the enemy."

He proceeded to march inland, toward Jackson. He was filled with an inner tension, a compulsion to get moving. By May 18, the Union men began investing Vicksburg. They were subsisting on food brought in by squads from surrounding farms and plantations. Grant was anxious to secure a base of supplies on the Yazoo River. He and Sherman rode to the bluff north of Vicksburg. The Rebels took some shots at them. Minié balls whistled past the generals' ears. They paid no attention. Instead they were filled with intense satisfaction. Grant could now reopen his communications with the north, receive supplies and reinforcements, and conclude the campaign. He had to force the Rebels to surrender. But they had built impressive fortifications. On May 19, Grant launched an assault. It was well led and fierce, but a failure. Grant's attempt to storm his way into Vicksburg cost him 157 killed, 777 wounded, and 8 missing, as against a total Confederate loss of about 250.

Grant settled into a siege. His plan was to keep active on the front lines while waiting for the Rebels to surrender to avoid starvation.

Life in Vicksburg was awful. People endured what no other city on the river has seen. Food supplies were so short that residents were reduced to eating mule meat and pea bread. Medical supplies were almost nonexistent. Water was so scarce that officers posted guards at wells to make sure none was wasted "for purposes of cleanliness." The citizens were forced to burrow underground or live in caves to avoid the well-nigh constant shellfire, which came both from Grant's artillery and Porter's fleet. They stuck it out. They even printed their newspaper on the blank side of wallpaper.

On the picket line Johnny Reb and Billy Yank discussed politics and swapped jokes and philosophy. They traded hardtack and coffee for tobacco. Sometimes they sent personal messages back and forth. Each army—Grant had almost 80,000 men, the Rebels about 30,000—contained regiments from Missouri. One day the pickets at Stockade Redan agreed to informal short truces. The area became a meeting place for relatives or friends of the Missouri troops and was called the Trysting Place.

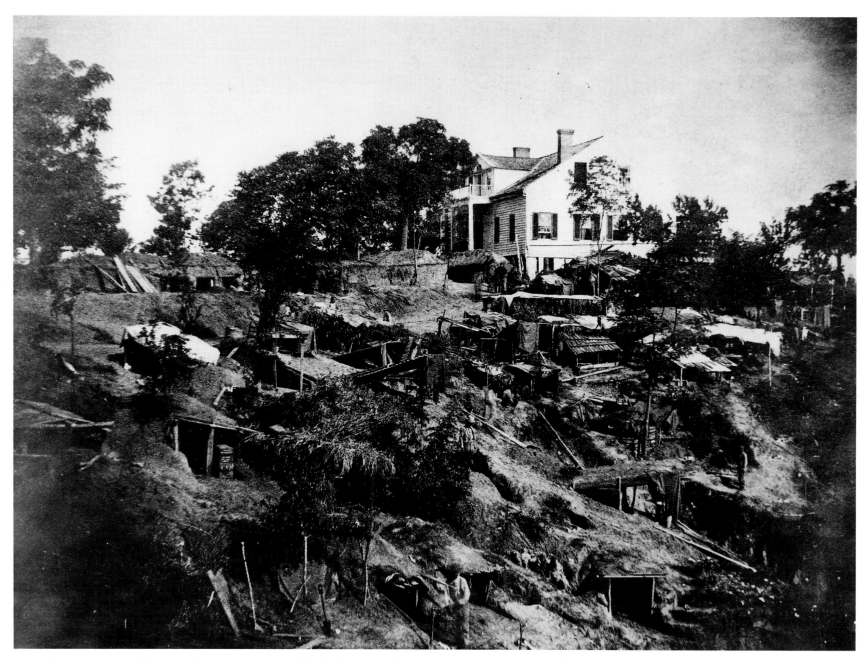

During the siege of Vicksburg, Union troops occupied Wexford Lodge and destroyed its fruit and vegetable gardens—a precious source of food—to build trenches and bomb shelters that would protect them from Confederate artillery fire. This image shows the dugouts of the 45th Illinois Infantry on the slopes below the embattled house.

CHICAGO HISTORICAL SOCIETY, NEG. #ICHI-08019

So tightly did Grant hold the ground that a Confederate defender wrote despairingly, "A cat could not have crept out of Vicksburg without being discovered." Grant also tried to speed things up. Men dug tunnels under the Confederate entrenchments. On June 25 and again on July 1, Grant ordered huge explosions set off. They blew off the tops of two hills and created a crater into which an assaulting column charged. The Rebels had heard the digging, surmised what was coming, and built parapets to the rear. From them they inflicted staggering casualties on the Yankees.

By then most of the Rebels suffered from illness and malnutrition. On July 3, Gen. John Pemberton sent a note to Grant proposing an armistice and the appointment of commissioners to write a surrender formula. Grant replied: "The useless effusion of blood you propose stopping can be ended at any time you may choose, by the unconditional surrender to the city and garrison." When Pemberton protested, Grant agreed to a modification—he was anxious to have the surrender take place on July 4—that would allow the Confederates to stack their weapons, give their paroles, and then go to exchange camps for POWs. So it was done.

Sherman immediately began moving his corps to other battles and campaigns in the East, but he took time to scribble a note to Grant before departing. He knew what the Mississippi meant to him and to the United States. "I can hardly contain myself," he exclaimed to Grant. "This is a day of Jubilee, a day of rejoicing to the faithful."

Grant was more subdued. At the conclusion of the most momentous and successful campaign ever on the Mississippi River, the architect of victory sent this report to the War Department: "The enemy surrendered this morning."

Sgt. Pleasant W. Bishop of the 94th Illinois—Stephen Ambrose's great-grandfather—was there. On July 4, 1863, he began a letter to his wife and children: "Since yesterday evening there has been to some extent a cessation of hostilities between our forces & the rebels." He noted that the pickets had been "together all along the line *shaking hands*, trading pocket knives, exchanging papers, etc."

At that moment Bishop received orders to prepare to march. He broke off his letter to resume on July 6. "Glorious news," he began. "I thank my God that I was permitted to *celebrate* the 4th of July by marching (at the head of Co. I) inside of the fortifications of Vicksburg." He examined the fortifications with a soldier's practiced eye and pronounced them formidable, reported that the mule meat stories were true, and thanked God for His blessings. "I would say that while I rejoice that Vicksburg is ours, it gives me no pleasure to see the destitution and the sufferings of fellow mortals in the Rebel Army, yet such must be their conditions unless they lay down their arms, and cease to fight against their God by fighting against their country. But I have been looking them over now for two days, and I find them to be just like people in other parts of the world, some of them are men of sense and some are not."

Abraham Lincoln, who started it all, got the last word. He had spent his youth on the Sangamon River, a tributary of the Illinois, which flows into the Mississippi. He had twice floated down the river to New Orleans, where he first saw slavery and vowed to do what he could to end it. He had been involved in litigation about the first bridge built across the river, at Davenport, Iowa. He had traveled across and up and down the river countless times. Possession of the river, he had declared, was the key to holding the Union together.

At the National Park at Vicksburg, the raised and restored U.S.S. *Cairo* is on display. It is an ironclad vessel, found at the bottom of the river more than a century after it sank. The ship was raised in an operation led by historian Edwin Bearss of the National Park Service and supported by

the state of Mississippi and private donations. James Eads had built it as part of a fleet. Grant later said that without Eads's fleet of ironclads, he could not have taken Fort Donelson in 1862 or Vicksburg the following year. The *Cairo* had been hit and sunk by Confederate batteries. When it was raised by Bearss and his team, it was full of implements of every kind, including mess gear and buttons, boilers and cannon. The equipment can be seen in various exhibits in the park's museum. A platform allows visitors to walk around the vessel, with many explanatory signs on how things worked. It is the only sunken warship in the river to be raised and restored.

When General Pemberton surrendered Vicksburg on July 4, 1863, the Union had opened the Mississippi River—except for Port Hudson, Louisiana. The Confederates still held on at Port Hudson with cannon on the bluff, the batteries preventing any traffic. Some 7,000 Rebels guarded the batteries from land attack. They occupied a 4 1/2 mile line of earth and timber entrenchments and had sufficient rifle ammunition and cannon balls to keep on fighting.

The Yankees had attacked the fortifications with some success but many setbacks. On June 6, 1862, Union gunboats headed for Memphis. About 10,000 citizens gathered to watch the Rebels drive them off. But the Union boats sank the enemy fleet, and the troops seized control of Memphis.

In December 1862, in New Orleans, Union Gen. Nathaniel Banks had replaced Benjamin Butler. Banks was a political appointment—he had been Speaker of the House of Representatives—with no military training or experience. But he knew politics. In his campaign to take Port Hudson, he brought along so many photographers that it became the most photographed action in the Western Theater of the Civil War. In May 1863, Banks marched his army north from Baton Rouge to take Port Hudson. With him were the Native Guards, made up of Free Men of Color recruited in New Orleans. The Native Guards had black officers, including Major Dumas, the highest-ranking black officer in the Union Army. (Some of the men were sons of the Free Men of Color who had fought with Andrew Jackson's force in the Battle of New Orleans in January 1815.) The Native Guards participated in Banks's attacks on Port Hudson. This was the first time an organized black unit fought for the United States. The blacks led the initial assaults on the Rebel fortifications and did well throughout the campaign.

Banks did not do well. His first assault, on May 27, 1863, was badly conceived, ill-coordinated, and a failure. Banks lost 1,800 men—more than the Union losses at the Battle of Shiloh. He tried again, then again, without success. He tried tunneling under the fortifications—without success. In the campaign, the Union forces suffered 10,000 casualties. In assaults in June, losses ran to 25 percent of his total force. He settled into a siege; it became the longest siege of the Civil War, indeed the longest in U.S. military history. On July 7, news of the Vicksburg surrender reached Port Hudson. Two days later the Rebels at Port Hudson surrendered. The Mississippi finally flowed unvexed to the sea.

In the 1960s, Prof. T. Harry Williams, the Civil War historian at Louisiana State University, led a drive to have the State of Louisiana acquire the main portions of the battlefield. In 1969, with the help of the Baton Rouge Civil War Round Table, he succeeded. Today it is a state park, with a museum and major parts of the Confederate fortifications, plus Union trenches and tunnels. Ed Bearss says they are the best of all surviving Civil War emplacements. Vicksburg has more, but they are restorations, not the originals as at Port Hudson. On the trail, a visitor can wander through them, see the Union trenches, the ravine the troops had to climb,

and the Confederate fortifications. It is a fitting remembrance of the last time an enemy force held a position that blockaded the river.

There is no area along the Mississippi River that is as time-warped as the Delta, that strange and haunted region that lies between Vicksburg and Memphis, a great agricultural garden of cotton, catfish, soybeans, and rice, where Civil War yarns and sharecropper blues mingle in an ethereal stillness unimagined in the East or West. David L. Cohn, in his lyrical 1948 memoir, *Where I Was Born and Raised*, called the region "a strange and detached fragment thrown off by the whirling comet that is America." William Faulkner described it in *Sanctuary* as "five thousand square miles, without any hill save a few bumps of earth which the Indians made to stand on when the river overflowed." But it was Tennessee Williams's character Big Daddy, in his play *Cat on a Hot Tin Roof*, who captured the region with the most straightforward accuracy ever, calling it "the richest land this side of the Valley Nile." It is also known throughout the world as the "Fertile Crescent of American Music," because this is where the blues first sprang to life. "A hundred years ago, in the heart of the Mississippi Delta, an impoverished region so hard and cruel that most who got the chance fled and seldom looked back, the blues were born," novelist John Grisham wrote in an introduction to *Visualizing The Blues*. "Raw, simple, emotional, the blues expressed the harshness of life in that tortured locale. Its first artists sang and played not for money or appeal, but simply for themselves. Their music soothed them; it was their escape."

Most of the legendary Delta bluesmen escaped poverty and headed to cities like Chicago or Memphis to launch successful recording careers. But the notes still linger. Along the river during harvest season, cotton fields simmer in the sun as far as the eye can see. The soil here is dark Delta silt, the finest growing dirt anywhere. If you pull off Highway 61, the road that transported migrating blacks from New Orleans and Memphis to Chicago in search of the promised land that is yet to be—and just stand and listen—you can often experience the most serene silence imaginable. Usually it only lasts for a few minutes because a semitrailer truck will come roaring past or a single-engine plane will suddenly appear, dusting the vast cotton fields. After a rainstorm, dozens of plump night crawlers slither onto the wet asphalt of Highway 61, bloated in the middle like tiny pythons, from gorging on the soil's abundant nutrients, bearing witness to the land's fertility. Today Highway 61 has become a new route of return, as people flock to the Delta in search of roots music and the great literature that sprang from this improbable garden. In particular, people come looking for traces of the enigmatic Robert Johnson, King of the Delta Blues.

Blues mythology has it that at the crossroads of Highways 61 and 49, outside Clarksdale, Mississippi, Johnson sold his desperate soul to the devil to play the meanest blues guitar in the region. As Johnson sings in "Crossroads Blues:"

> *I went to the crossroads*
> *Fell down on my knees. Asked the Lord above,*
> *Have mercy now, save poor Bob if you please.*

Today the intersection is a garish disappointment. Delta Donuts and Abe's Bar-B-Q sit on the corner surrounded by a strip of franchise gas stations and fast food restaurants. Recently a 20-foot-high "Crossroads" sign was erected with neon lights and blue guitars. Nothing could be further from the raw beauty of Johnson's haunting guitar than this disfunction junction—unless you're playing his music on your stereo, thereby numbing yourself to your surroundings.

Some say Johnson, who went on to record 29 seminal blues songs such as "Walkin' Blues" and "Travelin' Riverside Blues," got the best of the bargain. He died young—only 27—in August 1938, and his death is shrouded in rumor. One version claims he died in agony after being fed lye by a jealous girlfriend. According to another story, he was stabbed in a juke joint by a jealous husband. There are even two different graves claiming to be Johnson's final resting place: at Payne Chapel M.B. Church in Quito and at the cemetery next to the Mount Zion M.B. Church in Morgan City. The second monument is located off Highway 7 to fulfill Johnson's wish in his song "Me and the Devil Blues":

You may bury my body down
by the highway side
So my old evil spirit can catch a
Greyhound bus and ride.

One thing is certain: Without Johnson, rock-and-roll would not have been possible. "The blues had a baby and they called it rock-and-roll," Muddy Waters once noted.

Today, whenever darkness prevails in the Delta, when demons and spirits reign, it's the sound of Robert Johnson's blues that fills your head. Guitar chords, the relentless insect choir, Sunday preachers and harmonicas—that is the taproot of black music in America that still survives in the old form in various Delta bars and clubs. The sharecropper

Legendary bluesman Robert Johnson recorded 29 songs in his brief career in the 1930s, which set the stage for today's rock-and-roll.
ROBERT JOHNSON PHOTO BOOTH SELF-PORTRAIT.

shotgun shacks are largely abandoned, the persistent river floods are contained by the levees, and many new plantation owners live officially in faraway places like Europe, Japan, and the Middle East. But Johnson's sound is a constant in this strange land, which conveys the essence of the blues.

Thirty miles north of Vicksburg along Highway 61 there is a historical marker in Outward, Mississippi, demarcating the most celebrated bear hunt in American history. It stands next to a wild pear tree in front of the Outward Store, a rickety mom-and-pop market that specializes in catfish baskets and pickled pigs' feet. Surrounding the checkout counter inside are color photographs of happy hunters in modern-day hunting regalia, the khaki camouflage kind sold at Wal-Mart. Dog-eared copies of *Outdoor Life* are scattered about in barbershop fashion, as are rusted farm implements, which have risen to antique status. Only a large display case filled with "Onward, Teddy!" stuffed bears and G.I. Joe classic action figures of Lt. Col. Teddy Roosevelt in Rough Rider uniform distinguish this roadside store from hundreds of others. For within a couple miles of this kudzu-choked spot, a hunt took place that gave rise to a popular stuffed toy: the teddy bear, plus a slew of apocryphal stories.

It all began in mid-November 1902, when President Theodore Roosevelt, exhausted from a six-month showdown mediating between mine owners and striking members of the United Mine Workers (UMW), was in desperate

Beneath the searing sun, sharecropper homes line a dirt road that runs between endless cotton fields in Mississippi Delta country.

need of fresh air and relaxation. A few weeks earlier public schools and government offices throughout the Northeast and Midwest had to be closed because there wasn't enough coal to heat them, resulting in the President's threat that he would send Federal troops to reopen the locked mines of Appalachia. Finally, a settlement was reached through arbitration, and a relieved Roosevelt was ready to go on a four-day hunting expedition—a form of recreation he considered therapy as well as sport. Indeed, the American Museum of Natural History in New York—co-founded by Roosevelt's father—still has on display a number of wild animals shot by the 27th President. Roosevelt had been enthralled by animals since childhood, particularly bears. At the time of his excursion to the Delta, he was considered the world's foremost authority on grizzly bears, having written about them with scientific precision in several of his "out-door" books, including *The Wilderness Hunter*, published by G.P. Putnam's Sons in 1893. "A fighting bear sometimes uses his claws and sometimes his teeth," Roosevelt wrote of observing grizzly bears in the Rockies. "I have never known one to attempt to kill an antagonist by hugging in spite of the popular belief to this effect; though he will sometimes draw an enemy towards him with his paws the better to reach him with his teeth and to hold him so that he cannot escape from the biting." To Roosevelt, bears, with their fierce growls, razor-sharp claws, and fearless demeanor, embodied what he called "savage courage," the quality he most esteemed. Thus he saw bear hunting as ritualistic, the pursuit of a worthy adversary for a man and his dogs. The significance Roosevelt placed on the conquest of the quarry grew out of the Native American belief that by killing and eating a worthy animal, the hunter may acquire its qualities such as the cunning of a fox, the swiftness of a deer, the agility of a mountain lion. In 1912 Roosevelt would name his independent movement the Bull Moose Party after the animal that represented intractable stubbornness. The bear was a symbol of brawny toughness.

Roosevelt had eagerly accepted Mississippi Governor Andrew Logino's long-standing invitation to come south for bear hunting season. Naturally, politics also figured into Roosevelt's decision to go: Logino was up for reelection, and his opponent, James Vardaman, was a contentious white supremacist. When Vardaman heard that Roosevelt was coming to Mississippi to hunt, he denounced the President as that "coon-flavored miscegenist in the White House" and a "nigger lover" hell-bent on destroying the last remnants of Confederate culture. Vardaman was particularly rankled—as were many white Southern Democrats—that this Republican President had invited Booker T. Washington to dine at the White House on October 8, 1901, an unforgivable affront, he said, against Anglo-Saxon superiors. Vardaman took out advertisements in the Vicksburg and Jackson newspapers in hopes of derailing the Presidential trip, saying: "Wanted: 16 Coons to Sleep with Roosevelt when he Comes Down to Go Bear Hunting with Mississippi Governor Longy."

Whatever else can be said of Theodore Roosevelt, he certainly knew how to show off. The Illinois Central Railroad took care of his travel needs pro bono, and he, in turn, cut quite a figure on the over-one-thousand-mile journey from Washington to Vicksburg and to Smedes Plantation near Outward. Clad in a fringed buckskin jacket he had acquired in the Dakota Territories, topped off with a brown slouch hat, the President looked like a latter-day Daniel Boone, cartridge belt full of steel-jacketed bullets around his waist, adding an air of the Rough Rider ready for action.

Reporters covering his train ride noted that Roosevelt was reading a book by his friend, French ambassador Jules Jussenard, entitled *The Nomadic Life*, a history of the Crusades of the Middle Ages, and surmised that the text was meant to

inject some intellectual adrenaline and romanticism in preparation for the Great Bear Hunt. When the train entered the Delta, and the view from his compartment changed to plains scattered with bales of cotton ready for shipping to the textile mills of New England and Europe, Roosevelt waved at the black field hands, who lined the tracks for an unprecedented glimpse of a U.S. President.

When he arrived in Outward at noon on Friday, November 14, Roosevelt buoyantly thanked the engineer, signed autographs, and showed off his ivory-handled knife and custom-made Model 1894 Winchester rifle with the deluxe walnut stock. There to greet him at the tiny station were some of the other members of his hunting party, which included John M. Parker, who later became governor of Louisiana; John McIlhenny, an old Rough Rider who would found the Tabasco Company in New Iberia, Louisiana; and plantation owner Hugh L. Foote, whose grandson Shelby would become America's foremost Civil War historian.

The main tract of land Roosevelt would hunt on belonged to W.W. Magnum—a high-ranking partner in the Illinois Central, who once imported monkeys to this region hoping they would learn how to pick cotton. Camp was set up not far from the Mississippi River after a bushwhacking ride on horseback through a dense tangle of prickly underbrush, stunted pines, and canebrake. Supplies were delivered to the camp on mules; sleeping tents were put up in a semicircle next to a huge cooking tent that had been raised the day before. That first night, the men swapped bear stories around a roaring bonfire. Roosevelt's tales of his cowboy adventures in the Wild West days usually stole the show, but in this gathering one of the star raconteurs was an African American: Holt Collier, the best bear man in the Delta, who told yarns along with Robert Bobo, a white trapper who had brought nearly 50 of his prize hunting dogs on the expedition.

When John M. Parker commented that the rigors of swamp hunting for bear might be too hazardous for a sitting President, an outraged Roosevelt exclaimed, "This is exactly what I want!"

"Good," Parker shot back. "We will have bear meat for Sunday dinner!"—to which Roosevelt quickly replied, "Let us get the bear meat before we arrange for the dinner."

As usual, the President refused to be treated any differently from the rest of the hunting party. Although born to New York aristocracy, Roosevelt scorned the over-privileged effete. What's more, to the shock of some in the party, Roosevelt treated Bobo and Collier—who had been born into slavery and accorded the same respect as hired stable horses by most white Southerners—as comrades in arms. Collier in particular interested the President: His accuracy with a Winchester was legendary throughout the Delta, and he could shoot with either hand equally well. Collier had served as a Confederate scout for General Nathan Bedford Forrest during the Civil War. Plantation owners bragged that Collier had a better nose for bear than a thousand of England's finest hounds did for the red fox. His personal scorecard of kills, however grisly—considering that black bear have been hunted out of existence in the Delta—is impressive: Over a 40-year period he shot 1,600 bears. As proof, he wore a string of trophy bear claws around his neck, and the deep scars on his forehead served as a warning of what happens when your bullet only grazes a bear.

Collier and his baying hounds first picked up the scent of a bear on the morning of Saturday, November 15. For hours Roosevelt tracked the animal through mud gullies and thickets. Eventually convinced that the hounds had lost the scent, Roosevelt and company returned to camp for a late lunch. Collier continued the pursuit. Around 3:30 p.m. his dogs caught up with the 235-pound giant, and Collier

bugled for the President to take part in the kill. Chasing the bear into a watering hole, the dogs plunged in after it and refused to let up. Before long the pack had surrounded the doomed beast, lunging at it with bared fangs and yelping nonstop in a frenzy. With the sweep of a mighty forepaw, the bear seized one of the dogs by the neck and crushed it to death. Collier, irate at the loss, leapt from his mount and ordered his remaining dogs to attack. As they set upon the animal, Collier was able to get close enough to smash the bear's skull with the butt of his rifle, knocking out the beast. With a dog still gnawing at the bear's hind legs, Collier lassoed the bear around the neck and tied it to an oak tree.

Upon hearing the bugle, Roosevelt and his companions rushed to catch up with Collier. But the conservationist President was dismayed when he took in the gruesome scene: a dog lying dead in the dirt, two others seriously hurt, and a bloody, mangled bear tied to a tree, groaning for air. The light rain became heavier, bringing a chill of evening. Seemingly in unison, the other hunters cried, "Let the President shoot the bear." But the disgusted Roosevelt shook his head and refused to draw his Winchester. "Put it out of its misery," he ordered. John Parker pulled out a Bowie knife and slit the bear's throat, after which its carcass was slung over a horse and brought back to camp.

Hidden in the Roosevelt Collection at Harvard University is a picture of the dead bear strapped to a horse. The President's great-grandson, Tweed Roosevelt, unearthed the photograph in 1989 when he was researching the November 1902 hunt in preparation for an address to the Teddy Bear Society of America, a toy collectors' group, in Boston.

"I told them the truth," he recalls. "I didn't gussy it up. There never was a bear cub, and the bear with Teddy Roosevelt wasn't shot, but was knifed to death. They didn't like hearing it."

Reporters had swarmed around the President all that first day hoping to score a colorful bear-hunt dispatch from the Delta. The next morning, Sunday, November 16, the newspapers carried stories on the President's good sportsmanship, as shown in his steadfast refusal to shoot a captive bear. The *Washington Post*, for example, ran a front-page article, headlined "One Bear Bagged. But it Did not Fall a Trophy to President's Winchester," reporting that the President had been summoned "after the beast had been lassoed" and "refused to make an unsportsmanlike shot." Then the story took off. The next day's *Washington Post* featured a front-page Clifford Berryman cartoon, "The Passing Show," that depicted Roosevelt in his hunting regalia, with one hand holding his rifle butt on the ground and the other thrust out in a firm "No!" and a perplexed fellow hunter holding a black bear by a rope around its neck. The caption read "Drawing the Line in Mississippi"—a double entendre that many scholars believe referred to Roosevelt's fierce criticisms of the lynchings of African Americans in the South.

Berryman's cartoon became a hit and was reprinted nationwide, sparking praise for the President but also chuckles at his inability to bag a bear in Mississippi. "Naturally," Roosevelt wrote to a friend, "the comic press jumped at the failure and have done a good job of laughing over it." And then a middle-aged Brooklynite, Rose Michtom, made two plush toy bears, stuffed with excelsior and adorned with black shoe-button eyes, in tribute to the President who refused to fire upon a captive beast. Her husband, Morris, put the stuffed bears in the window of his stationery-novelty store; they sold immediately. Then Morris Michtom had a brainstorm: Why not seek President Roosevelt's permission to market the toy as a "Teddy Bear"? Michtom fired a letter off to the President, apparently in February 1903. The President supposedly wrote back a few

lines essentially saying okay. The couple's son, Benjamin Franklin Michtom, remembers that his parents framed Roosevelt's permission letter and hung it up on a wall in their Florida winter home; after they died, and the house was sold, the letter disappeared. No copy, however, has turned up among Roosevelt's voluminous Presidential papers, housed at Harvard University, or among his Presidential papers at the Library of Congress. The Teddy Bear became the rage in the toy business, and the Michtoms made a fortune.

Throughout the Delta it's talk of the floods—even more than the Civil War—which prevails. Every community in the Delta has been profoundly affected by floods, and several towns even disappeared. One of the most colorful early Delta towns was Napoleon, founded in 1833 at the junction of the Arkansas and Mississippi rivers. A center of river commerce and site of a U.S. Marine Hospital, Napoleon by the 1850s was the largest Arkansas town along the Mississippi south of Helena. Like Natchez-Under-the-Hill at night, it was a wicked carnival of a town. Mark Twain, who visited it as a young man and recalled it fondly, wrote colorfully about "the innumerable fights—an inquest everyday." Twain used Napoleon as his model for the fictional town of Bricksville, Arkansas, a locale of some lively moments in *Huckleberry Finn*. In 1882 Twain tried to revisit the town, but a steamboat captain

President Theodore Roosevelt, an avid hunter—here in Mississippi in 1902—sanctioned the first federal wildlife refuges.

informed the shocked author: "There isn't any Napoleon anymore.... The Arkansas River burst through it, tore it all to rags and emptied it into the Mississipp!... This boat is paddling along right now where the dead center of that town used to be...." All the town's structures had caved into the river, succumbing to the currents' torrential attack. Since then, on rare occasions when the river is at an extremely low stage, remains of the once bustling frontier town have been spotted among the exposed sandbars.

But it's the Great Flood of 1927 which the old-timers all recall, most beginning their storytelling with lines like, "And then the rains came. They came in amounts never seen before or since by any white man." And it's all true. The rains fell throughout the entire Mississippi River Valley, from the Appalachians to the Rockies. They caused widespread flooding that made 1927 the worst year ever. The flood brought more water, more damage, more panic, more misery, more death by drowning than any American had seen before, or would again.

The Civil War and World War I had caused far more death and considerably more destruction than the Great Flood, but they were man-made events. Their cost in lives and property had been justified by the results—slavery was abolished, the Union was saved, peace was restored to the world.

At the beginning of 1927, the Roaring Twenties were at their peak. People were glad to be alive after the Great War

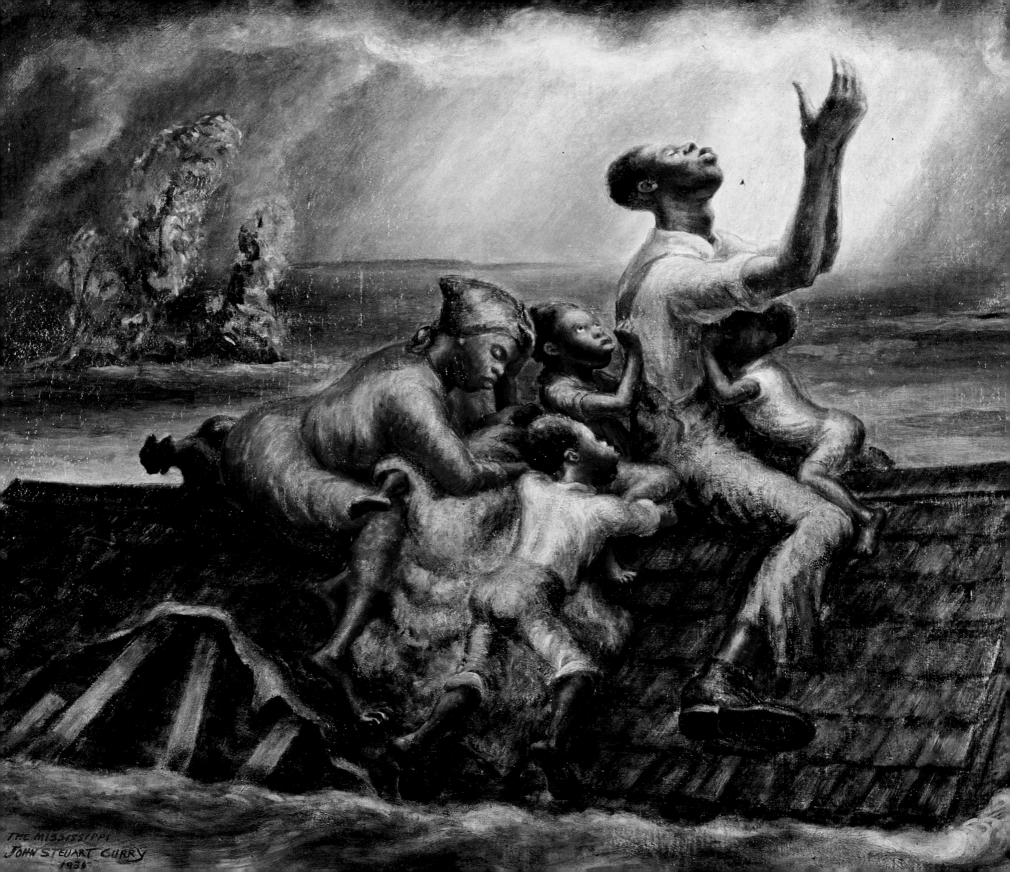

THE MISSISSIPPI
JOHN STEUART CURRY
1935

and were making strides in technology. Man had learned to convert the power of coal, oil, and falling water in rivers to generate electricity. With railroads, automobiles, and airplanes, man had conquered space and time. Modern medicine was on the way to conquering disease. The telegraph, telephone, and radio had made possible instant communication. Calvin Coolidge was President and all seemed to be right, or moving in that direction.

On the Mississippi River, progress was everywhere. Thanks to bridges, trains, cars, and trucks, people could cross the river without pause. Propellers, powered by the internal-combustion engine, drove ships upstream at a startling rate. Levees hemmed the river in on both banks, from St. Louis to beyond New Orleans, preventing floods. Eads's jetties had opened the mouth of the river. Before the 19th century, nothing man-made had ever moved faster than the speed of a horse. By 1927 far greater speed was commonplace. Man had taken control of his own life and was well on his way to controlling nature to suit his own purposes.

But no one anywhere could control or alter nature's most elemental forces—sun, tide, wind, snow, or rain. In 1926-27 in the Mississippi Valley, the rains came down in quantities that exceeded by ten or more times the average. John M. Barry tells the story in his award-winning 1997 book *Rising Tide: The Great Mississippi Flood of 1927 and How it Changed America*. In the winter the rains were so heavy that on the tributaries of the Mississippi the water had overflowed the banks, causing floods to the west in Oklahoma and Kansas, to the east in Illinois and Kentucky. On Good Friday, April 15, 1927, the *Memphis Commercial Appeal* warned: "The roaring Mississippi River, bank and levee full from St. Louis to New Orleans, is believed to be on its mightiest rampage.... All along the Mississippi considerable fear is felt over the prospects for the greatest flood in history."

That same morning, the rains had started again. Rains that were unbelievable, setting all-time records for their breadth and intensity. They came down over several hundred thousand square miles, covering much or all of the states of Missouri, Illinois, Iowa, Ohio, Arkansas, Mississippi, Texas, and Louisiana. In New Orleans that day there were 15 inches of rain—the greatest one-day rain ever known in a city that gets on average about 60 inches per year. Greenville, Mississippi, received more than 8 inches. Little Rock, Arkansas, and Cairo, Illinois, had 10 inches. The river swelled so high and flowed so fast that in Barry's words, "It was like facing an angry, dark ocean."

In 1993 came the greatest flood of the second half of the 20th century. At its peak, a million cubic feet of water per second flowed past St. Louis. In 1927 the river north of Greenville carried more than three million cubic feet of water per second. No one on record had seen anything like it or would again—at least to present day.

In the spring of 1927, the U.S. Army Corps of Engineers assured the public that the levees would hold. The Corps had built them, after all, and maintained them. But as had been the case at the mouth of the river after the Civil War, the Corps's many critics charged that it had overestimated its own prowess and underestimated the power of the river.

The Mississippi is never at rest. It runs to the sea in a continuous series of snail-like curves that approach 360 degrees. The river's sinuosity generates torrential forces. During floods it can reach up to 18 miles per hour.

A painting of the Great Flood of 1927 captures the anguish of one family who lost all but their lives to the the raging Mississippi River. The flood left more than 675,000 people homeless and countless dead. More than 300,000 had to be rescued from rooftops, trees, levees, and spots of high ground. The floods inundated 26,000 square miles, and near Greenville, Mississippi, the river was 70 miles wide.

The Corps built the levee system to confine the river. The levees cut the river off from its natural floodplain. And if that didn't work, the flow and thus the floods could be reduced with outlets that would divert part of the river into reservoirs or into another riverbed. The Atchafalaya River was the biggest outlet of all. It could carry most of the Mississippi's waters into the Gulf. The Corps could make the diversion happen, saving Baton Rouge and New Orleans. Another possible outlet was at Bonnet Carre, just above New Orleans. It could carry some of the river's waters into Lake Pontchartrain and then to the Gulf.

But outlets would not work, nor would levees, to control floods, at least according to Eads. To prevent floods, he had proposed cut-offs to eliminate the S curves to straighten and speed the river. The increased speed would scour the river's bed, even during lower water. The concentration of the river's force would lower the bed, so the river would carry more water faster and stay in its natural banks. By such correction, Eads had declared, "floods can be permanently lowered." The cut-offs would render levees superfluous. But no cut-offs were dug. Nor was another proposal tried— to build reservoirs on the Missouri, Ohio, and other tributaries to hold back water.

The Corps of Engineers—and thus the residents of the valley—relied on levees only. The levees were as far as a mile back from the natural banks. To contain high water, the Corps raised the height of the levees, from 2 feet to 7.5, feet to as much as 38 feet (the 1927 height at Morganza, Louisiana, upriver from St. Francisville). The Corps was confident that its levees-only system would hold in the river, and it so promised. The river might spread and rise, but it would continue to carry all the rain in the valley safely to the Gulf.

By late March, four separate flood crests had passed the junction of the Ohio and Mississippi rivers. The first crest had filled the river and brought it up to the levee height. The following three crests poured over the levees or pushed through them. On March 25 the gauge at Cairo, Illinois, had reached the highest stage ever known.

Still the rains came, in the Midwest, in the South, throughout the valley. The river rose higher. Most threatened was the Mississippi Delta between Memphis and Vicksburg. To save the land, people made frantic efforts to raise the levee by stacking sandbags on top. Charles Williams, an employee of former Senator Le Roy Percy's on one of the largest cotton plantations in the Delta, took charge. As author John Barry put it: He set up "concentration camps" on the levee protecting Greenville, complete with field kitchens and tents, for thousands of black plantation workers to live as they filled and placed sandbags.

The river, not the men, won the battle. On April 21 the water broke through the levees. Major John C.H. Lee, the Army's district engineer at Vicksburg (and in World War II chief quartermaster in command of the Services of Supply in the European Theater of Operations and called by the enlisted men, who hated him, "Jesus Christ Himself Lee") wired the chief of the Corps of Engineers, General Edwin Jadwin: "Levee broke...crevasse will overflow entire Mississippi Delta."

The crevasse, upriver from Greenville, was huge—a channel half a mile in width. More than double the amount of the water of Niagara Falls poured through—more than the entire upper river had ever carried. In 10 days it covered 26,000 square miles with water 10 feet deep. The crevasse continued to pour water, and the river was 70 miles wide.

Panic ensued. "Hundreds of workers on the levee climbed into a barge below the break to escape," Barry wrote. "A tugboat tried to push the vessel downstream, but the flow through the crevasse pulled it upstream. One white

man called out, 'Let's put all the niggers on the barge and cut it loose.' Another man, Charlie Gibson, interceded, 'We ain't goin' to cut the barge loose. I'll shoot you if you try that. If we go, we go together.' When the refugees arrived in Vicksburg—which was on the bluff above the floodwaters—before being allowed to land, they were ordered to sing Negro spirituals. They refused. Finally National Guard officers allowed them to disembark."

Senator Percy's son, Will, a World War I hero and a noted poet, took charge of the Red Cross relief efforts for the black people stuck on the levee. His first impulse was to evacuate them on steamers. On April 25, one steamer took 500 white women and children; another loaded 1,000 mostly black refugees. Four others were coming on, towing barges capable of carrying several thousand each. By then there were nearly 15,000 refugees on the levees, nearly all of them men working close to the crevasse. Will wanted to send them to Vicksburg and safety. The planters protested. They persuaded Le Roy Percy to instruct his son to leave those blacks on the levee. Cotton was the principal, indeed, almost the only, cash crop grown in the Mississippi Delta. Cotton was labor intensive—it was planted, hoed, and picked by hand. The planters grew rich because of it. The workers got $1 a day for their sunrise-to-sunset labor. The planters knew how miserable the lives of black families on the Delta were: almost no money, tar-paper cabins, no cars, little if any schooling, perhaps a chicken or two—perhaps not—no mules, no horses, collard greens and sweet potatoes to eat. The planters knew that if the blacks got out of the Delta, they would never return. They had nothing to come back to and any place was better than the Delta. Keep them here, the planters declared. Le Roy Percy backed them. Will Percy, after some feeble protests about putting their own economic welfare ahead of other people's lives, gave in.

In 1942, those same planters, or their sons, paid the local police to patrol the Illinois Central railroad depots to prevent the blacks from getting on the train to go to Chicago, where they could get work at big wages in the war industries. In 1944, the first cotton-picking machine came to the Delta. By 1945, the planters were buying one-way tickets to Chicago for the blacks.

On the levee the blacks filled and stacked sandbags, for which Percy set a pay scale of 75 cents per day. Some were put to work without pay unloading and distributing Red Cross food parcels, which were starting to come to Greenville by barge to feed 180,000 people and thousands of animals. Percy ordered all Greenville blacks to the levee. The camp stretched seven miles. There were too few tents, not enough food, no eating utensils or mess hall. Black men were not allowed to leave. Those who tried were driven back at gunpoint by the National Guard. The food they received was inferior to what the whites got. Canned peaches came in, but were not distributed to blacks for fear it would "spoil them." Whites kept the good Red Cross food for themselves. Giving it to the blacks, one citizen explained, "would simply teach them a lot of expensive habits."

Percy issued an order: "No rations will be issued to Negro women and children unless there is no man in the family, which fact must be certified by a white person. No Negro man in Greenville or their families will be rationed unless the men join the labor gang. Negro men drawing a higher wage than $1 a day are not entitled to the ration." In author John Barry's judgment, the levee was not a labor camp; it was a slave camp.

Not only blacks suffered such shocking treatment. In New Orleans, the power elite ordered the use of 78,000 pounds of dynamite to blow the levees downstream. The purpose was to let the water escape and lower the height of

the river in New Orleans. Plaquemines and St. Bernard Parishes, inhabited mainly by the French, were deliberately flooded out. The New Orleans leaders promised to pay the cost of the damage, but never did.

President Coolidge did nothing. Despite pleas from governors and mayors and other officials in the flooded states, he refused to visit any part of the area. The radio network NBC asked him to broadcast an appeal for relief funds on a historic nationwide hookup. He declined.

Secretary of Commerce Herbert Hoover chaired a special committee that handled the emergency. He used the position not to alleviate the suffering in the flooded areas, but to get publicity for himself. He became a hero—apparently the only hero to come out of the crisis—and thus won the 1928 Republican nomination for Presidential candidate.

For weeks the flood dominated the front pages of the nation's newspapers. Editors overwhelmingly named the flood the greatest story of 1927. Thus did nature triumph over man's attempt to conquer it.

Nature always wins. Sometimes sooner, sometimes later, but always the river will make its own route to the Gulf of Mexico. In 1928 in reaction to the Great Flood, Congress put in place the Jadwin Plan. The Corps of Engineers called the system Project Flood and assured the public that the changes would protect the lower Mississippi River from any

During the Great Flood of 1927, more than 325,000 people lived for up to four months in refugee camps like this one on high ground at Vicksburg.

flood considerably bigger than the 1927 flood. The Jadwin Plan is still in place and sets standards for higher and thicker levees than those of 1927. The Corps has built reservoirs, called lakes, on the tributaries and also adopted Eads's proposal for cutoffs.

"In the 1930s and 1940s, the Corps dug cutoffs that shortened the river by more than 150 miles. It eliminated a series of sharp curves called the Greenville bends, and the cutoffs lowered flood heights by 15 feet," Barry wrote. "Farther south, the Corps built the Old River Control Structure, halfway between Natchez and Baton Rouge, and, 20 miles downriver, the Morganza Floodway. These immense structures, made of concrete and steel, are designed to divert 600,000 cubic feet per second from the Mississippi River to the Atchafalaya. In 1963 the Corps built a massive dam to seal off the natural flow between the rivers." Without that dam, experts feared, the main current of the Mississippi would someday go into the Atchafalaya, leaving the port of New Orleans high and dry. Whether the dam will work or not is to be discovered. Barry said that "keeping the Mississippi in its own channel has become by far the most serious engineering problem the Corps of Engineers faces."

The river, not man, will decide. In many places, it has rejected the cutoffs built more than a half century ago. The river has regained one-third of these cutoffs. The struggle

between nature and man continues. It will last as long as humans inhabit the North American continent, as long as the rains continue to fall. In the end, the river will win.

Today downtown Greenville is sparsely populated, a shell of its former self. While many beautiful buildings, such as the Wetherbee House and Hebrew Union Temple, still survive, it's the legalized casino boats along the river with names like Bayou Caddy, Jubilee and Lighthouse Point, and Las Vegas Oasis that constitute the heart of the community's civic life. Greenville has become the nation's third biggest gambling mecca after Las Vegas and Atlantic City, and it's had a deleterious impact on blues culture. It has stripped business away from local juke joints on Walnut Street, which have nearly all folded. Ironically, the most popular tourist attraction in the area is the Birthplace of Kermit the Frog, an exhibit built along Deer Creek. Here Greenville native Jim Henson played as a boy, his fanciful

Conditions for refugees at Birdsong Camp in Cleveland, Mississippi, seemed tolerable; others operated as labor camps, holding black sharecroppers under guard.

imagination creating the ensemble of Muppet characters beloved by children all over the world.

Greenville honors Kermit, but it does little to salute the plethora of literary talent who hailed from this most unlikely of hometowns: Shelby Foote, Bern Keating, Ellen Douglas, Clifton Taulbert, and Walker Percy, among others. You can wander into the historic Live Oak Cemetery where bear hunter Holt Collier is buried, or worship at St.

Matthews AME Church as President Herbert Hoover did on his visit after the 1927 flood, but basically Greenville is a ghost town of a city. Only a block from the levee, for example, is the circa 1881 building at 201 Main Street, which was the former headquarters of the *Delta Democrat Times*. The newspaper is still in business elsewhere in town, but the old building is abandoned, with only a small marker indicating its past. Here were the offices of one of the most significant editors the South ever produced. From the Great Depression era to the signing of the Civil Rights Act in 1964, Pulitzer Prize-winning editor Hodding Carter had fought bravely for racial justice and religious tolerance.

His book, *Where Main Street Meets the River*, is a classic memoir recalling this gutsy editor's fights against racist Senator Theodore Bilbo and the Ku Klux Klan. Carter was also a first-rate poet. In *The Ballad of Catfoot Grimes and Other Verses*, Carter says:

His mother was a yellow girl,
My uncle's child, they say;
But such is not our greeting
when He comes my way.

Anyone interested in understanding the complex psychology of relationships between blacks and whites in the South should read Carter's bold poetry. ★

The commercial potential of the Mississippi River was the force behind the foundation of Memphis, Tennessee. The city is well-positioned on a set of bluffs overlooking the river, as in this late 19th-century sketch.

MEMPHIS

★

"If Beale Street could talk, If Beale Street could talk
Married Men would have to take their beds and walk...."

W.C. HANDY

THE LOUISIANA PURCHASE OF 1803 was the single most important event in the development of trade along the Mississippi around present-day Memphis—the primary commercial center for 105 counties in six states. Hernando de Soto, sent by Spain to claim North American territory, led the expedition of the first Europeans to pass through this area. In May 1541, on his journey through the southeast, de Soto and his party came out of the woods to behold the Mississippi River. At this point, immediately south of present-day Memphis, the river is one and a half miles wide. Eyewitness accounts from de Soto's odyssey expressed a marvel at the magnitude of the Mississippi, a river the Spanish named Rio Grande.

Two hundred and fifty years after de Soto reached this river bisecting the North American continent, fortune-seeking Americans were fanning west across the rolling Cumberland Plateau of Tennessee and north along the Mississippi. These pioneers discovered a spot that seemed ideally suited to urban development: At the northern end of the Mississippi Delta, the Chickasaw Bluffs dramatically rise several hundred feet along the eastern bank of the

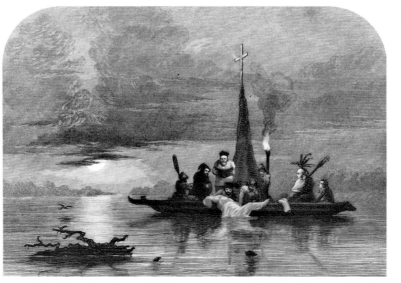

In 1542 Spanish explorer Hernando de Soto was buried at night in the Mississippi to keep his death a secret from hostile Indians, who feared him.

river. The bluffs afford protection from floods and access to river commerce. Today the city of Memphis, with a population of about 600,000, sits on these bluffs with a spectacular view of southwest Tennessee and northwest Mississippi; across the river extend the lowlands of eastern Arkansas. The bluffs' protected position was apparent to the local Chickasaw Indians, who lived in a small village where present-day Memphis stands. The commanding view from the bluffs lent the location an undeniable strategic importance, and the United States established Fort Pickering on the site in

1797—the spot where explorer Meriwether Lewis began his tragic journey eastward in the fall of 1809.

The story of Lewis and Clark's fabled journey up the Missouri from 1803 to 1806 has been told many times, most notably in their own journals. But the Mississippi also played a prominent part in Lewis's life. He had crossed the Mississippi eight times: four times from 1803-1804, during the early part of his expedition with William Clark and the Corps of Discovery; then in 1806 on the way back from the expedition; again when he returned to St. Louis in 1807 from Washington—after meeting with the President—to become Governor of Upper Louisiana; and finally on his last voyage.

On that final journey he was heading toward the Natchez Trace, which he would take to Nashville and on to Washington, D.C. The Mississippi River Valley in early September was hot, humid, and buggy. Lewis's boat proceeded slowly. He was in terrible condition, suffering from

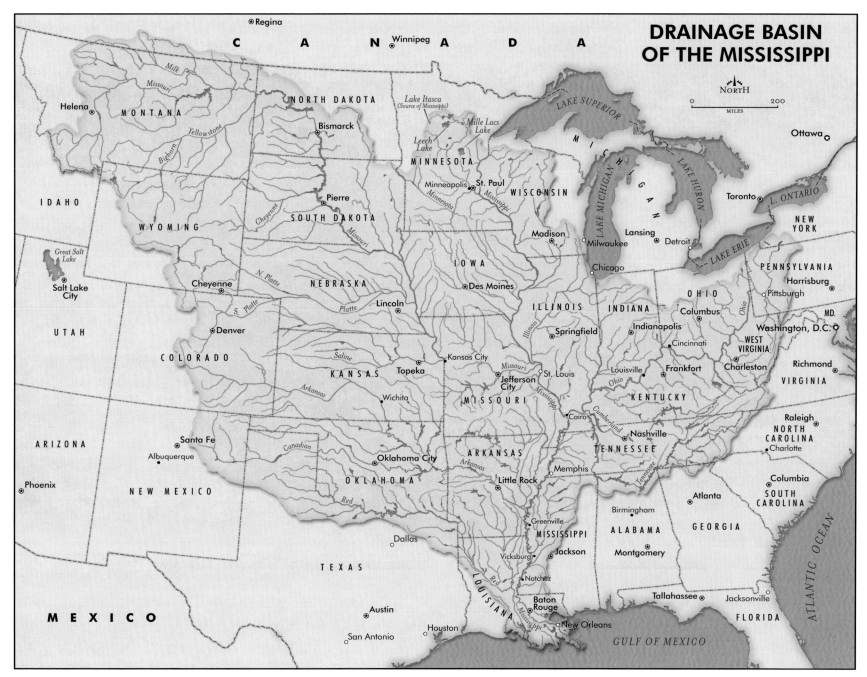

DRAINAGE BASIN OF THE MISSISSIPPI

NORTH

0 _____ 200
MILES

The Mississippi River drainage basin comprises six major river basins. The combined flow discharges on average 700,000 cubic feet of water per second into the Gulf of Mexico.

a malaria attack and a deep depression that caused him unbearable pain. Twice he tried to kill himself by jumping into the river, and he had to be restrained by the crew.

On September 15, he arrived at the Chickasaw Bluffs and Fort Pickering. The local commander, Captain Gilbert Russell, on being informed of Lewis's suicide attempts, "resolved at once to take possession of him and detain him until he recovered, or some friend might arrive in whose hands he could depart in safety."

Lewis was drinking heavily, using snuff frequently, taking three opium pills a day for his malaria, talking wildly, and telling lies. Russell deprived him of liquor, allowing him only "claret & a little white wine." For five days, Lewis showed no sign of improvement. Russell maintained a 24-hour suicide watch. Finally, Russell reported, "on the sixth or seventh day all symptoms of derangement disappeared, and he was completely in his senses, although considerably reduced and debilitated."

He was also ashamed of himself. Russell wrote, "He acknowledged very candidly to me after his recovery" that he had been drinking to excess. He said he was resolved "never to drink any more spirits or use snuff again."

Lewis could have sailed downriver to New Orleans, then gotten onto a sailboat headed for Washington. But British warships were prowling the Atlantic Coast, stopping American vessels and impressing American seamen into British service. Lewis had with him the journals of their expedition. What the British would give to have those journals! There was no danger of that on the Trace, which was the most heavily traveled road of the Old Southwest. The mail passed over it regularly. No robbery had been reported for years. There were inns along the way.

On September 29, as the cool weather came, Lewis, accompanied by his servant, Pernier, and Major James

Neely, set off and turned his back on the Mississippi River. Away from Russell and the suicide watch, he resumed drinking—or as Russell so heartbreakingly put it, "His resolution [never to drink again] left him." Neely later reported to Thomas Jefferson that on the journey Lewis "appeared at times deranged in mind."

On October 9, the party crossed the Tennessee River and camped near the present village of Collinwood, Tennessee. On October 10, Lewis proceeded east. Late in the afternoon he arrived at Grinder's Inn, 72 miles short of Nashville. He took a room. The next day, just before dawn, he shot himself twice and died.

Lewis and Clark were the first to explore the entire Mississippi drainage system. They knew the Ohio, Tennessee, Cumberland, Wabash, and Missouri rivers, and the tributaries of the Missouri. They had crossed the Rocky Mountains and canoed down the Clearwater, Salmon, Snake, and Columbia rivers. They knew the rivers of America, especially the Mississippi and its tributaries, better than anyone before and very few since. But on the site where Lewis killed himself, there was no river.

Fort Pickering continued to be a major frontier outpost, but it was not until Gen. Andrew Jackson led the repulse of Britain's last serious threat to American control of the Mississippi, at the Battle of New Orleans in 1815, that planning a city on the bluffs took hold. While the victory brought Old Hickory fame, it did not provide for his financial needs. He returned to Tennessee, where he became a land speculator. In 1819 Jackson, along with Revolutionary War Gen. James Winchester and Nashville judge John Overton, purchased a large tract of land along the fourth Chickasaw Bluff. These three famous investors dispatched Winchester's son, Marcus, to the area to design a town.

Once the survey was completed, the trio began selling land in their new city, which Winchester—an antiquarian—named Memphis, in remembrance of Napoleon's campaign at the ancient city of Memphis in Egypt. Although the renowned partners remained in Nashville, settlers began to move to the city they created.

Today there is no better place to study the history of Memphis and the Lower Mississippi than Mud Island, the body of land that sits near the Chickasaw Bluffs between the channels of the Mississippi and the Wolf River Harbor. Mud Island as an education center is a recent development.

Since the early 19th century citizens struggled with integrating Mud Island into the community at large. Periodically small farmers planted there, only to be flooded out, emerging again when the river levels became low. In 1917 a massive sandbar grew around the island, halting river traffic and forcing the U.S. Army Corps of Engineers to dig a canal that successfully diverted the Wolf River along the Memphis riverfront. Although the immediate problem was rectified, it proved to be only a temporary measure. Edward Hull "Boss" Crump, a longtime leader in Memphis politics, tried dynamite, under the assumption that if engineers could blow up enough of Mud Island, the rest would surrender and wash downstream. But the plan failed.

Finally in 1923, instead of trying to destroy Mud Island, the city decided to transform it into a recreational center for Memphis. Elaborate plans were drawn up, but nothing ever came of the venture. Instead, squatter shacks cluttered the waterfront, with rowboats occasionally shuttling these residents to Memphis for provisions. Matters changed in the early 1960s when Mud Island had to be built up above flood level and stabilized so that construction for I-40 and the new Hernando De Soto Bridge could begin. Suddenly Mud Island was seen as a virtue, a welcome spot for concrete pillars to reinforce the bridge. Almost overnight Mud Island became a prize location to build apartment high-rises and condominiums that afforded views of the Memphis skyline. Developers discussed erecting the world's tallest fountain and a horse-racing track on the island, but these schemes never took root. Finally, in 1973, a group of civic-minded Memphians decided to construct a Mississippi River Museum on Mud Island; it opened a decade later to great fanfare. From the mainland a monorail—which consisted of two cars suspended from cables beneath the foot bridge—would bring tourists to and from Mud Island to learn the history of America's great river.

The most prominent feature of Mud Island is the River Walk, a five-block-long scale model of the Mississippi from Cairo, Illinois, to the Gulf of Mexico—a replica in miniature of the lower thousand miles of the Mississippi. Some 800 gallons a minute course through the River Walk. In the clear waters, tourists can see the changing levels and intricate bends of the river, and they come away with an idea of the skill and effort required to navigate such an immense body of water. Dozens of historical plaques allow visitors to note landmark events in the river's life, whereas typical trees and shrubs give an idea of the plant life along the river: hawthorne in Missouri, willow oak in Tennessee, magnolias in Mississippi, and cypress in Louisiana. Cities and towns are also highlighted, causing great hometown pride to visitors from such places as Helena, Arkansas, and Quincy, Illinois. Eventually the River Walk flows into a one-million-gallon pool—the "Gulf of Mexico."

Wandering around Mud Island at dusk after visiting the attractions provides an opportunity to meditate on the Mississippi River's importance to American life. The view is the Arkansas flatlands to the west and downtown Memphis to the east. Looking into the water you can count some 160

species of fish swimming about, including 50-pound catfish that are caught on the island with regularity. Located on the riverbank is a 32-story stainless-steel structure known as The Pyramid, which houses a 22,500-seat indoor multi-purpose arena.

Along the way, you could see Memphis industry. Bales of cotton still fill the city wharves; nearly half of the U.S. cotton crop goes through the city. Memphis is home to three of the world's top five cotton dealers, as well as the world's longest cotton warehouse. Corporations like Federal Express, Holiday Inn, and Piggly Wiggly supermarkets call Memphis home. Memphis is second only to Chicago in the number of major railroad lines and freight carriers that run through the city. Watching cars zoom across the De Soto Bridge was a reminder that today most people simply cross the river, never taking the time to learn of its rich history. More than 30 bridges span the lower Mississippi River alone, leaving only nostalgia for the era of steamboats and ferries. But on the mainland, in the heart of Memphis, the rowdiness of Beale Street lives on. When the sun finally sets over the river, that's still the place to head to savor the best barbecue and blues in the world.

Beale Street first came into its own as an entertainment center in the 1890s when African-American professionals from the North began moving to the South. During the first decade following the Civil War, Memphis had been besieged with cholera and yellow fever epidemics, which killed 8,000 residents. Hearse drivers routinely made the rounds shouting, "Bring out your dead." Mass graves were dug to quickly bury thousands of corpses. The *Memphis Ledger* described the streets as "huge depots of filth, cavernous Augean stables with no Alpheus River to flow through and cleanse them." To lose a full tenth of a city's population to disease is a cataclysm hard to fathom. As a result of the epidemic,

Memphis fell into decline. Fortunately, though, Memphis responded to the disaster by overhauling its sanitary system, and by the 1890s the city was once again a boomtown, thanks to the lucrative cotton and timber trade. Beale Street, which stretches from the river eastward, became the new vice district similar to Storyville in New Orleans, a place where prostitution, all-night drinking, and gambling were enjoyed by rivermen, day laborers, and even the white elite.

Word spread through the Deep South that if you could sing or play an instrument, money was to be had on Beale Street. And that's just where W.C. Handy went when he arrived in Memphis in 1905 and perfected a new art form called the blues.

"The seven wonders of the world I have seen, and many are the places I have been," Handy remarked after he was celebrated as the "Father of the Blues" from coast to coast. "Take my advice, folks, and see Beale Street first."

William Christopher Handy was no stranger to the Deep South. He was born in a log cabin on November 16, 1873 in Florence, Alabama, and lived there for the first 19 years of his life. Handy was the son and grandson of African Methodist Episcopal ministers and, although his father would have preferred that he follow his family's ministerial tradition, instead of his own musical aspirations, Handy grew up irresistibly drawn to music. He played many instruments as a child, including guitar, trumpet, piano, and organ. The youngster was immersed in the Christian traditions of hymns and spirituals, which he heard regularly at Greater St. Paul African Methodist Episcopal Church.

Florence, however, is not the Mississippi Delta; it is not in Delta Blues country. The musical heritage in Florence is linked to the surrounding hills, the southern end of the Appalachian Mountain system, and to the traditions in northern Alabama and northeast Mississippi. Folks refer to

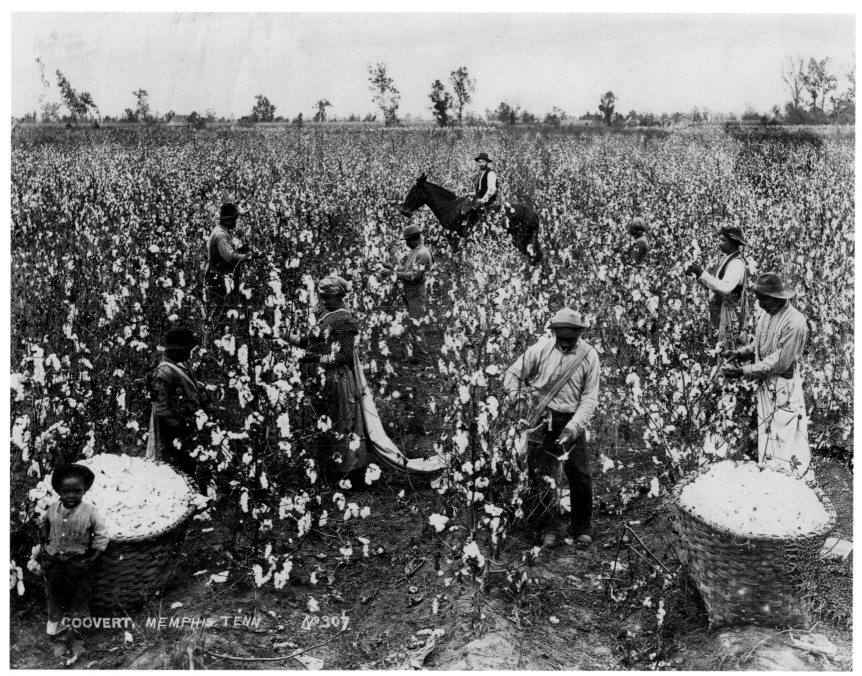

Black sharecroppers work a Tennessee cotton field in a tableau reminiscent of pre-Civil War days. Social change came slowly to the lower Mississippi.

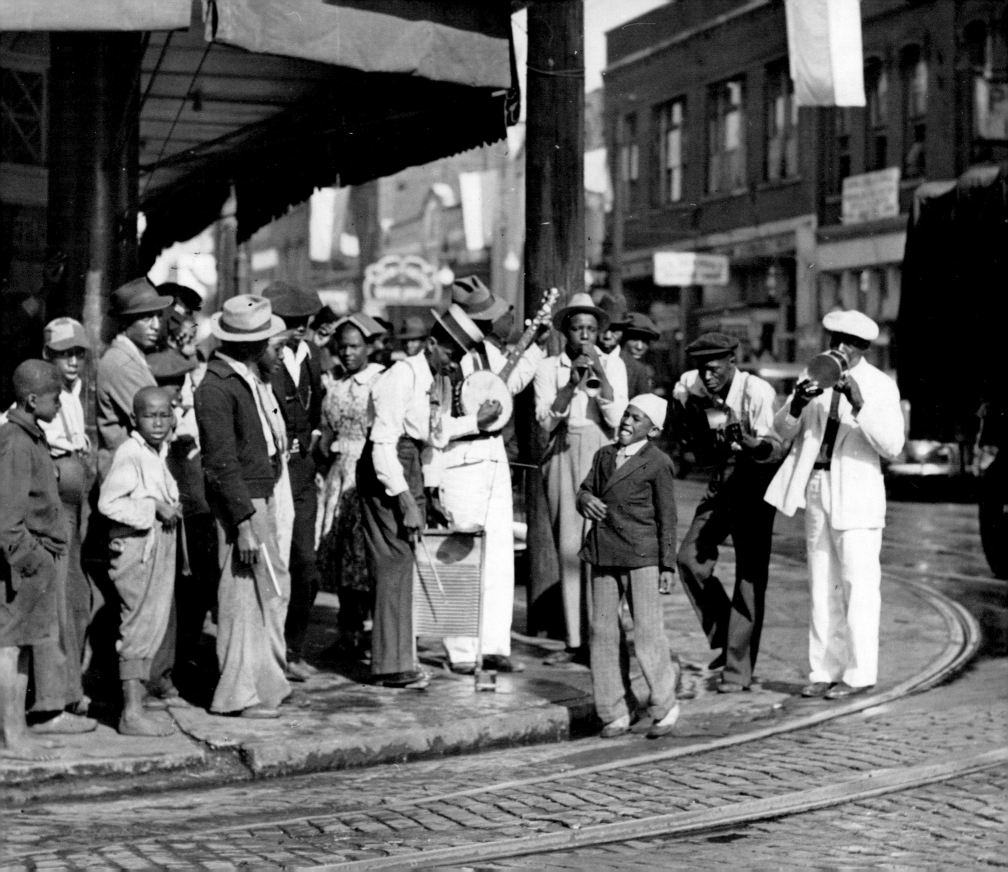

the indigenous sound as Hill Country Blues. Muscle Shoals Studios has capitalized on this by setting up a now-famous recording facility just outside Florence. The town itself sits on the banks of the Tennessee River as it flows through northwest Alabama and is nestled near the borders of Mississippi to the west and Tennessee to the north. Ringed by the hills of the southern end of the Tennessee Valley, Florence is not the Plantation South, but rather a region of small farms, an area where slavery had never taken root as it had in the plains of the Mississippi Delta. Consequently, this region had known abject poverty, but it had never had the unfathomable disparities of wealth that had persisted in the Delta.

When Handy later moved to the Mississippi Delta, he was exposed to cultural forces he had not known in rural northern Alabama. Handy called Clarksdale, Mississippi, home from 1903 to 1905, and in his autobiography, *Father of the Blues* (1941), he recounts his first exposure to the Delta Blues, a sound that would shape the rest of his life. He was sitting in a railroad depot in Tutwiler, Mississippi, waiting for a train, when he heard a destitute, old black man picking on a guitar. At times the man would apply the blade of his knife, instead of the fingers of his left hand, to the instrument's strings while he picked. Between this early slide guitar work and the man's mournful lyrics, the sound was unlike anything Handy had ever heard before. It was one of the earliest forms of the Delta Blues, and the experience proved to be an epiphany that altered the way Handy conceived of music.

As so many other aspiring musicians did, Handy eventually made his way to Memphis. The city became a magnet for black musicians from the South during the last years of the

19th and the first years of the 20th century. Beale Street was the focal point of this burgeoning black musical community, and Handy was drawn to it as well. He moved his family to a modest shotgun house at 659 Jenette Place and set up an office on Beale Street.

From 1912 to 1918, Handy published blues music from his Beale Street office, becoming the first person to achieve any commercial success with this new genre of popular music. That Handy found inspiration among the diverse assortment of souls who populated early 20th century Memphis goes without saying. All one has to do is examine his compositions from his Memphis years to see what he was able to achieve with this cutting-edge musical form. Working from his home, Handy penned "Beale Street Blues," the song that brought him notoriety. One verse of lyrics illustrates to the listener what would be heard if Beale Street "could talk:"

Married men would...take their beds and walk
Except one or two...
And the blind man at the corner who sings the Beale Street Blues.

In addition to "Beale Street Blues," Handy wrote a number of songs that brought attention to the city as a whole. "Memphis Blues" began life as a favor Handy did for Mr. E.H. "Boss" Crump. When Crump was running for mayor of Memphis in 1909, Handy's band was hired to stump for him at political rallies, and, specifically for these performances, Handy developed "Mr. Crump's Blues." The piece took form while Handy was socializing at a popular musicians' hangout called PeeWee's, located at 315 Beale Street. PeeWee's was owned and operated by two Italian men who

An impromptu jug-band concert draws a crowd to a corner of Beale Street, a center for entertainment—and vice—in Memphis, Tennessee, since the 1890s.

served as liaisons between musicians and the businessmen on the commercial side of the music industry. Surrounded by other Memphis blues artists, Handy's "Mr. Crump's Blues" metamorphosed by 1912 to become the now-famous "Memphis Blues," establishing Memphis as one of the urban hot spots for blues music.

Today the old Handy family residence, a small wood-frame house, has been moved from Jenette Place to 352 Beale Street, where it is run as a museum. The effect of Handy's creative energy has been preserved through his old sheet music, which lies strewn about the house. PeeWee's still stands at 315 Beale and is open to the public.

Handy's legacy has been further preserved through the creation of Handy Park. Until the area was officially designated for recreational use in 1931, the corner of Beale and Hernando Streets was the site of an outdoor marketplace. Blues musicians would congregate there and hold impromptu jam sessions. Since the square was converted to a park, musicians of all stripes have continued to meet here. On a steamy summer night, with the humidity from the Mississippi River hanging thick in the air, you can sit in Handy Park and listen to the sounds of a young hotshot guitar player as he picks his way through old Delta Blues standards such as "Love in Vain" or "Now I'm a Man." At times like these, you can close your eyes and imagine the musical exchanges that were taking place on this very site nearly a century ago, the sounds that gave America the blues.

Just blocks off Beale Street, in the South Main Street Historic District, is the National Civil Rights Museum housed in the former Lorraine Motel. The two-story motel, constructed in 1925, was originally intended for "Whites Only." But as World War II ended, it changed into an African-American establishment that hosted such eminent personalities as Cab Calloway, Roy Campanella, Nat King Cole, and Count Basie. The Lorraine Motel, however, entered the history books on April 4, 1968, when renowned civil rights advocate Dr. Martin Luther King, Jr., was assassinated on the balcony by a rifle blast. King had come to Memphis to help striking garbage workers earn more pay, better working conditions, and improved treatment from white supervisors.

Today the Lorraine Motel has been transformed into the finest civil rights interpretive museum in America. But as the visitor to the museum quickly learns, King had no direct connection to either Memphis or the Mississippi River short of making brief public appearances at churches and fundraisers.

Besides Beale Street and the National Civil Rights Museum, visitors to Memphis are usually compelled to make an obligatory pilgrimage to Graceland, what appears to be a modest colonial white-pillared mansion, which Elvis Presley bought for $100,000 when he was 22 years old. In the world of commercial airlines, pilot chatter is usually limited to stating the weather conditions, pointing out the Statue of Liberty on your right, or the Grand Canyon on your left. But when a pilot is about to land in Memphis, there is a special warmth to the intercom announcement, saying, "Welcome to Memphis, the home of Elvis Presley, the king of rock-and-roll."

Graceland, the second-most-visited home in America after the White House, is clearly unlike any other mansion along the Mississippi River: Graceland and its 13.8-acre grounds form a strange combination of historic home, religious shrine, and kitschy amusement park. Over 700,000 visitors arrive at this site annually for a glimpse of where Elvis lived, died, and is buried.

The interior of Graceland is a tribute to 1970s taste, that

awkward decade when Richard Nixon, Gerald Ford, and Jimmy Carter occupied the White House, and polyester, black lights, bell-bottom trousers, lava lamps, and eight-track tapes were the rage. The interior was designed by Elvis and his wife, Priscilla. Some of the choicer spots include the Jungle Room, with its carpeted ceiling, leopard-skin lamp shades, zebra-skin sofas, and ceiling mirrors, and the navy-and-lemon TV room, outfitted with three screens so Elvis could watch three football games at once, an arm's length from the well-stocked bar. The lengthy Hall of Gold, an 80-foot-long hallway crammed with platinum, gold, and silver records, leads to the Trophy Room, containing Elvis's costumes, outfits from films, and his extensive gun collection. Visitors are banned from the second floor, which includes his bedroom, office, wardrobe room, and his daughter's nursery.

Elvis Presley was a paradox, known both as a church-going youngster and later as a drug abuser. His full story is one of the more compelling Horatio Alger tales of modern times.

Elvis started life near the bottom, growing up poor, first in Tupelo, Mississippi, and then in Memphis. Even though he couldn't read a note of music, he fell in love with what he called "race records," the rockin' blues sound of the black radio stations that played B.B. King and Howlin' Wolf. In 1954 the 18-year-old Elvis made his first recording for Sam Phillips's Memphis-based Sun Records, in a style that drew from diverse sources—black

W.C. Handy fused African-American folk tradition with contemporary ragtime to create a unique style of music dubbed the blues in Memphis.

and white gospel, Perry Como-like croonings, rural and urban blues, and country—creating a dynamic new musical synthesis labeled "rockabilly." The Sun Records Studio, located at 706 Union Avenue, is now open to the public. In the early days, any artist could walk into the modest 18-by-30-foot room, and for $4 cut a single. Blues artists such as Howlin' Wolf, Little Milton, and James Colton recorded albums at Sun, as did Johnny Cash, Roy Orbison, Carl Perkins, Conway Twitty, and Jerry Lee Lewis. Touring the studio you learn that Rufus Thomas's "Bear Cat" was Sun's first hit, and that "Rocket 88," believed by many to be the first rock-and-roll song ever, was recorded here by Ike Turner, Jackie Brenston, and others in 1951. But the museum's main attraction is the WHGO microphone used the first time Elvis Presley's song "That's All Right, Mama" was aired.

Elvis's national recognition came in 1956, at the age of 21, when RCA Victor released the hit single "Heartbreak Hotel." Neither music nor adolescence was ever the same again. His lifelong manager, Col. Tom Parker, a hustler who once painted sparrows yellow to sell as canaries, steered him into sappy, patriotic ballads and to Hollywood, where he made 33 profitable but eminently forgettable "B" movies. After years of mediocre movies and songs, Elvis came back strong to record some of his finest songs—"Suspicious Minds," "Burning Love," and "In the Ghetto"—and to perform spectacularly on the December 3, 1968, Elvis TV Special. By

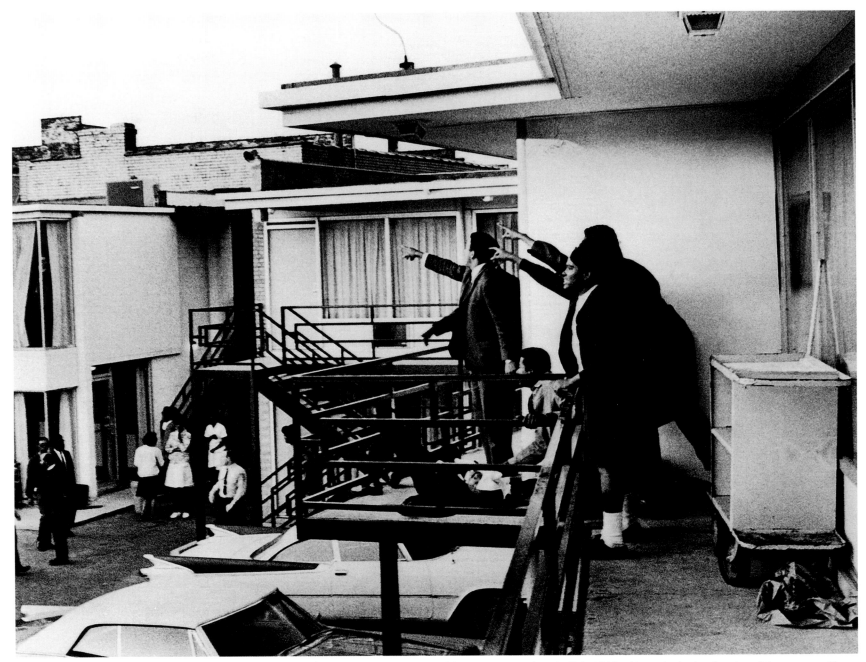

Seconds after a shot killed civil rights activist Dr. Martin Luther King, Jr., on the balcony of the Lorraine Motel on April 4, 1968, aides point in the direction of the gunman. The motel in Memphis, Tennessee, operates as a museum today and remains a repository of both tragedy and triumph for African Americans.

the early 1970s he had become most at home in sequined jumpsuits, performing for the Las Vegas dinner crowd and surrounded by a mob of bodyguards known as the Memphis Mafia. He became depressed and developed an eating disorder. Elvis Presley died on August 16, 1977, apparently of a heart attack. But this bare-bones outline of the vicissitudes of Presley's life scarcely does justice to his achievement as an American pop icon.

Elvis—who had 149 songs appear on *Billboard*'s Hot 100 Pop Chart—liberated America in many profound ways. Before Elvis, particularly in the South, Monday through Friday was a time of sunrise-to-sunset toil; Baptist Sunday in the South was for repentance, salvation, churchgoing, and family prayers. Saturday night was the time for excess, mayhem, drunken fights, midnight dances, and howling at the moon. Saturday night was the time to vent frustrations and blow off steam. Elvis's message to a whole generation of young Americans was that they weren't bound to this rigid cycle—Tuesday could be a Saturday night, every day could be a Saturday night. He pronounced rock-and-roll not merely a musical style but a life-style. One was not predestined to a life of work, drudgery, and more work; in a prosperous, postwar America, people had choices. You could dance the decade away if you liked: Follow your heart, and you'll find happiness.

It was this rock-and-roll attitude that triggered the social experiments of the 1960s, such as pursuing "free love" or questioning authority. In Eastern Europe and elsewhere in the world during the Cold War, the stakes were higher. Rock-and-roll took on a political coloration: It stood for rebellion against totalitarian tyrants and for putting your head on the dissident block, where it might be chopped off. Elvis Presley, who has globally sold more than one billion records, was as mighty as any politician of the postwar era.

And his influence continues: Today there are more than 600 active Elvis fan clubs worldwide.

For anyone interested in American history, particularly the Civil War, a pilgrimage to the Burkle House in Memphis, which sits back from the street sheltered by large, old magnolia trees, is a must. Here is the place to learn about the Memphis Underground Railroad—the name given to the many routes that blacks took to escape slavery in the South before the Civil War. A trip to the museum can be almost as harrowing as the stories it houses. The home of Jacob Burkle sits at 826 North Second Street in the industrial district of North Memphis, a blighted neighborhood of rubbish-filled vacant lots, shattered glass, and unkempt homes, most with flimsy plywood boarding up the windows.

The story of how Burkle, who emigrated from Germany to Memphis in 1850 to avoid conscription in Bismarck's army, became an Underground Railroad conductor, secretly helping hundreds of freedom-seeking slaves escape to the North, is shrouded in speculation. As the prosperous owner of the Memphis stockyard along the river, Burkle had achieved substantial wealth in a very short time. Herdsmen seeking shelter for their livestock used his expansive pens a mile from downtown as a convenient custody station. Before long he also opened a bakery and was embraced by the leading socialites as a true Southern gentleman, albeit one with an Old World accent. What nobody knew was that Burkle, like Oscar Schindler in Nazi Germany, had a conscience. The physical brutality and moral indignity of slavery sickened him. Unable to ignore the horrors of the so-called "peculiar institution," Burkle reportedly used his home as a sanctuary for fugitive slaves who in the dark of night would sneak out of his basement and dash for the river.

From Memphis up the Mississippi River to Cairo, Illinois, and then up the Ohio River, was one of the most

popular escape routes for fugitive slaves from the Delta headed on their perilous journey to Canada. Because there was no electricity at the time, the steamboats which docked in Memphis were blanketed in darkness at night. According to legend, Burkle would bribe various riverboat captains with gold; then he would sneak slaves aboard at night and hide them in the cargo stations. He ran this risky operation out of his well-secluded, seven-room estate, known by runaways as Slavehaven. The house is now open to the public.

The Slavehaven Underground Railroad Museum is operated by Heritage Tours, Inc., whose mission is to make the public aware of such compelling African-American historic sites as Elmwood Cemetery, with the unmarked graves of 300 slaves; Lee Park, the first monument dedicated to the heroic rescue of 32 people by an African-American laborer; the former site of Church Park and Auditorium—the first recreational, cultural, and civic center for blacks in Memphis, founded in 1899 by Robert R. Church, Sr., the nation's first black millionaire; Auction Square, which still has the granite marker believed to have been used for slave auctioning; and the site of the first office of editor Ida B. Wells, whose newspaper launched an international campaign against lynching.

But the Burkle House is central. Crammed with such 19th-century furnishings as drinking gourds, wooden washboards, and butter churns that depict the era, the house is an interpretive museum. Besides learning about how Burkle provided refuge to those seeking freedom, the visitor can study the walls; these are lined with reward posters for capturing runaways and newspaper advertisements paid for by the firm Forrest and Maples offering humans for sale at the auction block. Abolitionists such as Harriet Tubman, Sojourner Truth, and William Lloyd Garrison are honored in one of the museum's wings for their courage. Ghastly

monochrome portraits of beaten slaves with infected welts on their backs from horrendous whippings line one wall, making most visitors turn away in horror. We found an old *Memphis Appeal* story blown up on posterboard entitled: "Find Escaping Slave Nailed in Box." The article tells of a runaway who was discovered sealed in a wooden crate along the wharf front and suffocated, all for dreams of the Promised Land. The article ended with a stern warning to "those indiscreet gentlemen who are advocating the doctrine of emancipation" to cease propagating freedom at once, for the benefit of both master and slave.

The highlights of the museum are the dusty trapdoors that lead to a brick cellar that made a hiding place for slaves. A climb down the rickety stairs recalls the plight of hundreds of frightened slaves, quietly huddled together, willing to risk their lives for freedom, waiting for a signal that it was safe to sprint to the river. This musty cell is the ideal spot for schoolchildren to contemplate the Underground Railroad. "I ask the young people who come here, how long it would take them to flee the cellar and run to the Mississippi River for freedom," Elaine Turner, president of Heritage Tours says. "Their usual answer is two minutes."

Not everybody in Memphis is convinced that the Burkle estate is an authentic Underground Railroad sanctuary. After all, there is no proof, only what has been passed on by oral tradition. Even the state historical marker on the front lawn notes that "folklore" claims that this house was once a slave haven. Sorting out fact from fiction is not easy without primary sources. But the mystery of the Burkle Estate is part of its appeal. The museum reminds us that brutal systems and laws can be overturned when noble people risk their lives in the name of freedom.

Memphis played a pivotal part in the bitter conflict between the states. The city's strategic location atop the

Chickasaw Bluffs led it to become a Confederate military stronghold at the outbreak of hostilities. But Memphis fell into Union hands in 1862 and remained occupied until the war's close, thus escaping the destruction that befell other southern cities like Atlanta and Richmond.

Anybody wanting to understand more about Memphis during the Civil War should read the marvelous autobiography of Elizabeth Avery Meriwether. Published in 1958 by the Tennessee Historical Commission under the title *Recollections of 92 Years, 1824-1916,* the book was written so her grandchildren and great-grandchildren could learn their family history. Today it is a priceless reminder that war impacts families left at home nearly as much as it affects soldiers on the battlefield.

"We were all happy as birds," Meriwether writes about her life after giving birth to a son in 1857 and another one in 1859. "Then the unexpected happened. A world of trouble fell upon our beautiful Southland and for many years Life ceased to be the peaceful, uneventful thing it had hitherto meant for me—it came now to mean storm and stress, anxiety and trouble, hope and despair. When news of South Carolina's secession reached Memphis everybody was stunned; Tennesseans did not want to quit the Union."

But Tennessee did secede in 1860, and Meriwether's husband, Minor, became a lieutenant colonel with the Confederate Army, donning the gray uniform, placing two pistols in his belt, and riding off to fight. Suddenly she found herself alone, forced to raise two small boys on her

A young Elivs Presley gyrates during a performance in 1961, exhibiting the style that made him a sensation. His genius lay in his ability to mix the music of the melting pot that simmered in Memphis.

own. Minor was able to come home in 1862 for a brief period. When he had to return to the front, Elizabeth found that she was pregnant again.

That same year Memphis was captured by the Union Army. Union soldiers set up an encampment outside the Meriwether house. The soldiers helped themselves to the vegetables in the garden and the milk from the cow. Realizing her children would starve without getting milk, Meriwether asked the soldiers for a quart each day, which they gave to her.

Memphis was a strategic point for whoever controlled it because of its location on the river and the surrounding bluffs. When the Union Army first took the city, Gen. Ulysses S. Grant was the commander stationed there, but he was later replaced by Gen. William T. Sherman. Meriwether had dealings with both Union commanding officers. When a couple was sent by a helpful neighbor to live on the Meriwethers' land and to protect Elizabeth from the soldiers, the couple turned her outdoor kitchen into a saloon. Meriwether went to General Grant for help. A friendly Union soldier offered to back up Meriwether's story that once the "saloon operator" had actually chased Mrs. Meriwether out of her own yard with a carving fork.

Although her husband was a Confederate officer, General Grant issued a note that read: "To the Provost Marshal: See that Mrs. Minor Meriwether is protected in her home. U.S. Grant." The Provost Marshal promptly sent someone to remove the couple from Meriwether's home.

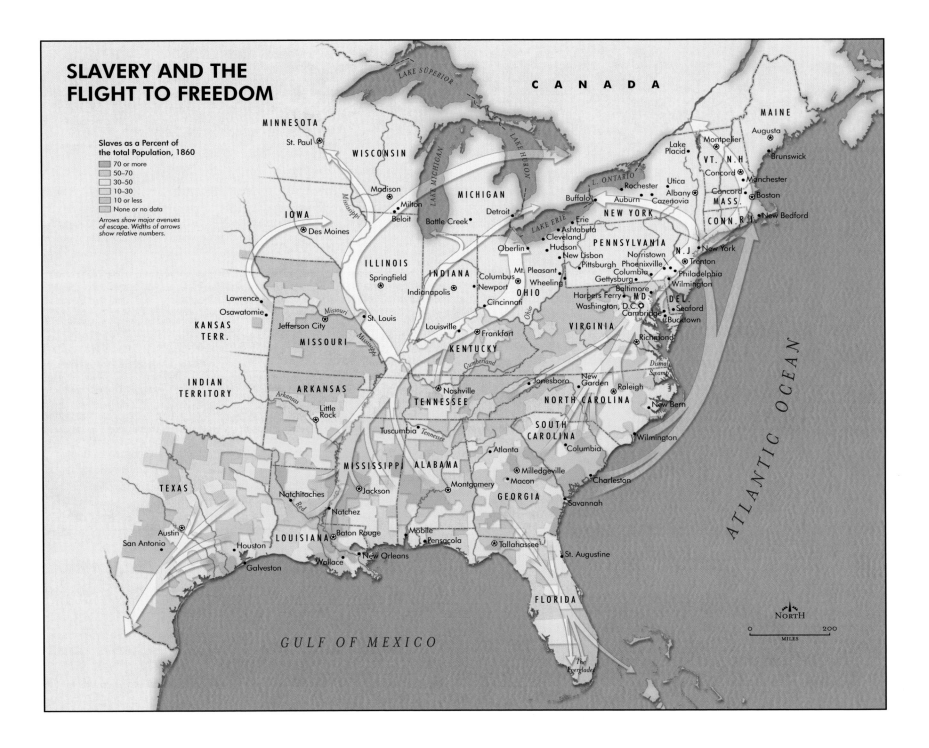

SLAVERY AND THE FLIGHT TO FREEDOM

Slaves as a Percent of the total Population, 1860

- 70 or more
- 50–70
- 30–50
- 10–30
- 10 or less
- None or no data

Arrows show major avenues of escape. Widths of arrows show relative numbers.

CANADA

LAKE SUPERIOR

MINNESOTA
St. Paul

WISCONSIN
Madison
Milton
Beloit

IOWA
Des Moines

LAKE MICHIGAN
LAKE HURON

MICHIGAN
Battle Creek
Detroit

MAINE
Augusta

Montpelier
Lake Placid
VT. N.H.
Concord
Manchester
Concord
MASS.
Brunswick

L. ONTARIO
Rochester
Utica
Albany
Boston

Buffalo
Auburn
Cazenovia

NEW YORK

CONN. R.I.
New Bedford

LAKE ERIE
Erie
Ashtabula
Cleveland
Oberlin
Hudson
New Lisbon

PENNSYLVANIA

New York

N.J.

ILLINOIS
Springfield
Indianapolis

INDIANA
Columbus
Newport

OHIO
Cincinnati

Mt. Pleasant
Wheeling

Pittsburgh
Columbia
Gettysburg
Harpers Ferry
Washington, D.C.

Norristown
Phoenixville
Trenton
Philadelphia
Wilmington
Baltimore

MD.
DEL.
Seaford
Cambridge
Bucktown

Lawrence
Osawatomie

KANSAS TERR.

Jefferson City
St. Louis

MISSOURI

Louisville
Frankfort

KENTUCKY

VIRGINIA

Richmond

Dismal Swamp

INDIAN TERRITORY

ARKANSAS
Little Rock

Nashville

TENNESSEE

Jonesboro
New Garden
Raleigh

NORTH CAROLINA
New Bern

ATLANTIC OCEAN

Tuscumbia
Tennessee

SOUTH CAROLINA
Columbia
Wilmington

TEXAS
Austin
San Antonio

Natchitoches
Natchez

MISSISSIPPI
Jackson

ALABAMA
Atlanta

Montgomery

Milledgeville
Macon

GEORGIA

Charleston

Savannah

Houston
Galveston

LOUISIANA
Baton Rouge
Wallace
New Orleans

Mobile
Pensacola

Tallahassee
St. Augustine

FLORIDA

GULF OF MEXICO

The Everglades

NortH

0 200
MILES

Her encounter with General Sherman did not go as well. Meriwether went to collect her rents one day and found out that Sherman had ordered her tenants to pay their rents to the Provost Marshal. Elizabeth took her deeds to Sherman to prove that she, not her husband, owned the property. Sherman did not care whether or not the deeds were in her name or her husband's. He asked her why she allowed her husband to join the Rebel Army. She said, "General Sherman, by all the laws you men have made, and by all the religions you men do teach, we women have been brought up to obey our husbands, not rule them. I had no power to keep my husband out of the army." Her response was shrewd but to no avail. Sherman told her as long as her husband fought for the Confederate Army, she could not have her property back.

The treatment by Sherman only became worse. In the fall of 1862, Rebels attacked Union gunboats. Sherman decreed that ten Memphis families would be exiled from the area for every boat attacked from then on. Elizabeth Meriwether's name was posted on the first list in November.

When she pleaded with Sherman to be exempt from the list because she was eight months pregnant, he retorted, "I am not interested in Rebel wives or Rebel brats. If you do not leave Memphis in three days you will be locked up in the Irving Block [a crowded, makeshift prison on the town square] as long as this war lasts."

With two sons, aged five and three, and a third child on the way, Meriwether left money for her taxes to be paid by a friend, packed up her things in her Rockaway carriage, and left Memphis. The refugees of war made their way south through the Hill Country of northern Mississippi to find the Confederate Army. The family was briefly united with Minor in Holly Springs, but the men moved on a few days later. Elizabeth and her children wandered through Mississippi and Alabama in need of food and clothing. Elizabeth gave birth to her third son on December 25, 1862. She and her husband named the child Lee, after Gen. Robert E. Lee.

Five months into 1863, Meriwether and her three boys traveled to Alabama to stay with her sister. As basic necessities were difficult to provide for her family, Meriwether decided to enter a writing contest. Her story, "The Refugee," won first place and brought her $500, and a visit from Jefferson Davis's brother, Joe.

As her financial situation worsened, Meriwether discovered that the friend in Memphis who was taking care of her

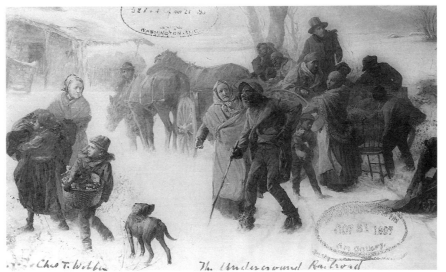

Conspirators with the Underground Railroad help an escaped slave climb a steep embankment along the Mississippi to deposit him on the route to freedom.

Abominable conditions drove some 40,000 slaves to flee the United States by 1860. Routes led them north toward Canada and south toward Mexico and the Caribbean.

taxes had died. She decided to go back herself to take care of her business. The trip was difficult. She hitched rides, took the train, and traveled a short way in a skiff over land that was flooded because of broken levees on the Mississippi.

After taking care of her monetary affairs, Meriwether returned to Alabama. She sewed an ingenious girdle that hid her gold so it would not be detected as she crossed the Union picket line. She made it back to her sister's house and spent another hard year trying to provide for her family.

When General Lee surrendered at Appomattox Court House, Elizabeth and her three sons went back to Memphis. Minor joined them a few months later.

After the military combat of the Civil War had come to a close, a maritime tragedy of unparalleled proportions occurred on the Mississippi on April 27, 1865. The side-wheel steamboat *Sultana*, some seven miles north of Memphis, Tennessee, carrying 2,300 just-released Union prisoners of war, plus crew and civilian passengers, exploded and sank. More than 1,700 people died. It was the worst maritime disaster in U.S. history, more costly than the April 1912 sinking of the *Titanic*, when 1,517 lost their lives. Because the *Sultana* went down in the chaos of returning armies, the disaster was not well covered in the news, and was soon forgotten.

As Gene Eric Salecker—a Chicago policeman who spends his off-duty time researching and writing about the Civil War—tells the story in *Disaster on the Mississippi*, the nautical accident occurred at 2 a.m., when three of the steamship's four boilers exploded. The death toll, which almost equaled

In her memoirs, Elizabeth A. Meriwether, a Memphis society matron, described the Civil War's impact on family life, and the hardships she endured at the hands of Union generals.

the number of Union troops killed at the battle of Shiloh—1,758—was the result of gross government incompetence. The *Sultana* was legally registered to carry 376 people. She had six times more than that on board because the captain had bribed army officers, and the former POWs wanted to get home at any cost.

When the Civil War began in 1861, about 1,000 steamboats plied the Mississippi River. From 1811 to 1850 there were 4,000 steamboat casualties, most of them caused by boiler explosions. Steamboats foundered on snags or sandbars, or someone would drop a cigarette, and the wooden structure loaded with bales of inflammable cotton would go up like a torch. The average life of a steamboat was reckoned at five years; after that it could be fairly sure of coming to a violent end. During the Civil War, engineers in the North labored to construct a sturdier steamboat that could ply the rivers for decades. The state-of-the-art *Sultana* was built in Cincinnati in 1863 and, after sailing down the Ohio River, was mainly traveling from St. Louis to New Orleans. The ship was a prototype with the most modern safety equipment. It had safety gauges that fused open when the internal boiler pressure reached 150 pounds per square inch; three fire-fighting pumps; a metal lifeboat and a wooden yawl; 300 feet of fire hose; 30 buckets; five fire-fighting axes; and dozens of life belts.

In April 1865, Union POWs were gathered at Vicksburg. The POWs were loaded on steamboats for the trip to Cairo, Illinois, with the government paying $5 per passenger. That was big money, which led to corruption—greedy steamboat

captains kicked back $1.15 to the army officers in charge if they filled the boats with men. The *Sultana* was the last to leave. One of its boilers had sprung a leak and needed repair, but instead of doing the job right—removing and replacing the bulge in the boiler—the *Sultana* captain ordered a patch of metal put over the bulge. That could be done in one day, while a proper repair would consume three or four days. Before the repair could be completed, other steamboats would come to Vicksburg from New Orleans and pick up the POWs, leaving the *Sultana* without these lucrative passengers. The army officers in charge understood; they wanted the *Sultana*'s kickback and loaded 2,300 POWs on board. Passengers were packed in so tightly they could barely stand.

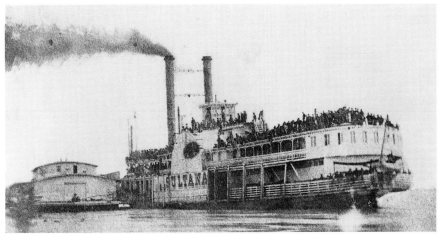
Overloaded with former Union prisoners of war, the steamboat *Sultana* embarked on its journey in 1865. Exploding boilers sank the boat, taking 1,700 people to a watery grave.

The POWs pushed and squeezed themselves onto the top or hurricane deck, the middle or second deck, and the main deck. After their experiences in the Southern prison camps, they could take anything to get back to the North and home to their families as quickly as possible.

At 9 p.m. on April 24, the *Sultana* left Vicksburg. The captain, J. Cass Mason, told an officer his ship had carried as many men before. He said the *Sultana* was a good vessel, and the men were in capable hands. "Take good care of them," the officer replied. "They are deserving of it." The *Sultana* was overcrowded, Mason knew, but he maintained that it was not overloaded.

On April 26, the ship docked at Memphis to pick up coal. At midnight she headed upriver. At 2 a.m.on April 27, the repaired boiler exploded. The resulting fire then caused two of the three other boilers to explode. Fire spread through midship, and the two smokestacks fell on the boat, crushing the hurricane deck and killing many men. Those who survived panicked, and rather than fight the fire, they began to jump into the river. The flames started sweeping toward the stern, causing more panic and jumping. The river was high, flowing fast, crowded with dead, drowning, and barely floating men. The *Sultana* was being consumed by flames. When the sun came up, there were bodies everywhere. The few survivors, holding onto their driftwood rafts, despite their perilous situation, began to sing.

A mere 800 of the 2,500 passengers survived (although 200 of them died later). On the ocean liner *Titanic*, 882 feet long, 1,517 died. On the steamboat *Sultana*, 260 feet long, the toll was nearly 200 greater. The ship, what was left of it, drifted downriver and sank opposite Memphis. There the *Sultana* lies today, covered with mud, at the bottom of the Mississippi River. An enterprising group made a serious attempt to raise the *Sultana* in 1955 in hopes of finding at least the metal remains of the exploded boilers and engines. Because of the shifting nature of the river, the steamboat remnants were never found. ★

THE RIVER IN FLOOD

★

"Levee broke...crevasse will overflow entire Mississippi Delta."

Major John C. H. Lee

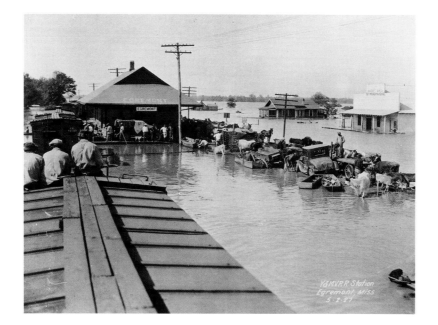

Citizens of Egremont, Mississippi, seek high ground from the 1927 flood at the train depot.
COURTESY MISSISSIPPI DEPARTMENT OF ARCHIVES AND HISTORY

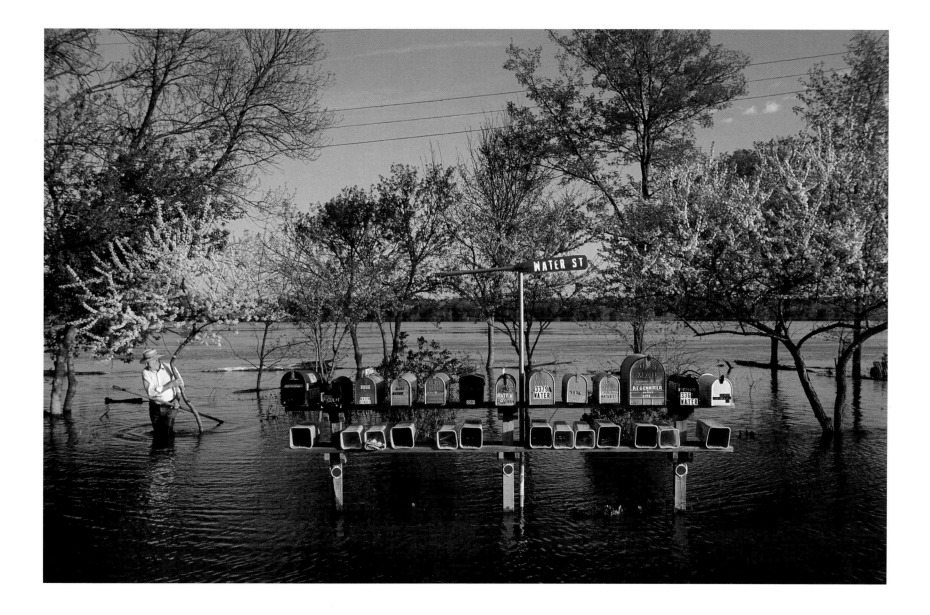

The swollen river delivers floodwaters and debris to Water Street near Muscatine, Iowa, in 2001.

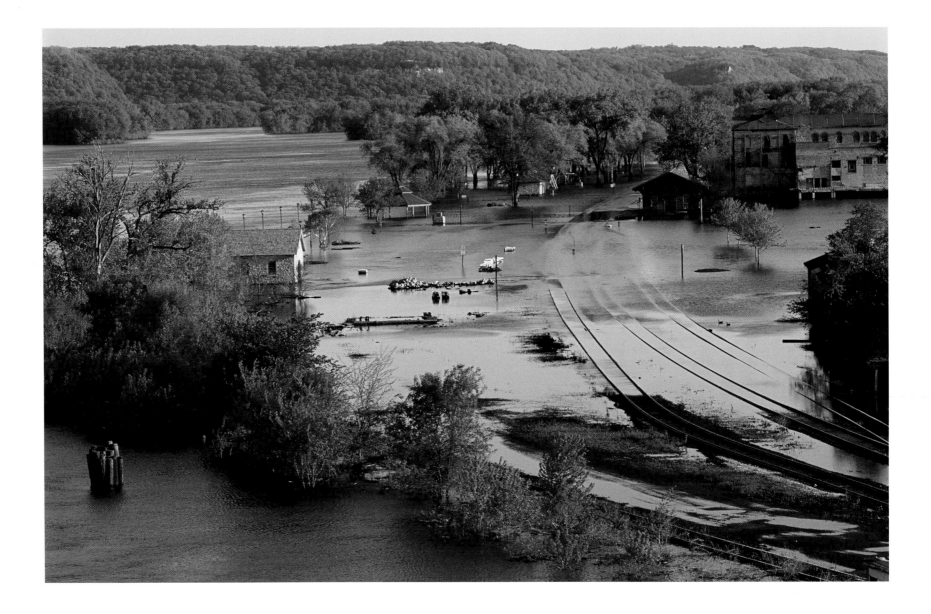

Historic Prairie du Chien, Wisconsin, endures the Mississippi flood of 2001.

Wading into the flood, two Canada Geese enjoy the rising water.

A bridge casts a long shadow on the rising Mississippi in Galena, Illinois.

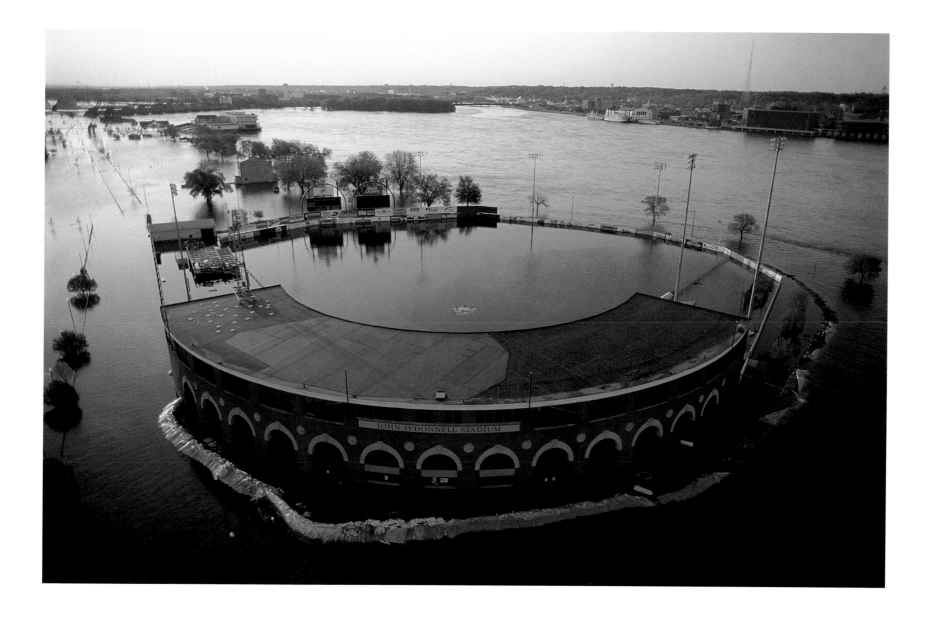

The Davenport River Bandits lose the home-field advantage to the Mississippi.

A rising foment disturbs a peaceful resting place in Davenport, Iowa. KERRY TRAPNELL

In Prairie du Chien, a cabin in the woods becomes waterfront property during flood season.

A panoramic view of the junction of the Ohio and Mississippi rivers marks the threshold to the northern expanse of the Louisiana Purchase. The marriage of these waters has created a force of nature that defies human efforts to conquer it.

THE GREAT CONFLUENCE

★

"I'm a Salt-River roarer. I love the wimmin and I'm chock-full of fight."

MIKE FINK

ANTICIPATION SWIRLED ACROSS AMERICA in January 1842 when popular novelist Charles Dickens boarded the steamship *Britannia* in Liverpool and sailed across the Atlantic Ocean to Boston Harbor. More than any other European writer, Dickens had captured the heartstrings of America with such unforgettable fictional characters as Oliver Twist, Little Nell, and Dick Swiveller, among dozens of others. Dickens's tweaking of Tory mannerisms and his puncturing of the hypocrisies of the British Empire, had made him a democratic cult hero throughout the United States. Now, on the heels of Frenchman Alexis de Tocqueville's famed 1831 journey to the United States, Dickens was coming to this "Citadel of Liberty" to write a single-volume travel book on his experiences, called *American Notes for General Circulation.* His itinerary included a visit to the western Illinois town of Cairo (pronounced Care-oh) on the Mississippi River.

The intrepid Dickens's expectations for the four-month journey were high. He treasured American readers of his novels above all others, particularly those from frontier settlements in the trans-Mississippi West. When a Memphis postmaster wrote him a gushing fan letter in February 1841, for example, he wrote back, "your expressing of affectionate remembrances and approval, sounding from the green forests on the banks of the Mississippi, sink deeper in my heart and gratify it more than all the honorary distinctions that all the courts in Europe could confer."

This warm sentiment, however, quickly dissipated upon his arrival to America. Although Dickens enjoyed being feted for two weeks in Boston, he had grown dismayed by the tabloid press, uncouth table manners, hypernationalism,

Laborers carry crates of live birds to market in Cairo, the largest port in southern Illinois, in the 19th century.

condonement of violence, and endless bragging by the time he arrived in New York. And no place disappointed him more than Cairo, Illinois.

"At the junction of the two rivers, on ground so flat and low and marshy that at certain seasons of the year it is inundated to the house-tops, lies a breeding-place of fever, ague, and death; vaunted in England as a mine of Golden Hope, and speculated in, on the faith of monstrous representations, to many people's ruin," Dickens wrote in *American Notes,* published in 1842. "A dismal swamp, on which the half-built houses rot away: cleared here and there for the space of a few yards; and teeming, then, with rank unwholesome vegetation, in whose baleful shade the wretched wanderers who are tempted hither, droop, and die, and lay their bones, the hateful Mississippi circling and eddying before it, and turn-

ing off upon its southern course a slimy monster hideous to behold; a hotbed of disease, an ugly sepulchre, a grave uncheered by any gleam of promise: a place without one single quality, in earth or air or water, to commend it: Such is this dismal Cairo."

Dickens's acerbic dismissal of Cairo makes for colorful reading but bad reporting. Tired from the discomforts of travel through frontierland, Dickens did not comprehend that Cairo was the vortex of the United States, more a depot for transshipping goods than a center of enlightenment. What isn't fully understood about his colorful excoriations is that he suffered financial losses in a junk bond scheme propagated by the local investment firm of Cairo City and Land Company. Charles Dickens, in other words, was fleeced by an uneducated band of frontier rubes. Anxious for revenge, he lampooned Cairo both in *American Notes,* and in his later novel, *Martin Chuzzlewit.* His vitriolic judgment of the Mississippi River at Cairo being "a slimy monster hideous to behold" stuck, and the town has suffered bad public relations ever since. Herman Melville, who never visited the town, added to the problem when he wrote in *The Confidence Man: His Masquerade* (1857), a novel about a Mississippi riverboat full of charlatans, that "at Cairo the old firm of Fever and Ague is still setting up its unfinished business."

We turned our backs on Dickens and Melville as we stood

Cairo, Illinois, sits at the confluence of the Ohio and the Mississippi. Traders from west of the Appalachians floated goods down the Ohio, to the Mississippi, and to the Gulf.

on the Boatmen's Memorial just south of Cairo on Route 51, a navigation marker and monument dedicated to those who lost their lives on the Mississippi River. The memorial is essentially a lookout tower, which surveys the marriage of the Ohio and Mississippi rivers as they merge to begin the 984-mile trip to the Gulf. Refusing to merge, the Ohio waters continue as a blue ribbon rippling far down the muddy Mississippi currents. Waterfowl wheel above the placid barges and tugs navigating the point. In the spring, when we visited, northern ice from Minnesota and Wisconsin was still floating downriver. At this point the Ohio River annually drains as much water as an area the size of France into the Mississippi. And it's clear.

Dickens didn't explore the area surrounding the "Greatest Confluence of Rivers in America," or he would have commented on the 350,000 acres of woodland that compose Shawnee National Forest, or on the 300-million-year-old sandstone formation towering over the Mississippi River, or on the staggering variety of flora and fauna. Unable to shake his English prejudices Dickens never visited the nearby Cahokia Mounds, now a World Heritage Site. The mounds constitute the most important site along the river. which was once inhabited by the vanished group of Native Americans named Mississippians by archeologists. A better observer of the area around Cairo was historian

A crevasse, or break, in the Mobile and Ohio levee from the flood of 1912 demonstrates the Mississippi's ability to defy human efforts to permanently control it.

Mann Butler, who in 1853 wrote in *Valley of the Ohio* that "The resources of the finest iron and lead, and coal and salt, are spread over this section of the United States in a profusion unequalled in the world."

The Boatmen's Memorial is located in Fort Defiance Park, which the *Chicago Tribune,* echoing Dickens, deemed "probably the ugliest park in America." But to our way of thinking, Fort Defiance, the Civil War post commanded by Gen. Ulysses S. Grant, which guarded the confluence of the Mississippi and Ohio rivers and became a major supply base for the western thrust into the Confederacy, is a must stop.

"Whatever nation gets control of the Ohio, Mississippi, and Missouri Rivers will control the continent," Gen. William Tecumseh Sherman wrote in 1861. He was right. Only two days before Fort Sumter's surrender, Union soldiers poured into Cairo, beating Confederate soldiers by a few hours. With utmost speed Union soldiers erected Fort Defiance, and Grant arrived to take command. Some 200,000 people stopped in Cairo during the Civil War, creating an economic windfall for many local citizens. The boom also provided seamier attractions for the soldiers stationed there. The once sleepy town became known as "Hell-Roaring Cairo" during the years Grant called the community his headquarters. It was a main stop on the Underground Railroad—a fact given new life with the recent discovery of slave hideaways in old storage bins under the sidewalks along Levee Street.

Following the Civil War, the town continued to boom. In 1867 alone, 3,700 steamboats docked along the often

Magnolia Manor stands as a sentinel from Cairo's heyday, when Civil War spending and steamship freight turned the city into a Mississippi boomtown.

flooded wharf. Before long, Cairo's combined annual river and rail shipments of $60 million proved to be the highest per capita commercial freight traffic in the United States. But as Chicago grew into the great railroad city of Illinois and the Model T Ford triggered a transportation revolution, Cairo went into decline. There used to be five railroads running through Cairo; only two remain.

"By now, the two-river town, overtaken by the 20th century, has settled into a Southernish somnolent state," Tom Weil wrote in 1992 in his book *The Mississippi River*, "a languid remnant of its once-lively, steamboat-stoked days of glory." And the town still gets bad press. "If you want to visit the most unusual theme park in America, try this Main Street," Nancy Gibbs wrote in the July 10, 2000 issue of *Time*. "It is a water slide of desolation, one abandoned building after another, a law office where the books rot on collapsing shelves. Last year the building inspector did a complete inventory of the town's structures—and condemned 108 buildings."

Today, Cairo citizens—proud of their historic heritage—are working hard to preserve their rich architectural gems—the most impressive being Magnolia Manor, a 14-room Italianate mansion located at 2700 Washington Avenue. Charles Galigher, a milling merchant whose fortunes rose from selling flour and corn for hardtack to the government during the Civil War, built the house in 1969. Through business transactions, he became a friend of General Grant. The Victorian elegance of this four-story mansion still dominates the tree-lined boulevard once known as Millionaire's Row. Galigher's financial success

allowed him to construct tennis courts adjoining the manor, which took up about ten acres in its glory days. The house and the courts were lit by carbide gas lights, brighter than electric lights. From the cupola of his dream house—where Grant stayed on several occasions after his Presidency—a spectacular view of the Mississippi and Ohio rivers could be enjoyed. The Cairo Historical Association now operates the Manor, maintaining the sheen of the elegant chandeliers, serpentine staircases, and marble fixtures.

Not far from Magnolia Manor is the Old U.S. Customs House, a rare example of Romanesque architecture in the American Midwest. This impressive limestone building was completed in 1872 for $225,000 and is one of the few surviving works of noted architect A.B. Mullet. The most interesting artifact inside is the flagpole from Grant's Union Army flagship the *Tigress*, the river packet which took him to the battle of Shiloh on April 6, 1862. The *Tigress* was sunk a year later at Vicksburg. The crew survived and returned the flagstaff to the citizens of Cairo. Outside the U.S. Customs House stands a Civil War cannon facing the Mississippi River.

Talk to people on the streets of Cairo and without question Grant is the local historic hero. But spend any time within a hundred miles of Cairo in a boat in either the Mississippi or Ohio river, and you'll instead hear tall tales about Mike Fink (or Miche Phinck, his preferred spelling),

Neither wild dogs or alligators could keep keelboater Mike Fink from hauling in catfish or shooting off a pig's tail, he boasted.

who is known as the Paul Bunyan of America's rivers. Born in a log cabin near Pittsburgh around 1780, Fink gained notoriety early on as an Ohio Valley Indian scout and ace marksman with a Kentucky rifle. Oral tradition claims that Fink, who was 6 foot 3 inches and weighed 180 pounds, was all muscle and brawn. Fink soon learned he could make a steady living out of being a keelboatman, or poleman, a job that went to the best athletes in the West.

At the time of the Louisiana Purchase, exotic boats of all kinds were plying the Mississippi and Ohio rivers. This was the dawn of the so-called Keelboat Age on the western rivers. The New England writer Timothy Flint found himself at the outpost town of Fort Pitt (Pittsburgh) during this time and was stunned to see so many odd boats so loaded with household goods that they looked like they were about to sink. "You can scarcely imagine an abstract form in which a boat can be built that in some part of the Ohio or Mississippi you will not actually see it in motion," Flint wrote of his observations in *Recollections of the Last Ten Years*.

The main attraction on the rivers, the nautical star of the pre-steamboat era, were the keelboats—sleek-prowed, boxlike, shallow draft vessels with a roof. At the time of the Louisiana Purchase, these boats housed tens of thousands of people anxious to trade in Cairo or New Madrid or Natchez or New Orleans. The average craft was 60 feet in length and 8 feet in width, and like the wagons that later blazed across

the Oregon Trail, the boats carried families, livestock, and household items such as furniture, cooking utensils, food, and whiskey. An average keelboat could carry up to 50 tons of freight either up- or downriver. And that was its marvel. Whereas a flatboat could only go downriver, a keelboat could battle the pull of the current upriver, though it took a crew of polemen to do it.

Because most polemen were illiterate frontiersmen, they left few written records of their exploits. But polemen could tell a tall tale. And so grew the exaggerated deeds of fellow boatman Mike Fink, who, the stories claim, had such muscular powers that he was "half-horse, half-alligator."

Fink traveled the Mississippi River from 1790 to 1822, and hundreds of stories were written about him in 19th-century newspapers and magazines. He was nicknamed The Snapping Turtle on the Ohio and The Snag on the Mississippi. Keelboatmen were known to be boasters, but Fink outdid them all. He claimed he could "out-run, out-jump, throw down, drag out, and lick any man in the country. "I'm a Salt-River roarer," he said. "I love the wimmin and I'm chock full of fight."

His reputation for guzzling a gallon of whiskey a day without seeming besotted was lauded by his rough-hewn cohorts, but it was his marksmanship that made him feared. It was said that Fink could shoot the tails neatly from five pigs feeding on a Mississippi riverbank as he passed by in a

A keelboat—a boat that could be pushed, pulled, rowed, and sailed—was the work of Meriwether Lewis, who understood the navigational challenges of America's rivers.

boat. And supposedly Fink could pluck a tin cup off a woman's head from one hundred yards away. There are even apocryphal stories written about Fink's encounters with such legendary frontiersmen as Davy Crockett and Daniel Boone.

One fact about Fink's career is certain: He loathed the coming of the steamboat on the Ohio and Mississippi rivers because it meant that civilization was encroaching on his freedom. Fink knew human brawn could not surpass steam when it came to moving a boat upriver. Angered by the sound of a calliope—a keyboard instrument on the steamboats—he headed west in 1822, with two trapper friends known as Carpenter and Talbot, on a journey to Yellowstone. That winter Fink and Carpenter got into a heated dispute over a Blackfoot squaw. By spring, Fink and Carpenter had made up enough to play the Rocky Mountain-version of William Tell. Carpenter trusted his old friend to shoot a tin cup off his head. But Fink had elevated his pistol two inches too low and shot Carpenter in the head, killing him instantly. Later that evening, Fink began drinking heavily and bragged he had killed his rival on purpose. An infuriated Talbot, suspicious all along that Fink had premeditated the accident, grabbed one of his dead friend's pistols and shot Mike Fink in the chest. News of Fink's death spread throughout the waterways of America, and every keelboatman annoyed with the wedding-cake-type steamboats spat tobacco in the Mississippi and took a swig of Kentucky whiskey in Fink's honor.

Mike Fink's legend still reverberates on the Mississippi thanks to the men and women of the U.S. tugboat, towboat, and barge industry—an honorable trade that dates back to the time when ancient Egyptians floated goods downriver. Unfortunately, watermen have suffered bad publicity in recent years because of the *Exxon Valdez* accident of March 24, 1989. On that night, the large oceangoing tanker ran aground in Prince William Sound, Alaska, spilling 11.2 million gallons of Alaskan North Slope crude oil into the sea. The accident gave the entire maritime industry the ill repute of being environmentally reckless.

In truth, many experts say water transportation is both efficient and environmentally friendly. Brochures by the Watermen Association state the following statistics: A single standard-size jumbo barge has the same capacity as 58 trucks or 15 railroad cars. One 15-barge tow has the same capacity as 225 railcars or 870 trucks, which, placed end to end, would extend 11.5 miles. If the cargo aboard a 40-barge tow were moved to the highways, it would occupy a convoy of 2,300 trucks which, spaced 150 feet apart, would extend 90 miles. The U.S. inland waterways system comprises more than 25,000 miles of navigable waterways serving over 200 inland and coastal ports. Barges move roughly 16 percent of our nation's freight for just 2 percent of the freight cost.

Water transportation is also the most fuel-efficient way to move cargo. One gallon of fuel can move one ton of cargo 514 miles by barge. By contrast, one gallon of fuel can move the same ton of cargo only 202 miles by rail and 50 miles by truck. Barges produce a fraction of the emissions of trucks and trains. Ships and barges also have the lowest number of spills, according to the U.S. Department of Transportation. All vessels are subject to strict prohibitions on the discharge of oil and solid waste into the water. Tank barge owners must develop spill-response plans. Under the Oil Pollution Act of 1990, all tank barges must be equipped with double hulls by the year 2015; these are currently being phased in, and 70 percent of tank barges are already equipped with them.

We learned these facts when we boarded the *Marge Kovac*, a towboat owned by MidSouth Towing that is headquartered in the Ohio River town of Metropolis, Illinois. These boats are called a "tow" although they push—not pull—the cargo. The day we went upriver, Capt. Robert Conyers of East Prairie, Missouri, had 35 barges of iron ore pellets from Venezuela in tow. He fell in love with the Mississippi as a boy growing up in Arkansas. Conyers's first job was building dikes from Cairo to Venice, Louisiana. Then he did revetment work for bank protection and worked as a deckhand on a construction-rock boat. Conyers moved to mate position, then to pilot, and captain. He passed his Coast Guard exams with flying colors and is now a master of the river, able to steer a floating three-acres of cargo between the stone piers of a bridge. And as we quickly learned, nobody enters the wheelhouse without his permission.

Our corporate host was Merritt Lane III, the smart and genial 39-year-old president of Canal Barge Company, Inc. (CBC), a midsize company that owns 540 barges and more than 20 towboats, based in New Orleans. "Anytime I can spend time with our onboard personnel, I do it," Lane told us. "The folks who work on the Mississippi are the ones who respect its power the most, and I learn a lot from them." Lane's grandfather began CBC in 1933, and Lane is proud that his barges ply the river daily from New Orleans to St. Paul. CBC started out with a single thousand-barrel, all-welded steel tank barge, the *CBC-1*. Complete with a pumping unit, the *CBC-1* was the first vessel of its kind on the Mississippi River-Intracoastal Canal system in 1933 Currently, CBC has some of the most environmentally friendly, technologically advanced equipment on the rivers.

For its liquid-cargo trade, CBC has double-skinned barges carrying specialty chemicals such as caustic soda, styrene, benzene, and pseudocumene and refined products such as lubricating oils and asphalt, as well as barges carrying molten sulfur, black oil, and other heated products. The company also has hopper barges to transport dry-bulk commodities such as grain and coal. The company's deck barges support the oil and gas industries and transport overdimensional project and heavylift cargoes. These massive barges are floating warehouses.

The *Marge Kovac* and other air-conditioned pilothouses of today would be unrecognizable to Mark Twain. They are equipped with coffeemakers, water fountains, radar systems, telephones, voice recorders, and electronic positioning systems. Captain Conyers's pilot chair looks like an overstuffed recliner on wheels. A fax machine and a Fathometer, better known as a sounder—which helps to prevent sandbar groundings—can be found on the console next to him.

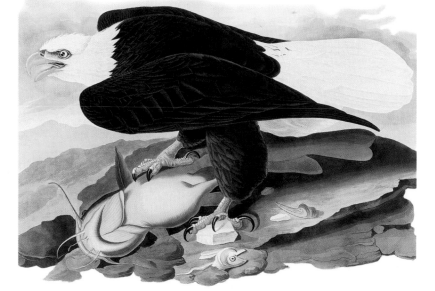

The Bald Eagle still thrives along the banks of the Mississippi, which serves as a flyway for more than 40 percent of the migratory birds of North America.

All towing vessels on the Mississippi River must comply with equipment requirements, which include the above as well as navigation lights, rate-of-turn indicators, and depth finders. The equipment comes in handy along certain stretches. Two of the most dangerous spots on the Mississippi River are Algiers Point in New Orleans because of a hairpin turn and heavy traffic, and Wilkerson's Point near Baton Rouge because of the treacherous eddy.

In the 19th century, riverboat captains were the big men in town. Their image has been tarnished because of Capt. Joseph Hazelwood's poor judgment on the *Exxon Valdez*. "People think you're some kind of pirate," Conyers told us. "Rivermen don't get the respect they used to." Besides watching for treacherous conditions and delivering his cargo safely, a captain is responsible for his crew. A typical towboat moving a flotilla of barges wired together, each of which carries 1,500 tons of cargo, has a pilot, a chief engineer, and a deck crew who work together in close quarters for 30 days at a time. The work is hard and sometimes dirty. A rule of thumb is, if you don't lean on anything, you stay clean. Nevertheless, the men we met spoke of the honor of living on the Mississippi and of learning its every twist and turn. The quarters are first-rate, with a cook who feeds them hearty meals, an exercise room, and a TV lounge on board. Still, they say, nothing quells the pain of missing their families. Captain Conyers had a three-week-old grandchild named Jack in Cape Girardeau, Missouri, and Conyers still hadn't seen him. "The river is a universe unto itself," Conyers said.

A starting deckhand makes about $27,000 a year.

Advancement can be rapid for those who have the ability and perseverance. The industry has developed training procedures, including simulators such as those used by airline pilots, but most of the learning is by experience, based on apprenticeship under skillful captains.

The main task of those working on a towboat is keeping the barges tied together and pushing them toward their destination. The barges, which typically have a life expectancy of 20 to 30 years, are held together by 35-foot-long, one-inch-diameter steel cables and ratchets. The biggest hazards for the crew are trips, falls, and strains from improper lifting. A rule on a barge is to never step on any cargo, gear, or fittings and to be hyper-concerned about the inflammability of the cargo.

The load of iron-ore pellets, which the *Marge Kovac* was carrying, was brought to Cairo, then up the Ohio River to Wheeling, West Virginia, to a steel mill. Who knows: An iron ore pellet from the *Marge Kovac* could end up anywhere—as part of a beam in a Boston high-rise or in a Ford Explorer in Seattle. The slag is used for asphalt and other things after it is smelted.

Competition in the towing business is heated, yet the different boats all pass each other daily on the Mississippi. So despite the professional competition, a fraternity of

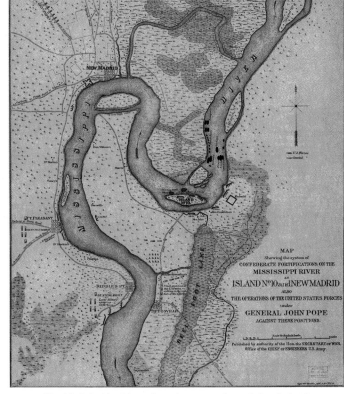

The Mississippi undulates through so many dramatic bends that it actually flows east, or west, or even north for brief stretches. The current drops tons of sediment, creating ever-changing sandbars.

respect has developed among the men and their companies working the waterway. Under U.S. law, all vessels operating along the Mississippi River between domestic ports must be U.S.-flagged, U.S.-built, U.S.-crewed, and U.S.-owned.

Despite this fact, in many ways the Mississippi has become a United Nations for shipping. Flags from dozens of countries wave along the waterway from the mouth of the Mississippi to Baton Rouge. "Globalization" is the new buzzword. More than 60 percent of U.S. grain exports, shipped each year to world markets, begin their journey on river barges on the Mississippi and Illinois rivers. The cost efficiency of barge transportation helps American exports stay competitive in global markets. This is critical for American farmers, who face intense competition from lower-cost, subsidized foreign agricultural producers. The skill of Mississippi tow captains is so renowned that many have been summoned all over the world to teach the latest methods of navigating acres of barges down the rivers.

One thing we learned from traveling on both the *Delta Queen* and the *Marge Kovac* is that the best way to study our great river is from the middle of it. The view is never tedious, for there is always a sweeping play of life along the levee: Whether it's Bald Eagles nesting, or motorboats racing, or children waving American

flags from the banks of an unspoiled willow thicket, the eye never gets tired.

This variety inspired painter John Banvard to leave his home in Louisville, Kentucky, and to travel down the Mississippi from Cairo with a portfolio filled with pencils and sketchpads. In 1842 the Mississippi was still considered the frontier, and his ultimate goal was breathtaking in scope: to paint a three-mile-long canvas of sights along the river from St. Louis to New Orleans. "The river's current was averaging from four to six miles per hour," Banvard wrote in his memoir. "So I made fair progress along down the stream and began to fill my portfolio with sketches of the river shores. At first it appeared lonesome to me drifting all day in my little boat, but I finally got used to this."

According to Paul Collins, in his book *Banvard's Folly*, Banvard returned home to Kentucky nearly two years later with thousands of sketches and endless tall tales. Banvard began to work on what would become the largest painting in the world. Bursting with hubris, he set up a studio in a barn outside of Louisville and began painting a three-mile-long canvas with the same feverish passion that Leonardo da Vinci applied to the Sistine Chapel. Banvard was a first-rate landscape painter, and his canvas included log cabins, medicine-show flatboats, cottonwood groves, mud banks, Native Americans,

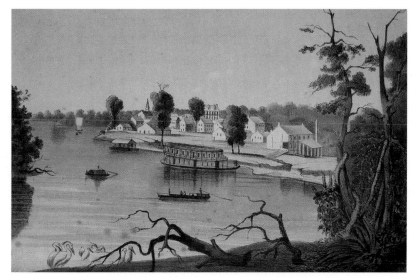

The tranquil settlement of New Madrid, Missouri, at the heart of the Mississippi Valley, was disastrously shaken in 1811-12 by one of the most intense series of earthquakes recorded on the continent.

and everything he saw along the river. Banvard's hope was to let the citizens of the East Coast and Europe feel as if they were traveling down the river in a stage show featuring his massive canvas stretched between two rollers, operated on one side by a crank.

A Lt. Selin Woodward visited Banvard in his workshop and wrote to a friend describing the scene. "Any description of this gigantic undertaking...would convey but a faint idea of what it will be when completed.... The remarkable truthfulness of the minutest objects upon the shores of the rivers, independent of the masterly, and artistic execution of the work will make it the most valuable historical painting in the world, and unequaled for magnitude and variety of interest, by any work that has been heard of since."

Banvard's "Three Mile Painting" made him an overnight celebrity. After a brief showing in Louisville, he took his panorama to Boston in November 1846, where in six months more than 250,000 people saw it. He earned a hefty profit. Audiences packed into Armory Hall to hear his tall tales, while the crank moved the Mississippi across the stage, and a piano played waltzes. In addition, Banvard sold a program entitled "Description of Banvard's Panorama of the Mississippi River." John Greenleaf Whittier was so moved by the performance that he entitled one of his books *The Panorama and*

An exposed, double set of roots on trees along the Mississippi floodplain shows how the river forces its neighboring environment to adapt to it.

Other Poems. Likewise Henry Wadsworth Longfellow composed *Evangeline* after seeing the multimedia performance. "We want a national epic that shall correspond to the size of the country," Longfellow wrote in his novel *Kavanaugh*, "that shall be to all other epics what Banvard's panorama of the Mississippi is to all other paintings—the largest in the world."

The sold-out Boston crowds encouraged Banvard to bring his painting to New York City and London, and the money kept pouring in. Queen Victoria requested a private showing of "The Three Mile Painting" at Windsor Castle, generating a firestorm of publicity. The show even traveled to Paris where Banvard was accorded a feting worthy of Benjamin Franklin. In 1852 he returned to America with the reputation of being the first millionaire artist in history. P.T. Barnum, astounded by the financial bonanza the painting was reaping, quickly had a similar panorama done of the Nile River. Panorama mania swept America.

But the money soon went to Banvard's head, Collins reported. Banvard decided to build a massive museum in Manhattan so his Mississippi River painting could be seen by more and more people. He had built an extravagant auditorium, which seated 2,000. Although the museum opened to great fanfare on June 17, 1867, it went bankrupt within ten weeks. Creditors now chased after Banvard the way autograph seekers had come for him a decade before. Unsure of what to do, Banvard and his wife fled to the village of Watertown, South Dakota, in the Great Plains. His huge canvas soon became a useless relic of a bygone era. The show was over and "The Three Mile Painting" fell into disrepair. The Watertown Opera House eventually acquired the canvas for a pittance and chopped it up into small sections to use for local stage productions. Other portions of the moving masterpiece were used to insulate Dakota houses from the winter cold. The once celebrated artist spent his declining days penning some 1,700 poems—only a handful of them, however, were published. He died in 1891 a pauper but knowing that his "Three Mile Painting" did as much to popularize the Mississippi River as did Mark Twain's books.

In keeping with Banvard's grand portrayal of the Mississippi, a 2001 achievement by New Orleans painter Alan Gerson is "Riverun." His 2-by-77-foot painting of a river passing through an imaginary city is modeled predominantly on the Mississippi as it passes through New Orleans, Memphis, Cairo, and St. Louis. Gerson's idea was to paint a visual novel that would show the complexities of life surrounding a river. The title "Riverun" derives from James Joyce's novel *Finnegan's Wake*, and Gerson considered dozens of literary metaphors ranging from Heraclitus, who never stepped in the same river twice, to Huck Finn getting lost on the current of the Mississippi, to Albrecht stealing gold from the Rhine maidens. "Riverun" is modeled on diverse aspects of the Mississippi River, and Gerson's style draws from such painters as Grant Wood, George Grosz, Max Beckman, and Charles Steeler. The scope of the contiguous series of horizontal paintings is monumental, and unexpected. There is an odd Southern surrealist, or magical-realist, quality to Gerson's art that evokes a place, described by one critic, "where Kafka meets Twain." It's the melding of these two philosophical outlooks that makes "Riverun" an important achievement: Gerson takes the absurdist, existential vision of Kafka and applies it to the romantic notion of the Mississippi, which Twain forever etched on the American imagination with a steamboat pilot's smile.

One old frontier settlement that Banvard sketched some 70 miles downriver from Cairo was New Madrid, Missouri. The quiet town of 3,200 sits at the north end of a sinuous horseshoe curve in the Mississippi, which turns north nearly 180 degrees. Known as the Kentucky Bends, it is one of the

widest parts of the river. Dense timber and natural river sloughs provide marvelous hunting and fishing opportunities, and also a chance to study such species as the Bald Eagle, Mississippi Kite, and Swainson's Warbler.

Although the town's setting is idyllic, its past is not. New Madrid is etched in the annals of seismic history as the epicenter of the infamous 1811-12 earthquakes whose tremors jarred people as far away as Virginia—where Thomas Jefferson was awakened in his sleep—and Washington, D.C., where church bells suddenly started ringing. Tourists now come to New Madrid to buy T-shirts with sayings like "It's Our Fault," and swim in nearby Reelfoot Lake in northern Tennessee where land caved in, and water filled the crater.

But there was nothing humorous about the New Madrid earthquakes when they hit. "The earth began to shake and totter to such a degree that no persons were able to stand or walk," eyewitness Godfrey Lesieur told a reporter shortly after the first quake. "This lasted perhaps for one minute, and the earth was observed to be as if it were rolling in waves of a few feet in height, with visible depressions between."

The earthquakes dramatically altered the terrain. Plumes of sand and water spouts were shooting up from the ground like Yellowstone geysers, some 30 feet in the air. The initial quake triggered waterfalls in the Mississippi and, in one section, caused the current to run backward for three days. There was one 100-mile tract from New Madrid to Marked Tree, Arkansas, where liquefaction occurred, causing lowlands to flood and the earth surface to fissure.

"The ground rose and fell in successive furrows like the ruffled waters of a lake," naturalist John J. Audubon, who was drawing in the region at the time, recorded in his journal. "The earth waved like a field of corn before a breeze." Unlike most earthquakes in which the initial jolt is the largest, there were three main shocks of near equal proportion:

December 6, 1811; January 23, 1812, and February 7, 1812, estimated at a magnitude of more than 8 on the Richter scale. Damaging aftershocks continued intermittently for more than a year.

Seismographs were nonexistent in the 19th century, but it's believed the New Madrid quakes exceeded in magnitude the worst ones California experienced in the 20th century. Which raises the question: Are residents of the Mississippi River Valley today susceptible to experiencing another serious earthquake? The answer is—yes. But studying the fault lines is extremely difficult for, unlike the San Andreas Fault, the ones that run approximately from Memphis to St. Louis along the Mississippi are buried under thick layers of sediment. Arch C. Johnston, a seismologist at the University of Memphis, is now studying the 1811-12 quakes, trying to determine the likelihood of another geological disaster in the future. Along with some colleagues, Johnston has recently discovered that the fault that created Reelfoot Lake is at least three times greater than previously thought.

"When you think about it, it sounds pretty outrageous that the greatest river in North America was faulted three times by an earthquake, creating waterfalls or rapids in the Mississippi," Johnston says. "But their descriptions were pretty accurate. It's like they had been telling us all along where the fault was, but it was just last year that we found it."

Ever since the Loma Prieta quake of 1989 wreaked havoc in the San Francisco Bay area, Californians have taken measures to protect themselves from the next rumble. Towns within the quake zone of Cairo and New Madrid are not prepared, believing these freakish events would not happen again. This is a mistake. Most structures in the region could not withstand even a moderate earthquake. The prospect of collapsing freeway overpasses and severe flooding is real. Sparsely populated or nonexistent during the New

Madrid quakes, the cities of St. Louis, Memphis, and others in the Mississippi Valley risk massive destruction when the next great quake shakes this seismic zone.

About a hundred miles from Cairo the town of Ste. Genevieve, Missouri, was once considered the gateway to the wilderness west of the Mississippi. French settlers came to the region in the early 1700s to farm. It soon became a stopover for explorers and would have surpassed St. Louis in size if not for constant flooding. Moses Austin, who introduced new methods for mining and smelting lead in Ste. Genevieve, kept a journal, which offers the optimism of the frontier settlement in 1797. Excerpts of his journal in the *American Historical Review* described the town: "Ste. Genevieve is about two miles from the Mississippi on the high land, from which you have a commanding view of Country and River.... The old Town stood immediately on the bank of the River in an Extensive plain but being Sometimes overflowed by the Missisipe and the Houses washed into the River by the Falling of the Bank. It was thought advisable to remove the Town to the heights. The Place is small, not over 100 Houses, but has more Inhabitants than Kaskaskia and the Houses are in better Repare, and the citizens are more Wealthy. It has some Indian Trade, but what has made the Town of Ste. Genevieve is the Lead and Salt that is made Near the place, the whole of which is brought to Town for Sale, and from thence Shipped up and Down the River Missisipe.... When the Lead Mines are properly worked, and

BANVARD;
OR THE
ADVENTURES OF AN ARTIST;
A Biographical Sketch.

LONDON:
PRINTED BY REED AND PARDON
PATERNOSTER ROW.

Muralist John Banvard
courted fame and fortune with
a three-mile-long painting of the Mississippi.

the Salt Springs advantageously managed, Ste. Genevieve will be a place of as much Wealth as any on the Missisipe."

Wandering around Ste. Genevieve today, it's hard to imagine that the town was once prosperous. Many downtown storefronts are boarded up, and limestone dust from local quarries is omnipresent. Constant flooding made the town an unappealing place to live. It also became clear that the key to trade in the upper Mississippi Valley would be proximity to the mouth of the Missouri, a fact Pierre de Laclede acted on when he founded St. Louis. Among the crumbling buildings are a few gems in need of historic preservation. The Jean Baptiste Valle House, at the corner of Main and Market Streets, was the home of the last commandant of colonial Ste. Genevieve, serving as the Spanish government office until the Louisiana Purchase transfer. The Dufour House on Merchant Street was built by Parfait Dufour, a scout for Lewis and Clark, and an old fur trading post still stands on Second Street. There is hope that the National Park Service can rescue these sites. For like most of the historic towns between Memphis and St. Louis along the Mississippi, neglect reigns supreme. "Indifference has been an active destroyer," preservationist Neil H. Porterfield explains. "Ste. Genevieve has witnessed the deliberate destruction of its historic buildings. The pioneer spirit that called to new settlers lies buried in this town. But it is still recognizable. As the Mississippi prevails in its strength, communities like this along its banks deserve the preservation of their historical heritage." ★

CHAPTER EIGHT

ST. LOUIS

★

"I do not know much about gods; but I think that the river Is a strong brown god—sullen, untamed and intractable...."

T.S. ELIOT

Old St. Louis, represented by its domed Court House, shares ground with the city's newest structure in the making in the 1960s—the Jefferson National Expansion Memorial. The Arch—which opened in 1968—celebrates St. Louis's history as the Gateway to the West.

ON JANUARY 10, 1899, VARIOUS REPRESENTATIVES OF THE 13 STATES carved from the Louisiana Purchase territory gathered in St. Louis at the Southern Hotel for a bold decision. Two years earlier the Missouri Historical Society and a handful of newspapers had agitated for a plan to properly celebrate the 100th anniversary of the territorial acquisition by Thomas Jefferson. Citizens from these states offered numerous suggestions on how to commemorate a diplomatic event of such magnitude, ranging from reenacting the Lewis and Clark Expedition to simultaneous fireworks displays in all the state capitals. But at the Southern Hotel, a blue-ribbon committee made a decision they never regretted: They would have a World's Fair in St. Louis to be called The Louisiana Purchase Exposition, with the U.S. Government as co-sponsor. Their goal was nothing less than creating an electrical city "wherein will be displayed all the achievements of science, art, and industry with which the world begins the 20th century."

During the next few years excitement over the fair grew. The committee had raised $15 million for stock in the Louisiana Purchase Exposition Company—$5 million from the U.S. Government, $5 million from the city of St. Louis, and $5 million by popular subscription. After much debate, St. Louis set aside 1,240 acres in Forest Park to turn into a magical city able to accommodate nearly 20 million visitors from some 50 countries. They built three hotels for the grand opening and expanded others. Rand McNally and Co. published a guidebook of the fair grounds so visitors could find their way around.

In a surreal burst of imagination, this bustling Mississippi River port erected villages depicting the

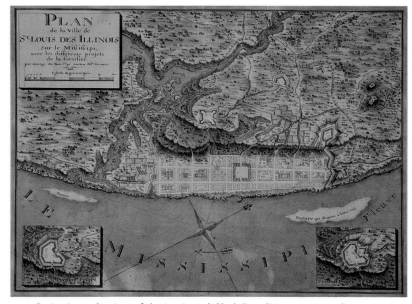

St. Louis, at the time of the Lewis and Clark Expedition, was a trading post of barely a thousand people. The French had built fortifications along the river to deploy troops in case their interests were threatened.

Tyrolean Alps and the rain forests of the Philippines, Zen gardens of Japan and the Holy City of Jerusalem, Indian pueblos and Inuit villages. Gondoliers from Venice came to pole their craft over a mile of waterways. Visitors could rent roller chairs powered by a "propeller" to drive them around the park. The main gate led to the 600-foot-wide plaza of St. Louis with an imposing plaster statue of St. Louis of France to welcome visitors. At the other end of the plaza, at the Great Basin, rose the Louisiana Purchase Monument, created by E.L. Masqueray, a 100-foot-high column on a 55-foot-wide base, topped by a sculpture of peace. All the statuary within the fair compound related to the human or natural history of the Louisiana Territories. The south side of the

monument was decorated with statues of Robert Livingston, James Monroe, and other figures associated with the signing of the Louisiana Purchase in Paris. Additional sculptures around the base represented the Mississippi River. Because ambitions ran so high, the fair—slated to open in April 1903—had to be postponed for a year. But it was worth the wait. Never before, or since, has an American exposition created such grandiose displays.

The focal point of the fair was Festival Hall, with a gold-leafed dome larger than the one on St. Peter's Basilica in Rome. The auditorium held 3,500 people and boasted the world's largest organ with 10,159 pipes. (After the fair, the organ was dismantled and shipped by train to Wanamaker's Department Store in Philadelphia. That's where it is today, still considered the largest pipe organ in the world, although the store is now a Lord & Taylor branch.) During the World's Fair, the Festival Hall—designed by New York architect Cass Gilbert—was the site of the first international peace conference, 15 years before the League of Nations was founded after World War I. In front of Festival Hall, the Centennial Cascade, spouted water high into the air, flanked by two smaller cascades that descended from the East and West Pavilions. These pavilions housed some of the fair's most memorable restaurants, including one German and one Italian one.

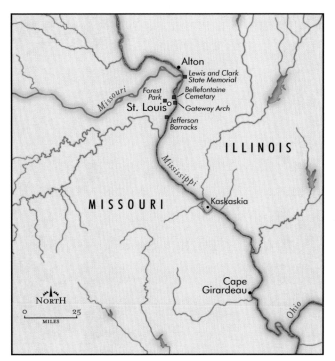

At St. Louis, Missouri, the powerful Missouri River joins the Mississippi. From here in 1804 Lewis and Clark explored the Louisiana Purchase.

Culinary historians credit the St. Louis World's Fair for inventing American fast food. Besides 45 sit-down restaurants, there were 80 fast-food vendors who introduced hot dogs, ice-cream cones, and iced tea. So-called health food concession stands offered a medicinal new soda called Dr. Pepper and the high-protein spread peanut butter. A popular dessert introduced at the fair was pink spun sugar sold as fairy floss, soon to be known as cotton candy.

But food was secondary to the technological marvels unleashed at the fair. The Sage of Menlo Park—Thomas Edison—came to St. Louis to set up mind-boggling electrical exhibits which signaled the dawn of the 20th century. "It shines with a brightness too high to grasp," an observer noted in his diary about the Palace of Electricity. Visitors were thrilled to be able to make telephone calls from the fairgrounds to Chicago or New York. Researchers demonstrated new high-tech methods of dairy breeding and corn growing. A company showcased an electric broiler, which could cook both sides of a rib-eye steak in six minutes. More than 140 different automobiles arrived at the fair for visitors to test-drive, compliments of upstart companies like Ford Motor and Packard. Air-conditioning also debuted at the fair, which changed many people's lives, particularly those living south of the Mason-Dixon line. And the most miraculous of all, when darkness blanketed St. Louis, a few switches would be

flipped on, and more than half a million electric light bulbs would suddenly illuminate the fairgrounds. Sweeping searchlights with changing colors brought oohs and aahs from the tourists who came from virtually every hamlet and town in the United States to see for themselves the miracle of St. Louis.

The most celebrated visitor was President Theodore Roosevelt, who delivered the fair's inaugural address on April 30, 1903. He paid homage to the so-called Spirit of St. Louis, particularly the architectural and technological marvels in progress, but mainly his speech was a powerful oration on the historical significance of the Louisiana Purchase and the need for pioneer values in American life.

"We have met here today to commemorate the 100th anniversary of the event which more than any other, after the foundation of the government and also excepting its preservation, determined the character of our national life," President Roosevelt said of the Louisiana Purchase, urging that America continue to expand. "[Continental expansion] stands out in marked relief even among the feats of a nation of pioneers, a nation whose people have from the beginning been picked out by a process of natural selection from among the most enterprising individuals of the nations of Western Europe. The acquisition of the territory is a credit to the

The Observation Wheel, now popularly known as the Ferris wheel, for its inventor Samuel J. Ferris, was one of the attractions at the World's Fair in 1904.

broad and far-sighted statesmanship of the great statesmen to whom it was immediately due, and above all to the aggressive and masterful character of the hardy pioneer folk to whose restless energy these statesmen gave expression and direction, whom they followed rather than led. The history of the land comprised within the limits of the Purchase is an epitome of the entire history of our people."

Coinciding with the World's Fair were the 1904 Olympic Games, which St. Louis hosted. It was the first Olympic competition held outside Europe, and American athletes made their mark. International participation was low, and the United States swept the medals in the track and field 100-yard and 220-yard sprints, as well as the 26-mile marathon. The event promoted national awareness of the Olympic Games, which until then had been a preoccupation of the Eastern elite.

Before the World's Fair and Olympics, St. Louis had a reputation for being an unruly city. Founded in 1764 as a fur trading post by Pierre de Laclede and René Auguste Chouteau, it was named after royalty: King Louis IX, who was canonized in 1297, and became the patron saint of then-reigning Louis XV. But St. Louis never captured the essence of European grandeur. It was a frontier outpost whose main post-Louisiana Purchase attraction was the Jefferson

On peak days, more than 400,000 visitors swelled the avenues of the 1904 Louisiana Purchase Exposition for a chance to see the world come to St. Louis.

Barracks, established as the primary station for military troops heading west.

In a *Harper's* magazine article on the 1904 fair, George Leighton summed up an impression of the river port. "Between 1890 and 1900, St. Louis produced 60 millionaires and saw its public services go to ruin," he wrote. "The city water was undrinkable; the city streets were strewn with craters; the city hospital was an unfinished scarecrow, a monument to thievery." The great muckraking editor of *McClure's* magazine, Lincoln Steffens, called St. Louis "the worst governed city in the land." Quite simply, the World's Fair and Olympics of 1904 put St. Louis on the map as an international city. So it made sense that the next generation of St. Louis's leading citizens wanted to find another, equally extravagant way to celebrate Westward Expansion.

The Jefferson National Expansion Memorial—commonly called the Gateway Arch—was first conceived in the early 1930s when Luther Ely Smith, a wealthy St. Louis attorney, served on a federal commission to build a monument to Revolutionary War-hero George Rogers Clark in Vincennes, Indiana. Smith came home and lobbied mayor Bernard Dickmann, insisting that St. Louis erect "...a suitable and permanent public memorial to the men who made possible the Western Territorial Expansion of the United States, particularly President Jefferson." The problem with the World's Fair, Smith believed, was that it only celebrated the Louisiana Purchase on its centennial. What St. Louis needed was a signature memorial like the Eiffel Tower in Paris or the Statue of Liberty in New York. A nonprofit, nonpartisan group of civil leaders formed to decide on building a monument to Thomas Jefferson's American vision.

Squabbles at once ensued. America was in the throes of the Great Depression, unemployment had reached 11 million, and finding millions of dollars from either the federal government or the private sector was no easy task. But President Franklin Roosevelt liked the idea, and after some intense negotiations, the newly formed Jefferson National Expansion Memorial Association obtained an agreement that the National Park Service would manage the new memorial. The association acquired land along the Mississippi by condemnation of old buildings rather than purchase. With the exception of the Old Courthouse, the Old Cathedral, and the Old Rock House, the riverfront was in a state of disrepair. The memorial was seen as an urban revitalization project, reclaiming the Mississippi as the heart of St. Louis. A crucial first step in this process was removing the elevated railroad viaduct along the river's edge.

Just as the association had worked its way through a maze of financial arrangements and legal ordeals, World War II broke out, and everything was put on hold. As soon as the war ended, Smith raised $225,000 to launch an architectural competition for the Jefferson Expansion Memorial. He believed the memorial needed a central feature like a shaft or arch, something "spiritual" that would celebrate American civilization. With egalitarian gusto the competition began on May 30, 1947, and was deemed open to all architects, landscape architects, sculptors, and painters who were citizens of the United States. The winner was Eero Saarinen, whose design of a giant stainless steel arch was considered perfect in both form and symbolism.

Saarinen was born in Finland in 1910, his father a respected architect, his mother a sculptor, weaver, and photographer. At age 12 Saarinen won his first contest: a matchstick design competition in Helsinki. The following year, in 1923, the family immigrated to the United States. They settled just north of Detroit, where the father headed the Cranbrook Institute of Architecture and Design. Although Eero studied architecture at Yale University and in

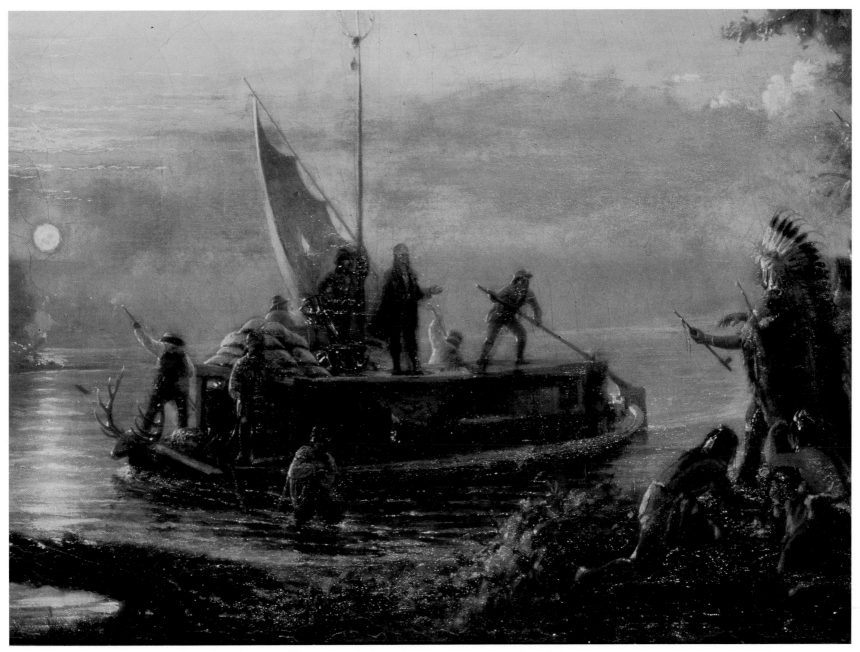

Indians greet a boat of trappers, set with the task of building the settlement of St. Louis, as they pole their way to the western Mississippi shore
in a romanticized painting by August Becker. The placement of the town, whose first permanent dwellers arrived in 1764, proved somewhat ill-advised.
The territory west of the river had secretly been ceded to Spain two years earlier. St. Louis's culture remained French although technically it was part of New Spain.

Europe, gaining a reputation for innovation and competence, he remained trapped under the large shadow cast by his father. Returning to Cranbrook to teach, he was looking for an architectural project that would showcase his individuality. He therefore entered the St. Louis competition with great enthusiasm, anxious to build not just a memorial to Jefferson but to the dynamism of the "American Dream." "The major concern," Saarinen later reflected, "was to create a monument which would have lasting significance and would be a landmark of our time.... Neither an obelisk nor a rectangular box nor a dome seemed right on this site or for this purpose. But here, at the edge of the Mississippi River, a great arch did seem right."

It took two decades to bring Saarinen's 630-foot stainless-steel-faced arch from blueprint to reality. Like all such ambitious undertakings, legalities and funding slowed the process down. The groundbreaking for the arch took place on June 23, 1959, but it was not officially dedicated until May 25, 1968. Today it draws more than 3.5 million visitors annually. The Arch is everything Smith decreed it should be: a memorial to Jefferson, the Louisiana Purchase, Westward Expansion, and modernity—soaring into the sky from the west bank of the Mississippi. The Arch became a symbol of the city and a celebration of its people. And the world took notice of the architect: He was commissioned to design the General Motors Technical Center near Detroit; the TWA Terminal and the CBS Headquarters building in New York City; the Dulles International Airport near Washington, D.C.; the U.S. Embassies in London and Oslo; the David S. Ingalls Hockey Rink at Yale University; and numerous other architectural gems. Unfortunately Saarinen died of a brain tumor in 1961, and never got to see all his projects completed. But his vision lives on in the structures he created.

"The Gateway Arch marked the beginning of a new life for countless pioneers," National Park Service historian Michael A. Capps has written. "The desire was to move boldly toward the future. The Arch is ultimately a monument to all those with a vision—Thomas Jefferson, the American pioneers, and Eero Saarinen."

Within blocks of the Gateway Arch stands a rather nondescript modern office building, which is the home of the true bible of all men and women who earn a living on the Mississippi River: *The Waterways Journal*, a weekly publication since 1887. From editor John Shoulberg's office you have a view of a large grain elevator on the Illinois bank of the river and the many commercial and recreational vessels that travel up and down the Mississippi past St. Louis.

The original name of the newspaper was *The River*; it became *The Waterways Journal* with the April 9, 1892 issue. Reading old copies of the *Journal* offers insights into what life was like for watermen. There are stories about levee building, steamboat wrecks, floods and cyclones, employment opportunities, Corps of Engineers projects, oil spills, Bald Eagles, and motorboat racing. During its first decades, the *Journal* published news columns from various communities with such titles as Cairo Cullings, Paducah Plucks, Hill City Hits, and Galliopolos Gossip. Many writers used pseudonyms for their columns with names like Buck E. T. Plank, Tom Sawyer, Coal Shovel Bill, or Huckleberry Finn. The authors were often riverboat captains. When Walt Disney opened Frontierland in Disneyland at Anaheim, California, he had as a main attraction a replica steamboat named *Mark Twain*. Hanging prominently in the pilot's cabin was a framed copy of the first edition of *The Waterways Journal*.

Today you can board almost any commercial vessel on the Mississippi and find a copy of the venerable glossy. Recent stories have included a profile of the Sons &

Daughters of Pioneer Rivermen (S&D); a report on a new inland container ship capable of carrying 566 40-foot containers that will fit in most river locks, and an exposé on the heroic role the U.S. Coast Guard plays in keeping the Mississippi safe for recreational boating. After the World Trade Center and Pentagon terrorist attacks of September 11, 2001, *The Waterways Journal* published a series of "Loose Lips Sink Ships" editorials discussing the need for tighter river-port security.

During World War II the government turned to manufacturing vessels at shipyards along the Mississippi, to avoid enemy attacks on coastal facilities. "In a sense, the inland waterways came to the defense of the nation," one editorial said. "The best thing we can do now is to react to this new war by making certain that our waterways will not be devastated by terrorists. Businesses everywhere should sort out the weak spots in their operations and fix them."

Whereas the Gateway Arch is named after Thomas Jefferson—who never saw the Mississippi—it should also be viewed as a memorial to Meriwether Lewis and William Clark. The two explorers came to St. Louis in December 1803—on the outbound voyage to the Pacific. Lewis later lived in the city from March 1808 until his fated journey east in September 1809. Clark remained in St. Louis from 1808 until his death in 1838. Clark is buried there. Lewis and Clark spent much more time living on the banks of the Mississippi than they had on the Missouri and Columbia rivers—with which they are linked through their epic voyage.

The two explorers came to the Mississippi when everything west of the river in Upper Louisiana belonged to Spain. They saw St. Louis in its infancy, and watched it grow. Other members of the Corps of Discovery settled in St. Louis or nearby. There is no better place to tell some of the stories of Lewis and Clark than in St. Louis.

On November 20, 1803 the Corps of Discovery first moved up the Mississippi. They had come down the Ohio in their keelboat and pirogue and now turned upriver, against the current. Over the next few days, the men worked their craft upstream, seldom making more than one mile per hour. Even more maddening, the river twisted and turned to such an extent that today's 25 air miles to Cape Girardeau were 48 river miles. It took four days to reach the Cape.

Louis Lorimer had founded the town some 20 years earlier. Lewis called on him; told that Lorimer was at a horse race, Lewis went there. "The scene reminded me very much of their small raises (races) in Kentucky among the uncivilized backwoodsmen...; they are men of desperate fortunes, but a little too loose in either character or property," he noted.

On November 28, the expedition reached the army post at Kaskaskia, on the Illinois side, some 60 miles below St. Louis. On December 12, the expedition got to the mouth of Wood River Creek, across from St. Louis. There Clark set up winter camp. Lewis was in St. Louis to meet with the Spanish lieutenant governor of Upper Louisiana, Lt. Col. Carlos Dehault Delassus. The transfer of the territory from the Spanish back to the French and then to the Americans would not take place until the spring of 1804, and Delassus was still in command. Lewis told him that the objective of his expedition was to explore the Missouri country, purely for scientific purposes. Delassus told his superiors, "According to advices, I believe that his mission has no other object than to discover the Pacific Ocean, following the Missouri, and to make intelligent observations, because he has the reputation of being a very well educated man and of many talents."

St. Louis was 40 years old, with a population of a little under a thousand, mainly French. The town was central to

A weathered stone fort, serving as a 19th-century granary, stands as a lonely reminder of the Spanish era near St. Louis along the Mississippi.

the fur trade for the huge region drained by the Missouri and the upper Mississippi. Most of the trade goods for the Indians came across the Atlantic Ocean, then traveled up the Missisippi from New Orleans or downriver via the Great Lakes from Montreal to reach St. Louis. From there the goods fanned out via individual traders, who paddled their canoes to the farthest reaches of the frontier. They returned with stacks and stacks of beautiful furs that brought a king's ransom in Europe. St. Louis was bursting with trade.

Lewis did a survey, the first survey done by an American of any part of the Purchase. He consulted with Antoine Soulard, the surveyor general of Upper Louisiana for the Spanish. Soulard told Lewis that the 1800 census recorded a population of 7,215 in Upper Louisiana, 1,195 of whom were slaves. Perhaps half of the whites were Americans.

What Delassus and Soulard saw, Napoleon had come to realize as well. There was no force on earth that could stop the flow of American pioneers westward. Good, cheap land was a magnet that reached all the way to Europe. The pioneers were the cutting edge of an irresistible force. Rough and wild though they were, they were the advance of millions of Europeans who would follow in a mass migration.

The Louisiana Purchase opened to Americans and Europeans a vast territory. The formal transfer of Upper Louisiana to the United States would speed the flow of Americans crossing the Mississippi River to take up new lands, or go into business, or trap furs, or whatever excited the imagination. The characteristics of the Purchase land were virtually unknown to geography, because—except for the Native Americans—it was uninhabited. The myth arose that the Purchase lands were almost a Garden of Eden.

Lewis and Clark were Thomas Jefferson's exploring eyes and ears. Lewis began in March 1804, when he sent boxes of natural-history specimens to the President. He included

cuttings from trees owned by businessman Pierre Chouteau, who had gotten them from an Osage Indian village 300 miles west of St. Louis. Lewis named the tree "Osage apple" (today called Osage orange). The fruit was never eaten, Lewis explained, but the wood was perfect for making bows.

On March 9, 1804, the ceremony took place for the formal transfer of Upper Louisiana. Lewis acted as America's chief official witness. There were detachments of 30 Spanish soldiers and American troops from Fort Kaskaskia under the command of Capt. Amos Stoddard. When the Spanish flag was struck, Colonel Delassus folded it and presented it to Stoddard, who then ran up the French flag. The crowd, composed of nearly all the French residents of St. Louis, cheered. With tears in their eyes, the French asked the Americans if they could allow their flag to wave over St. Louis for one night. Stoddard agreed. On the next day the Stars and Stripes was raised.

Lewis returned to the camp across the river on March 31, 1804, for a ceremony to enlist 25 men he and Clark had selected to be members of "the Detachment destined for the Expedition through the interior of the Continent of North America." Thus was the Corps of Discovery formed. Today you can visit the Lewis and Clark State Historic Site in Hartford, Illinois, and see a monument that marks the point where Lewis and Clark set off on their epic journey to explore the West. The monument overlooks the confluence of the Mississippi and Missouri rivers.

It was to this confluence that the Corps of Discovery looked each morning. They saw the Missouri pouring into the main stream, so powerful, its muddy waters driven clear across three-quarters of the width of the mighty Mississippi, the Missouri being the more powerful of the two. Not until May was the party ready to launch its trip westward. In early May 1804, while Lewis was in St. Louis, he received Clark's

commission from the War Department. It was for a lieutenant, not a captain. Lewis was mortified. He had given his word that they would be co-commanders. He immediately wrote Clark, "I think it will be best to let none of our party or any other persons know any thing about the grade." This was done. The men of the Corps of Discovery addressed both Lewis and Clark as captain, and the two shared the command throughout the expedition. In December 2000, President William Jefferson Clinton promoted Clark to full captain, to date from March 1804. Clinton also gave Clark's slave York the rank of sergeant in the Army.

On May 14, 1804, Clark wrote in his journal, "fixing for a Start." He was about to leave the Mississippi behind. That afternoon they shoved off at four o'clock, "under a jentle brease," crossed the Mississippi, and entered the Missouri, to begin their long journey that would blaze the first American path across the North American continent.

Meriwether Lewis (left) and William Clark used St. Louis as a staging area for their Voyage of Discovery, exploring the length of the Missouri River and continuing west to the Pacific Ocean.

More than two years later, on September 23, 1806, the returning expedition's canoes swept out of the Missouri and back into the Mississippi. Seeing the armada, the residents of St. Louis ran to the bank. The enlisted men asked permission to fire a salute. Lewis granted it. The residents gave three cheers and a hearty welcome. As the canoes swung into shore, the locals pounded the men on their backs and asked never-ending questions. One resident reported, "they really have the appearance of Robinson Crusoes—dressed entirely in buckskins."

The site where they landed is near the middle of the 630-foot stainless steel Arch that today rises from the river. Two and a half years before, at the start of their expedition, the Stars and Stripes had gone up in St. Louis. Now the men who had planted that flag for the first time on the Pacific Coast, in November 1805, came back to St. Louis.

Lewis and Clark went East, to report and be honored. Jefferson appointed Lewis to the post of Governor of Upper Louisiana Territory and Clark to Brigadier General of Militia and Superintendent of Indian Affairs for the territory. The headquarters were in St. Louis, and they returned there in 1808.

The writer Washington Irving described the city at the time of Lewis and Clark's expedition: "Here to be seen were the hectoring, extravagant, bragging boatmen of the Mississippi, with the gay, grimacing, singing, good-humored Canadian voyageurs. Vagrant Indians of various tribes loitered about the streets. Now and then a stark Kentucky hunter, in leather hunting-dress, with rifle on shoulder and knife in belt, trode along. Here and there were new rich houses and ships, just set up by bustling, driving, and eager men of traffic from the Atlantic states; while, on the other hand, the old French mansions, with open casements, still retained the easy, indolent air of the original colonists."

The Spanish were still present as well. Here, midway along the river, sprang up a city that was leading the way west. St. Louis was a frontier town, the farthest outreach to the

west of American civilization. But because the river gave St. Louis access to the world, and its inhabitants were a mix of three nationalities, it had the air of a true cosmopolitan city. The 1,000 citizens of 1803 had grown to 5,000 by 1808.

It was a city of contrasts. The Spanish and French merchants led princely lives. They had huge tracts of land and enjoyed a lavish lifestyle. The great majority of the population, meanwhile, was illiterate and owned little. The men were mainly boatmen, the essential industry of St. Louis. It was their muscle power that made it possible for the merchants to move goods upriver. The boatmen were always in debt to their bosses, who often treated them badly.

A swelling number of young Americans were taking their risks in the West. One of Lewis's gubernatorial aides warned him, "We have among us a set of men turbulent and ungovernable in their dispositions, which I believe may be accounted for, from that spirit of enterprize and adventure which brought them first into the country."

Lewis's duties as governor put him in contact with men who had been or would be famous, most notably Daniel Boone and Moses Austin. Boone had lived on the banks of the Missouri before Lewis and Clark passed through, and

The Stars and Stripes went up as the French flag came down in the central square of St. Louis in 1804. The ceremony marked the transfer of the northern Louisiana territories from France to the United States.

Lewis appointed him magistrate of the Femme Osage district. Lewis had various dealings with Austin, who held lands southwest of St. Louis that were rich in lead. But Lewis was a bad politician and a sick man besides. On September 4, 1809, he traveled down the Mississippi on his last voyage.

Clark's post-expedition life in St. Louis was one of eminence, pleasure, and meeting his responsibilities. During his more than 30 years as Superintendent for Indian Affairs, he was so trusted by the Indians west of the Mississippi River that there were no Indian wars. The Indians called him the "red-headed chief." He made a controversial peace with the Osage tribe that lasted; he built Fort Osage on a bluff near modern-day Independence, Missouri. In 1813 Clark became governor of the newly formed Missouri Territory. He led volunteers in several military campaigns during the War of 1812. He traveled up the Mississippi to create forts, including the first in what is now Wisconsin. He was also surveyor general for Illinois, Missouri, and Arkansas. In 1828 he plotted the site of Paducah, Kentucky. Clark had to sign a pass to anyone going up the Missouri—without it, no trip. West of the Mississippi he had more power than the President of the United States.

He had many famous visitors, including the Marquis de Lafayette, the German Prince Maximilian of Wied, the artists George Catlin and Karl Bodmer, and mountain man William Sublette.

Clark maintained close relations with the expedition's guide Toussaint Charbonneau, his Indian wife Sacagawea, and their son Jean Baptiste Charbonneau. They bought a farm from Clark near St. Louis. Clark put the boy, whom he called Pomp, into a school, where he began to learn. After some months there, Charbonneau and Sacagawea left to help build Fort Manuel on the upper Missouri River. Correspondence from the fort's commander shows that Sacagawea died there in 1812, at 25 years of age.

Clark eventually adopted their daughter Lizette; there is a document of the St. Louis orphans court proceedings that records the adoption. Pomp got his education and went on to an adventurous life, traveling through the West and Europe, and finally living in California. Charbonneau lived on the upper Missouri, where Clark provided him with jobs in the fur trade and in the Indian Service as an interpreter.

Clark, with his wife, Julia Hancock Clark, and their son, Meriwether Lewis Clark, lived out his life on the Mississippi River. He died on September 1, 1838 and was later re-interred at Bellefontaine Cemetery in St. Louis, a sanctuary noted for its beautiful trees and ornate tombstones. On Clark's towering monument, first unveiled in 1904 during the World's Fair, are inscribed these words: "His life is written in the History of His Country" and a passage from the Bible (Deuteronomy 1:21): "Behold, the Lord thy God hath set the land before thee: go up and possess it."

Bellefontaine Cemetery got its start in 1849 when a group of St. Louis citizens formed the Rural Cemetery Association and incorporated the hilly 138-acre burial ground located at 4947 W. Florissant Avenue. Many curves in the roadways and large oak trees provide the cemetery with the aura of a city park. It was loosely modeled on Mount Auburn cemetery in Boston.

Besides William Clark, many illustrious men and women are buried there, whose lives contributed to the westward growth of America following the Louisiana Purchase. We visited the graves of James Eads, whose St. Louis bridge, completed in 1874, was the engineering feat of the 19th century and the first bridge of steel construction to span the Mississippi, linking East and West; of Captain Henry M. Shreve, who developed the shallow-draft steamboat, which was riding on the water instead of plowing through it; and of Captain Isaiah Sellers, the most famous steamboatman between St. Louis and New Orleans for more than 40 years—the man to call out "mark twain," when measuring the depth of the river. The phrase gave Samuel Clemens the idea for his pen name. And we visited the grave of Senator Thomas Hart Benton.

Benton became the first Missouri Senator in 1821 when the state joined the Union, a position he held for 30 years. Benton's fight for gold and silver currency earned him the nickname Old Bullion. As a noted congressional orator and historian, he was a stout defender of the Union in Congress and supported Westward Expansion. He was responsible for the eastern portion of the Missouri Pacific Railroad starting at St. Louis, thus making the city a 19th-century railroad center. Infamously, he was also known for frequent duels. In a fight with lawyer Charles Lucas on Bloody Island in the Mississippi in 1817, he wounded Lucas in the first duel and mortally wounded him in the second one.

Besides Bellefontaine Cemetery, Blueberry Hill—a St. Louis bar and eatery near Washington University—honors other St. Louisans. In 1988 owner Joe Edwards created the St. Louis Walk of Fame, in which nearly 100 notables of St.

Louis, ranging from poet Maya Angelou to photographer Walker Evans, from painter Charles M. Russell to playwright Tennessee Williams, are honored with a large brass star on the sidewalks along the 6200-6600 blocks of Delmar Boulevard in the University City Loop. Edwards conceived the St. Louis Walk of Fame not only as a way of commemorating the citizens' many contributions, but also as a way of adding enrichment to an urban thoroughfare. Each year on the third Sunday in May, the induction ceremony of the Walk of Fame takes place on an outdoor stage next to Blueberry Hill. There is always a concert of ragtime and Dixieland jazz, followed by the keynote address and the induction of the honorees.

A featured star at the Walk of Fame is the city's most famous literary lion—poet T.S. Eliot—a leader of the early 20th-century modernist movement in poetry. Born on September 26, 1888 in a large house at 2635 Locust Avenue, Eliot spent much of his childhood contemplating the Mississippi and later drew upon it for inspiration in his poetry and drama. "I feel," Eliot wrote to a St. Louis newspaper, "that there is something in having passed one's childhood beside the big river which is incommunicable to those who have not."

The dapper son of Henry Ware Eliot, a manufacturer of bricks, and Charlotte Chanpe Stearns, a volunteer social worker and a novice poet, he attended Smith Academy, the preparatory department of Washington University, which had been founded by his paternal grandfather. Always infatuated with words, he contributed short stories and verse to the *Smith Academy Record.* Upon graduation in 1905 he was selected class poet, and then headed to Milton Academy in Massachusetts, before entering Harvard College in 1906. His mentors were the philosopher George Santayana and the critic Irving Babbitt.

"The river cast a spell over the entirety of my life," Eliot maintained. "It was always with me."

Raised in a strict upper-class Victorian household where puritan values prevailed, the young Eliot never romanticized steamboat pilots and river men as did the young Samuel Clemens. To him the river was not about people, it was a force of nature like the Atlantic Ocean he encountered during summers spent in Gloucester, Massachusetts. In later life he considered writing a book of childhood reminiscences to be entitled "The River and the Sea" —the two natural forces which infuse his poetry. One of his most mature monologue poems—"The Love Song of J. Alfred Prufrock"—was named after an old red brick furniture warehouse, which still stands in St. Louis along the levee. The imaginative fog in that poem was more likely soot from the factory chimneys, which lined the riverbank.

An 18th-century engraving depicts Daniel Boone,
the Kentucky frontiersman famous for exploring unmapped land.
He also helped open up the territories west of the Mississippi.

Symbolizing the transition from steamboat to railroad, the Eads Bridge, built in 1874, was the first steel-truss structure to span the Mississippi, turning St. Louis into a rail hub.

Foul water and poisoned air were stark realities of St.Louis's waterfront until the 1950s. Somehow, though, Eliot managed to see beyond the industrial haze.

Eliot's greatest reference to the river can be found in his deeply religious and philosophical poem: "The Dry Salvages," written in 1941, seven years before he won the Nobel Prize for literature:

I do not know much about gods; but I think that the river
Is a strong brown god—sullen, untamed and intractable....

Although Eliot believed that the Mississippi ran through his soul, he was never a champion of St. Louis, spending his adult life in New England, New York, and Great Britain. In a letter to philosopher Herbert Read, however, he explained that because of his Missouri origins he was never really a Yankee or a Tory. He called himself a "resident alien" in America and a "foreigner" in England. It was the Mississippi above all else that he clung to as a place of origin, the greatest reservoir of artistic inspiration he knew.

"The river itself has no beginning or end," Eliot wrote. "In its beginning it is not yet the river, what we call the headwaters is only a section from among innumerable sources which flow together to compose it."

There are so many sports legends included on the St. Louis Walk of Fame that it would take a book just to write about them. Henry Armstrong, for example, is the only boxer to hold world titles simultaneously in feather-, welter-, and lightweight class in one year. He grew up in St. Louis and was an honor student at Vashon High School. During the Great Depression he was known as Homicide Hank for dominating his opponents with his windmill style. Constant training and incredible stamina earned him 152 victories in 14 years. He retired from boxing in 1945,

returning to his hometown as a Baptist minister, training young boxers at the YMCA, and directing the Herbert Hoover Boys' Club. When the Boxing Hall of Fame opened in 1954, Armstrong was one of the first inductees.

The often forgotten James Thomas Bell also has a bronze star on the St. Louis Walk of Fame. African-Americans had been barred from playing Major League Baseball until 1947, when Jackie Robinson made his debut with the Brooklyn Dodgers and broke the color barrier. Until then, blacks played in the Negro Leagues, and "Cool Papa" Bell, so named because of his calm demeanor on the field, was perhaps the best in league history. Known as the fastest player on the St. Louis Stars, a powerhouse in the Negro National League, Bell was known to steal two bases on one pitch or score from second on a sacrifice play. Satchel Paige embellished on Bell's speed, claiming he "could turn off the light and be in bed before the room was dark." Bell batted .400 several times and stole 175 bases in one year. He was inducted into the Baseball Hall of Fame in 1974.

The most colorful sports figure is Yogi Berra. He was born May 12, 1925, and grew up on Elizabeth Street in the St. Louis neighborhood called the Hill. After serving in World War II, Berra played for the Yankees in the 1946 season and hit a home run in his first at bat. He led his team to win 10 of 14 World Series. Famous for his fractured English such as "It ain't over til it's over," he is often quoted as an offbeat philosopher. Berra was a three-time most valuable player and broke numerous world series records. As a coach, he led his teams to five World Series, winning three. In 1972, Yogi Berra was elected into the Baseball Hall of Fame.

But the greatest athlete to ever hail from the greater St. Louis area is Jackie Joyner Kersee. Born Jackie Joyner in East St. Louis, Illinois, on March 3, 1962, she became inspired by a 1975 television movie about Babe Didrickson

to compete in multiple athletic events. Beginning at age 14, she won four consecutive National Junior Pentathlon Championships and played volleyball and basketball. A basketball scholarship brought her to UCLA, where she earned All-American honors as a four-year starter at forward for the Bruins. Her UCLA coach, Bob Kersee, encouraged her to train for the multiple-event contests. She married Kersee in 1986 and began to set world records in long jump and heptathlon. In all, she won six Olympic medals, including two gold and a silver in the heptathlon. She moved back to the St. Louis area, and in 2000 opened her most prized accomplishment—a youth center bearing her name in East St. Louis. Jackie earned a reputation as the world's best all-around female athlete, and she is an inspiration to women around the world.

The pantheon of St. Louis musical greats at the Walk of Fame is also impressive, including dancer Josephine Baker, pop diva Tina Turner, and bluesman Albert King. But the indefatigable Chuck Berry trumps them all in one regard. When NASA launched the 1977 Voyager craft into space—which is now some 7.3 billion miles from Earth—its capsule cradled drawings of a man and a woman, a map of the solar system, copies of the United States Constitution and the Declaration of Independence, and a recording of Chuck Berry's 1958 hit single "Johnny B. Goode." The song was named for the guitar legend's birthplace, 2520 Goode Ave. (now Annie Malone Drive) in St. Louis, where his family

Memories of the Mississippi course through the poetic works of St. Louis native T.S. Eliot, photographed in the 1940s.

home once stood. On the eve of our 700-mile voyage up the Mississippi from St. Louis to St. Paul, which we took on the famed *Delta Queeen* steamboat, we decided that dinner with Berry, who lives just outside St. Louis in Ladue, would set the perfect all-American tone for our launch.

Dressed in a sky-blue sequined shirt, captain's cap, and comfortable black loafers, Berry, 73, was in a cheery mood when he greeted us at Blueberry Hill. He had just returned from a two-week stint in Europe, performing "Memphis" and "Back in the U.S.A." to sold-out audiences from London to Oslo. Berry was accompanied by James Williams, a self-effacing former truck driver who has been a loyal friend since childhood. We had come to talk with Berry about the Mississippi River, which has been a source of inspiration to him since his wild days at Simmons Grade School and Sumner High School, the first secondary school for blacks west of the river. The school's alumni also include Arthur Ashe, Robert Guillaume, Bobby McFerrin, and Dick Gregory.

"The river was just always there," Berry says about his relationship with the Big Muddy. "When you live here, you can't really ever get away from it." Through allusions to cars and the Greyhound bus in such songs as "No Particular Place to Go" and "Promised Land," Berry has created an artistic commentary on American life, its fluidity, is mobility, and the restlessness beneath its surface, much as Mark Twain did when writing about life on the Mississippi in *The Adventures of Tom Sawyer*.

Although Berry is best loved for his jackhammer guitar riffs, comical duck walk, and thunderous live performances, he is the poet laureate of St. Louis who, since 1955 has transformed everyday American realities—hot dogs, Coca-Cola, going to work, and adolescent love—into ageless pop masterpieces. At Blueberry Hill, in a glass case, hangs Berry's guitar, the Gibson ES-350T, on which he composed such hits as "Rock-and-Roll Music," and other sonic-beat songs that have become soundtracks to our frenetic lives.

Whereas that maple-necked guitar with its rosewood fingerboard, loop-style tailpiece, and stereo wiring is a historic relic, the exuberant Berry himself is not. Trim and muscular, he still plays guitar with a reckless, good-time abandon. Once a month, he performs at Blueberry Hill. Without Berry it's hard to imagine the Beatles, or the Rolling Stones, or U2. John Lennon called him "my teacher," and Brian Wilson described the Beach Boys sound as "Chuck Berry guitar with four freshmen harmonizing." At the height of the punk movement, Sid Vicious said that the Sex Pistols were just trying to "bring a modern version of Chuck Berry's music to a new generation of rockers."

It's the people of St. Louis who have swayed Berry to stay in his hometown, even when Hollywood and New York periodically beckon. "Sometimes I'm only gone for an hour and want to come right back," he says. "But there are other times when the river just hems you in." But Berry, an original inductee into the Rock and Roll Hall of Fame, has never abandoned the banks of the Mississippi.

When we departed Blueberry Hill, and Berry walked out into the sultry night air with his childhood buddy at his side, everybody dining at the outdoor cafes on Delmar Avenue glanced at him with warm smiles of recognition. They were not engaged in a celebrity sighting. They simply understood—with hometown pride—that Chuck Berry is St. Louis's finest, the rock icon with his star grounded underfoot and his incomparable music zooming far into space. Perhaps the true measure of Chuck Berry's impact on American culture lies engraved upon the disc of "Johnny B. Goode" which flies aboard Voyager.

"Look, it's the greatest honor of all," Berry says, "but mainly it's always humbling to remember that the cosmos is mighty compared to Earth; all of us are just so little by comparison."

When asked if he ever looks up at the stars and wonders how far "Johnny B. Goode" has reached, Berry turns somber. "Sure," he says softly. "I know it's gone beyond our solar system and is somewhere in the heavens." And then he offers a smile full of self-confidence. "That's as good as it gets, Jack," he says. "That's as good as it gets." ★

Early rock-and-roll legend Chuck Berry still shines as one of the brightest among the stars of American popular music.

THE DELTA QUEEN

★

"The river is a universe unto itself."

CAPT. ROBERT CONYERS

The golden age of steamboats ended with the advent of railroads.

The modern *Delta Queen,* on a cruise, churns past freight barges.

Box cars form a right angle with the flowing lines of the river.

A searchlight guides the *Delta Queen* through foggy twilight.

Two generations of river gazers stand transfixed by the perpetual flow.

Like curious dolphins, speedboats race by a plodding paddleboat.

Reminiscent of another era, two modern-day paddlewheelers slip past each other.

Silos along the upper Mississippi hold grain for shipment downriver.

Some 80 miles upriver from Mark Twain's hometown, the city of Nauvoo, Illinoin, appears a prosperous sight in this 1853 engraving. Joseph Smith and his Mormon followers had settled there in 1839. After Smith's murder, the persecuted Mormons fled to Utah in 1846.

CHAPTER NINE

MARK TWAIN COUNTRY

★

"...[the river] told its mind to me without reserve, delivering its most cherished secrets as clearly as if it uttered them with a voice."

MARK TWAIN

SHORTLY BEFORE HIS DEATH IN 1986, the great Argentine novelist Jorge Luis Borges made a literary pilgrimage to Hannibal, Missouri, to pay homage to Samuel Clemens, whose nom de plume was Mark Twain. Meticulously dressed in a three-piece suit, the blind octogenarian arrived in town and was immediately escorted to the Mississippi River levee. Suddenly, to the surprise of all present, he began walking trancelike into the muddy waters until the river rushed up to his chest. "Now," Borges declared, "I understand the essence of America."

By virtue of this baptism, Borges learned why the great river's nickname is the Big Muddy. Over the years the Mississippi gave rise to endless tall tales from river men. One story described the huge steamboat *Hurronico,* whose hull was said to be jointed to let it slip around the bends, and another, called the *E. Jenkins,* which was so poorly constructed that it took half a year for its wheel to make a single turn. But the stories relating to the incorrigibly thick, omnipresent mud all ring true. Mark Twain could best them all. He wrote in *Life on the Mississippi* of making a return visit to Missouri and meeting a man who was new to the region. The man asked what to do when overcome by thirst; he said he could swallow the Mississippi River water only if he had "some other water to wash it down with." This aside caused Twain to reflect. "Here was a thing which had not changed; a score of years had not affected this water's mulatto complexion in the least; a score of centuries would succeed no better. Every tumblerful of it holds nearly an acre of land in solution. If you let your glass stand half an hour, you can separate the land from the water as easy as Genesis; and then you will find them both good: the one good to eat, the other good to drink. The land is very nourishing, the

Few writers are as intimately linked to their hometowns as Mark Twain, standing in the doorway of his house in Hannibal, Missouri, the setting for two of his novels.

water is thoroughly wholesome. The one appeases hunger; the other, thirst. But the natives do not take them separately, but together, as nature mixed them. When they find an inch of mud at the bottom of their glass, they stir it up, and then take the draught as they would gruel. It is difficult for a stranger to get used to this batter, but once used to it, he will prefer it to water. This is really the case. It is good for steamboating, and good to drink; but it is worthless for all other purposes, except baptizing."

Twain should know: He spent more time living and thinking and writing about the Mississippi than any other major American writer. And the town Borges visited—Hannibal, Missouri (population 17,700)—is today a virtual shrine for his literary accomplishments. Twain was born in 1835 in Florida, Missouri, and moved to Hannibal when he was four years old. The area served as the primary setting of his most endearing fiction.

We visited Twain's boyhood home in Hannibal at 208 Hill Street, the model for Tom Sawyer's picket-fenced abode, and climbed the steps to the back upstairs bedroom that was shared by Clemens and his younger brother, Henry. From here Tom Sawyer sneaked out at midnight to frolic

with Huckleberry Finn in *The Adventures of Tom Sawyer.* The dining room we remembered as the setting for the "painkiller medicine" incident, when Tom dosed the family cat, Peter, with patent medicine.

Near the house are other Twain sites worth touring, such as the Elijah Hawkins home at 211 Hill Street, immortalized in *Tom Sawyer* as Becky Thatcher's home, and 205 Hill Street, the law office of Twain's father. But for those interested in learning about Mark Twain, the writer, and his love for the Mississippi, the museum at 120 Ninth Main is not to be missed.

The first floor of the museum is devoted to Twain's writing, with large interactive exhibits examining five of his major works. Norman Rockwell came to Hannibal in the mid-1930s when commissioned to illustrate special editions of *Tom Sawyer* and *Huckleberry Finn.* He prepared eight illustrations for each book. Rockwell loaned, then donated, 15 of the illustrations to the Mark Twain Museum. Another artist, Missourian Thomas Hart Benton, also illustrated a number of Twain's books, and 69 of these drawings are on display in the museum. Our favorites were various sketches from Twain's *Life on the Mississippi*—one of the great American travel books and our constant companion as we plied the

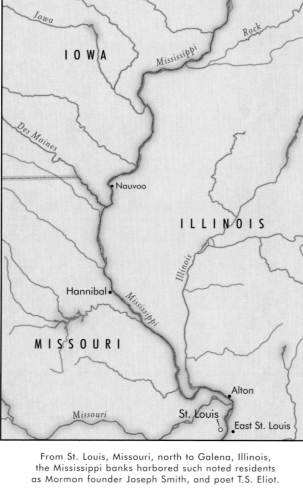

From St. Louis, Missouri, north to Galena, Illinois, the Mississippi banks harbored such noted residents as Mormon founder Joseph Smith, and poet T.S. Eliot.

2,350 miles of the great river. We never tired of reading passages from Chapters 4 through 17, which vividly depict the history of the steamboats and the villages along the Mississippi. "The face of the water in time became a wonderful book that was a dead language to the uneducated passenger," Twain wrote, "but which told its mind to me without reserve, delivering its most cherished secrets as clearly as if it uttered them with a voice."

At the museum we heard about a green hill in Hannibal that young Clemens liked to climb to survey the glistening Mississippi River. This was long before his celebrated years as a steamboat pilot and best-selling author.

One summer, Clemens and his best buddy, Will Bowen—a friendship that would provide the basis for Huck Finn and Tom Sawyer—decided to dislodge a large boulder on the rise and roll it into the Mississippi to see whether it would sink. After much toil, they succeeded, only to watch it become a runaway menace, thundering down the wrong side of the slope, crushing bushes and shrubs until it crashed into a cooper's shop, causing shocked workers to flee in terror. Clemens never saw his boulder sink.

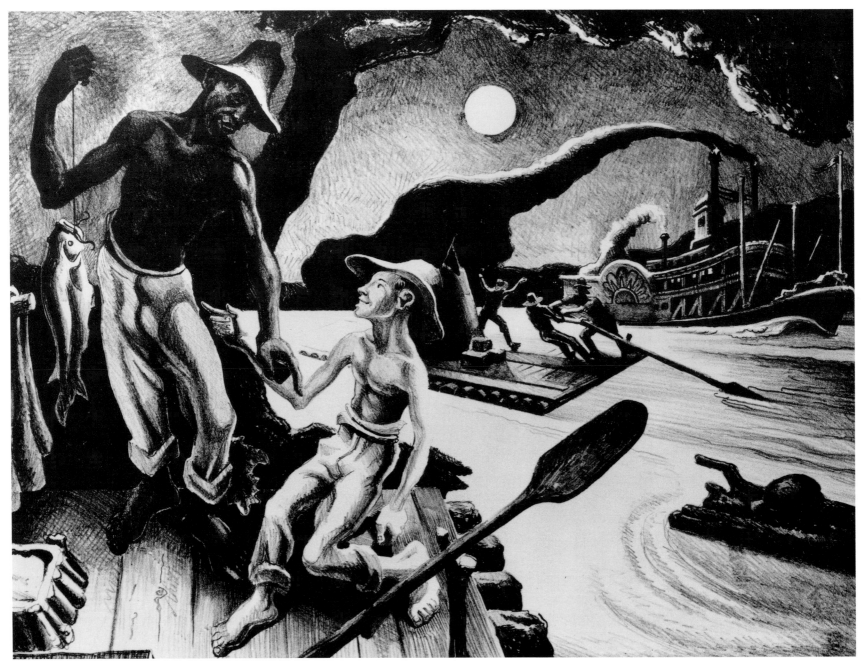

Thomas Hart Benton's 1936 lithograph "Huck Finn" features two signatures of the artist's work: the sinewy limbs of Huck and his friend Jim, and depictions of rural life.
HUCK FINN, THOMAS HART BENTON, 1936, © T.H. BENTON AND R.P. BENTON TESTAMENTARY TRUSTS/VAGA

One unsinkable saga, one even more memorable, surrounded the near-death of a red-headed Irish girl named Margaret "Molly" Tobin, who grew up in Hannibal just four blocks from Clemens. As the story goes, 9-year-old Molly was frolicking along a mud bank one day when a cyclone swept her into the Mississippi. After nearly drowning, she washed ashore. When the rain stopped, the exhausted child looked up to see a benevolent white-haired stranger hovering over her. It was her family's friend Sam Clemens, who quipped, "Where the devil will I find you next?"

Fact and fiction are so exquisitely intertwined in Hannibal today—and in the lives of Clemens and Molly Tobin, later known as Mrs. J.J. Brown—that reality is a frowned-upon concept. A visit to the restored Molly Brown Birthplace and Museum, located on Denkler's Alley near the downtown Historic District, nevertheless may shed some light on the woman famed for surviving the *Titanic* disaster of 1912 as the "unsinkable Molly Brown."

When reporters interviewed Molly after the luxury liner sank, killing more than 1,500 people, she credited her survival to typical Brown luck. "We're unsinkable," she said. The label stuck, and she became a celebrity. As Molly wrote her daughter: "After being brined, salted, and pickled mid-ocean, I am now high and dry. Enclosed clipping will tell all." But it wasn't until 1933, when Denver reporter Gene Fowler's book *Timberline* created the fictionalized portrait of Molly Brown, that she became a Mississippi River folk hero.

Fowler portrayed Molly—who moved from Hannibal to Colorado and married James Joseph Brown, who'd struck the largest vein of gold known at that time—as an eccentric social outcast. Years after Twain tended to her on the Mississippi, she reciprocated by helping the lifeboat survivors of the *Titanic* as if she were Florence Nightingale on a battlefield. In 1956 Caroline Bancroft perpetuated the myth

in a booklet titled *The Unsinkable Mrs. Brown*. Furthermore, in 1960 a hit musical based on her life played on Broadway, and in 1964 the story was made into a movie starring Debbie Reynolds. Her myth had become so embedded in America's folklore that astronaut Virgil "Gus" Grissom dubbed Gemini 3 "the Molly Brown," as insurance that his space capsule wouldn't sink upon splashing down in the ocean. A question that continues to plague the town historians of Hannibal, however, is: Did Mark Twain and Molly Brown actually meet? Some say 17-year-old Molly chatted with the celebrated author while waitressing at the Park Hotel, and he encouraged her to move west to find fame and fortune. This story is probably apocryphal.

In 1886 she moved to Leadville, Colorado, a boomtown where gold nuggets were said to be so plentiful, they could be plucked from the ground. Although their paths may have crossed on Twain's visit home during a lecture tour in 1885, it is unlikely they stopped to talk. What is true, however, is that Molly avidly read all of Twain's books and came to believe that his tales were the greatest contribution to American literature since Walt Whitman's *Leaves of Grass*.

After the *Titanic* disaster, Molly traveled the world, lecturing on everything from steamboats and Tom Sawyer to the Gold Rush. She bragged about surviving a cyclone on the Mississippi, a typhoon on the Indian Ocean, and an iceberg in the Atlantic Ocean. She wrote an article about Twain's hometown for *The Denver Post,* further linking their legacies.

When World War I broke out, Brown—by this time a die-hard suffragist—spearheaded a project to transcribe Twain's works into Braille for soldiers blinded in action. And in 1926, after attending the unveiling of the bronze Tom and Huck statue in Hannibal—erected on the very hill where Clemens tried to roll his boulder into the river—she organized an effort to house his belongings in what's now the

Mark Twain Boyhood Home and Museum. Thus in a strange, serendipitous way, these two famous Hannibalians legitimized their phantom history: Molly Brown had become caretaker of Mark Twain's artifacts.

About 120 miles south of Hannibal, perched high on top of the bluffs, sits Alton, Illinois. It is known as the River Bend area because it's the only place in the United States where the river flows from west to east. When Father Jacques Marquette journeyed down the Mississippi River with his partner Louis Joliet, he recorded in his journal an incredible sight: a large, birdlike monster painted up on the bluffs overlooking the river. The creature was named the Piasa (PIE-a-saw) by the Illini Indians, which means a bird that devours men. In his diary Marquette described the bird being "as large as a calf, with horns like a deer, red eyes, whiskers like a tiger, a face like a man, the body covered with green, red, and black scales, and a tail so long it passed around the body, over the head, and between the legs." Legend claims that a band of Illini led by Chief Ouatoga killed the menacing Piasa.

Today an image of the legendary Piasa bird can be seen on the bluff just north of Alton on the Great River Road. This gigantic replica is a 20-foot-high and 40-foot-wide reminder of Native American culture along the Mississippi River. Bald Eagles congregate every December not far from this site, spreading their wings and soaring high over the bluffs. They stay until the end of winter and can be seen up close at the Riverland Wetlands at Piasa Harbor and on the Brussels Ferry near Grafton. Besides Bald Eagles, the rich forestlands and sunny glades surrounding Alton are teeming with deer, chipmunks, wild turkeys, foxes, and coyotes. It's a marvelous spot to bird-watch, as more than 230 species call the area home, including the Pileated Woodpecker, the largest woodpecker species in the United States.

A legend says that the man-eating Piasa bird harassed the Illini Indians for generations, until a wise chief sent the demon fowl plunging into the Mississippi by shooting poison arrows at the vulnerable spot under its wings.

The true founder of Alton is Rufus Easton, a land speculator who was also postmaster general of St. Louis. Convinced that the natural harbor and hilly terrain would draw homesteaders to the location, he named the town after his son, Alton. The steamboat era had arrived on the Mississippi River, and Easton was sure that a small fortune could be made by opening a ferryboat landing in Alton. He started a ferry service in 1818, and soon numerous steamboat captains called Alton home. The most legendary captain was Joseph Brown, who also ran a mill in Alton and sent his flour to New Orleans. One of his boats, *Little Eagle*, claimed most of the speed records between Alton and St. Louis, making the trip in seven hours. Promptly, other boat lines competed and engaged in veritable races on the Mississippi River. The first boat to come into Alton would be the first

one to unload its cargo and the first one to depart to pick up freight at the next stop. The call went out to construct faster boats. People started building houses with lookouts along the river so that they could watch the racing steamers coming into dock. Passengers aboard a racing steamer felt lucky, because it made for an exciting ride. The townspeople poured out to the riverfront and cheered when the swiftly moving boats arrived in port. The winner would claim a pair of gold-covered antlers and proudly display the prize in the pilothouse until it had to be passed on to the next champion. The boat racing ended abruptly on February 16, 1854, when a tragic accident occurred. The steamer *Kate Kearney* exploded as it was pulling away from the dock in St. Louis, killing 50 people and injuring 25.

By 1837, Alton was incorporated as a city. The German reporter Henry Lewis later claimed "the rapid development of the city of Alton from its original condition to its present prosperous state is not easily matched in enterprising Western America." Unfortunately that very year of incorporation brought shame on Alton. The abolitionist minister and editor of the Alton *Observer*, Elijah Lovejoy, was murdered by a mob of pro-slavery sympathizers. Then the seething killers confiscated his press, which had recently arrived, courtesy of the Ohio Anti-Slavery Society, tossed it out a window, smashed it into pieces with rifle butts, and dumped the broken parts into the Mississippi River.

Overnight Lovejoy became a martyr for upholding the First Amendment. He was buried in an unmarked grave in the Alton City Cemetery. Decades later his body was exhumed and given a proper burial. Thomas Dimmock, the editor of the *National Democrat*, raised the funds to place a 90-foot monument at his new gravesite in the name of freedom.

Alton is also remembered as the site of the seventh and final debate between Abraham Lincoln and Stephen Douglas, held on October 15, 1858. Lincoln, a Republican, and Douglas, a northern Democrat, were competing for a seat in the U.S. Senate. The debate was one of the largest political events to be held in Alton, with more than 6,000 people attending. The debate took place on a wooden platform in front of the new city hall and lasted three and a half hours. Although Douglas won the senatorial seat, he lost the Presidential election to Lincoln two years later. Today Lincoln Douglas Square is a monument to this transcendental moment in American politics. Full-size bronze replicas of Lincoln listening and Douglas pontificating convey the dedication both men felt for their social beliefs.

Throughout the Civil War, Alton served as an important depot for the Underground Railroad, as escaped slaves from the Confederacy used the houses along the riverfront as safe houses. One stop on the Underground Railroad was the Enos Apartments at 325 East Third Street, the basements of which included a series of rooms and passageways 15 feet below street level. Today many of Alton's African-American families can trace their roots back to the Civil War era.

Alton's most famous native son was African-American trumpeter and jazz composer Miles Davis. Davis's connection with the Mississippi is evident from the first paragraph of his 1989 autobiography, *Miles.* "Listen. The greatest feeling I ever had in my life—with my clothes on—was when I first heard Diz and Bird together in St. Louis, Missouri, back in 1944. I was 18 years old and had just graduated from Lincoln High School. It was just across the Mississippi River in East St. Louis, Illinois." Like so many other people born in river country, Davis evokes the Mississippi as a point of geographical reference: He understood that the differences between the two cities named St. Louis—the one in Missouri, the other in Illinois—run deeper than the river itself. Davis was born on May 26, 1926, at 1112 Millner in

Alton. He was named after his father, who was named after his father—making him Miles Dewey Davis III; the family, however, called him Junior, a designation that he hated. His father was from Arkansas, raised on a farm, owned by Miles Dewey Davis I, Miles's grandfather. The first Miles had been such a proficient bookkeeper that he was employed by whites and made a very good living. Eventually, he saved enough to buy 500 fertile acres in Arkansas—an unprecedented purchase by an African American at that time. But trouble soon arrived. His business acumen enabled him to purchase so many acres that the whites who had employed him grew jealous and chased him off his land. The prevailing white sentiment was that a black man should never be too successful. Miles's grandfather lived with death threats from white men for most of his life. He even employed his son—Miles's uncle—as a bodyguard to protect himself against the white men's ill intentions.

In his autobiography, written with the assistance of Quincy Troupe, Miles Davis recounts how the men in his family were always ahead of their time, finding success as artists, businessmen, and musicians who played for the plantation owners before slavery was abolished. These early Davis men performed Bach and Beethoven for a white audience—but after the Civil War "they only let black people play in gin houses and honky tonks." Reconstruction Era whites did not want African Americans to play classical music—they only wanted to hear Sunday spirituals or the cotton-field blues.

Miles Davis's father was only 24 years old when he earned a degree in dentistry in 1924—one of a handful of black men to do so. After graduating from Northwestern University, he married Cleota Henry Davis. She played the violin and the piano and had been an organ teacher in Arkansas. Miles remembered his mother as a striking woman, with a high sense of style. He attributed his vanity to his mother, whose strong, independent personality often clashed with his own.

Miles's parents first settled down in Alton, Illinois, where Dorothy Davis and Miles Dewey Davis III were born, then moved the family to East St. Louis when Miles was a year old. The family took up residence on 14th and Broadway, a "white" neighborhood where Miles Davis II opened his dental practice above Daut's Drugstore. The family lived above the office.

Miles learned a lot from his father, whose politics were more aligned with those of Dr. Marcus Garvey (who founded The Universal Negro Improvement Association and African Communities League) than with those of the more conservative National Association for the Advancement of Colored People (NAACP). He was very pro-black—what was known as a "race man" in those times. He admired Garvey for the way he instilled in African Americans a sense of standing united.

When Miles decided to take up jazz, he followed a rich and complex tradition of African-American music that surged through the Mississippi Valley. He received his first trumpet as a gift from his father's best friend, a black physician named Dr. John Eubanks—Uncle Johnny to Miles. Elwood Buchanan, one of Miles's father's patients, as well as his drinking buddy, offered to give Miles trumpet lessons for free. Miles's father bought him a new trumpet on his 13th birthday, despite his mother's strong disapproval. She wanted to give Miles a violin. Buchanan, who understood Miles's passion for the trumpet, stood behind the gift. When Miles took up the instrument, St. Louis already had a strong tradition of black trumpet players, led by such greats as Robert Shoffner, Leonard "Ham" Davis, Irving "Mouse" Randolph, Eddie Randle, Harold "Shorty" Baker, Charles Creath, Dewey Jackson, Ed Allen, Clark Terry, and George

Hudson. At this time the Davis family moved to a house at 1701 Kansas in East St. Louis.

Miles Davis's musical genius was evident from the beginning. Buchanan trained him with strong attention to technique, and Miles's soul and passion for the music came through loud and clear. His innovative style helped him to earn the reputation of being the greatest leader and catalyst in the history of jazz. His ability to bring out the best in the musicians around him was unequalled. He encouraged the musicians he played with to listen to each other, and not to play what immediately came to mind, but to take it to the next level—in effect, improvising more soulfully than they had ever done before. He can justifiably be termed a musical genius who spearheaded several distinct periods of jazz.

In the late 1940s, such recordings as "Move" and "Bobplicity" had a huge influence on "cool" or "West Coast" jazz. In 1954 the release of the album *Walkin'* signaled the start of "hard bop." In 1957 the highly influential *Birth of the Cool* showed how Miles had refined his playing style, aiming for understatement rather than the more hurried tempo of the great bebop players. Miles's playing was slower, with fewer notes. The late 1950s were marked by Miles's experiments with modal playing, which signified a harmonic change in jazz. Before this modal experimentation, the average jazz song contained somewhere between 12 and 20 chord changes. Miles's song

Modern jazz great Miles Davis crossed musical barriers like so many bridges over the Mississippi from East St. Louis.

"Milestones" on the album by the same name contained only two chord changes. The new approach can be compared to Picasso's Blue Period. The artist was painting with only one color, but the infinite levels of expression within this one color enabled intense and unprecedented variation.

Davis further developed his modal experimentation on the album *Kind of Blue,* and on the album *E.S.P.* in 1965 when he formed the quintet of Miles Davis, Wayne Shorter, Ron Carter, Tony Williams, and Herbie Hancock. Their music would now be called "the new thing," or "modern jazz." In 1968 the release of *Filles de Kilimanjaro* signaled the electrification of jazz, moving closer toward rock music by including electric keyboards along with his electrified trumpet connected to a wah-wah pedal. Miles certified his first gold record in 1976 with *Bitches Brew,* which sold 500,000 copies in the U.S. on its first release. With this album he invented jazz-rock and what would later be known as fusion.

Miles's musical evolution continued into the 1980s with *You're Under Arrest,* an album that featured versions of Cyndi Lauper's "Time After Time" and Michael Jackson's "Human Nature." Always the innovator, Miles began working on a jazz/rap album with Easy Mo Bee in 1991, which would be released late that year as doo-bop. That same year, Miles performed with the Gil Evans Orchestra and the Montreux Festival Band, conducted by Quincy Jones—his first performance of classics by Evans in more than 30

years. This performance showed that Miles Davis had come full circle in his musical career, revisiting the material of his past and illuminating it anew with the grace and knowledge of his genius.

According to Benjamin Cawthra, curator of *Miles: A Miles Davis Retrospective*, an exhibition on the trumpeter's life and music displayed at the Missouri History Museum in 2001, many St. Louisians are unaware of his origins in their region, due in part to the area's deeply ingrained racism. People in St. Louis fail to see East St. Louis as their sister city, which traditionally has been categorized by the color of its citizens' skin and its poverty. Two separate histories have formed, where there should be one. The Missouri History Museum's exhibition on Miles was the first major retrospective on the musician's life, and as the catalog noted, "The *Miles 2001* celebration in St. Louis and East St. Louis began as an effort to bridge the issues of race and the river, with the 75th anniversary of Miles Davis's birth as the catalyst."

What we understood from the retrospective was that Davis transcended jazz, embodying every modern musical innovation imaginable. Historian Gerald Early put it best: "Miles Davis, the American bad boy of jazz, our Huckleberry Finn, the adventurous capitalist artist, our great American picaro, who 'lit out for the territories' and survived. It is one of the great tales of 'manhood' and morality in modern American culture." Davis's last performance was at the Hollywood Bowl on August 25, 1991. Less than a month later he died of a stroke in Santa Monica, California. His music is celebrated all over the world. "Only the strong," Davis believed, "survive in jazz."

In Alton, Illinois, a real, local hero is Robert Pershing Wadlow, whose height of 8 feet 11.1 inches qualifies him as the tallest person in history, as recorded in the *Guinness Book of World Records.* He was born in Alton on February 22, 1918, weighing a healthy 8 pounds and 5 ounces. After that, weekly, he grew at an abnormal rate. By the time he was eight years old, he was 6 feet 2 inches tall and weighed 195 pounds. His parents, Addie and Harold Wadlow, tried desperately to help him maintain a normal life. But wherever he went, people gawked and pointed at him. At age 13 he joined the Boy Scouts, and word spread throughout America about his height: He had just reached 7 feet 4 inches, and his shoe size was 37. His height handicapped him from having a normal childhood. He never got on a boat on the Mississippi River, for example, for fear that if he fell in no one would have the strength to pull him out.

The International Shoe Company hired Wadlow as its spokesman when he turned 20, having him visit more than 800 towns in 41 states, holding up his large feet to amaze audiences at county fairs and Masonic lodges. He traveled America with his father, who had removed the front passenger seat in the family Ford so Robert could sit in the back seat and stretch out his legs. Together they traveled more than 300,000 miles for the shoe company, even making an appearance in Hollywood. Because he was so quiet and polite, never getting upset at children who shrieked at his appearance or parade spectators who cackled, Wadlow became known as the Gentle Giant all across the Americas. He was essentially seen as a circus curiosity. What nobody understood was that Wadlow had a serious medical condition: His active pituitary gland produced massive levels of growth hormones. Today medical protocols could control the excess. In 1920 there was no help. So Wadlow suffered gigantism, wearing leg braces, suffering blisters, and having little sensation in his feet. His moment of glory came in 1937, when he exceeded 8 feet 4 inches, surpassing the record previously held by an Irishman in 1877. Three years later, while making an appearance in Manistee, Michigan,

he became seriously ill. A blister on his right ankle had grown infected, confining Wadlow to a hospital bed. Despite emergency surgery, the infection lingered, and his temperature continued to rise. On July 15 at 1:30 a.m. Wadlow died in his sleep, only 22 years old.

The people of Alton were grief-stricken by news of Wadlow's death. They brought his body home, made a special 1,100-pound casket, and closed all the city businesses for his funeral. It took a dozen pallbearers and the assistance of eight cemetery workers to properly lower Wadlow into his grave. More than 40,000 people signed the guest register, and his tombstone simply read: "At Rest." The family destroyed most of Wadlow's belongings shortly after the funeral; they refused to have his shoes and clothes auctioned off as freak memorabilia. As the years passed, the citizens of Alton continued to pay homage to the Gentle Giant, and in 1985 a bronze statue of him was erected on the campus of the Southern Illinois University School of Dental Medicine.

Alton is not the only town in Illinois capitalizing on its heritage. When *Time* magazine reporters journeyed down the Mississippi to capture the pulse of America for a special edition of the magazine, they described how history along the river has been airbrushed for the sake of tourism. In Hannibal, Missouri, the writers noted, visitors saw little Toms and Beckys running over the faux cobblestone streets, but no Jim; while in the town of Kimmswick, Missouri, the local historical society was planning a reenactment of the Civil War battle fought there although it was only a skirmish that involved three Confederate soldiers hiding in a cave.

Nowhere is this sanitized approach to history more prevalent than in Nauvoo, Illinois, which the church of Latter Day Saints has transformed into a Mormon Disneyland, where "the Mormons celebrate their 19th cen-tury village life as they rebuild the town and its temple as a pilgrimage spot—but gloss over the bloody religious battles that led to their being pillaged and expelled in the first place," Nancy Gibbs wrote in *Time*.

The history of Nauvoo, particularly the trials and tribulations of Joseph Smith, is worth retelling. Joseph Smith was born on December 23, 1805 in Sharon, Vermont. When he was 11 years old, his family moved to Manchester, New York, at a time when religious ferment was spreading. Wandering alone in the woods in 1820 Smith asked God for guidance. The Lord delivered, urging Smith not to join any existing religious organization, but to prepare himself for doing great deeds. A few years later Smith claimed the angel Moroni visited him with revelatory news: He would soon be presented with gold plates in which a book was engraved in an unusual language. In 1827 Smith is said to have received the plates and furiously began translating them. It became the *Book of Mormon*, a divinely inspired history of early peoples of the Western Hemisphere. Using this holy scripture as background, Smith and five associates founded the Church of Jesus Christ of Latter-Day Saints at Fayette, New York.

Smith, as leader of a new religion, moved to Kirkland, Ohio, anxious to convert new settlements to his faith. But Smith made as many enemies as friends in the Ohio Valley, often occasioned by his anti-slavery statements. He was imprisoned after a small Mormon versus anti-Mormon skirmish, but escaped to Independence, Missouri, with followers in tow.

Moving from Missouri in 1839, Smith bought land 70 miles north of Quincy and founded the settlement of Nauvoo (the beautiful place) in Illinois. "The place was literally a wilderness," Smith wrote. "The land was mostly covered with trees and bushes, and much of it was so wet that it was with the utmost difficulty that a footman could get

through, and totally impossible for teams." This was to be Smith's new City of Zion, his kingdom on the Mississippi, and he began planting four-acre blocks divided into four lots so that each family could have vegetable gardens and raise livestock. The first settlers were Smith's diehard followers, true believers in the book of Mormon. Soon converts came pouring in from New England and New York. As if a miracle had occurred, in three years his followers had grown to 16,000 Mormons living in or around Nauvoo.

Smith was politically astute, and he achieved essentially home rule for Nauvoo. He was commander the Nauvoo Legion, for example, an independent part of the Illinois State Militia. His followers called him "The Prophet." At the same time he was mayor and chief magistrate, lieutenant general, newspaper editor, real estate promoter, and banker. Using the Mississippi as the means for developing commerce, Nauvoo soon grew into the largest city in Illinois, with a population of 12,000. A magnificent Mormon temple was built, the city streets were beautifully lined with trees and flowers, and the number of exquisite red brick Federalist-type homes gave the river community a bit of East Coast elegance.

But all was not right in Nauvoo. The idyllic port never attracted enough boats, and businesses floundered. Smith's controversial belief in polygamy caused other Christian churches around the state to loathe the Mormons. Unwisely

At nearly 9 feet, the "Gentle Giant," Robert Wadlow, had to fold himself into the back seat of a car whose front seat was removed.

Smith had his followers vote in Mormon blocks, first siding with the Whigs and then with the Democrats. Daily it seemed, Smith was making new enemies. The most formidable one was Dr. John C. Bennett, a Mormon who had been quartermaster general of the Illinois militia, but broke ranks with the church. He began spreading rumors that the Mormons planned to overtake Illinois by armed force.

Meanwhile, Missouri officials demanded Smith be extradited on charges of treason, murder, and arson.

With his Kingdom on the Mississippi under attack by powerful anti-Mormon forces, Smith headed to Washington, D.C., to ask President Martin Van Buren for federal protection; but Van Buren refused. Disappointed, but full of hubris, Smith announced he would become a candidate for U.S. President and dispatched the so-called Twelve Apostles of the Mormon church to help spread the gospel of the Latter-Day-Saints. People throughout Missouri and Illinois were outraged by Smith's audacity, claiming that among other misdeeds he used the Nauvoo Legion to destroy an opposition newspaper's facilities. In June 1844 the angry governor of Illinois demanded that Smith appear at the county seat of Carthage, 18 miles from Nauvoo, to explain his conduct. "I am going like a lamb to the slaughter," Smith said as he departed, and he was right. Upon his arrival in Carthage, he was presented with a Missouri warrant for treason. Although

this charge held no merit in Illinois, Smith and his brother, Hyrum, were placed in the two-story jail. Word spread that the Prophet was held captive like a common crook. The governor, in a foolish move, asked the Carthage Grays militia unit to guard the Smiths, knowing that the militia members were strongly anti-Mormon. Within hours a vigilante mob gathered around the small jail, and the Carthage Grays offered only passive resistance when the mob broke down the door shouting anti-Mormon epithets. A skirmish ensued, and both Smiths were shot dead. The Prophet, founder of the Mormon church, was now a martyr.

Fear crept throughout Illinois that a full-fledged religious war was imminent. Luckily, cool heads prevailed in Nauvoo. Worried that Missourians might cross the Mississippi River and destroy their town, the citizens quickly buried the Smith brothers in unmarked graves. A statewide broadside was published asking citizens to refrain from harming Mormons. Meanwhile, Smith's loyal followers prayed that justice would prevail in a court of law: It did not. The murderers of the Smiths were acquitted, anti-Mormon harangues continued, and Nauvoo was constantly harassed by mob violence. Representatives from nine Illinois counties met in Carthage to demand that the Mormons be expelled from the state. A deal was struck with John J. Hardin, a former U.S. congressman who was in charge of keeping order in Hancock: He ordered all violence against the Church of Latter-Day Saints halted at once. He had the promise from Brigham Young that the Mormons would move to some far-flung place west of the Mississippi River.

Young, who filled the power vacuum caused by Joseph Smith's murder, immediately oversaw the manufacturing of 2,500 wagons. "We want teams, and we want money and merchandise," the Mormon paper *Nauvoo Neighbor* declared. After months of preparation Young led the first 400 families across the frozen Mississippi to find a new Land of Zion some 1,500 miles away. As they crossed the river, Smith's grand notion of an Illinois kingdom was lost. Over the next few years nearly all the Mormons of Nauvoo headed to Utah. An exception was Joseph Smith III, grandson of the Prophet. He stayed in Nauvoo and became the leader of a separate Mormon denomination, which deemed itself the Reorganized Church of Jesus Christ of Latter-Day Saints. Like his grandfather, the young Smith believed Nauvoo on the Mississippi River was a divine place chosen by God—an assessment believed by other "true believers."

Like Joseph Smith, Ulysses S. Grant had also moved from Missouri to the Illinois side of the Mississippi. After resigning from his first stint in the Army in 1854 and failing as a hard-scrabble farmer in Missouri, Grant tried selling real estate in St. Louis without success. In the spring of 1860 he moved his wife, Julia Dent Grant, and their children to Galena, Illinois, where he went to work as a clerk in his father's harness shop. Galena, located in the northwestern corner of Illinois, was the busiest Mississippi port between St. Louis and St. Paul, and on the eve of the Civil War it was bursting with commerce.

Native Americans called the land around Galena "Manitoomic," which translates as sacred ground or God's country. They mined the hills for lead ore long before French explorers discovered this mineral-rich region. But it was the Louisiana Purchase that convinced the U.S. Congress to create the Upper Mississippi Land Mine District around Galena. In 1829, 20 years before the California Gold Rush, fortune seekers from around the world ventured to Galena to participate in the first large mineral rush in American history. But Grant and his extraordinary wife found little riches in Galena, only

Nauvoo Legionnaires, the private militia of Mormon founder Joseph Smith (mounted far left), prepare to ride at his command.

hard times. He was working in his father's leather goods store for a small salary.

Julia Grant, although a slave-owner herself who had hardly ever lifted a finger in the kitchen or done any housework, made the best of a bad situation. Historians have neglected Julia, but she was of stout heart and good will, an excellent mother and wife, whom Grant adored. She was, as the great Civil War historian Bruce Catton wrote, "a likable person with three dimensions."

She was also a good writer, although her *Personal Memoirs* languished unpublished for almost a century. She described Galena of 1860 as "a charming, bustling town nestled in the rich ore-laden hills of northern Illinois. The sun shone so brightly that it gave us the impression of a smiling welcome." If she did not prosper there, she managed to oversee a good home, "a nice little brick house of seven rooms, which was nestled high up on the hill on the west side of the town with a lovely view." She fondly remembered, "I soon felt quite at home in this picturesque town and among these most charming people."

When the war began in 1861, she immediately backed her husband in his determination to serve the Union Army. She found that "Galena was throbbing with patriotism." When the war was won in 1865, "the General and I returned to Galena." There was "a tremendous and enthusiastic outpouring of the people to welcome him." The town held a parade. Then "we were conducted to a lovely villa exquisitely furnished with everything good taste could desire (and which, we were told, was to be our own) from Galena." After Grant's two-term Presidency, the couple went on a round-the-world tour, described by Julia in her memoirs, with the kind of details that make a good travelogue.

Today this city of 3,600 residents prides itself on being the home of the 18th President of the United States. An astounding 85 percent of Galena's buildings are listed in the National Register of Historic Places. We visited Grant's two-story brick home at 500 Bouthillier Street, which has been restored as it appeared during the post-Civil War period and the Grant Presidency. Grant's children gave it to the city of Galena in 1904. Today it is owned and operated by the Illinois Historic Preservation Agency. The house is filled with family portraits.

An Egyptian funerary scene is one of three illustrations in Joseph Smith's *Book of Abraham*, allegedly based on an ancient text he translated. It serves as an inspiration to his followers.

While traveling from St. Louis to Galena we were surprised by the many stories we heard of unforgettable journeys to New Orleans. Among the most memorable are the exploits of Captain Paul "The Fearless Frogman" Boyton. Born in Dublin, Ireland, in 1848, he moved to America as a teenager and served in the Union Navy during the Civil War. Thrilled by what he called nautical adventure, Boyton traveled to Sonora, Mexico, to dive. He served as a soldier of fortune in the Franco-Prussian War; joined the Paris Commune; conspired to free Cuba from Spain; toiled as a South African diamond miner; and

became a lifeguard in Atlantic City, saving 71 swimmers from death at sea.

Returning to Ireland in 1874, Boyton became a legend when he leapt from a ship 40 miles from the coast during a storm. His reason? He wanted to see if his invention, a new waterproof rubber suit, could save his life during a furious gale. After struggling nearly seven hours in the water, he reached land. His vulcanized rubber suit, which had on each thigh and breast a tube for inflating air by mouth, may have looked ridiculous, but it became the prototype outfit for scuba divers all over the world. The only part of his body exposed to the storm was his face. He swam on his back, feet foremost, with the help of a double-bladed paddle thrashing at 100 strokes a minute. This stunt proved, as Peter Lyon wrote in *American Heritage,* that Boyton was "no ordinary harum-scarum daredevil" but a swimmer with "a positive genius for recklessness."

The Fearless Frogman entered the annals of Mississippi River history when, in early 1876, he floated from Alton to St. Louis in his watertight rubber suit. People lined the riverbank to catch a glimpse of this strange swimmer in the weirdest costume ever seen on a human figure. In the coming years he would float down the Rhine, the Rhone, the Seine, the Po, the Loire, the Tiber, and the Targus. In

Ulysses S. Grant, wife Julia, and son Jesse enjoy a vacation in New Jersey. At the time their home was in Galena, Illinois.

America, he journeyed the length of the Missouri, the Yellowstone, the Ohio, the Hudson. He was a pop star who claimed that no river current could defeat him. Refusing to touch land on these journeys until he reached his destination point, Boyton towed a small boat called the *Baby Mine,* in which he stowed food and water for his meals en route. Soon a cigar was named after him, editorials praised his water heroics, and he was in demand at county fairs across the country. Even President Ulysses S. Grant called himself a "Paul Boyton afficionado."

Bored by the trappings of celebrity, Boyton headed to Peru to serve in their navy in a war against Chile. One evening Boyton swam at night to a Chilean man-of-war, affixed 125 pounds of dynamite to its hull, then watched it blow to smithereens. Although Peru lost the war, Boyton was given the rank of captain in tribute to his bravery. He moved to New York, opened up a bar and grill at 38 West 29th Street called The Ship, and contemplated his next exploit. The Mississippi haunted Boyton: It was his greatest challenge, and he planned two great float trips to conquer it. His first voyage was from Oil City, Pennsylvania, to the Gulf of Mexico via the Ohio-Mississippi River—a staggering 2,342 miles made in 80 days. His longest trek, however, which he writes about with great fanfare in his autobiography *Roughing It In Rubber,*

was in 1881 when he floated more than 3,580 miles from the mouth of the Cedar Creek, in Montana, to St. Louis. He left on September 17 and reached his destination on November 20. "Conquering the Mississippi," Boyton told the crowd that greeted him in St. Louis, "is more thrilling than licking all the rivers in the world combined."

Following his Mississippi River exploits, Boyton went on to open Sea Lion Parks and was one of the founders of Coney Island. He died at his home in Sheepshead Bay on Long Island, largely forgotten but still taking to the ocean for daily swims. More than any other man, Boyton is credited with making water sports and swimming pools popular in America. "If not in technique, at least spiritually he was the precursor of the frogmen, and the skin divers, and the water-skiers, who slip so smoothly through the seas today," author Lyon wrote in homage of the Fearless Frogman. "Paul Boyton was the first to dare the waters."

We had Boyton, Twain, and Lincoln all in mind when we read about the unusual journey down the river made in the 1980s by an African-American journalist named Eddy L. Harris. He had the courage to travel the entire length of the river by canoe, from Lake Itasca to the Head of Passes, and write a first-rate book about his experiences entitled *Mississippi Solo*. Much of the narrative focuses on issues of race, with the character Jim from *Adventures of Huckleberry Finn* always in mind. "The Mississippi River is laden with the burdens of a

CAPT. PAUL BOYTON.
SWAM THE STRAITS OF GIBRALTAR MAR. 20, 1878.

Stuntman Paul Boyton wears a watertight rubber suit, a precursor to modern diving gear. In it, he swam the Mississippi.

nation," the book begins. "Wide at St. Louis where I grew up, the river in my memory flows brown and heavy and slow, seemingly lazy but always busy with barges and tugs, always working—like my father—always traveling, always awesome and intimidating." There are many memorable pages in *Mississippi Solo*, but we found Harris's descriptions of portaging around the numerous locks, built by the Corps of Engineers during the Great Depression, the most heartbreaking. "Between 1930 and 1940 the engineers constructed—miraculous it seems even to me—and put into operation most of the 29 locks and dams," Harris wrote. "If it didn't make me so sad for the river's sake, this magnificent feat would merit praise. What the engineers did was to destroy the river, and in its majestic place was left a series of slack water pools. This means very little flow, no current, and hard work for a man in a canoe because the river pouts and will not help much."

Yet Harris also praised the Corps of Engineers for constructing a great number of small boat harbors, which allow easy access to and from the river. And he reminds us that it was the Corps that purchased land in conjunction with the U.S. Fish and Wildlife Service to create a long campground that extends all the way from St. Paul to St. Louis. "I can camp anywhere I please," he wrote, "for as long as I please and know that, except for the areas around towns and cities and developed commercial sites, which are few, the river and the land are mine and wild." ★

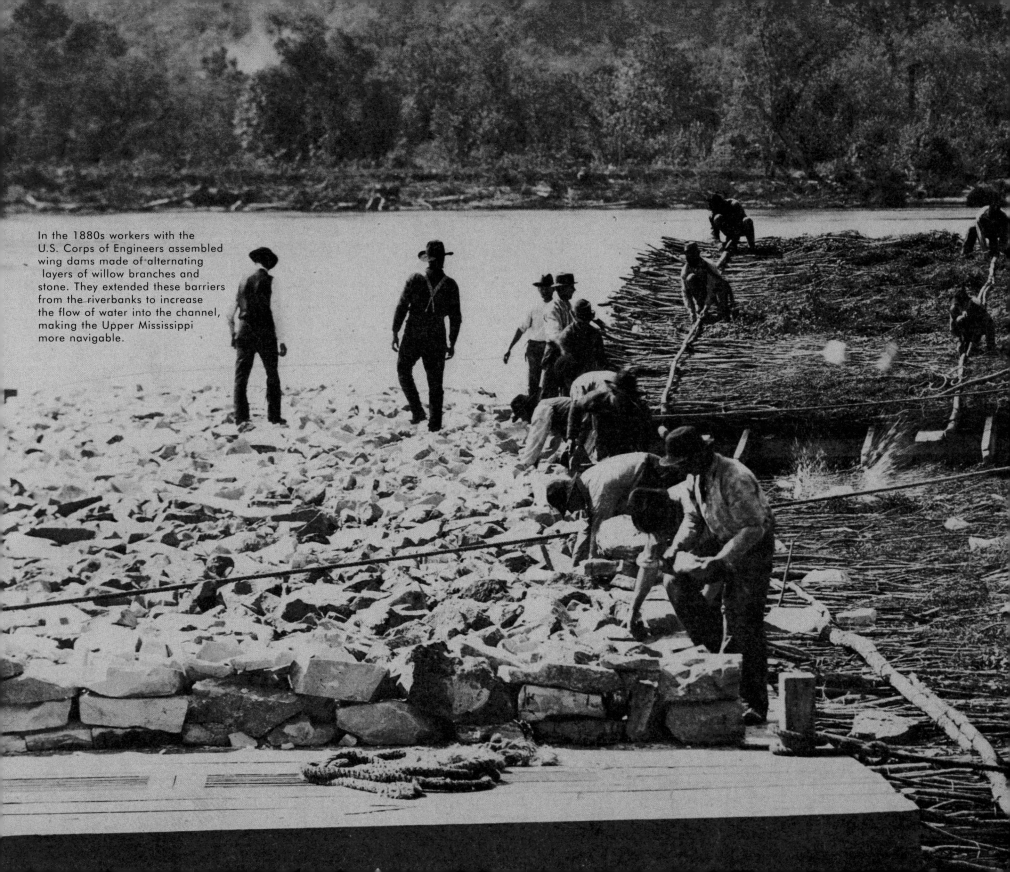

In the 1880s workers with the U.S. Corps of Engineers assembled wing dams made of alternating layers of willow branches and stone. They extended these barriers from the riverbanks to increase the flow of water into the channel, making the Upper Mississippi more navigable.

THE QUAD CITIES AND DUBUQUE

★

"It comes at us bigger than life. The Mississippi—
artery of a continent, lifeblood of a country."

GARRISON KEILLOR

SEVEN YEARS BEFORE THE SIGNING OF THE LOUISIANA Purchase agreement changed the United States, the French traveler Count Constantine Volney noted that "this great, this magnificent Mississippi…is a very bad neighbor." The Mississippi's floods, snags, sandbars, and rapids had long been impediments to new settlement. Ever since Jefferson purchased the Louisiana Territory, the U.S. government has tried mightily to tame the unruly river.

The first engineers along the waterways of America were the Native Americans who built fishing weirs and irrigation ditches. In 1785, two years before he became chairman of the Constitutional Convention, George Washington had organized a company to clear rocks and boulders from the Potomac River. From Massachusetts to North Carolina, the Santee, James, Delaware, Susquehanna, Schuylkill, and Merrimack rivers were made navigable by canals. These successes led Congress to create the U.S. Army Corps of Engineers in 1802. The Corps's engineers were to be trained at the U.S. Military Academy at West Point. In the decades following the Louisiana Purchase, the Corps of Engineers constructed dams and canals, ports and roads, forts and airfields, and missile and space facilities. But the Corps is best known for controlling the upper reaches of the Mississippi by dint of myriad lock and levee systems.

The Corps took up the task of taming the great river in 1822, shortly before steamboats began operating north of St. Louis. S. Bernard and Joseph G. Tolten, two engineers studying how to improve its navigation, conducted the first official survey of the Mississippi. In their report they recommended locks to improve and develop commerce. Two

In 1852 aquatic engineer Charles Ellet produced the first comprehensive plan to control the water flow of the Mississippi.

years later the U.S. Supreme Court decided in *Gibbons* v. *Ogden* that the power of the federal government to regulate interstate commerce included the power to regulate river navigation "so far as that navigation may be in any manner connected with commerce."

The decree gave Congress the legal authority to fund river improvements. But when the Mississippi broke its banks in 1828 in one of the worst floods of the 19th century in the United States, the Corps of Engineers had not yet implemented a disaster control plan.

It was not until 1852 that the Corps of Engineers set out to control the Mississippi River. That year, Charles Ellet, a civil engineer, completed topographic and hydrographic surveys of the Mississippi Delta. His subsequent report to Congress advocated increased federal responsibility for flood control of the lower Mississippi, as well as a comprehensive plan for preventing trouble by constructing levees, reservoirs, and diversion channels. Work based on Ellet's recommendations was considered, but never got underway. In April 1861 when Confederate Forces fired on Fort Sumter in Charleston, South Carolina, America was launched into Civil War. The next several years found the nation occupied with the trials of war, and residents along the river abandoned their flood

control efforts altogether. The levees deteriorated rapidly. The general neglect resulted in untold damage to the system, as whole sections fell into disrepair and were washed away by the river. Another major flood in 1862 added to the damage, followed by further stresses on the levees from military operations in 1863 and 1864. In the Union's effort to take the Confederate fort at Vicksburg, for example, Union soldiers under Gen. Ulysses S. Grant's command blew up the great Yazoo levee. By the end of the Civil War, river control was a shambles.

A decade later the need to improve the Mississippi was widely recognized. Congress authorized James B. Eads to construct jetties at the mouth of the Mississippi River. Then in 1879 Congress established the Mississippi River Commission (MRC) to "take into consideration and mature such a plan or plans and estimates as will correct, permanently locate, and deepen the channel and protect the banks of the Mississippi River, improve and give safety and ease of navigation thereof, prevent destructive floods, promote and facilitate commerce, trade, and postal service." The commission would consist of three Corps of Engineers officers, one of whom would serve as that body's president; one who would represent the U.S. Coast and Geodetic

On the Upper Mississippi, the Quad Cities metropolis—Davenport and Bettendorf, Iowa and Moline and Rock Island, Illinois—is second only to Minneapolis/St. Paul.

Survey; and three civilians, two of whom would be civil engineers. All MRC appointees would be nominated by the President, and be subject to confirmation by the U.S. Senate.

Yet, for all the bureaucratic gravitas, the river continued to have its way. Only three years after creation of the MRC, the disastrous flood of 1882 devastated the entire Delta area. Inundated levees crevassed and collapsed, causing staggering losses in Arkansas and Louisiana as houses were swept away in the torrent. When the flood receded, the Corps went back to work, toiling in earnest to control the wild waterway.

"The military engineers of the Commission have taken upon their shoulders the job of making the Mississippi River over again," Mark Twain wrote in 1896 in *Life on the Mississippi,* "a job transcended in size only by the original job of creating it. They are building wing dams here and there, to deflect the current; and dikes to confine it in narrower bounds; and other dikes to make it stay there." Although an admirer of the Corps of Engineers, Twain doubted their efforts would succeed. "They have started in here with big confidence and the best intentions in the world; but they are going to get left." Twain was proved right: Major floods occurred again in 1912 and 1913.

"The Mississippi River has a mind of its own," is the way Woodrow Wilson described the river. When the next great flood came in 1927, the MRC was helpless to watch as an area of about 26,000 square miles went under and more than 600,000 people were displaced. The breached levees embarrassed the Corps in no small measure and damages amounted to about $1.5 billion. Out of the disaster grew the Flood Control Act of 1928, which committed the government to sharply increase funds to contain the Mississippi. This legislation established the Mississippi River and Tributaries (MR&T) Project, the nation's first comprehensive flood control and navigation effort.

Since the Great Flood of 1927, the Corps of Engineers has gone to great lengths to protect residents from the periodic ravages of the Mississippi. Yet humankind still has not mastered the river, as those who survived were reminded when the latest great flood in 1993 killed 50 people, destroyed 55,000 homes and exacted more than $15 billion in property losses. Everybody we talked to in Iowa cities such as Burlington and Dubuque and Davenport had stories about the 1993 flood. They were perplexed as to why the Corps of Engineers was unable to prevent such a massive disaster. In response to the Great Flood of 1927, Congress had voted for sharply increased funds for the Corps of Engineers. The Corps's overall mission was to speed the river's flow by making its course shorter and straighter—so it could run faster to the Gulf of Mexico and so its waters would not rise—and to erect dams on strategic tributaries that would form lakes to hold back flooding.

The engineers went to work with a vengeance. By 1937 the Corps had dug out 64 million cubic yards of earth to make cutoffs that shortened the lower river by 150 miles. The enormous undertaking also raised 600 miles of levees and constructed countless new ones—some as far as five

miles back from the riverbanks—to allow the river to spread out onto its ancient flood plain. Finally the Corps built dams to create lakes to store any excess water, which could be released slowly once the river dropped below flood level. The largest of these, Fort Peck Dam on the Missouri in eastern Montana, was built by order of President Franklin D. Roosevelt, primarily because he believed such projects were a way to provide work for the vast number of Americans out of jobs during the Great Depression. The dam created Fort Peck Lake, which covers an area almost 150 miles long and 6 miles wide. With this lake and the others created downstream by dams in the Dakotas, there would be no more floods on the Mississippi. So was the promise.

But the rains and the snows came. In the winter of 1992-93, they were heavy, saturating the ground so that it could not absorb more water. As opposed to 1927, the bulk of the rain fell in the upper Mississippi Valley region. In the spring of 1993 there was more rain, then more. By the middle of July, it had rained for 49 straight days in the Midwest, sometimes as much as 12 inches in a single day. The tributaries rose, and as a consequence, so did the Mississippi.

People worried, but they depended on the new levees and the cutoffs to protect them. In many places the riverbanks were armored with so-called mattresses made of slabs of reinforced concrete—each 4 feet long, 14 inches wide, and 3 inches thick—and placed one on top of the other. At St. Louis, the concrete floodwall was 11 miles long. In Hannibal, Missouri, the levee stood 31 feet higher than the river bottom, in Ste. Genevieve, Missouri, 38 feet higher. In Quincy, Illinois, the levee stood 28 feet above the river channel. There the normal height of the river was 11 feet.

At Cairo, Illinois, where the Ohio flows into the Mississippi, the Corps built a cutoff to be used in emergencies. When the lower Mississippi rose and threatened to

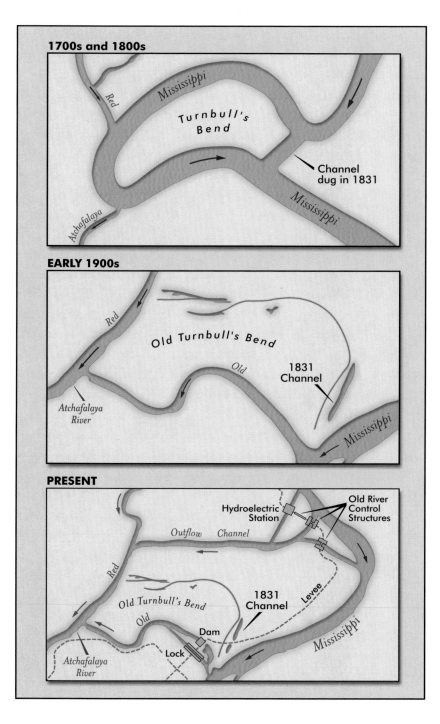

1700s and 1800s

Red

Mississippi

Turnbull's Bend

Channel dug in 1831

Mississippi

Atchafalaya

EARLY 1900s

Red

Old Turnbull's Bend

Old

1831 Channel

Atchafalaya River

Mississippi

PRESENT

Hydroelectric Station

Old River Control Structures

Outflow Channel

Red

Old Turnbull's Bend

Old

1831 Channel

Levee

Dam

Lock

Atchafalaya River

Mississippi

overrun the levees, the Corps could blast open fuse plugs to let water out of the Mississippi. Almost one fourth of the water in the river would flow through. By building another levee ten miles to the west, the system would lead the flow away to the west, then put it back in the main river at New Madrid, Missouri, 30 miles downstream. On January 25, 1993, the Corps blasted it open. Surely the improvements would hold the river within the system.

They did not. The melting snow, the rain, and the subsequent rise of the river meant that the Mississippi, with all its safety structures, was now penned into its channel. Because the river could not spread out over its flood plain, it had no place to go except up. And it did.

Quincy, near the middle of western Illinois and upstream from Hannibal on the other side, stood on a bluff overlooking 110,000 acres of fertile farmland protected by a 54-mile-long levee, part of a levee district named Sny Island. When passing Quincy, the river can carry 250,000 cubic feet of water per second without flooding. But by the summer of 1993 the river was carrying more than 500,000 cubic feet per second. The rise of the river forced the close of one of Quincy's two bridges across the river. On the Missouri side, with no levees, the floodplain was under water. A storm on June 30 brought the river level up another two feet. By the morning of July 1, the water had risen a foot below the top of the Illinois levee and continued to rise an inch an hour. It was time to evacuate. People packed their belongings and farm animals and fled to higher ground.

Hundreds of people from the surrounding area came to help raise the Sny levee and fortify a weak section. Through the day and night, volunteers put in boards and beams, then

To relieve flooding, the U.S. Corps of Engineers in 1831 dug a channel at Turnbull's Bend, in Louisiana. The Mississippi changed course, and the channel became obsolete. Today a system with a dam and levee controls the flow.

backed them with thousands of sandbags. They put some 42,000 sandbags in place, each weighing 30 to 40 pounds. But on Sunday, July 4, more rains came. Levees upstream gave way, flooding more than 10,000 acres, but it reduced the pressure on Quincy. Still more rain came. The levee began to give way. Upstream at Niota, Illinois, prisoners volunteered to help with the sandbags. They were mainly first offenders sentenced for nonviolent crimes, mostly marijuana possession or sale. The young men worked at Niota—and elsewhere—for nine straight days, in rain, sun, heat, humidity, and mud. The townspeople supplied them with food, and they kept working. Despite the effort, the levee broke on July 10. Some of the prisoners wept.

At Ste. Genevieve, some 1,200 volunteers arrived to help. They filled and put in place over one million sandbags, raising the levee by ten feet and backing up the sandbags with 100,000 tons of rock. The city was saved. In Hannibal, where townspeople raised the levee from 31 feet above the river bottom to 34 feet, the river crested at 32 feet, and Hannibal was spared. So was St. Louis, protected by its 11-mile-long concrete floodwall. At Quincy, however, part of the Sny levee gave way, and 44,000 acres were flooded, covered by 15 feet of water.

"The 1993 flood was the worst ever known north of Cairo," Patricia Lauber wrote in *Flood: Wrestling with the Mississippi*. There was major damage along the Missouri River and the other tributaries. The floods covered millions of acres of farmland and drove 36,000 people from their homes. The most severe flooding came along 464 miles of the Mississippi, from McGregor, Iowa, down to St. Louis.

Bad as it was, the 1993 flood was not as severe as the one on the lower Mississippi in 1927. Congress and the American people responded to the 1993 flood by wanting real change. Instead of building more levees, the federal government began a process of buying whole towns or parts of them, along with farms, on the flood plain and moving the residents to higher ground. Moving people would cost less than rebuilding levees and paying for flood relief. Let the river spread rather than rise and try to hold it in, was the idea. Within two years, 8,000 families had sold their property to the government and moved to higher ground.

By allowing the river to spread, flora and fauna will reap the benefits. Birds, deer, and other animals will return to the flood plain. At high water, the animals will move to higher ground while the fish can swim into the flooded areas to spawn. Ducks and geese will fly in to nest and feed. When the water drains off, the creatures will return to the flood plain. But this exchange does not take place all along the Mississippi Valley, and people will continue to fight the river. In the end the river will win. Just ask anyone who lived along the Mississippi in 1927 or 1993.

We spoke to numerous residents of the Quad Cities—the largest metropolitan area on the Upper Mississippi River between Minneapolis and St. Louis—who remember both floods. With a population of more than 400,000, the Quad Cities rest on the banks of the Mississippi and comprise the riverfront cities of Davenport and Bettendorf in Iowa, and Moline/East Moline and Rock Island in Illinois. Located in the heart of the Midwest, the Quad Cities are within a day's drive of several major metropolitan areas such as Chicago, St. Louis, Des Moines, and Minneapolis.

The beautiful town of Davenport, population 100,000, was the largest city along the Mississippi River without proper flood protection in 1993. On July 9 the river was 23 feet deep at the crest, a staggering seven feet above normal level at Lock and Dam 15. The flood lasted for 43 days, with the river coursing through at up to 12 miles an hour. The local economy was devastated. The gambling casinos on the

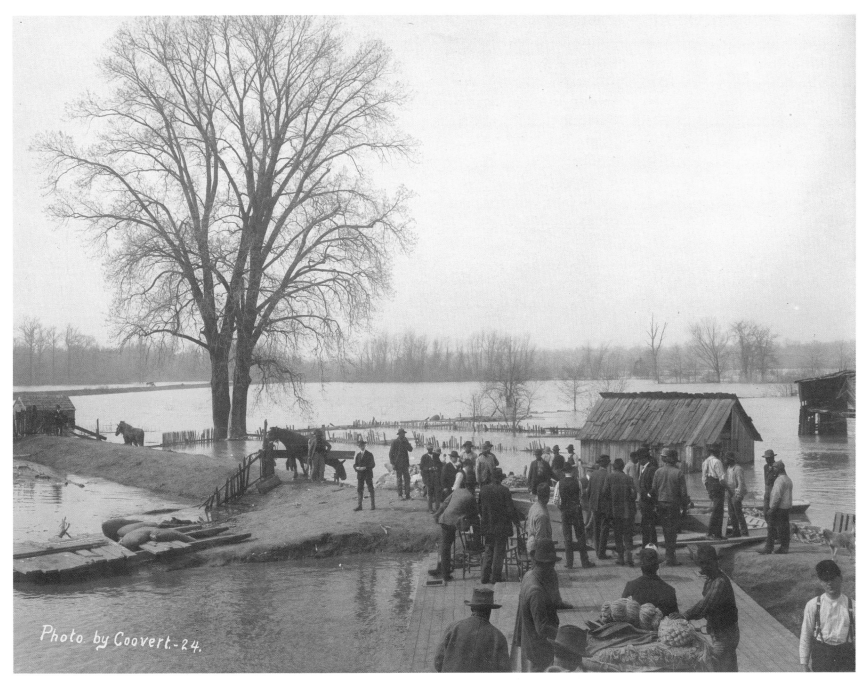

Photo by Coovert.-24.

Residents of Mound City, Arkansas, inspect a levee after a flood in 1903. Despite improved designs, the Mississippi continues to devastate the land all along its course.

waterfront, for example, were decommissioned for the summer. The waterfront stadium—home of the River Bandits baseball team—was shut down. Local humorists began lobbying that the stadium could be reopened if they held "50 cent carp night" and "jet-ski competitions between innings." A favorite line in Davenport during the disaster was: "What is the difference between Minnesota and Iowa lakes? Iowa lakes have cities in them." But the humor was merely a way of coping with the disaster. Since the disaster, a great debate ensued, whether to build a 7-to-15-foot-high wall on the waterfront. Davenport is lucky in one regard: Its 11 miles of waterfront property are owned by the city, so it's publicly controlled and used as parks, marinas, and city projects. Most homes are built above the flood plain. Only time will tell whether the city will decide to build a levee.

At the time of the Louisiana Purchase, the central Mississippi Valley—particularly the area around the Quad Cities—was still inhabited by various Indian tribes, most notably the Sauk and Fox. Where the Rock River flows into the Mississippi, the Sauk had established the village Saukenuk. Its population rose to about 7,000 people, and the town was considered the largest Indian settlement in North America. The Sauk erected various small villages along the Mississippi around the Quad City area to grow maize and trap for fur. It was almost a paradise, a special place where two rivers came together with forest and prairie. During the American Revolution, however, Saukenuk had become a battleground of the Revolutionary War. The village was destroyed in 1780 by American troops because the Sauk sided with the British Army.

Following the Purchase in 1804, several Sauk Chiefs ceded the village land to the Jefferson Administration. The Sauk warrior Black Hawk, however, who was not a chief,

refused to recognize the cession as legal. The rich soil made for good farmland, and the Mississippi and Rock rivers provided fish, turtles, and a transportation route. Black Hawk wanted to live there all his life. He had been born in Saukenuk and was fully distrustful of the United States government. He first tasted glory during the War of 1812 when the pro-British Indians—of whom he was a leader—defeated the Americans in two Mississippi battles. By stopping Maj. Zachary Taylor's plans to overtake Saukenuk and develop a fort in its place to protect white settlers moving to the area, Black Hawk became a hero to his people. His animosity toward Americans became legendary. "You know the cause of our making war," Black Hawk once stated. "It is known to all white men. They ought to be ashamed of it. The white men despise the Indians and drive them from their homes."

The showdown between Black Hawk and the United States government began in 1830. Manifest Destiny was taking hold, and it became federal policy to eradicate Native Americans from the frontier. President Jackson's orders drove the Sauk from their land in Illinois and had them move across the Mississippi to Iowa. For more than a year the Sauk struggled there with failing crops largely due to bad weather. That's when Black Hawk decided to take matters into his own hands and engendered a confrontation with U.S. militia that was later known as the Black Hawk War.

In April 1832 he led some 1,500 Sauk and Fox—including women and children—across the Mississippi to Illinois, demanding the return of their ancestral fields. Once in Illinois an army of 4,000—with General Harry Atkinson in charge of U.S. Army Forces and Henry Dodge and James Henry in charge of the militiamen—began tracking Black Hawk's band. Many of the soldiers were destined to later fame: They included 23-year-old Abraham Lincoln, Captain in the Illinois Volunteers; and Col. Zachary Taylor

(both future U.S. Presidents); Lt. Jefferson Davis (future President of the Confederacy); Gen. Winfield Scott; Lt. Robert Anderson (who at Fort Sumter fired the first shot of the Civil War); Lt. Albert Sidney Johnston (Confederate Commander at the Battle of Shiloh); and Gen. William Clark and his son, 24-year-old Meriwether Lewis Clark.

A number of bloody skirmishes occurred—including the battle of Wisconsin Heights—and Black Hawk headed north, hoping to find sanctuary among the Winnebago tribe. "I started, over a rugged country, to go to the Mississippi, intending to cross it, and return to my nation," Black Hawk wrote in his autobiography. "Many of our people were compelled to go on foot, for want of horses, which, in consequence of their having nothing to eat for a long time, caused our march to be very slow. At length we arrived at the Mississippi, having left some of our old men and little children, who perished on the way with hunger."

With so many troops coming after him, Black Hawk tried three times to surrender, with his scouts carrying a white flag. But on each occasion they were fired on. Disaster was soon in store for Black Hawk in what became known as the Battle of Bad Axe, the last Indian battle east of the Mississippi. At issue was possession of the town of Rock Island, Illinois. Whoever controlled the rapids in the Mississippi there could stop all traffic.

On August 2, as the Sauk and Fox tried to ford the Mississippi or escape by raft near what is now Victory, Wisconsin, U.S. Army troops attacked them. Ignoring a truce flag, soldiers boarded the steamboat *Warrior* and fired on the Indians. The chase turned into a massacre with hundreds of Indians dying in the river. Those who managed to cross the Mississippi were met there by Eastern Sioux, allies of the Americans, and were also slaughtered. The total Indian losses were nearly 750 in the campaign. Although

Bad Axe is little known, more Indians died there than at the famous massacres at Washita, Sand Creek, or Wounded Knee. A brokenhearted Black Hawk escaped Bad Axe and made his way to the Winnebago village at Prairie La Crosse. He entered the lodge of a chief and told him he was prepared to surrender to the American war chief and would pray to the Great Spirit for mercy. The squaws made him a white dress of deerskin and comforted him for a night. He then rode off to Fort Crawford at Prairie du Chien to admit defeat: The Black Hawk War was over, the great Indian warrior of the upper Mississippi was now a prisoner of the U.S. government. Lts. Jefferson Davis and Robert Anderson took him down the Mississippi to St. Louis, where he was imprisoned in ball and chains until April 1833. By this time Black Hawk had become a curiosity, and he was taken on tour of the East Coast. In Washington, D.C., he met with President Andrew Jackson, but the purpose of the trip was to imprison him again at Fortress Monroe in southeastern Virginia. This was too much for William Clark. He wrote the Indian commissioner in Washington in outrage that Black Hawk and his people had learned "the folly and hopelessness of contending against the arms of the United States." He demanded that the government restore them "to their friends and country." It was done, and Black Hawk returned to the Mississippi.

On September 21, 1832, a treaty had been signed in East Davenport whereby the Sauk and Fox ceded all of their land in Illinois plus a 50-mile-wide strip of land on the west bank of the Mississippi. This tract of six million acres is known in the history books as the Black Hawk Purchase. It took four days to complete the signing. Western artist George Catlin came by canoe from Wisconsin to paint and sketch the Sauk before they left their native lands. He wrote of the stretch of the river around the Quad Cities that "There is no more beautiful country in the world."

A band of Sauk and Fox Indians on a raft is ambushed by the U.S. Army and militia aboard the steamboat *Warrior*. Accounts conflict as to whether the Indians were surrendering or attacking. In this last skirmish of the Black Hawk War in 1832, the Indians were trying to reach the west bank of the Mississippi near what is now Victory, Wisconsin, after a failed attempt to regain their homeland on the Illinois side. According to Black Hawk's autobiography, when U.S. Forces attacked, the Indians signaled for surrender, but to no avail. Those few Indians who made it across the river were massacred by a band of Eastern Sioux, who were allies of the Americans. In this encounter—later called the Battle of Bad Axe—nearly 750 Indians died, more than at the last stands at Washita, Sand Creek, or Wounded Knee.

As compensation for relinquishing Illinois land, the Sauk and Fox received $20,000 and 40 kegs of tobacco a year. In addition, to "give a striking evidence of their mercy and liberality," the Jackson Administration agreed to give the tribes 35 beef cattle, 12 bushels of salt, 30 barrels of pork, and 50 sacks of flour for the widows and children of men lost in the Black Hawk War. Upon his release from prison, Black Hawk moved with his family to land at the Iowa River, then the Des Moines River. He died on October 3, 1838 at 71 years of age and is buried at the river bottom. He claimed that his people had lived at Rock Island for 1,000 years, which sounded dubious to us, until we visited the Effigy Mounds near Marquette, Iowa, across from Prairie Du Chien. Some of those mounds are 3,000 years old.

But the name Black Hawk continues to resonate throughout the upper Mississippi River region. The Black Hawk State Historic Site, a forested 208-acre tract in Rock Island, has a museum that includes full-size replicas of Sauk winter and summer houses. There is also an 18-ton granite statue of the legendary warrior, and downtown Rock Island boasts a three-story mural in his likeness. Black Hawk's name is on plazas, banks, a local college; and Chicago's NHL hockey team bears his name. The U.S. Army paid this Native American warrior a high honor: They named their best helicopter after him. But the greatest tribute of all to Black Hawk is paid by the University of Illinois Press who makes sure that his autobiography stays in print so future generations will better understand the terrible price the Sauk paid in the name of Westward Expansion.

The surrender of Black Hawk encouraged more and more Europeans to move west in search of a better life. In 1837 the population of Davenport, for example, was only 90. But in 1848 some 250 German political immigrants settled in Davenport. Within a decade they numbered 3,000, nearly 20 percent of Davenport's population, establishing their own communities with German schools and newspapers. A large migration of Belgians and Swedes were drawn to Moline, Illinois, at the same time to work in a new plow factory established by blacksmith John Deere.

Moline was founded on a vision: David B. Sears, believing he could generate power from the Mississippi River, ventured north from Cairo, Illinois, following the Black Hawk War. He purchased land in an unincorporated area known as Rock Island Mills to build a stone mill capable of grinding wheat and sawing lumber. Sears's pioneering effort led to a proliferation of mills along the riverbanks. Business was so good that the mills often ran nonstop for weeks. Log rafts moving as much as 10 million board feet of lumber from the logging camps of Minnesota and Wisconsin were a common site in the Quad Cities during the 19th century.

Much of the lumber sawed by Sears was used to construct the first railroad bridge to cross the Mississippi. Built between Rock Island and Davenport, it opened with great fanfare in 1856. A headline in the Chicago Democratic Press read: "The Mississippi River crossed by the iron horse.... The Greatest Feat of the 19th century." An intense rivalry between the railroad and steamboat companies ensued for control of the Midwest. Citizens living in the Quad Cities area had no real political affiliation: They were either pro-steamboat or pro-railroad depending on their economic outlook. Tempers flared when angry steamboat companies tried to damage the railroad bridge by ramming it with boats. The most celebrated accident occurred when the steamboat *Effie Afton* hit a pier and was destroyed. The furious boat owners sued the railroad, hoping that bridges across the Mississippi would be banned.

The railroad hired three lawyers, including Abraham Lincoln of Springfield, Illinois. He journeyed to Rock

Island to represent the railroad against the steamboat company in court, which was claiming that bridges obstructed the "navigable character" of the river. The showcase trial ended in a hung jury. But the pro-railroad argument became known as the Lincoln Doctrine when it was settled in the U.S. Supreme Court in 1862. It read, in part: "A man has as good a right to go across a river as another has to go up or down the river...the existence of a bridge which does not prevent or unreasonably obstruct navigation is not inconsistent with the navigable character of the stream." Thus the railroad won its case. Settlement in the Quad City area increased, and the steamboats' relevance decreased. Lincoln had become a hero to the railroad industry. By 1876 three major train lines served the area: the Chicago, Rock Island, and Pacific; the Chicago, Burlington, and Quincy; and the Chicago, Burlington, and St. Paul.

But it was a journeyman blacksmith from Vermont named John Deere, born just two months after the signing of the Louisiana Purchase, who changed farm labor by inventing a self-scouring plow ideally suited for the western frontier. Throughout the Green Mountains region Deere was known for fitting shoes on horses and fixing broken rifles. His name was synonymous with craftsmanship and attention to detail. But stories of steamboats plying the Mississippi filled his imagination, and he dreamed of moving to the Great Plains, a vast prairie rumored to be ideal for growing wheat. In the mid-1830s a client returned to Vermont after spending months in Grand Detour, Illinois. He convinced Deere that this town was sorely in need of a blacksmith, as European immigrants were pouring into the region, ready to till the virgin soil. In 1837, with only a pocketful of coins and a few tools, he set out for Illinois, promising his wife Demarius that he would send for her and their children once he established himself in Grand Detour.

It did not take long. Deere quickly realized that the cast-iron plows of the East performed abysmally in the heavy soil of the Midwest. Mud clung to the plow bottoms and had to be scraped off. This laborious work slowed down farmers considerably. Deere realized a fortune could be made if he invented a plow with a smoother blade that would stay clean as it was pushed or pulled across the field. Deere fashioned a new plow from a broken steel saw blade. Hundreds congregated at Lewis Crandall's homestead near Grand Detour to watch the new tool at work. They were in awe of the plow, ordering their own on the spot. A local reporter who witnessed the event confirmed that John Deere's plow could "cleave without carrying the rich alluvial earth."

It was not until 1848, however, that budding industrialist John Deere located his company's first plow manufacturing plant on the banks of the Mississippi River in Moline. His reason for leaving Grand Detour was simple: The river provided both waterpower and a shipping port. The Mississippi could bring finished John Deere plows to market in St. Louis and New Orleans. Soon his Moline factory was producing 1,000 plows a year. He quickly became the hero of farmers throughout the Midwest, for his plows were of high quality and efficient. Throughout Illinois and Iowa he would hold plow demonstrations, gathering disciples wherever he went, always bent on manufacturing new steel plows, cultivators, corn and cotton planters, and other farm tools. The name John Deere stood for excellence in agriculture. "I will never put my name on a plow," he vowed, "that does not have in it the best that is in me."

Shortly after the Civil War the business was incorporated under the name of Deere & Company. And although John Deere died in 1886, his family continued to run what became the largest agricultural equipment manufacturing enterprise for the next century. Today, just like Black Hawk,

the name John Deere—particularly the yellow and green logo with an antlered deer in the middle—is omnipresent in the Quad Cities. We visited the John Deere Pavilion in the restored riverfront area of downtown Moline, named John Deere Commons. The Pavilion is one of Illinois's top five tourist attractions, a place to learn about the history of agriculture and its future. Computer simulation displays explain how corn is grown and harvested. And there is a collectors' center where you can study vintage John Deere equipment and memorabilia, as well as the modern Green Giant tractors. We also ventured up a hill near the Commons to tour the Deere-Wiman House, built in 1872, and Butterworth Center, built in 1892, two majestic homes that tell the story of how the Deere family prospered in the Quad Cities. If you follow the Mississippi River a few miles east to Riverside Cemetery, there perched on a bluff overlooking the river valley is the grave of John Deere. From the cemetery we journeyed to the Administration Center to see the international headquarters of Deere & Company. This magnificent building with expansive glass windows is without question an architectural gem, designed by Eero Saarinen of St. Louis Gateway Arch fame. The star of all these Moline exhibits is the sod-busting plow, which helped launch the Bread Basket Revolution in the American Midwest.

Another reason why the Quad Cities became such a center of transportation is the 964-acre island called Rock Island—like the Illinois city on the banks of the river—or Arsenal Island, the largest island in the upper Mississippi, between Illinois and Iowa. The U.S. Government had acquired the island in 1804 as part of a general treaty agreement with the Sauk. After the War of 1812 soldiers sent from St. Louis built Fort Armstrong on the western end of the island to protect fur traders and to control passage to the upper regions of the Mississippi River. During the Civil War

it became a U.S. Army arsenal where more than 12,000 Confederate prisoners were held. Beginning with the Spanish American War of 1898, the arsenal produced a wide variety of military equipment including mess kits, canteens, and artillery. During World War II nearly 20,000 workers produced tanks, rifles, and machine guns at the arsenal. Encompassing 18 acres, Building 299 was constructed as America's largest defense warehouse. Military equipment is no longer built on Arsenal Island, but a first-rate military history museum includes artifacts from the wars in Korea, Vietnam, and the Persian Gulf.

Another attraction of Arsenal Island is the home of Col. George Davenport—namesake of Davenport, Iowa. Born in Lincolnshire, England, in 1783, he came to America at the time of the Louisiana Purchase, eventually making his way to the Mississippi and becoming quartermaster at Fort Armstrong, with the rank of colonel in the Illinois militia. After his service, he traipsed the banks of the Mississippi, trapping beaver and hunting wild turkey with his partner Russell Farnham. They sold thousands of pelts to the American Fur Company. Over the years Davenport cultivated many friendships with the Winnebago in the region. At age 40 Davenport built a two-story house on Arsenal Island, which became the leading business and literary salon for the upper Mississippi region. Everything from British Imperialism to Indian affairs was discussed at his dinner table. The house became the so-called Cradle of the Quad Cities. But on July 4, 1845 tragedy struck. A group of outlaws, called "Banditi of the Prairie," burst into the house and murdered him. His son, Bailey, continued in his father's footsteps, as real estate entrepreneur and banker. He served five terms as the Democratic mayor of Rock Island.

After Davenport's murder, his friend Antoine Le Claire named the town of Davenport across the river in Iowa in his

honor. Le Claire has his own namesake city, historic Le Claire, a short drive from the Quad Cities on the west bank of the Mississippi. The son of a French Canadian father and a Potawatomi mother, Le Claire learned English in St. Louis under the sponsorship of William Clark. Given his mixed blood heritage, Le Claire served as an Indian agent and interpreter at Fort Armstrong, where he befriended the Sauk. A large, rotund entrepreneur with a hearty laugh, he was deeded choice Iowa farmland in the Black Hawk Purchase of 1832. He accumulated wealth as a thrifty realtor and built an elaborate Italianate mansion at 630 East 7th Street in Davenport as a town showcase. When Black Hawk was released from jail, he turned to Le Claire, who spoke the local Indian languages fluently, to translate his autobiography. The successful collaboration resulted in the only authentic account we have from the point of view of an Indian who fought against the United States.

The town named after this entrepreneur is located at the juncture where the Mississippi River turns to the southwest,

Trains pull directly into the John Deere factory in Moline, Illinois, while steamboats ply the river behind it. The various shipping options helped turn Deere's plow works into one of the most successful plants in the country.

a stretch of river known as the Upper Rapids. Before the Corps of Engineers dredged the river and raised the water level by building locks and dams in the 1920s, this was a danger zone of river boulders, eddies, and hidden sandbars for steamboats. The town once had more riverboat pilots per capita than any city on the Mississippi.

A famous elm tree marked the beginning of the rapids. River pilots and deckhands could wait in the elm's shade for the next sternwheeler to arrive. They were hired to complete the trip to Davenport, where they were discharged to return to Le Claire by the first boat or wagon and repeat the process.

Today Le Claire celebrates the men who conquered the Upper Rapids. Many of the pilots' homes have survived and were rcognized on May 7, 1979 as part of the nine-block Cody Road Historic District listed in the National Register of Historic Places.

The district was named after Le Claire's most famous native son: William "Buffalo Bill" Cody, who was born along the riverbank on February 26, 1846. His father, riverboat

pilot, Isaac Cody had moved the family from Cincinnati on the Ohio to Le Claire on the Mississippi because the wages were better there. The site of the original Cody log cabin no longer exists; a wheat field grows where it once stood. A cabin similar to the Cody birthplace can be seen at Walnut Grove Pioneer Village. Young Cody left Iowa early. He became a Pony Express rider at age 14 and later served as a scout in the U.S. Army during the Civil War. He became a buffalo hunter, providing meat for hungry Union Pacific Railroad workers as they built the transcontinental railroad. His assuredness with a rifle earned him his nickname, "Buffalo Bill." From 1868 to 1872, Cody served as a civilian scout for military forces fighting Indians in the West. His valor along the Platte River earned him the Medal of Honor. In 1872 Cody began his long career as a buckskin showman and professional dandy. He became widely known for his Wild West shows, which re-created harrowing battles between cowboys and Indians, and he toured the United States and Europe between 1880 and 1913. The show introduced to the world such legendary Wild West figures as Teton Sioux Sitting Bull, sharpshooter Annie Oakley, and frontiers-woman Calamity Jane. The shows made Buffalo Bill a rich man. He invested in land in Nebraska and in the area now known as Cody, Wyoming. He died in 1917 and is buried on Lookout Mountain, near Denver, Colorado.

Today you can tour Buffalo Bill's homestead in Le Claire and visit the museum that tells the story of his river town. A massive cross section of the old elm, which helped riverboat pilots, rests in the levee museum, as does a collection of inventions by Prof. James Ryan, including an example of an airplane flight recorder commonly called the black box. People who don't take to water can tour the dry-docked Lone Star riverboat, built in 1865. This former water taxi changed vocation in 1876, when it became a towboat pushing logs down the river. It was remodeled once again from wood power to coal at the Kalke Boat Yard in Rock Island in 1899. It is the oldest surviving wooden-hulled work boat.

Politics are a favorite sport in the Quad Cities, and the president whose biography most intersects with the upper Mississippi is Ronald Reagan, whose boyhood heroes were Mark Twain and Buffalo Bill. On a sultry August day in Davenport, the sun beating down on the grain elevators that dot the banks of the Mississippi, we talked about Reagan in an asphalt parking lot with columnist Bill Wundram, who has spent his past 55 years writing for the *Quad City Times*. We were standing on the site of the old Perry Apartments, which were demolished in 1992. Wundram showed us a treasured artifact: the wooden medicine cabinet door from Room 510, where Ronald Reagan lived in 1933, while working as a radio announcer for station WOC (World of Chiropractic). "His tiny fifth-floor apartment used to look out on the Mississippi," recalls Wundram. "I took this door from his old quarters just before they tore the building down. This river was an integral part of his boyhood years, and this door is the only souvenir from his Davenport days."

Reagan was born and raised closer to the Mississippi River than any other U.S. President. When recalling his youth, Reagan ignored the gloomier aspects of Mark Twain's murky Mississippi stories and called his entire coming of age "one of those rare Huck Finn-Tom Sawyer idylls." Reagan's father, John Edward Reagan, a shoe salesman, was born in Fulton, Illinois, in 1883, a year after Twain first steamboated up the Mississippi. He married Nelle Wilson, and moved to Tampico, Illinois, situated along the Rock River, where Ronald was born on Feb. 6, 1911. "The Reagans were under the spell of the Mississippi, of all the muddy bright promises it meant to break," historian Garry Wills writes in *Reagan's America*, in a chapter titled "Huck Finn's World."

In 1939, upon graduating from Eureka College in Eureka, Illinois, Reagan followed Twain's notion of "lighting out" for the territories and made the 65-mile westward trek to Rock Island, Illinois. He rode the ferry across the Mississippi and got off at the Davenport dock, looking for work as a radio broadcaster. Reagan, 21, equipped with radiant optimism and an effervescent smile, was hired to announce sports at WOC, located on the top floor of the Palmer School of Chiropractic.

In early February he returned to Davenport—which Twain called a "beautiful city crowning a hill"—with a tattered suitcase and black trunk, and moved into Perry Apartments, a well-maintained residential hotel where actors and vaudeville circuit stars such as Sarah Bernhardt and Al Jolson once stayed. More impressive to Reagan, who was captivated by Wild West lore, was that William "Buffalo Bill" Cody grew up 15 miles upriver in Le Claire, Iowa, and lived for a brief spell in Perry Apartments. Buffalo Bill's brother, Sam, is buried nearby in Longrove Cemetery.

Though Reagan lived in Davenport for only three months, they were crucial ones in his professional development. WOC was 10 years old and the radio voice of the Quad Cities and beyond. Its motto being "Where the West begins and in the state where the tall corn grows." Not only did WOC have a 50,000-watt signal, one of only 17 stations licensed with that range capacity, but it was one of the first stations to relay broadcasts from New York as part of the development of NBC. Davenport gave Reagan a shot at being a big-league broadcaster.

Antoine Le Claire applied the talents learned from his father and the language skills of his Indian mother to create a fortune in Davenport, Iowa.

The Great Depression, however, had ravaged Davenport, and from Reagan's window he could see families living in shanty boats along the river and black soot billowing at the city dump at the foot of Gaines Street. The screeching and flapping of river bats, which infested the Perry's walls, kept him awake at night. Lucile Mauget, a WOC retiree, recalls Reagan's biggest worry in those days: "Dutch always joked that he was afraid the Murphy bed would close him up inside."

Every morning, he would walk six blocks uphill to the Palmer School, where he could eat a hot meal for free at the cafeteria. It was on the cafeteria's radio that Reagan heard his hero, President Franklin D. Roosevelt. Wildly impressed by FDR's patrician self-confidence, Reagan began imitating the President's Hyde Park accent on the air.

The primary purpose of WOC was to promote the Palmer School of Chiropractic, and owner B.J. Palmer was a regular P.T. Barnum of spinal alignment in this regard. Whether it was parading a huge papier-mâché spine down Brady Street, running "tallest corn" contests, or writing catchy jingles about bones, Palmer had a knack for garnering attention for his school and profession. It's little wonder that Reagan was soon dismissed from his job, ending up at a sister station in Des Moines, because he refused to read a mortuary advertisement after spinning the song "Drink to Me Only With Thine Eyes." He had broken the cardinal rule of WOC: disregarding a sponsor. Reagan left Davenport in May 1933, headed west, and never looked back. Like Buffalo

Bill, Reagan was embraced as a folk hero, and with his growing skill as a great communicator, he trod the path to Hollywood, to the California governor's mansion, and then to the White House.

The best place to learn about the upper Mississippi is in Dubuque, Iowa, located about 70 miles north of the Quad Cities. Dubuque has been a significant port city since it was incorporated in 1833 as a lead-mining boomtown and became an important boat-building center. The river has been the city's greatest natural asset. In 1891 the Iowa Iron Works Company built the famous torpedo boat *Ericsson* in the harbor for the Spanish American War. A few years later they launched the *Sprague*, considered the world's largest towboat. Riverboat pilots preferred Dubuque because the town boasted the only protected harbor between St. Louis and St. Paul. Today more than 126 million tons of commodities are shipped on the upper Mississippi alone, including grain, coal, chemicals, and petroleum. Revenues from Mississippi commercial fishing exceed $1.7 million annually.

Cognizant of their essential relationship with the Mississippi, the citizens of Dubuque, a progressive city of 62,000 people, decided in 1995 to build America's River, which includes a $188 million riverfront development, featuring the National Mississippi River Museum and Aquarium, which celebrates the historical, environmental, educational, and recreational majesty of the river. Partnering with the U.S. Fish and Wildlife Service, the U.S. Army Corps of Engineers, and the

Resting on animal pelts and posing as the great prairie hunter, Iowa-born William "Buffalo Bill" Cody was one of America's first great showmen.

U.S. Coast Guard, the museum houses five major aquariums, bringing to life such distinct river habitats as a backwater marsh, flooded bottomland forest, the main channel, an otter pond, and a delta bayou swamp with alligators and snapping turtles. In hands-on exhibits, young people can create a flowing river, study river hydrology and flooding, and simulate piloting a towboat. A one-and-a-half-acre wetland shows the natural history of the river with exhibits of Native Americans, fur traders, fishermen, and clammers. The museum displays historic riverboats, including a National Historic Landmark steamboat, four towboats, two boathouses, and 20 smaller craft. Fiber-optic technology connects the center with sites across the country. Because Dubuque is centrally located in the Upper Mississippi National Wildlife and Fish Refuge, which extends for 261 miles along the Mississippi, it's the perfect place to study the river here. The museum's National Rivers Hall of Fame, which includes members from 38 states, tells the human story of the people who live, work, and make history on our inland waterways.

Upon leaving the riverfront complex, you'll have learned astonishing facts, such as: Nearly 18 million Americans drink the water of the Mississippi and its tributaries, and NASA astronauts in space can easily identify the Big Muddy when they look back to Earth. As National Public Radio commentator Garrison Keillor notes in the opening lines of *River of Dreams,* an award-winning film shown daily in the museum's auditorium: "It comes at us bigger than life. The Mississippi—artery of a continent; lifeblood of a country." ★

THE HEADWATERS

★

"What had long been sought, at last appeared suddenly."

HENRY R. SCHOOLCRAFT

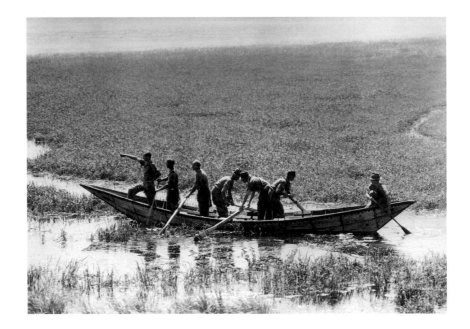

A 1932 ceremony reenacts the discovery of the Mississippi's headwaters in Minnesota.
PHOTO BY MPLS JOURNAL, MINNESOTA HISTORICAL SOCIETY

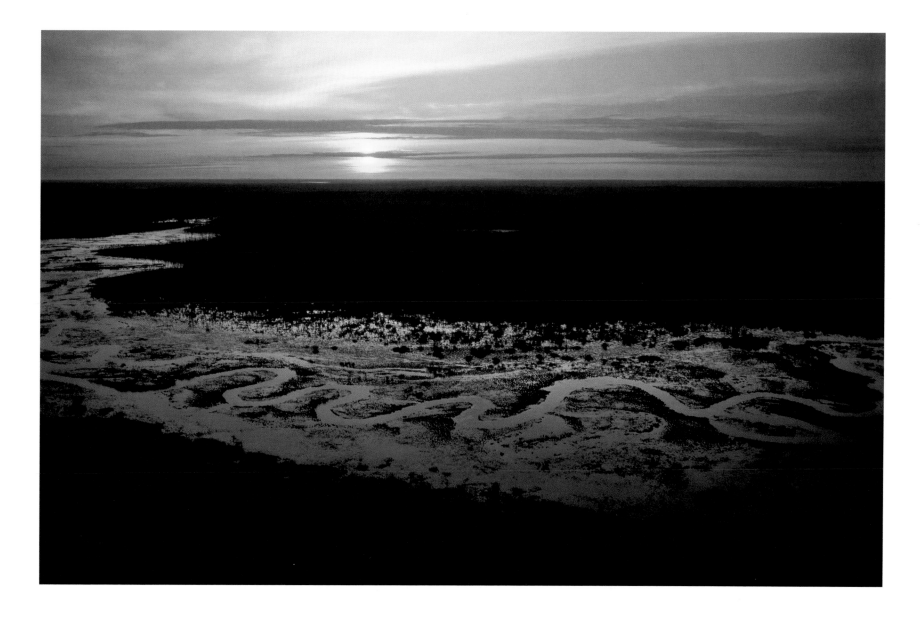

Under a rising sun, the Mississippi meanders south from its source at Lake Itasca.

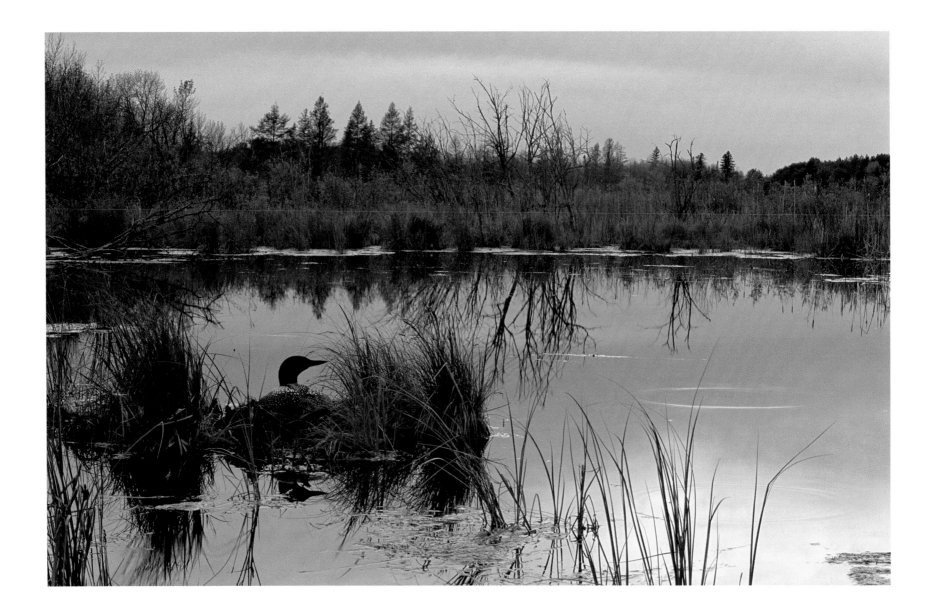

A loon nests in marshy lake country in northern Minnesota. KERRY TRAPNELL

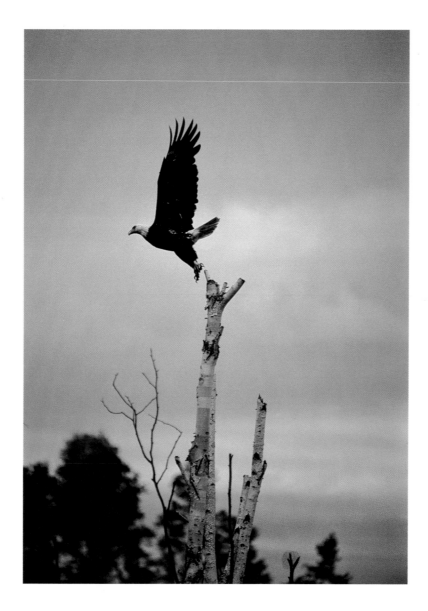

Master of the Minnesota lakes, a bald eagle takes flight from its tree stump. KERRY TRAPNELL

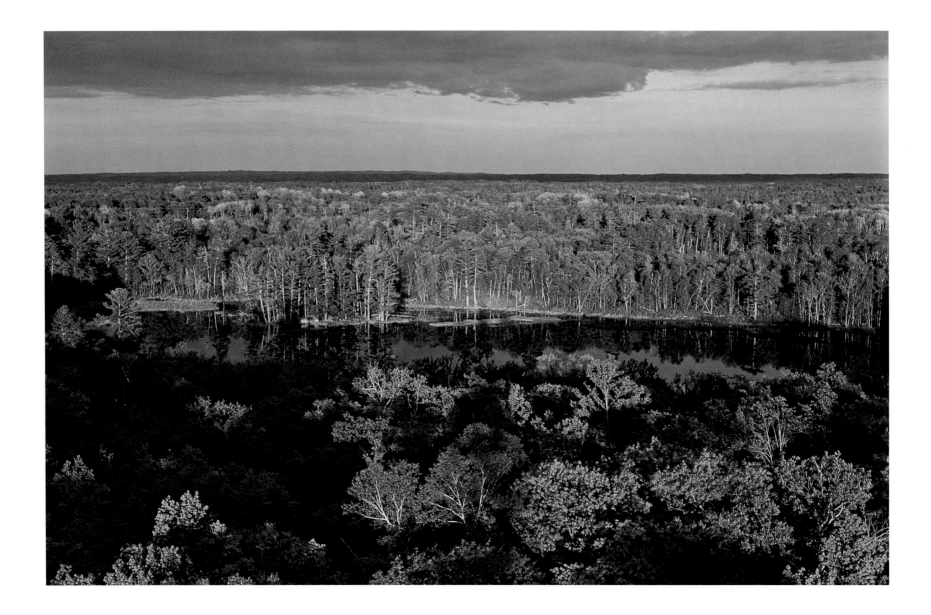

Marshy woodlands fill the horizon of Itasca State Park in Minnesota. KERRY TRAPNELL

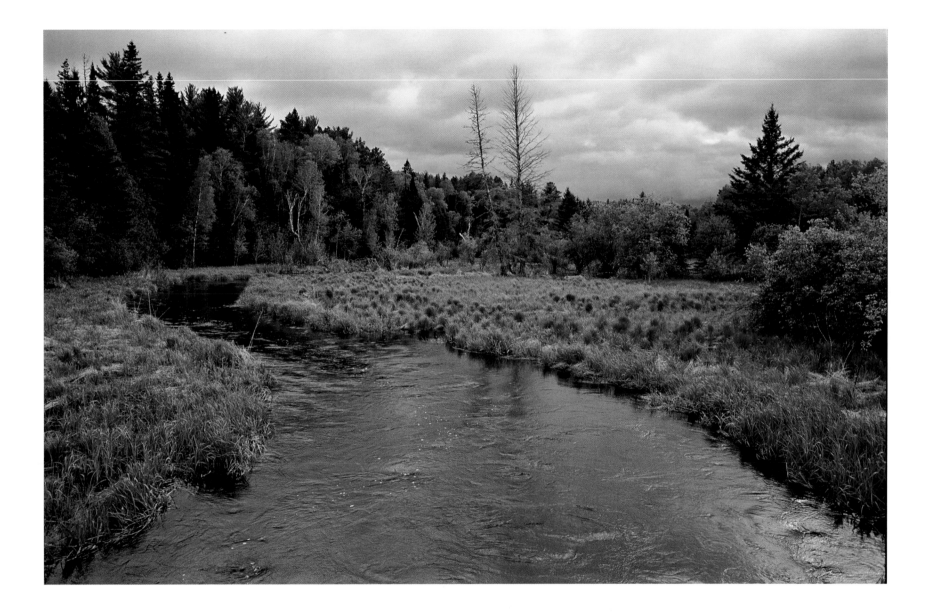

Stream-like near its source, the budding Mississippi flows northward, then southward to maturity.

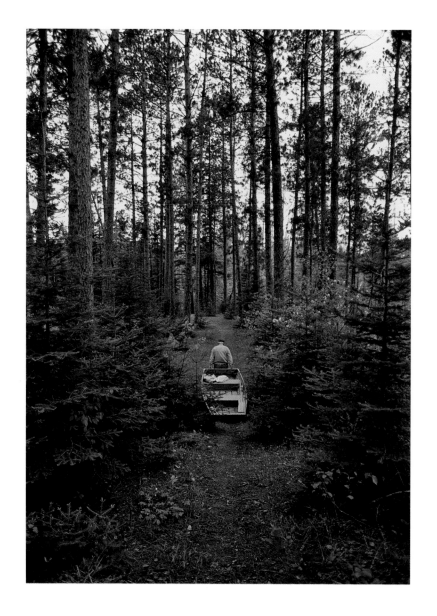

Tall timbers flank a fisherman pulling a johnboat to Lake Itasca.

A whimsical sign salvaged by Dr. Allen Kringlee near Lake Itasca, Minnesota, indicates the Mississippi's origin.

The Fort Snelling Bridge spans the Mississippi near its northernmost navigable reach. Built in 1825 at the junction of the Mississippi and Minnesota rivers, Fort Snelling was an ideal vantage point from which America seized control of the fur trade from the British and established authority over America's frontier territory.

CHAPTER ELEVEN

MINNESOTA

★

"I look back at what the Mississippi is to me, and it's the giver of life."

JIM JONES, JR.

IT WAS A RAINY WINTER MORNING in 1805, and President Thomas Jefferson was stricken with a painful bout of Louisiana Fever—daydreaming of escaping the confines of the District of Columbia and journeying westward to explore the vast territory, he had purchased for the United States. As he studied his large map of North America, he was plagued by a cartographic omission: Where were the headwaters of the Mississippi River? Did it spring from the Arctic Circle? Was Lake Superior the source? Did British Canada control the headwaters? Why had the early European explorers such as Marquette and Joliet failed to find the source? Jefferson, the classics scholar, remembered reading the Greek philosopher Pliny a few years earlier and was struck by a particular line.

"The beginnings of a river are insignificant," Pliny wrote, "and its infancy is frivolous; it plays among the flowers of a meadow, it waters a garden, or turns a little mill." Jefferson disagreed with this strange notion. He was obsessed to discover whether the Mississippi was America's river or would have to be shared with British Canada. He had dispatched Lewis and Clark on their Voyage of Discovery two years earlier. Now he was pleased to learn from a letter by Gen. James Wilkinson—Commander of the U.S. Army and one of two commissioners chosen to govern the Louisiana Territory—that he would send a young lieutenant named Zebulon Pike to lead a voyage up the Mississippi River.

Pike—born on January 5, 1779 near Trenton, New Jersey—was well suited for the job. Fascinated by the exploits of George Washington as a boy, Pike joined the Army in 1794 and became a second lieutenant in 1799. He was posted to Kaskaskia, a colorful outpost and the first capital of Illinois, only six miles above the Kaskaskia River's confluence with the Mississippi. Occasionally he would journey to

Lt. Zebulon M. Pike led an expedition to find the headwaters of the Mississippi, but he misidentified its source. In his explorations of the West he mapped much of Colorado.

Pittsburgh or Cincinnati for supplies, earning the title of barge commander. In the summer of 1805 President Jefferson called him to duty: He was to leave his post as commander at Kaskaskia and travel to St. Louis to organize an expedition to the upper Mississippi.

On August 9, 1805, with plenty of gunpowder and provisions on board, the 26-year-old Pike and 20 handpicked soldiers from the First Regiment of the U.S. Infantry began their arduous journey poling up the Mississippi. It would be a nine-month, 5,000-mile trek in a 70-foot-long wooden keelboat with a square sail. Supplies included several small barrels of whiskey, corn meal, tobacco, writing paper, ink, guns and powder, and tents. The entire expedition cost the Jefferson Administration about $2,000. In their search for the headwaters, Pike and his men were instructed to negotiate peace treaties with Indian tribes they encountered along the way and to assert legal claim to the area. Jefferson also was anxious to discover the economic potential of the upper Mississippi region, and he wanted to stop any illicit British fur trade operations

there. "You will please to take the course of the river and calculate distances by time," Wilkinson had informed Pike, "noting rivers, creeks, highlands, prairies, islands, rapids, shoals, mines, quarries, timber, water, soil, Indian villages, and settlements in a diary to comprehend reflections on the winds and weathers."

Pike kept a detailed journal of the voyage. The natural scenery he described was—and still is—spectacular. They passed hundreds of little islands, covered with a luxurious growth of wild grasses, a profusion of trees: hard and soft maple, black walnut, white birch, silver poplar, box elder, cottonwood, red and white cedar, juniper, wild apple, and burr oak. In short, it was an arborist's nirvana. The trees in their autumnal splendor presented the Pike Expedition with a riot of fiery colors no artist could paint. As they rowed up the river, jagged bluffs came into view around every bend in the river, and occasionally they oared past an ancient Indian mound steeped in mystery. Herds of elk were feeding along the water's edge, and the men spotted mink, racoon, deer, and wild geese. Beavers had constructed log-mud dams in shallows, and otters floated alongside the boat, playing on their backs.

They reached Dubuque, Iowa, the first outpost of any

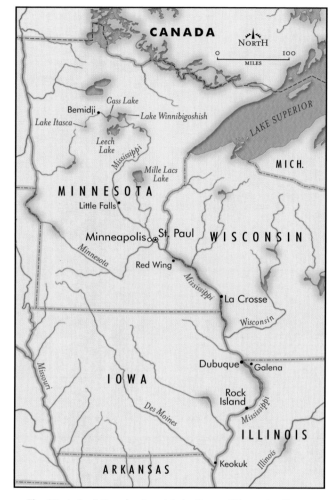

The Mississippi River begins at Lake Itasca, Minnesota, Henry Schoolcraft discovered in 1832. Earlier explorers claimed Leech and Cass lakes as headwaters.

consequence, on September 1. Following orders from Wilkinson, the expedition visited Julien Dubuque, who ran an extremely profitable lead mine, a concession he had finagled from the Sioux Indians. The tireless Dubuque mined between 20,000 and 40,000 pounds of lead ore a year. Pike dispatched a lengthy report to Wilkinson, explaining how the mining operations worked; then he and his men moved on.

Some 400 miles upriver from St. Louis, they made camp in Prairie du Chien, Wisconsin, an isolated frontier outpost. The densely forested country north of this trading center was wild and largely unexplored. That September Pike found a strategic 500-foot bluff overlooking the Mississippi on which to build an American fort a few miles south of Prairie du Chien. He decided to exchange the keelboat for a couple of bateaux—small boats that would more easily maneuver through the shallows—and the expedition paddled on, past Dakota villages and undulating prairies. As the Mississippi water changed from brown to blue, the bluffs grew in stature. On an island where the Mississippi joins the Minnesota River (known then as St. Peter's River), Pike signed a treaty with Dakota representative, Le Petit Corbeau, leader of the

Kaposia village of Mdewakanton Sioux. This was the first U.S. treaty signed west of the Mississippi. Pike had purchased 155,520 acres of upper Mississippi land for $200 worth of gifts, 60 gallons of whiskey, and a pledge of $2,000 to be paid later.

The U.S. Government established Fort Snelling—near present-day St. Paul—atop the bluff in 1819; it remained an active army post until 1946. The island, where the treaty was signed, is now called Pike's Island and is a part of Fort Snelling State Park.

By late September, winter started to close in on the Pike Expedition. The men were surprised that snow squalls arrived so early and that at night the temperature fell to zero. But they pushed on, worried that they were ill-equipped for winter. Their voyage was further slowed down by the Falls of St. Anthony in Minnesota Territory. With great strain the Pike Expedition successfully portaged around the roaring falls. (Today the falls are part of the Twin Cities.) The falls, named in 1680 by the French explorer Father Louis Hennepin in memory of his patron saint, Anthony of Padua, were the most abrupt drop in the Mississippi River. The 16-foot turbulent cascade was a sacred site to both the Ojibwe and Dakota peoples.

By the time Pike and his men had made their way north of the falls, most of them were ill with whooping cough, strep throat, and pneumonia. For a while they traveled overland, carrying the bateaux on their shoulders, which they found easier than rowing against the current. As the Canadian wind increased in velocity, the temperature continued to drop, and staying warm became a full-time job. Ice formed in the river, and the prairie became a frozen tundra.

By mid-October the Pike expedition built a stockaded shelter south of Little Falls, Minnesota, on the west bank of the river. This small structure became known as Fort Pike. They hunted game and ate wild rice for sustenance. While wintering near Little Falls, Pike and a small contingent headed north, reaching a fur post at Leech Lake on February 1, 1806. Whenever the expedition encountered British traders, they demanded that the Stars and Stripes go up and the Union Jack come down. Ravaged by the weather and without the help of any expert Indian guides, Pike's men were exhausted. They built toboggans to pull each other through the snow. Pike spent little time exploring Leech Lake, declaring it "the main source of the Mississippi," and promptly started back to St. Louis.

He was proven wrong in 1832 by Indian Agent Henry Rowe Schoolcraft. But it didn't matter much that the true headwaters—Lake Itasca—were eight miles away. The American flag now flew in the upper Mississippi region even if the headwaters were misidentified. Pike's flag-raising gestures turned out to be important in the negotiations that eventually settled the United States-Canada border. By demanding that British flags be taken down, Pike laid claim to land up to the northern rim of Minnesota.

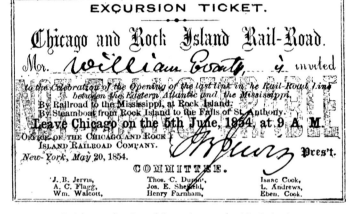

EXCURSION TICKET.

Chicago and Rock Island Rail-Road.

Mr. *William Boaty*, is invited

to the Celebration of the Opening of the last link in the Rail-Road line between the Eastern Atlantic and the Mississippi.
By Railroad to the Mississippi, at Rock Island.
By Steamboat from Rock Island to the Falls of St. Anthony.
Leave Chicago on the 5th June, 1854, at 9 A.M.

ORDER OF THE CHICAGO AND ROCK ISLAND RAILROAD COMPANY.
New-York, May 20, 1854. Pres't.

COMMITTEE.

J. B. Jervis, Thos. C. Durant, Isaac Cook,
A. C. Flagg, Jos. E. Sheffield, L. Andrews,
Wm. Walcott, Henry Farnham, Eben. Cook.

A ticket to the Grand Excursion on the Mississippi— a party-boat ride hosted by the founders of the Chicago and Rock Island Railroad—was an invitation to the event of the year in 1854.

Delivering his annual message to the U.S. Congress on December 2, 1806, Jefferson reported on both the results of the Lewis and Clark Expedition and the Pike Expedition. "Very useful additions have also been made to our knowledge of the Mississippi," Jefferson stated, "by Lieutenant Pike, who has ascended to its source and whose journal will be shortly made ready for communication to both houses of Congress."

While Jefferson was praising Pike to Congress, the unflappable explorer was trekking past the southwestern borders of the Louisiana Purchase. The Jefferson Administration wanted him to travel up the Arkansas and Red rivers, and gather information about the Great Plains and adjacent Spanish territory. One afternoon, like a mirage, he saw "a small blue cloud" on the far western horizon, which turned out to be the towering Rocky

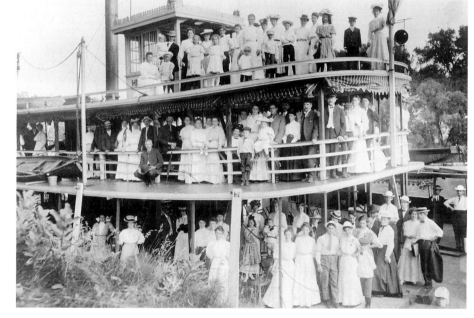

Party guests fill three levels of the *Hiawatha*, a steamboat commissioned to carry Grand Excursion guests from Rock Island, Illinois, to St. Paul, Minnesota.

Mountains. The Appalachian Mountains were hills by comparison. The tallest peak he encountered in Colorado, but never climbed—Pike's Peak—is named for him. From Colorado, Pike headed far into New Mexico, crossing the Sangre de Cristo Mountains. Spanish authorities immediaely arrested Pike and confiscated the expedition's most valuable property, namely maps, notes, and papers. Pike was imprisoned in

Santa Fe, New Mexico, and Chihuahua, Mexico. In 1807 Pike and his men were permitted again to travel eastward, under Spanish military escort through Texas, and to cross back into U.S. territory.

Jefferson urged Pike to publish his journals in 1810. Four years before the publication of the Lewis and Clark journals, the American people received *An Account of Expeditions To The Sources of the Mississippi, And Through The Western Parts of Louisiana, and A Tour Through the Interior Parts of New Spain,* the first written report about the trans-Mississippi territory.

The latter part of the report described the weakness of Spanish authority in Santa Fe and the profitability of trading with Mexico. The report offered valuable information about the geography of those areas and stirred thousands into seeking their fortunes in Texas.

Although an outstanding explorer, Pike not only misidentified the Mississippi River headwaters, but he also conveyed the erroneous notion that the fertile Great Plains were a "Great American Desert." As he wrote in his memoir, "These vast plains of the western hemisphere may become in time equally as celebrated as the sandy deserts of Africa."

Pike died at age 34, while leading American troops in an assault of Upper Canada, York (now Toronto, Ontario), during the War of 1812. His name, however, lives on. Besides a great peak and the island, ten counties and eighteen towns were named after him, as were five lakes, three rivers and two bays.

Pike rendered America a great service by voyaging up the Mississippi and planting American flags wherever he went. His expedition focused attention on the disputed boundary dividing the Louisiana Purchase from Canada. The British had been claiming land as far south as the Missouri River. Eventually the United States and Great Britain worked out their border issues. Pike's choice spot for Fort Snelling rapidly grew into the Twin Cities of St. Paul and Minneapolis through a steady influx of European immigrants during the 1820s.

In St. Paul—originally named Pig's Eye—steamboats reached the upper limit of practical navigability. Here the river was shallow and strewn with boulders, and the Falls of St. Anthony blocked the way farther upstream. By the mid-1850s tens of thousands of immigrants, attracted by the promise of prosperous lives in Minnesota, were traveling on steamboats to St. Paul. The number of steamboat arrivals grew from 256 in 1854 to 1,068 in 1858. Each steamboat carried several hundred passengers, but by the 1870s the boats' heyday had ended, and immigrant travel to Minnesota shifted to overland transport, principally to railroads.

One steamboat event, however, is still talked about in Minnesota: the Grand Excursion of 1854, the most celebrated tourist extravaganza of the era. We learned about the event from Elizabeth M. Vander Schaaf and Gregory K. Page, who sent us their pamphlet on the history.

During three days in June, a flotilla of seven steamboats packed with 1,200 distinguished passengers plied their way up the Mississippi River from Rock Island to St. Paul, a distance of some 280 miles. The *Chicago Tribune* gushed over the participants as "the most brilliant party ever assembled in the West, an ex-president, statesmen, historians, diplomats, poets, and the best editorial talent in the country."

The excursionists were the guests of Henry Farnam of Sheffield and Farnam, the company contracted for the Rock Island Railroad. Farnam was in a mood to celebrate. His firm had recently linked the East Coast to the Mississippi River by laying railroad tracks from Rock Island to Chicago. Now travelers from New York or Philadelphia could arrive on the banks of the Mississippi after only a three-day journey—a boon compared to the three weeks it usually took by coach, wagon, or canal boat. This was an achievement worth celebrating, and Farnam planned a big event, although he started off small. He chartered a single steamboat from the Minnesota Packet Company to take some family members and friends during high-water season, from Rock Island, Illinois, to St. Paul, Minnesota Territory. Excursions on the upper Mississippi had been popular with tourists since the 1830s, when steamboats began to make the voyage upriver to Fort Snelling. Vacationers flocked to see the upper river's famous scenery. The bluffs and Lake Pepin area were said to be more spectacular than the castles on the Rhine in Germany. Getting there had never been easier than with Farnam's railroad.

Nor had the region's unspoiled acres ever looked so prime for development, especially as Congress had recently ratified the 1851 treaties with the Dakota in Minnesota, which made much of the land available for settlement.

News of Farnam's A-list excursion made the rounds through the social set, and before long the invitation list grew. Farnam had to hire a second boat, then a third, and more. Arriving by rail from all points east, a lucky 1,200

assembled in Chicago; many others had to be turned away. The august group included former President Fillmore, his son and daughter, historian George Bancroft, renowned judges, clerics, Ivy League professors, erstwhile politicians, including the former mayor of New York, and two former state governors, a landscape painter of the Hudson River school, and the novelist Catherine Sedgwick. A group of reporters and editors represented no fewer than 50 of the nation's newspapers.

On June 5, the party left Chicago aboard two trains festooned with streamers and flowers. As the train reached Rock Island, the passengers cheered at their first glimpse of the Mississippi, "amid the firing of cannon, the waving of flags and the acclamation of the multitudes," according to *The New York Times*. A banner at the train station proclaimed, "The Mississippi and the Atlantic shake hands."

The choice of Rock Island as this nexus was no accident. The town was well-situated on two fronts: it was relatively close to Chicago, which had already staked out its role as the Midwestern hub for rail traffic from the East, and it stood well above the lower rapids at Keokuk, Iowa—a rough 12-mile stretch of the river that frequently made passage impossible for loaded vessels during low-water levels. What's more, Rock Island itself—that is, the stony outcropping in the Mississippi across from the town—made Rock Island the easiest place to bridge. Indeed, the first railroad bridge across the Mississippi River would be built there, opening only two years after Farnam's party. At this early date, his railroad was called the Chicago, Rock Island and Pacific Line, an indication that his ambitions lay farther west.

They stopped at Galena, then Dubuque—the beginning of the most remarkable stretch of Mississippi scenery. The writers and reporters tried mightily to convey the beauty of the landscape. A writer in *The New York Times* stated, "I request

you to pile the [Hudson River] Highlands on the Palisades [of New Jersey] and very often the Palisades upon the Highlands, that you may get some idea of the scenery of the upper Mississippi. You would, even then, fall short of any tolerable notion of its peculiar wild grandeur. Perhaps you have beheld such sublimity in dreams, but surely never in daylight walking elsewhere in this wonderful world. Over 150 miles of unimaginable fairy-land, genie-land, and world of visions, have we passed during the last 24 hours.... Throw away your guide books; heed not the statements of travelers; deal not with seekers after and retailers of the picturesque; believe no man, but see for yourself the Mississippi River above Dubuque."

The boats stopped at La Crosse and Trempeleau, then continued on to their destination, St. Paul, a full day ahead of schedule. In 1854 St. Paul was a newly incorporated city of about 6,000 people and was growing rapidly. The excursionists had only a short time to see St. Paul and the area's attractions, but their unexpectedly early arrival found their hosts unprepared to escort them around. In the ensuing scramble for transport, the 1,200 guests turned into a "motley cavalcade:" a governor rode off on a sorry-looking nag, a senator hung onto a coach's baggage boot, a prominent historian squatted on the top of a crazy van, various ladies perched over the hind axle of a lumber wagon, and an eminent newspaper editor straddled the barrel of a city water cart. All were headed to the storied Falls of St. Anthony, still unsullied in those days before St. Paul's twin—Minneapolis—became a city. The east bank of St. Anthony was only a small village near a few lumber mills. The excursionists held a "mingling of the waters" ceremony at the falls, in which a bottle of water from the Atlantic Ocean was poured into the Mississippi River.

After a farewell dinner and reception at the capitol with

speeches by Fillmore and Bancroft, one of the Easterners proclaimed himself mayor and mockingly said: "We welcome you, ladies and gentlemen, to the 'horse-pie-talities' of St. Paul. You came up here expecting to find us a half-civilized, half-fed race of beings; but now you may go home and tell that we are just as good-looking and well-dressed as any of you Yankees."

The *Chicago Tribune* summed up the visit as "thus happily ended, without a single accident or disturbance to mar the harmony and pleasure, the most magnificent excursion, in every respect, which has ever taken place in America." Local and national news coverage of the Grand Excursion continued for nearly a month, as the reporters' dispatches made it into their papers, and Midwestern papers reprinted what the Eastern press said. Catherine Sedgwick's article about the expedition in *Putnam's Magazine* underlined her conviction that a trip on the upper Mississippi was a "must-see" for any foreign tourist or honeymooning couple. The 1,200 swells traveling with Farnam constituted a population larger than that of most settlements on the Minnesota side of the Mississippi River. Before the 1851 treaties with the Dakota, white settlement had been limited to landings for steamboats for loading wood, and for loggers to assemble rafts, or for commercial ventures with the Dakota and trading posts.

The year after the excursion, steamboat travel to St. Paul doubled, adding 30,000 emigrants to the Minnesota Territory. With the new population, Minnesota joined Illinois, Iowa, and Wisconsin in becoming a state in 1858.

Jane Muckle Robinson (standing) helped keep river traffic near St. Paul on course from 1885 to 1921 by lighting a group of navigational lanterns every night.

The Grand Excursion served to "acquaint the men of capital and influence" with the upper Mississippi. That is also the premise of the St. Paul Riverfront Corporation's plan for a Grand Excursion 2004. Some 40 communities, the states of Minnesota, Wisconsin, Iowa, and Illinois, and dozens of organizations have joined to prepare the upper Mississippi for this event. The most dramatic feature will be a Grand Flotilla of steamboats, paddle-wheelers, spectator boats, and pleasure craft on the Mississippi. The flotilla will gather in the Quad Cities on June 25, 2004, and sail north, stopping in port towns along the way to arrive in the Twin Cities on July 4, 2004.

"What better way of celebrating the rebirth of the upper Mississippi River cities could there be than to reenact the event that first put our region on the map for the rest of the nation?" asked Twin Cities' WCCO television news anchor, Don Shelby. "The summer of the year 2004 will be the sesquicentennial of the Grand Excursion. A regional celebration at that time can become an incentive to prepare for the national spotlight and can help focus redevelopment efforts toward a common goal."

We learned the most unusual American factoids by talking to members of the St. Paul Riverfront Corporation. For example, "I cotton to you" became the 19th-century phrase that meant "I like you" because the raw cotton that was the chief cargo on the riverboats stuck to your clothes. Around such river ports as Red Wing and St. Paul, troubadours would wander around with

their fiddles, playing "Shenandoah," "Yankee Doodle," or the like for coins. Therefore, if you didn't work, you were accused of "fiddlin' around." The "outland" was considered to be anything west of the Mississippi, and pioneers who traveled there were called "outlanders." Their rough demeanor and buckskin clothing were thought to be "outlandish." And because steamboats used coal and wood to fire their boilers, they had tall fluted smokestacks to throw the fiery cinders behind their wooden superstructure. As the fanciest quarters on a steamboat were located on the upper deck above the malodorous animals below, the well-to-do were closest to the flutes or smokestacks and were said to be "high-falutin."

Like the St. Paul River Commission, the National Park Service is also on a mission to remind Americans of the role the river played in the development of Minnesota and the Twin Cities. On November 18, 1988, without much media fanfare, Public Law 100-696 established the Mississippi National River and Recreation Area (MNRRA) as a unit of the National Parks system. It was an achievement aimed to protect, preserve, and enhance the significant value of the Mississippi River corridor through the Twin Cities Metropolitan Area. The designated area includes 72 miles of the Mississippi River and four miles of the Minnesota River. The area encompasses about 54,000 acres of public and private land and water in five Minnesota counties. It's a landmark initiative which encourages coordination of federal, state, and local programs. Any supporter of the river will be pleased to read the "Comprehensive Management Plan" for MNRRA. For Minnesota is determined—along with Iowa—to make sure future generations can enjoy and comprehend their Mississippi River heritage. "National areas will be preserved, appropriate treatment of cultural resources will be ensured, economic resources will be protected, and public use will be enhanced," the report assures.

"Recreational activities will be available to visitors in the corridor, including fishing, hunting, boating, canoeing, hiking, bicycling, jogging, cross-country skiing, snow shoeing, picnicking, birding, taking photographs, and participating in interpretive and educational programs."

One section of the river for which MNRRA deserves particular praise is the so-called Mississippi Mile, which runs through downtown Minneapolis. For decades Minneapolis has turned its back on the river, but now a renaissance is in full swing. During the golden era of the 1880s to the 1930s, Minneapolis was the flour-milling capital of the world, and some of the old buildings are now made accessible to visitors. You can tour the historic seven-story-high Pillsbury "A" Mill, which in its day was the largest flourmill on the globe.

"The mills stood at St. Anthony Falls in their corona of flour dust like block houses guarding the rapid of the river," *The New York Times's* Harrison Salisbury recalled. "The grain poured in from Montana, the Dakotas, the Red River Valley. It poured into the Minneapolis mills, and the flour in its cotton sacks and its great jute cloaks filled counties' red freight cars and poured out over the country and over the world." Even today the Minneapolis Grain Exchange is still one of the world's largest cash grain markets.

We enjoyed visiting the Stone Arch Bridge, built in 1883 by James J. Hill's Minneapolis Union Railway Company; the Upper St. Anthony Falls Lock and Dam, the northernmost of the 29 locks connecting Minneapolis with the Gulf of Mexico; and historic Nicollet Island with its lovely riverfront inn. There are dozens of small parks, walking paths, and bikeways throughout the city.

Charlie Maguire, known as the Singing Ranger, is one of the park service's greatest assets. Like some clean-cut Bob Dylan (who was born in Hibbing, Minnesota), wearing an

official Smoky-the-Bear hat and olive-green uniform, with a mahogany guitar slung over his back, Maguire has done more to educate the public about the upper Mississippi than anybody else we encountered. An excellent harmonica player and old-time storyteller, Maguire has composed more than 800 songs. As a teenager growing up in Clarence, New York, he became friends with Lee Hayes, the folksinger who co-wrote "If I Had a Hammer" with Pete Seeger. Maguire went on to write two musicals for the Great American History Theatre in St. Paul: "Mesabi Red" and "Orphan Train." Now he is a regular guest on Garrison Keillor's *A Prairie Home Companion*. We first met Maguire in the Lilydale Regional Park, his pants rolled up to his knees, wading in the river. His mission is straightforward: "My job is to raise the profile of the Mississippi—to make the river a 'people's river' again."

Blessed with an affable demeanor, the Singing Ranger is immensely popular in Minnesota. Maguire has recorded seven albums, his best—by far—is "Great Mississippi." The songs of this album tell stories about such characters as Ozawindib, the American Indian who led Henry Schoolcraft to the river's headwaters in 1832, and Robert T. Hickman, an ex-Missouri slave who traveled up the Mississippi to found the Pilgrim Baptist Church in St. Paul. "Charlie Maguire...speaks and sings for a region, the Midwest, which he finds to contain the true heart of the nation," Hayes wrote of the Minnesota troubadour. "His songs are made of plain things and plain people.... Truthfully, he is a rather dour young man, but then he picks up the guitar and is transformed into a singer of strength and command. He rides herd on an audience, as Woody Guthrie did."

Essentially Maguire is a river activist, determined to preserve the 72-mile stretch of the Mississippi from Dayton to Hastings. His songs are filled with history of the area. One of his most appreciated services is penning a folk song titled "Light the River," about Jane Muckle Robinson, one of the Mississippi's unsung heroes. Born in Belfast, Ireland, in 1863 to James and Margaret Muckle, Jane immigrated with her parents and seven siblings to Minnesota when she was 18 years old. In 1881 she married Robert Robinson in Dundes, Minnesota. The couple soon moved to the town of South Park, located along the Mississippi near South St. Paul. That's when her legend began, and it continues to grow.

The year was 1885, and Jane Muckle Robinson was in need of work. She signed on with the Department of Commerce and Labor as a light keeper along the Mississippi. A strong woman, she was responsible for the nightly lighting of four river channel lights from Dayton's Bluff to the St. Paul Stockyards. Her official mandate read: "The lights must be lighted by sunset and kept burning brightly until sunrise, then extinguished. Clean, trim, and fill the lantern daily. Use a feather or soft pine stick to clean the burner. Polish the glass. Keepers must acquaint themselves with the best method of managing their lights and should freely ask questions when in doubt. Ignorance will not be considered an excuse for inefficiency."

No matter how cold or frozen the river, Lamplighter Jane rowed along the banks of the Mississippi every day for 36 consecutive years. She estimated that she rowed more than 50,000 miles to keep the lights burning for captains along her portion of the river. She realized that if she were delinquent in any way—a boat might founder and lives would be lost. For decades around St. Paul the name of Jane Muckle Robinson was synonymous with reliability. Upon retiring, she turned the lighthouse service over to her children; it had become a family business.

Nobody has done more to popularize St. Paul (population 280,000) than Garrison Keillor, whose *Prairie Home*

Companion radio show is recorded live most Saturday nights from the Fitzgerald Theatre. Keillor was reared in a suburb of St. Paul and has recalled his growing-up years with sly humor in his Lake Wobegon stories. Today he lives with his wife, Jenny Lind Nilsson, a classically trained musician, on a bluff overlooking the Mississippi. Their neighborhood—Summit Hill—is graced with magnificent Victorian, Queen Anne, Tudor, and Georgian homes. Unlike Minneapolis, there is a leisurely atmosphere to St. Paul, which reminded us of a southern river town. With great eloquence Keillor spins yarns about Old St. Paul. The city was not always quiet, he reminded us. In the early decades of the 1900s St. Paul was a safe haven for gangsters and bootleggers including Al Capone. If a mobster wasn't seen for awhile in New York or Chicago, people would say, "He's either in jail or in St. Paul."

When in St. Paul, it's also worth spending an afternoon in Keillor's Hill District to follow the ghost of novelist F. Scott Fitzgerald. For St. Paul—not Long Island, Paris, or the French Riviera—is the home of this genius wordsmith. The best place to start is at the brick building at 481 Laurel Avenue where Fitzgerald was born on September 24, 1896, a mile-and-a-half from the river. It is known as San Mateo Flats. Fitzgerald's parents had moved here two months before the future author of *The Great Gatsby*—and other

Two skips sweep a path for a stone in a curling match on the frozen Mississippi. The surface of the upper river freezes from late December through March.

enduring classics—arrived on the scene. St. Paul at the turn of the last century was conservative, traditional, and provincial. The Mississippi was no longer the primary lifeline to the greater world—the railroads were. As a boy Fitzgerald saw the riverfront as a mercantile highway void of romance. Ugly warehouses and dilapidated docks where bums scoured for leftovers were the reality of the wharf during this era. The city had turned its back on the river; buildings faced Summit Avenue, not the Mississippi. Fitzgerald wrote about this fact for the *Saturday Evening Post* in "The Popular Girl," his first two-part story published February 11 and 18, 1922: "The continuity of these mausoleums was broken by a small park, a triangle of grass where Nathan Hale stood ten feet tall with his hands bound behind his back by a stone cord and stared over a great bluff at the slow Mississippi. Crest Avenue ran along the bluff, but neither faced it nor seemed aware of it, for all the houses fronted inward toward the street."

Today St. Paul is reclaiming its river heritage. Fitzgerald fans even pay homage to a row house—designed by Cass Gilbert, master architect of Minnesota's State Capitol, the U.S. Supreme Court, and the Woolworth Building in New York—where, it is said, Fitzgerald was conceived. According to the *St. Paul Pioneer Press*, some 75 houses and buildings in the Hill District have a direct connection to Fitzgerald or his

family. When historian David Page—co-author with John Koblas of *F. Scott Fitzgerald in Minnesota*—wandered around St. Paul to retrace the novelist's childhood years in his state, he was surprised by how many old-timers remembered him unfavorably. A public outrage even ensued when someone suggested that a street be named after him. Fitzgerald's detractors saw him as a happy-go-lucky glamor boy-turned-alcoholic, not a masterful prose stylist. But in 1996 St. Paul did throw a centennial bash to celebrate his accomplishments, spearheaded by Keillor. "Mississippi River towns have given birth to numerous writers of merit," he noted at the time. "The Delta claims Faulkner, St. Louis T.S. Eliot, and St. Paul has F. Scott Fitzgerald. We're proud of him."

After leaving in 1922, Fitzgerald never returned to St. Paul, but he wrote a number of his 160 short stories about the area. His best, "The Ice Palace," is about a southern woman who becomes lost in an ice palace during a Minnesota winter carnival. In St. Paul he also worked on *Tales of the Jazz Age*, a lauded collection of short stories, and his novels *This Side of Paradise* and *The Beautiful and the Damned*. He mentioned dozens of Hill District landmarks in his works; as one example, he deemed the beautiful Cathedral of St. Paul "a plump white bulldog on its haunches." Today you can visit Old St. Paul Academy at 25 N. Dale Street, a yellow brick building where Fitzgerald attended school from 1908 to 1911. It was here that he published his first short story in the school paper, entitled "The Mystery of the Raymond Mortgage."

Novelist F. Scott Fitzgerald—shown with his wife Zelda—frequently used Minnesota settings in his stories, drawing on his early life in St. Paul.

Of particular interest is the Scott and Zelda Fitzgerald residence at 626 Goodrich Avenue, which he describes in his essay "Author's House." The dynamic young couple moved into this Victorian-era house in 1921 after the birth of their only child. Fitzgerald had become a celebrity because of the wild success of his first novel, *This Side of Paradise*, the story of a young man coming of age at Princeton University. Much larger chunks of his second novel, *The Beautiful and the Damned*, were written in the house's tower room, where a bird's-eye view of the Mississippi can be had. "It's small up there, and full of baked silent heat until the author opens two of the glass windows that surround it, and the twilight blows through," he wrote about the tower. "As far as your eye can see, there is a river winding between green lawns and trees and purple buildings and red slums blended in by a merciful dusk." Yet when Fitzgerald died of a heart attack in Dec. 21, 1940, he still had never owned a home.

It's been said that Fitzgerald grew up in "genteel shabbiness" in St. Paul and that the Mississippi served as the social stratification line. That is true. The poor lived along the river flats, whereas the wealthy lived on the bluffs. Stories are told about how he organized secret clubs, rode in sleighs to Town-and-Country clubs, practiced at the Ramaley School of Dance, and mingled with the best families in St. Paul, while never having enough money in his own pockets. Fitzgerald fancied himself rich, but had the soul of a poor boy. In "The Scandal Detectives," another story set in St. Paul, Fitzgerald wrote: "In sordid poverty, below the bluff two hundred feet

Schoolchildren in Minneapolis help move the John H. Stevens house, the first permanent home in the city, from the river to a new downtown park in 1896.

away, lived the 'micks'—they had merely inherited the name, for they were now largely of Scandinavian descent—and when other amusements palled, a few cries were enough to bring a gang of them swarming up the hill, to be faced if numbers promised well, to be fled from into convenient houses if things went the other way." He disliked the inherited wealth of St. Paul, and therefore became a social critic of the upper crust. "Let me tell you about the very rich," he complained in a short story. "They are different from you and me. They possess and enjoy early, and it does something to them, makes them soft where we are hard, and cynical where we are trustful, in a way that, unless you were born rich, it is very difficult to understand. They think, deep in their hearts, that they are better than we are because we had to discover the compensations and refuges of life for ourselves. Even when they enter deep into our world or sink below us, they still think that they are better than we are."

Fitzgerald seldom mentions the Mississippi by name in any of his fiction because he knew that the days of Mark Twain steamboat braggadocio were long past: The river had become an industrial sewer, the untamed wilderness of Zebulon Pike conquered by hordes of well-mannered European settlers. As he wrote in *The Great Gatsby,* "The frontiers once upon a time seemed a fresh green breast of the new world. Its vanished trees, the trees that made way for Gatsby's house, had once pandered in whispers to the last and greatest of all human dreams: for a transitory enchanted moment man must have held its breath in the presence of this continent."

Books on growing up on the Mississippi set the standard for American literature, topped by Mark Twain's *Tom Sawyer* and *Huck Finn.* Although Fitzgerald never wrote in great detail about the Mississippi River as it flows through Minnesota, another renowned American did. Charles A. Lindbergh grew up on a farm near Little Falls, in central Minnesota. The property line to the northeast, a couple of hundred yards from the front porch of the home, was the Mississippi River. Lindbergh once said that the river "has wound its way in and out of my life like the seasons."

The Mississippi was often on the mind of aviator Charles Lindbergh, whose fondness for the river was surpassed only by his passion for flying.

In 1969, when the Minnesota Historical Society was restoring the home—a donation in honor of Lindbergh's father—Russell W. Fridley of the Society asked Charles Lindbergh to write some reminiscences of life on the farm as a guide to the staff doing the restoration. Lindbergh replied with 85 handwritten pages, "simply with the idea of recording the information," jotted down from around the world. In 1972 the Minnesota Historical Society published the memoir under the title, *Boyhood on the Upper Mississippi: A Reminiscent Letter,* illustrated with many photographs.

The book carries the reader away to another place and time, describing life on a Midwestern farm, pre-electricity, pre-automobile, or tractor. Lindbergh gives descriptions of his father, a congressman, and his mother, of politics and farming, the Minnesota winter, his own schooling (outside and inside a classroom), and methods of travel. His mother, Evangeline Lodge Land Lindbergh, a high-school chemistry teacher when she met his father, had been drawn to the farm because of its beauty and its location. She thought living beside the Mississippi was "highly romantic."

In the garden, the boy and his mother grew flowers and vegetables—potatoes, carrots, beets, cabbages, tomatoes, and corn. "When the tomatoes were ripe, my father loved to pull them off the vines and eat them with a little salt. I ate them, too, but I liked best of all the sweet corn my mother cooked. She cooked on a wood stove.... [Her] dishes were simple and wonderfully good. She fried, boiled, baked, and roasted. We usually had meat three times a day, along with vegetables, salads, and fruits. For dessert we had pies (apple, peach, berry, pumpkin, gooseberry), puddings (bread, tapioca, plum), cakes (angel, chocolate), and cookies."

Lindbergh's feelings for the farm are evident throughout. He expressed them best in his book *Wartime Journals.* When he described life on the Isle of Illiec, the island off the coast of Brittany that he and his wife, Anne, had purchased in 1938 and lived on for two years, he said, "The old farm at Little Falls is the only other place I have loved as much."

Always there is the river. Lindbergh's father took him there to teach him to swim. "Our swimming place in the Mississippi was roughly two hundred yards to the north of our house," Lindbergh wrote. "There a small gap passed through the mound line next to the river, and beyond the gap a flattop, granite boulder made an excellent seat when one was not in swimming." Once as a boy "I waded out beyond my depth in the river and found myself swimming, scared, surprised, and delighted toward the shore. I can still see the smile of proud amusement on my father's face as he stood in the water nearby. Within three or four years, I was swimming down the river's rapids. From spring to fall there was a tremendous change in the flow of the river. In August, I could wade all the way across."

The fluctuating depth of the river created problems for those who were using it commercially, the loggers. They floated the logs cut in northern Minnesota down the river to Minneapolis. But at low water, logjams blocked the route. "Sometimes we would go down to the river and walk out on logjams," Lindbergh recalled. "These jams were often quite big. [Then] the bateaux and wanigans came through to clear them. The 'river pigs' would give exhibitions of logrolling and break up the seemingly unbreakable jams."

The Lindberghs' icehouse was filled with big ice cakes, cut from the Mississippi in the winter. It was the boy's job to split a cake into a size suitable to fit in the icebox, then haul it into the house. He explains how he learned to hunt, to drive a car, and to sleep in the screened-in porch, even in the winter.

In 1915 father and son set off in the family's Model-T Ford (Lindbergh learned to drive it at age 11, two years previously) to Lake Itasca. There they got into what Lindbergh called "a 16-foot clinker-built rowboat," constructed of overlapping boards. The two Lindberghs rowed for five days, going downriver from Lake Itasca to Cass Lake. Getting out, the boy discovered that the rowboat "was too heavy for me alone to drag out of the water and up the bank." The danger of high water, drifting logs, or theft made him determined. With his father's help, he got it up the ten-foot bank. That fall they returned to Cass Lake and proceeded down the river to Aitkin, Minnesota.

In 1920 Lindbergh left the farm to go to college. He chose the University of Wisconsin, "probably more because of its nearby lakes than because of its high engineering standards. Then, as now, I could not be happy living long away from water." In 1923 he bought his first airplane. He used it for barnstorming and flew to Little Falls, where he landed on the farm.

"I felt nostalgia then if I ever felt it in my life," he concludes *Boyhood on the Upper Mississippi,* "for I knew the farming days I loved so much were over. I had made my choice. I loved still more to fly."

Today the Charles A. Lindbergh House, operated by the Minnesota Historical Society, is unchanged. The furnishings are there as Lindbergh remembered them. The park, 328 acres, includes the Lindbergh History Center and the Weyerhaeuser Museum. The nature path from the house to the museum winds along the west bank of the river, and is the same path young Lindbergh used to get to his swimming hole. Somehow it is fitting that the entire area surrounding Little Falls is a bird sanctuary. As a boy, Lindbergh had studied their habits with passion.

The upper Mississippi between the Twin Cities and Little Falls is a fine place for bird-watchers. Without even trying we could see Peregrine Falcons, Black-capped Chickadees, Killdeers, and Blue Jays. The National Park Service operates a Birding Boat—a Mississippi paddlewheel-

Henry Rowe Schoolcraft served as an Indian agent for the Upper Great Lakes region in the 1830s.

er that departs during spring and summer from Harriet Island in St. Paul and Boom Island in Minneapolis. Participants are provided with a complimentary Birding Boat field guide, featuring full-color drawings of commonly seen birds. The guide includes maps of the Mississippi through the Twin Cities that provide the bird-watcher with historic and contemporary landmarks.

The stars of all bird cruises throughout the upper Missisippi are Bald Eagles, which can be seen gliding high above the river and nesting along the various locks. Whenever we spotted an eagle during our river travels—including two behind Lindbergh's house—we were awed. No bird is more majestic. The Bald Eagle is still a protected species throughout the lower 48 states, and much of its nesting and feeding habitat is being encroached on by humans. We were fortunate to pet and feed a domesticated eagle named Challenger, thanks to the non-profit American Eagle Foundation. The bird was named in honor of the space shuttle crew who perished in an accident in 1984. Challenger had been blown from a nest as a hatchling during a horrendous storm and was raised by its Wisconsin resucers. Because Challenger was handled by humans at a young age, it proved impossible to release it into the wild. Not that its rescuers didn't try. In 1989 they released the one-year-old bird, and it immediately flew toward an unsuspecting man to beg for food. Startled, the

Men row a bateau into Lake Itasca in a 1932 reenactment of the discovery of the headwaters of the Mississippi. A party led by Henry Rowe Schoolcraft reached the lake one hundred years earlier. An amateur ethnologist, Schoolcraft was drawn to the upper Mississippi by his curiosity for the local Ojibwe Indians. He married into one of the tribe's prominent families. Schoolcraft enlisted members of his new family and used their knowledge of the area to lead a team to the source of the Mississippi.

man was about to club it to death. Luckily someone inter-
vened. Challenger was placed under the care of the
Foundation by federal and state fish and wildlife agencies to
be used for educational purposes. The bird has been an
ambassador for its species ever since. Today Challenger is
the only Bald Eagle in the United States trained to free-fly
into Major League sports stadiums during
the playing of the national anthem.
Whether at Yankee Stadium shortly after
the World Trade Center bombing, at the
opening of the National D-Day Museum's
Pacific Wing in New Orleans, or at numer-
ous World Series games, to see Challenger
flying as the Stars and Stripes waves is a quin-
tessential American moment.

Heading north of Little Falls, the
Mississippi gets bluer, cleaner, and nar-
rower. We were en route to the true source
of the Mississippi River—Lake Itasca—only
about a hundred miles from the Canadian
border. Once officials realized that
Zebulon Pike had misidentified the head-
waters as Leech Lake, a bevy of other
explorers sought fame and glory by trying
to find the real source. Michigan
Territorial Governor Lewis B. Cass organ-
ized an expedition in 1820, arriving at a
calm water pool now known as Cass Lake,
one hundred miles south of Lake Itasca.
Three years later, an Italian named Giacomo Constantino
Beltrami, accompanied only by a few Chippewa Indians who
served as canoe paddlers, likewise went in search of the
source. When a small pack of Sioux attacked them, the
Chippewa fled, leaving Beltrami all alone. Any other person

"Paul Bunyan"
Bemidji, Minn

Lumbermen who logged Minnesota's forest
created the folk legend of Paul Bunyan.
His statue greets visitors to the
headwaters city of Bemidji.

would have given up. Filled with grandiose notions that he
was a modern-day Marco Polo, he reached eventually, with
the help of a mixed-blood Indian, a patch of water which he
claimed to be the true source of the Mississippi. He named it
Lake Julia, in honor of Countess Giulia Medici Spoda.
"Like Aeneas I have roamed through the unknown world
and have discovered the well-spring of the
Mississippi," he wrote. "Oh, happy day.
From this day on, I will be counted among
the immortals." He returned to St. Louis
to boast about his accomplishment and
wrote two books touting his discovery. But
nobody believed his story.

Finally, the historian Henry Rowe
Schoolcraft, who was also a trained miner-
alogist, solved the mystery of the headwa-
ters. Schoolcraft had been a member of
Lewis B. Cass's expedition in 1820. He was
haunted by his team's failure and decided
to take matters into his own hands. On July
10, 1832 he left Cass Lake on a short trip
to find the headwaters. Wisely he brought
with him the Chippewa Chief Ozawindib,
who knew the Minnesota north country
better than anyone else. After three days in
a canoe, they arrived at a reed thicket,
plodded through it, and found a virgin
lake. Schoolcraft was certain that this
sparkling lake was the true source of the
Mississippi. He immediately raised an American flag, fired
off rifles, and cobbled together three syllables from two
Latin words "veritas caput"—the true head—and called his
discovery Lake Itasca. His report was full of unbridled
enthusiasm; after all, it had been 313 years since the first

Europeans had encountered the Mississippi River, and still no one else had found the headwaters. "We followed our guide down the sides of the last elevation with the expectation of momentarily reaching the goal of our journey," he wrote. "What had been long sought, at last appeared suddenly. On turning out of a thicket, into a small weedy opening, the leering sight of a transparent body of water burst upon our view. It was Lake Itasca."

Today Lake Itasca State Park encompasses 32,000 acres, about 50 square miles of preserved woodlands surrounding the lake. The terrain could not be more different from the subtropical Head of Passes. In Louisiana the river is thick and muddy and wide, exuding a pungent odor. It's a menacing river where hundreds of swimmers have died trying to cross it. In Minnesota the river glides through glacier country, and even in summer there is a nip in the air at night. More than 1,000 crystal-clear lakes in the area are known as Headwaters Country; you can drink from any of them. One of the greatest thrills for a visitor is simply stepping across the smooth rocks in the two-foot-deep brook that trickles into Lake Itasca. A brown wooden sign with bright yellow lettering reads: "The Mighty Mississippi Begins To Flow On Its Winding Way 2,352 Miles To The Gulf of Mexico."

We camped under towering stands of red and white pines near Lake Itasca and thought about the river. We explored spruce bogs and canoed in the birch-lined lake. As a fire roared, we spoke of archaic buffalo hunters who once roamed the bogs of Lake Itasca, and of the folk legend Paul Bunyan, whose giant statue we encountered, along with his blue ox, Babe, in nearby Bemidji, Minnesota—the closest city to the headwaters. At dusk we tossed a piece of pinewood into Lake Itasca and watched it slowly float away. Would it make it all the way to Charles Lindbergh's house in Little Falls, we

wondered? Could it float over the various locks and dams and end up someday in the Gulf of Mexico? Was it possible that the small log would land on the sandy shores of Africa as Jack Kerouac envisioned? Or were we just being American romantics daydreaming about a river where everything seemed possible?

But mainly we thought of Thomas Jefferson and the Louisiana Purchase. By dispatching Lewis and Clark—to explore the West all the way to the Pacific Ocean—and the Pike Expedition—to find the headwaters of the Mississippi and to map the land up to the Rocky Mountains—Jefferson created the modern United States. His Presidential accomplishment is unparalleled except for Lincoln's leadership during the Civil War. We thought of all the Native Americans who had lived along the great river when buffalo herds were plentiful and the U.S. Army Corps of Engineers had yet to build a single lock.

One thing we knew for certain from our many months of travel: The Mississippi was both the spiritual heart and economic backbone of our country. During our last night along the river, we read out loud from a pamphlet by Jim Jones, Jr., of Bemidji, Minnesota, a member of the Ojibwe Indian tribe, the Leech Lake Pillager Band. His words rang truer to us than those of Twain or Wright or Eliot. It has come to serve as our endearing sentiment.

"I look back at what the Mississippi is to me, and it's the giver of life," Jones wrote. "Everything is a circle—a circle of life. That river's been around here for thousands of years, and people have been using it for thousands of years. And people will continue to use it for the next thousands of years, as long as we keep that circle, don't ever try to sever all the spines that go to it, because the Mississippi is just one part of that web." We were—and are—lucky to be part of the Mississippi River spine, which pulls our nation together. ★

BIBLIOGRAPHY

★

Ackroyd, Peter. *T.S. Eliot, A Life,* Simon and Schuster, 1984.

Adams, Henry. *History of the United States of America During the Administrations of Thomas Jefferson,* The Library of America, 1986.

Ambrose, Stephen E. *Americans at War,* University Press of Mississippi, 1997.

Ambrose, Stephen E. *Lewis & Clark, Voyage of Discovery,* National Geographic Society, 1998

Ambrose, Stephen E. *Undaunted Courage,* Simon & Schuster, 1996.

American Heritage, eds. *Steamboats on the Mississippi,* Troll Associates, 1962.

Armstrong, Ellis. *History of Public Works in the United States, 1776-1976,* Chicago: American Public Works Association, 1978.

Armstrong. Louis. Dan Morgenstern *Satchmo - My Life in New Orleans,* Da Capo Press, 1986.

Baldwin, Leland D. *The Keelboat Age on Western Waters,* University of Pittsburgh Press, 1941.

Barry, John. *Rising Tide: The Great Mississippi Flood of 1927 and How it Changed America.* Simon and Schuster, 1997.

Bartlett, Richard A. *Rolling Rivers: An Encylopedia on America's Rivers,* McGraw Hill, 1984.

Billington, Ray Allen. *Westward Expansion: A History of the American Frontier,* Macmillan, 1982.

Blumberg, Rhoda. *What's the Deal? Jefferson, Napoleon, and the Louisiana Purchase,* National Geographic Society, 1998.

Brown, Alan. *Literary Levees of New Orleans,* Starrhill Press, 1998.

Butler, Mann. *Valley of the Ohio,* Kentucky Historical Society, 1971.

Carleton, Mark T. *Politics and Punishment: the History of the Louisiana State Penal System,* Louisiana State University Press, 1971.

Carter, Hodding. *Where Main Street Meets the River,* Rinehart, 1953.

Childs, Marquis. *Mighty Mississippi, Biography of a River,* Ticknor & Fields, 1982.

Collins, Paul. *Banvard's Folly,* Picador USA, 2001.

Cox, Isaac Joslin. *The West Florida Controversy, 1798-1813,* Johns Hopkins Press, 1918.

Curtis, Nancy C. *Black Heritage Sites, The South,* The New Press, 1996.

Davis, Miles, with Quincy Troupe. *Miles,* Simon & Schuster, 1989.

Dickens, Charles. *American Notes for General Circulation,* Ticknor and Fields, 1867.

Dohan, Mary Helen. *Mr. Roosevelt's Steamboat,* Thorndike Press, 1982.

Dupuy, Eliza Ann. *The Planter's Daughter: A Tale of Louisiana,* W.P. Fetridge, 1857.

Early, Gerald, ed. *Miles Davis and American Culture,* Missouri Historical Society Press, 2001.

Erickson, Lori. *The Mighty Mississippi, A Traveler's Guide,* The Globe Pequot Press, 1995.

Flint, Timothy. *Recollections of the Last Ten Years,* Southern Illinois University Press, 1968.

Fugina, Frank J. *Love and Lure of the Upper Mississippi River,* Frank Fugina, Winona, Minnesota.

Geuss, Theodore. *The Mississippi,* The University Press of Kentucky, 1989.

Where the Mississippi and Missouri rivers meet rises the Lewis and Clark State Historic Site. Its vertical tablets signify the states through which the explorers traveled.

Glewwe, Lois A. *South St. Paul Centennial 1887-1987*, South St. Paul Area Chapter of the Dakota County Historical Society, 1987.

Gore, Laura Locul. *Memories of the Old Plantation Home and A Creole Family Album*, Vacherie, 2000.

Grant, Julia Dent. *Personal Memoirs*, G.P. Putnam's Sons, 1975.

Grant, Ulysses S. *Memoirs and Selected Letters*, The Library of America, 1990.

Hall, B.C. and C.T. Wood. *Big Muddy: Down the Mississippi Through America's Heartland*, Plume, 1937.

Handy, W.C. *Father of the Blues*, Macmillan Company, 1941

Hollon, W. Eugene. *The Lost Pathfinder*, University of Oklahoma Press, 1949.

Howard, Robert P. Illinois, *A History of the Prairie State*, William B. Eerdmans Company.

Hotaling, Edward. *The Great Black Jockeys*, Rocklin, California, 1999.

Kane, Harnett T. *Bayous of Louisiana*, W. Morrow & Co. 1943.

Kaplan, Lawrence S. *Thomas Jefferson, Westward the Course of Empire*, Scholarly Resources, 1999.

Keating, Bern. *The Mighty Mississippi*, National Geographic Society, 1971.

Kennedy, Roger. *Burr, Hamilton and Jefferson: A Study in Character*, Oxford University Press, 2000.

Ker, Henry, *Travels Through the Western Interior of the United States*, 1810.

Lauber, Patricia. Flood, *Wrestling With the Mississippi*, National Geographic Society, 1996.

LeClair, Antoine, interpreter. *Autobiography of Ma-Ka-Tai-Me-She-Kia-Kiak or Black Hawk*, Press of Continental Printing, 1882.

Lindbergh, Charles. *Boyhood on the Upper Mississippi: A Reminiscent Letter*, Minnesota Historical Society, 1972.

Nevitte, Eliza. *Shannondale*, Appleton, 1850.

Page, David and Jack Koblas. *F. Scott Fitzgerald in Minnesota: Toward the Summit*, North Star, 1996.

Peterson, William J., *Steamboating on the Upper Mississippi*, State Historical Society of Iowa, 1868.

Pike, Zebulon M. *An Account of Expeditions to the Sources of the Mississippi and Through Western Parts of Louisiana...by Order of the Captain-General in the Year 1805-07*, Conrad & Co., Philadelphia, 1808.

David S. Reynolds. *Walt Whitman's America*, Knopf, 1995.

Remini, Robert V. *The Battle of New Orleans*, Viking, 1999.

Salecker, Gene Eric. *Disaster on the Mississippi*, Naval Institute Press, 1996.

Samuel, Ray, Leonard V. Huber, Warren C. Ogden. *Tales of the Mississippi*, Pelican, 1981.

Sansing, David G., Sim C. Callon, Carolyn Vance Smith. *Natchez: An illustrated History*, Plantation Publishing Company, 1992.

Saxon, Lyle. *Lafitte the Pirate*, Pelican Publishing Company, 1992.

Schwieder, Dorothy. *Iowa, The Middle Land*, Iowa State University Press, 1996.

St. Louis Walk of Fame: 75 Great St. Louisans, St. Louis, *1998*.

Jerry E. Strahan. *Andrew Jackson Higgins and the Boats That Won World War II*, Louisiana State University Press, 1994.

Troen, Selwyn K., Glen E. Holt, eds. *St. Louis*, New Viewpoints, 1977.

Twain, Mark. *Life on the Mississippi*, Bantam Books, 1981.

Ward, Geoffrey C. and Ken Burns. *Jazz: A History of America's Music*, Knopf, 2000.

Weil, Tom. *The Mississippi River*, Hippocrene Books, Inc., 1992.

Westfall, Donald H. *Charles A. Lindbergh House*, Minnesota Historical Society Press, 1994.

Wolfe, Charles & Kip Lornell, *The Life & Legend of Leadbelly*, HarperCollins, 1992.

Wright, Richard. *Black Boy*, Prentice Hall, 1998.

ARTICLES:

"A River Runs Through It," Los Angeles Times Book Review, March 17, 2002

"Great River's Mouth Opens...to Swallow the World," *USA Today*, April 26, 2001.

"Great Trees Grow into History," *USA Today*, April 26, 2001.

"Life on the Mississippi," *Time*, June 10, 2000.

"Memphis Manor Gave Escaping Slaves Refuge," USA Today.com, May 4, 2001.

"Myth of the Great Mississippi Bear Hunt," *Oxford American*, Nov./Dec.2000.

INDEX

★

CONTRIBUTORS/ACKNOWLEDGMENTS/CREDITS

★

THE CONTRIBUTORS

SAM ABELL: National Geographic Photographer in Residence Sam Abell has worked with the National Geographic Society since 1970 and has photographed more than 20 articles on cultural and wilderness subjects. Sam Abell has published nine books with National Geographic, including *Seeing Gardens* in 2001 and *Australia: Journey Through a Timeless Land* in 1999. In 1998 he collaborated with Stephen Ambrose to publish *Lewis & Clark: Voyage of Discovery*. His other books include *The Inward Garden: Creating a Place of Beauty and Meaning* (Little, Brown & Company, 1995) and *Contemplative Gardens* (Howell Press, 1990). In 1990, Eastman Kodak published a retrospective monograph of Sam Abell's photographs entitled *Stay This Moment*. A companion exhibit was at the International Center of Photography in New York. A book of his best personal and professional work, titled *The Photographic Life*, will be published in 2002. Sam Abell is on the board of trustees of the George Eastman House and is founder of the Center for Photographic Projects in Santa Fe, New Mexico. He lives in Albemarle County, Virginia, with his wife, Denise.

STEPHEN E. AMBROSE: Renowned historian Stephen Ambrose has written several national bestsellers including *Wild Blue, Nothing Like It in the World, Citizen Soldiers, Undaunted Courage,* and 14 other books including the celebrated *Band of Brothers,* which became a 10-part series on HBO. He has appeared in and consulted on many documentaries and films, including: Ken Burns's special on Lewis and Clark, "Lewis and Clark: Great Journey West." He worked with Steven Spielberg on the film "Saving Private Ryan" and the documentary "Price For Peace." A retired Boyd Professor of History at the University of New Orleans, he founded the National D-Day Museum in New Orleans. In 1999 the President of the United States awarded him the National Humanities Award. In 2000, the Secretary of Defense awarded him the Distinguished Civilian Service Medal. His book *Love Song To America* is due for publication in Fall 2002. He lives in Bay St. Louis, Mississippi, with his wife, Moira.

DOUGLAS G. BRINKLEY: Dr. Douglas Brinkley currently serves as Director of the Eisenhower Center for American Studies, and is a Professor of History at the University of New Orleans. His most recent publications include *Rosa Parks* and the *American Heritage History of the United States.* Three of his books—*Driven Patriot: The Life and Times of James Forrestal; Dean Acheson: The Cold War Years;* and *The Unfinished Presidency: Jimmy Carter's Journey Beyond the White House*—were selected as *New York Times* "notable" books. Doug Brinkley has written extensively for journals including *Newsweek, Time, American Heritage, The New Yorker, The New York Times, The Wall Street Journal,* and *The Atlantic Monthly.* He has been historical consultant for numerous films and television specials including the A&E/The History Channel documentary on the Mississippi River. He is American History commentator for National Public Radio, regular contributor to the *Los Angeles Times* Book Review and a frequent guest on CNN, C-SPAN, The Today Show, CBS Evening News, among other programs. His book *Wheels for the World: Henry Ford, His Company and a Century of Progress* will be published in Spring 2003. He lives in New Orleans with his wife, Anne.

ACKNOWLEDGMENTS

This book was written to help commemorate the 200th anniversary of the Louisiana Purchase of 1803. Both of us were asked to serve on the Bicentennial Honorary Committee, chaired by the First Lady of the United States, Laura Bush; a request we gladly embraced. For people living west of the Mississippi River the Louisiana Purchase—like the Fourth of July Day is for the original 13 colonies—is their real Independence Day. We're proud that *The Mississippi and the Making of a Nation*—like the unprecedented exhibit in the New Orleans Museum of Art titled "Jefferson's America and Napoleon's France" (curated by Dr. Gail Feigenbaum, an associate director of the Getty Research Institute in Los Angeles) is part of this grand historical remembrance. The exhibit would have been impossible without the bold and creative leadership of the museum's director, E. John Bullard. We would like to thank all our colleagues who are serving with us on the Honorary Committee for not forgetting the past. Among those a special nod of gratitude is in order to our dear friend Corinne Claiborne (Lindy) Boggs, a direct descendant of William C.C. Claiborne, who served as the first territorial governor of Louisiana from 1803 to 1809 and who officially accepted the territory from France.

While researching the Louisiana Purchase, a debt was incurred to the National Archives in College Park/Washington, D.C. and the Ministère des Affaires Etrangères in Paris. We also want to thank Dr. Daniel P. Jordan, President of the Thomas Jefferson Memorial Foundation for keeping the spirit of the Sage of Monticello alive. And what a joy it is to see Louisiana's license plates all read: "Louisiana Purchase Bicentennial" —a reminder to everybody in the Pelican State about the genius of Jefferson's effort to build an "Empire of Liberty." These things don't happen without public servants willing to act.

Special thanks to Governor Murphy J. Foster, U.S. Senator John B. Breaux and Mary Landrieu, and Secretary of the Louisiana Department of Culture, Recreation, and Tourism Philip J. Jones. And, not to be forgotten, the tireless do-gooder Mary Perrault, executive director of the Louisiana Purchase Bicentennial, who has made us all look good.

We wrote this book as part of the ongoing Mississippi River Heritage Project at the Eisenhower Center for American Studies at the University of New Orleans. The project is coordinated by our Associate Director Kevin Willey, who organized our numerous trips up and down the Mississippi with great skill and good humor. He also spearheaded our research efforts, answering every query imaginable. Hugh Ambrose, our agent for this project, served as our liaison within National Geographic. He was remarkable. Sarah Rowe, a budding Latin American historian, spent countless hours fact-checking and tracking down secondary sources. She was also in charge of manuscript preparation. At an early stage in the book Erica Whittington, now working on her doctorate in history at the University of Texas-Austin, was invaluable during the formative stages of this new project. Likewise, Andrew Devereux, working on his master's degree in Medieval History at the University of Toronto helped us research the first five chapters. Katherine Adatto assisted us while traveling on the *Delta Queen* from St. Louis to St. Paul, enduring long hours of research and computer work on the river. Michael Edwards provided us with an immeasurable sum of research and support. And Eva Reitspiesova, an exchange student from the Czech